100 Flying Birds

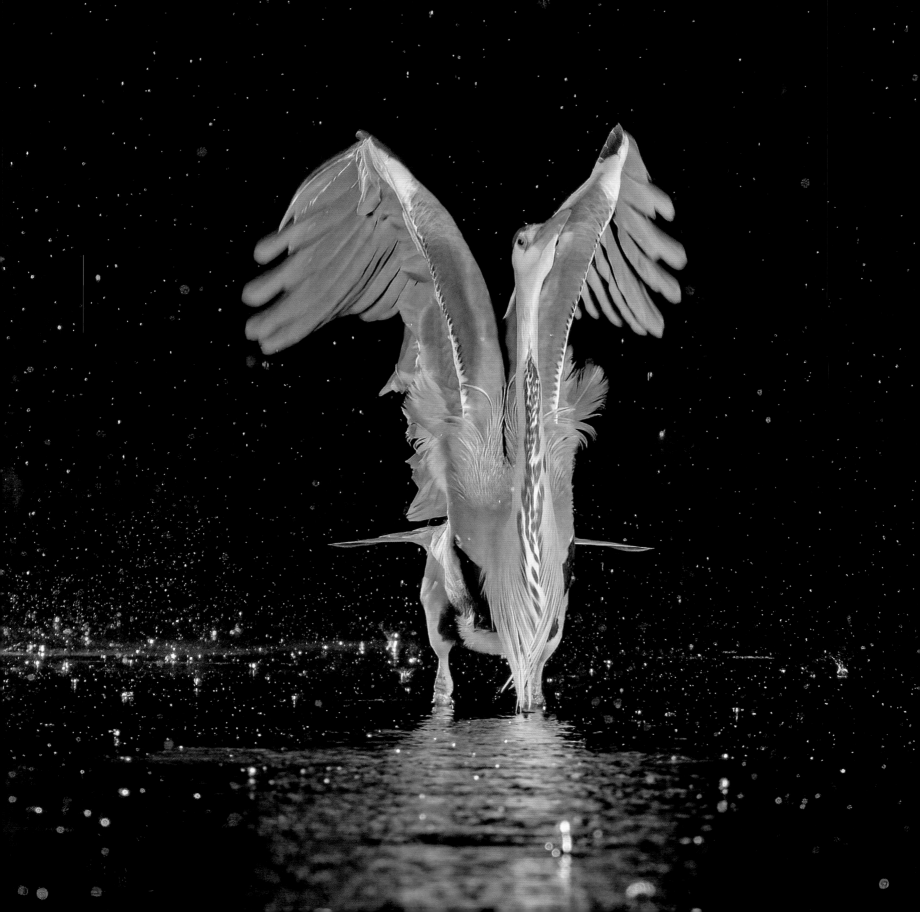

100 FLYING BIRDS

Photographing the Mechanics of Flight

Peter Cavanagh

FIREFLY BOOKS

A FIREFLY BOOK

Published by Firefly Books Ltd. 2021
Copyright © 2021 Firefly Books Ltd.
Text copyright © 2021 Peter Cavanagh
Photos copyright © 2021 Peter Cavanagh, except as listed on the left

All rights reserved. No part of this publication may be reproduced, stored in a retrieval system, or transmitted in any form or by any means, electronic, mechanical, photocopying, recording or otherwise, without the prior written permission of the Publisher.

First printing

Library of Congress Control Number: 2021935118

Library and Archives Canada Cataloguing in Publication
Title: 100 flying birds : photographing the mechanics of flight / Peter Cavanagh.
Other titles: One hundred flying birds
Names: Cavanagh, Peter, author, photographer.
Description: Includes bibliographical references and index.
Identifiers: Canadiana 2021016851X | ISBN 9780228103332 (hardcover)
Subjects: LCSH: Birds—Flight—Pictorial works. | LCSH: Birds—Flight. | LCSH: Photography of birds.
Classification: LCC QL698.7 .C38 2021 | DDC 598.19/7—dc23

All photos and images are by the author unless otherwise credited.

l=left, *r*=right, *t*=top, and *b*=bottom

Fromokdbooks, 300*br*; Robert S. Harrison, author portrait; Brandon Hedrick, 158; Brian Choo, 281*t*; Karl-L. Schuchmann, 289*l*; Soteras F, 289*r*; Vintners' Company, 135

Alamy: Guillermo Avello, 207*b*; Patrick Guenette, 231*t*; The History Collection, 281*b*; Oldtime, 298*b*; PA Images, 243; Yulia Ryabokon, 113*r*; Erik Scholgl, 41*l*; Tristar Photos, 207*t*; Peter Robst, 183*b*

Shutterstock: Angelinast, 15*t*; Chloe7992, 161

iStock: nalzisart, 15*b*

The Advanced Reading for this title can be found at the following:

Published in the United States by	Published in Canada by
Firefly Books (U.S.) Inc.	Firefly Books Ltd.
P.O. Box 1338, Ellicott Station	50 Staples Avenue, Unit 1
Buffalo, New York 14205	Richmond Hill, Ontario L4B 0A7

Cover and interior design: Hartley Millson
Editor: Darcy Shea

Printed in China

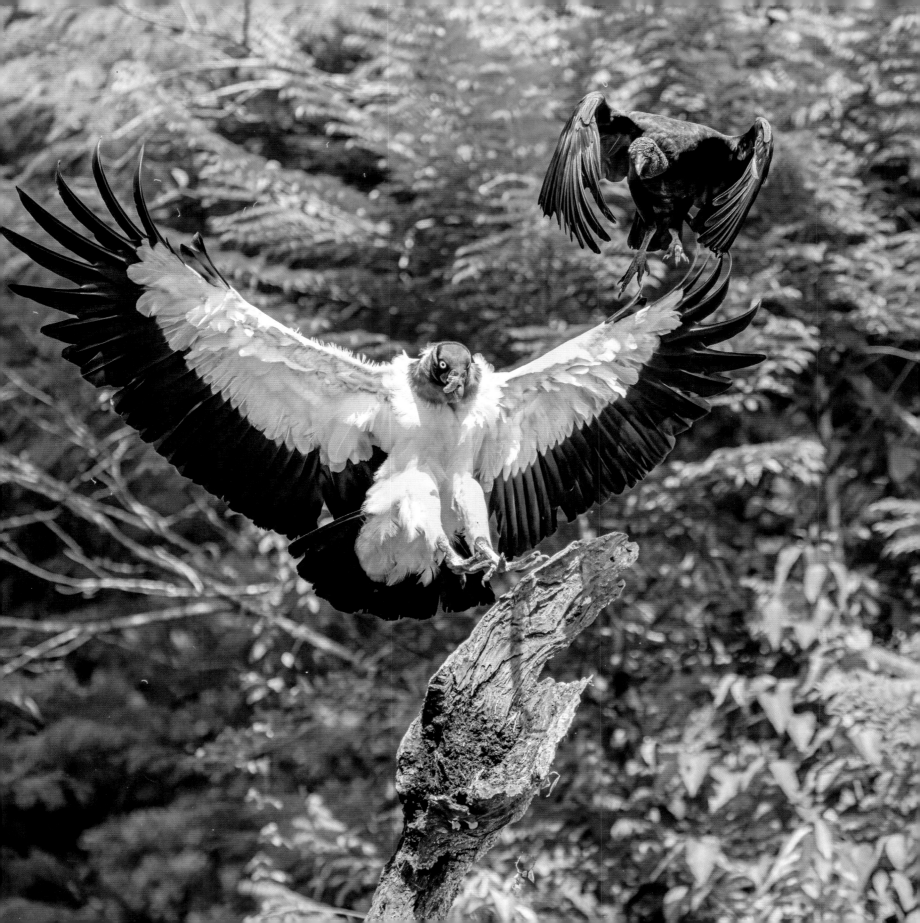

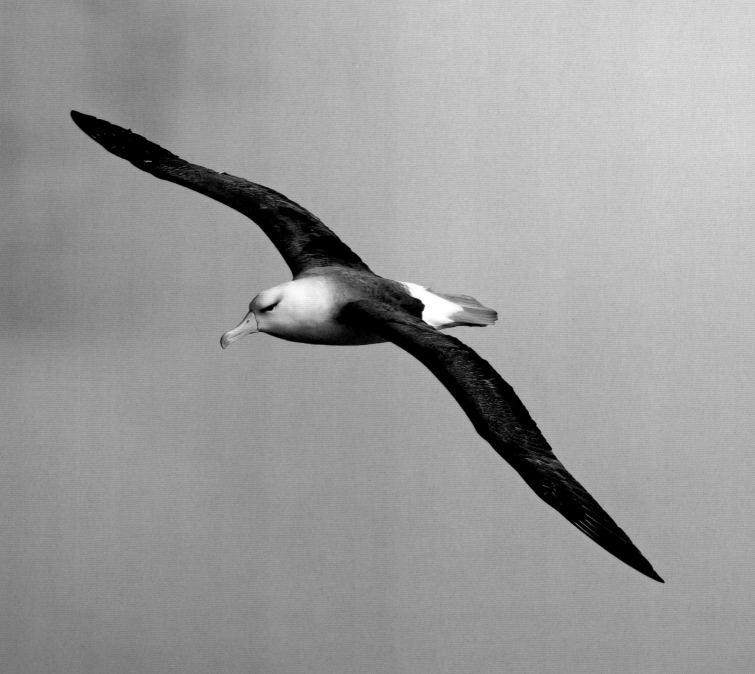

Contents

Preface *10*

1 Eagles 13

White-tailed Eagle
Steller's Sea-Eagle
Wahlberg's Eagles
Bald Eagle
White-tailed Eagles
Bateleurs
Golden Eagle
African Hawk-Eagle
African Fish-Eagle

2 Hummingbirds 37

White-whiskered Hermit
Koepcke's Hermit
Peruvian Booted Racket-tail
Marvelous Spatuletail
Sword-billed Hummingbird
Rufous-crested Coquette
Purple-throated Woodstar
Rufous-tailed Hummingbird
Shining Sunbeam

3 Gulls & Terns 61

Belcher's Gull
Caspian Tern
Lava Gull
Glaucous-winged Gull
Inca Tern
Sandwich Tern
Yellow-legged Gull
Swallow-tailed Gull
Antarctic Tern

4 Small Waterbirds 85

Dunlins
Band-rumped Storm-Petrels
Hawaiian Stilt
Black Skimmer
Black Skimmer
Black-tailed Godwits
Red-billed Tropicbird
Whimbrel
Boat-billed Heron

5 Large Waterbirds 109

Red-footed Booby
Blue-footed Booby
Magnificent Frigatebird
Saddle-billed Stork
Roseate Spoonbill
Brown Pelican
American White Pelican
Goliath Heron
Southern Giant-Petrel

6 Ducks, Geese & Swans . . 133

Northern Pintail
Buffleheads
Snow Geese
Ruddy-headed Goose
Canada Goose
Trumpeter Swans
Whooper Swans
Yellow-billed Pintail
Upland Goose

7 Raptors 157

Short-eared Owl
Snowy Owl
Red-tailed Hawk
Osprey
Snail Kite
Black Kite
Galápagos Hawk
Blakiston's Fish-Owl
Striated Caracara

8 Condors & Corvids 181

California Condor
Andean Condor
The Temple of the Condor
American Crow & Bald Eagle
Andean Condor
Common Raven
Red-billed Chough
Common Raven
Andean Condor

9 Cranes 205

Whooping Cranes
White-naped Cranes
Hooded Crane
Sandhill Cranes
Sandhill Crane
Sandhill Cranes
Red-crowned Cranes
Red-crowned Crane
Red-crowned Crane

10 Songbirds 229

Brewer's Blackbird
Woodland Kingfishers
White-crowned Sparrow
Red-winged Blackbird
European Starlings
Española Mockingbird
American Goldfinch
Cedar Waxwing
Rufous-chested Swallow

11 Favorites 253

Atlantic Puffin
Southern Yellow-billed Hornbill
Snowy Sheathbill
Southern Rockhopper Penguins
Collared Aracari
Glossy Ibis
Red-and-Green Macaws & Scarlet Macaws
Wandering Albatross
Northen Gannets
Keel-billed Toucan

Epilogue *279*
Endnotes *286*
Further Reading *304*
Index *316*
Acknowledgments *320*

Preface

Species
American Avocet (*Recurvirostra americana*)

Location
Great Salt Lake, Utah

Settings
Canon EOS-1D X | EF 500 mm f/4L IS USM
1/2000 sec at f/16 | ISO 1600

Flight is the essence of bird life. Flying has allowed birds to thrive through cycles of environmental and climatic change since they evolved from dinosaurs about 140 million years ago. Birds fly to escape from predators, to migrate to more favorable climates and to extend their food choices beyond what is available in their neighborhoods. They fly in all types of weather, perform feats of aerobatic excellence, have wings that are self-repairing, and they can take off from and land on everything from a fragile twig to a seething ocean.

Not surprisingly, humans with aspirations of flight have looked to birds for inspiration and instruction. Leonardo da Vinci wrote a treatise on the flight of birds with illustrations of Black Kites (*Milvus migrans*), which informed his design of flying machines; Otto Lilienthal died when he tried to glide like the migrating White Storks (*Ciconia ciconia*) of his native Pomerania; and the Wright brothers filed a patent for warping wings that emulated the flight of Turkey Vultures (*Cathartes aura*). More recently, the upturned wing tips of jet aircraft mimic the "fingers" of birds' terminal primary feathers[1], and the slotted leading edges of aircraft wings are directly copied from the alula ("thumb" wing) in birds. There is, not surprisingly, a rich trove of scholarly articles devoted to biomimetic aircraft.

Photographing birds in flight has been my consuming passion since I moved to the Pacific Northwest 12 years ago. This pursuit has been informed by my academic training in anatomy and biomechanics, my studies of aerodynamics in pursuit of a private pilot instrument rating

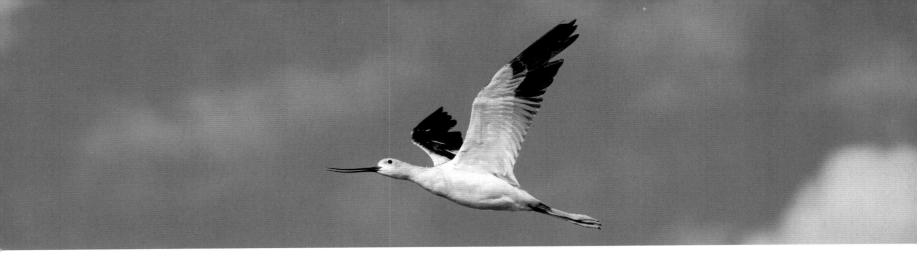

and a lifelong interest in photography and the outdoors. It has taken me from the cliffs of Iceland to the ice pack of the Antarctic Peninsula, which is a substantial part of the route that the Arctic Tern (*Sterna paradisaea*) takes on its astonishing round-trip migration of up to 49,710 miles (80,000 km)[2].

For me, there is no contest between a photograph of a stationary bird and one in flight — the flight shot is almost always the hands-down winner! The fragile span of outstretched wings and the arc of a graceful flight path are irresistibly beautiful. Capturing this feat in a few megapixels is a privilege and a joy, but flight photography generally makes greater demands on equipment, technique and the photographer's patience and body. It is astonishing that early photographers, who did not have the benefit of autofocus lenses and power-driven shutters, were able to achieve such fine results.

I have gathered 100 of my favorite flight images into 11 broad groups, some functional and others taxonomic. Each image is accompanied by its own unique story. Sometimes the bird itself is the story — its history, naming or conservation status, or some aspect of flight mechanics. For other photos, the scene's ambiance and uniqueness take center stage. I occasionally mention key technical aspects of the image, and the stories associated with some photos combine all of the above.

The dimensional details (where available) and names of the birds are primarily taken from the Cornell Lab of Ornithology's authoritative website Birds of the World[3]. The status of each species is as listed at the time of access to the IUCN Red List[4]. The sex of the bird is indicated only when there is marked sexual dimorphism (other than differences in size). Often, I include footnotes with other photographs and further explanation of the topic. Following the endnotes for each chapter, a list of some further reading is provided, so that interested readers can follow up with their own research. An advanced reading list can be found here: https://www.petercavanagh.us//100-flying-birds-advanced-reading, including links to primary sources. There are mountains of interesting papers on avian flight and these leads will help you find them.

Photographs serve and augment memory. As I browse the more than 500,000 photographs of birds that I have taken, I can clearly recall the locations and circumstances in which I took almost every image, but the one thing that photographers like more than capturing images is sharing them. It is my great pleasure to share these birds, these places and these stories with you.

Peter R. Cavanagh
Lopez Island, Washington
2021

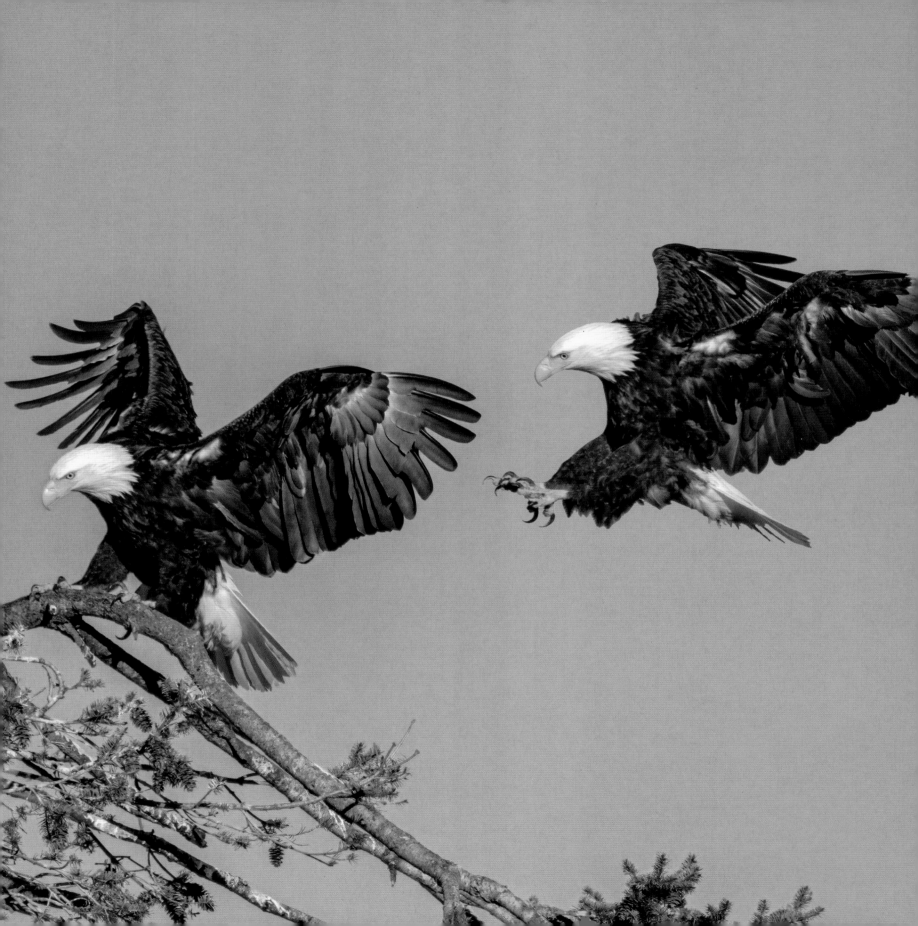

1
Eagles

Previous Spread

Species

Bald Eagle (*Haliaeetus Leucocephalus*)

Location

Lopez Island, Washington (April)

Settings

Collage of four images of the same landing | Olympus OM-D E-M1X | M 300 mm f/4 + MC-20 (x2) | 1/2000 sec at f/8 | ISO 800

The undisputed majesty and power of eagles has led rulers over millennia to use these raptors as symbols and icons, perhaps seeking to appropriate their noble qualities. In Greco-Roman mythology, Zeus's messenger — and deliverer-in-chief of thunderbolts — was a Golden Eagle (*Aquila chrysaetos*). The constellation Aquila (Latin for eagle), one of the 48 constellations described by Ptolemy in the second century CE, represents Zeus's Golden Eagle. Much later in history, Adolf Hitler adopted the same bird as a Nazi icon to revive the flames of nationalism.

Eagles also appear on the flags of several countries today, and the Bald Eagle is, of course, at the center of the Great Seal of the United States, which was adopted by the U.S. Congress in 1782. This seal is carried by every American on the back of a dollar bill and by many on the front of their passport. Parenthetically, it shows an anatomically inaccurate representation of the wings (not enough primary feathers). The eagle clutches 13 arrows (representing the original states) and an olive branch intended to show that the United States has a strong desire for peace but will always be ready for war.

It is well known that Benjamin Franklin felt that placing the Bald Eagle in such an exalted position was entirely inappropriate. He was amused that some thought the representation actually looked like a turkey. He wrote to his daughter Sally that "[the Bald Eagle] is a bird of bad moral Character: he does not get his living honestly ... too lazy to fish for himself, he watches the labor of the fishing hawk [Osprey] and when that diligent bird has at length taken a fish ... the bald eagle pursues him and takes it from him." These observations show that Franklin was a keen watcher of eagles, since it is indeed true that Bald Eagles would much prefer their food presented ready-to-eat.

But when food is scarce, the Bald Eagle can be a fierce and relentless hunter. I once saw a Bald Eagle fly into a flock of terrified ducks and

wound a straggler such that it fell into the water. Immediately, the eagle's mate joined the hunt, and the two birds took turns dive-bombing the unfortunate victim. Initially, the duck dove under the water just before one of the eagles, with talons outstretched, approached. Eventually, the exhausted duck could no longer coordinate its dive with the approach of the eagles, and it was unceremoniously yanked from the water and carried to a high treetop.

Eagles are still revered birds. There are many Indigenous North American myths, rituals and artworks that honor Bald Eagles. The birds are sometimes seen as divine guardians or communicators and are even sometimes seen as the creator of life.

Eagle feathers hold special importance in many Indigenous ceremonies. This is recognized in the United States today by federal laws that protect Bald and Golden Eagles and prohibit the possession of eagle feathers by all who are not tribal members. The Thunderbird, one of the most powerful symbols of Indigenous American mythology, borrows heavily from eagle features. It is described as being so massive that it can carry a whale in its talons, just as an eagle carries a fish.

I find eagles to be an irresistible target for photography. A tall Douglas Fir that is visible from my living room on Lopez Island, Washington, is a frequent morning host to one or two Bald Eagles. When I see their bright white heads, I stop whatever I am doing, grab the camera and tripod, and set up beneath the tree. Since I primarily shoot birds in flight, this is usually a recipe for a long wait. Johan Oli Hilmarsson, the author of the *Icelandic Bird Guide*, told me that there is an expression in Icelandic that can be translated as "sitting like an eagle." It refers to a person who simply cannot be coaxed into action. Bald Eagles have certainly earned this reputation and are masters at conserving energy. They choose a vantage point overlooking the water and, at about 20 second

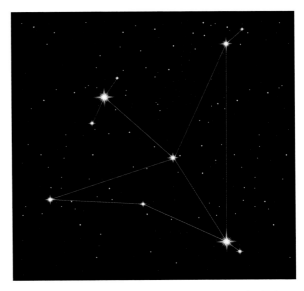

The constellation Aquila. The eagle's eye, Altair, is the 12th brightest star in the night sky.

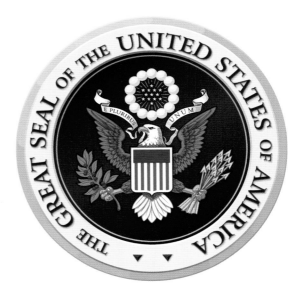

The Great Seal of the United States was approved in 1782, contrary to the wishes of Ben Franklin.

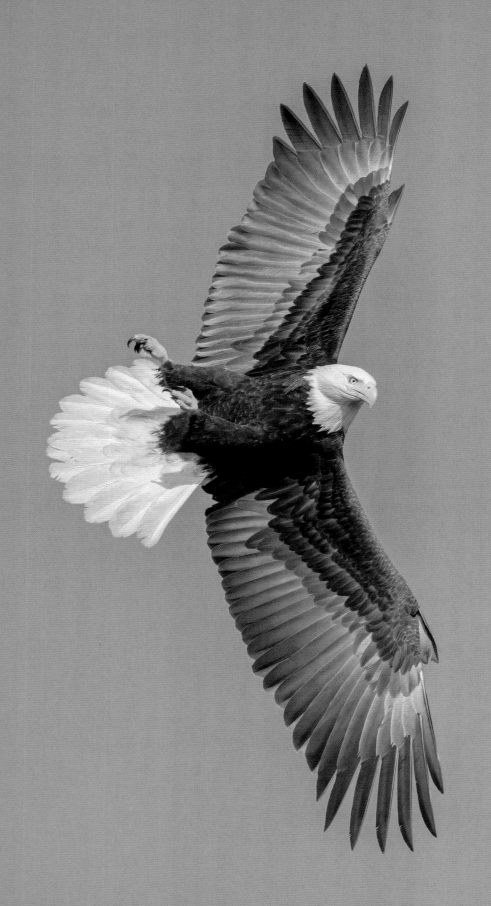

intervals, swivel their heads through more than 180 degrees, deploying their superb vision to identify any change in the landscape that might denote a new food source.

Despite being compellingly photogenic, many eagles are difficult photographic targets, particularly when there is bright sunlight. This is due to the huge dynamic range in the light they reflect. In a Bald Eagle or African Fish Eagle (*Haliaeetus vocifer*), for example, the head and tail can be as white as a field of fresh snow in sunshine, while the underside of the wings can be like a dark alley at night. Although the human eye can discern detail at both ends of this wide spectrum, the camera is unlikely to be as successful.[1]

The most frequent result is that the head and tail of the eagle are "burned out," appearing as pure, saturated white without any feather detail. With a different exposure, the head and tail could look perfect, with feather-by-feather detail, but the rest of the bird appears to be an unnatural dark gray. Topping the list of solutions for the photographer is avoiding photographing eagles in direct sunlight. Since this is not always possible, photographers are advised to use a combination of "stopping down" the aperture (exposing for the white parts of the bird rather than the average brightness of the field), toning down highlights and bringing up the shadows in post-processing.[2]

Technical details aside, the goal in photographing eagles is to capture their magisterial beauty, their dominant behavior and, perhaps by so doing, provide insight into their universal appeal.

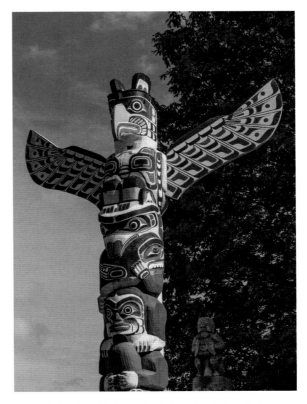

An eagle-inspired bird atop the Kakaso'Las Totem Pole in Stanley Park, British Columbia.

Bald Eagle (*Haliaeetus leucocephalus*) Sitka, Alaska

White-tailed Eagle

Species
Haliaeetus albicilla

Length
2.4–3.0 ft. (74–92 cm)

Wingspan
6.3–8.0 ft. (193–244 cm)

Weight
Male: 6.8–11.9 lb. (3.1–5.4 kg)
Female: 8.2–15.2 lb. (3.7–6.9 kg)

Conservation Status
Least concern

Population
20,000–49,999 birds; increasing

Every winter afternoon at 1 p.m. sharp, a man with a small bucket of fish walks out onto a snow-covered field in front of the Akan Crane Center in Hokkaido, Japan. The fish are intended for the revered Red-crowned Cranes (*Grus japonensis*) that fly in, hoping to supplement their meager winter rations. When the first fish is thrown, the air is suddenly a frenzy of raptors who have been perching silently and discreetly on the surrounding trees, awaiting this moment. After a few chaotic minutes, the raptors have snatched all the fish, and the cranes are invariably still hungry. It is a curious ritual — a sacred duty with a secular outcome — that also provides photographers with opportunities to shoot magnificent raptors, such as this adult White-tailed Eagle, in full-on scavenging mode.

I love the alignment of the bird in this image. The head is almost perfectly horizontal, while the rest of the body is rotated about 50 degrees in a dynamic equilibrium that balances the wing forces against the inertial demands of the tight right turn. The legs flare toward the inside of the turn, and the bird grasps the fish in a single claw that, like those of other *Haliaeetus* eagle species, is specially adapted to make sure that prey will not slip out.

Capturing this fast-moving action (and most of the other shots in this book) required a tripod-mounted two-axis gimbal to allow me to swing the 15-pound (7 kg) camera and lens effortlessly through horizontal and vertical arcs. Lighter weight mirrorless cameras are bringing shots like this within reach of much smaller handheld camera-lens combinations.[3]

Akan Crane Center, Hokkaido, Japan (February)
Canon EOS-1D X | EF 500 mm f/4L IS USM | 1/2500 sec at f/9 | ISO 640

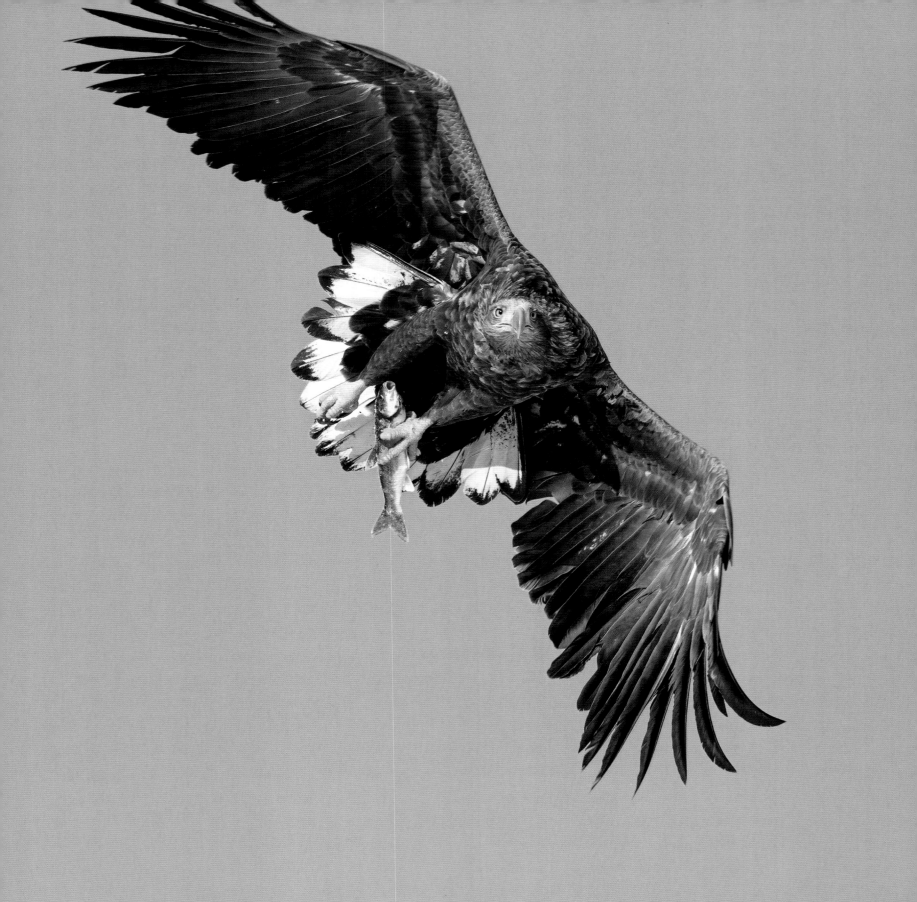

Steller's Sea-Eagle

Species
Haliaeetus pelagicus

Length
2.8–3.4 ft. (85–105 cm)

Wingspan
6.4–8.0 ft. (195–245 cm)

Weight
Male: 10.8–13.2 lb. (4.9–6.0 kg)
Female: 15.0–19.8 lb. (6.8–9.0 kg)

Conservation Status
Vulnerable

Population
3,600–3,800 mature birds; decreasing

The Steller's Sea-eagle is the queen of all eagles. Like most raptors, the female Steller's is larger than the male. An adult female bird can weigh almost 20 pounds (9 kg) and have a wingspan of 8 feet (245 cm). The thrill of my first glimpse of this magnificent animal, with its almost comically large bill and yellow eye highlighted against the crystal-clear blue sky, is still vivid. The intense white patches on its wings, head and tail make it look as though it has just flown through a heavy snowstorm.

The Steller's is much larger than its nearest relatives, the Bald Eagle and White-tailed Eagle, but there are worrying differences in the population sizes and trends: The global population of Bald Eagles outnumbers Steller's by about 50 to 1. Bald Eagles are increasing in number, but Steller's are decreasing. As with many at-risk raptors, lead poisoning from shot in prey is a significant cause of morbidity and mortality. The approximately 4,000 remaining adult birds in this species are also threatened by the usual palette of anthropogenic factors, including habitat destruction, oil and gas drilling and disruption of fish movement by dams. Several multinational protection and management plans are currently in place (the species has protected status in Russia, Japan, China and South Korea). We can only hope that these efforts will be sufficient and successful.

The bird is named after the fascinating 18th-century German naturalist and explorer Georg Wilhelm Steller (1709–1746). Like another explorer whose name has been used as an eagle patronym (Wahlberg, see page 22), Steller also has several other species named for him, including the Steller's Eider (*Polysticta stelleri*), Steller's Jay (*Cyanocitta stelleri*) and Steller's Sea Lion (*Eumetopias jubatus*). Steller's Arch on Bering Island in Russia and the mineral Stellerite also honor him.

Akan Crane Center, Hokkaido, Japan (February)
Canon EOS-1D X | EF 500 mm f/4L IS USM | 1/2500 sec at f/9 | ISO 640

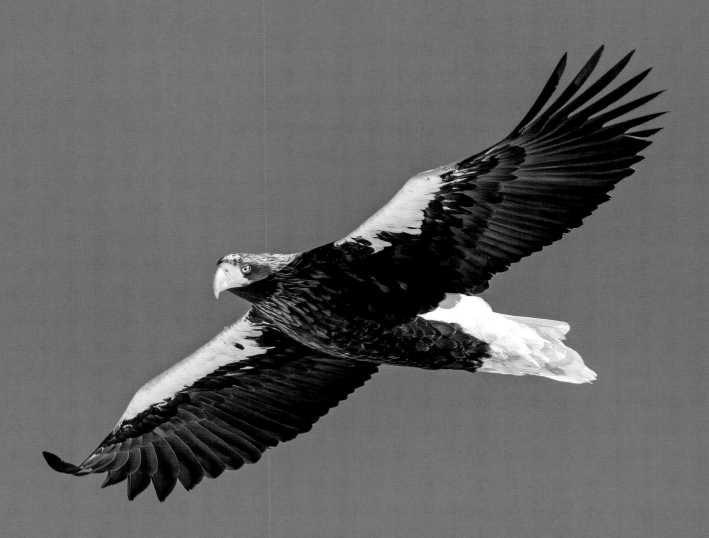

Wahlberg's Eagles

Species
Hieraaetus wahlbergi

Length
21.0–24.0 in. (53–61 cm)

Wingspan
4.2–4.8 ft. (130–146 cm)

Weight
Male: 0.9–1.9 lb. (437–845 g)
Female: 1.5–3.1 lb. (670–1,400 g)

Conservation Status
Least concern

Population
Approximately 9,000 pairs; stable

Death by charging elephant is the stuff of nightmares, but such was the fate of Johan August Wahlberg, a Swedish academic who perished in 1856 and whose name is associated with Wahlberg's Eagle. My encounter with this most common of Africa's eagles started just before noon on a gray January day just north of Satara Camp in South Africa's Kruger National Park. It ended after I had taken over 400 images almost an hour later. As stakeouts go, this one was relatively brief and extremely productive, yielding 10 images (including seven flight shots) that I considered to be "keepers."

I am often asked how many images I shoot in a given day. On this particular trip to the Kruger, the daily count varied from a high of 3,248 to a low of 870 images. The low number reflects long periods of waiting for a bird to fly, and the high numbers were from times when many interesting and active birds were present. Concealed in these numbers is the fact that I usually shoot in continuous mode at 10 images per second.

The birds were very active at this shoot, making several arrivals and departures to the branches of a dead Leadwood tree. This type of behavior simplifies the photographer's workflow, since he or she can fix the tripod and use manual focus to secure sharp images anywhere in the chosen plane. Depth of field with a 500 mm lens is extremely small, however, and if the bird lands after flying toward the camera, this technique results in a blurred image. In these situations, I use a wired shutter release cable so that I am not peering through the viewfinder, but rather standing to the side, watching the bird intently for signs of movement, sometimes through binoculars. It also helps to have a colleague, as I did in this case, shout "incoming" as he or she scans the wider horizon for an approaching bird.

Satara, Kruger National Park, South Africa (January)
Canon EOS-1D X | EF 500 mm f/4L IS USM | 1/4000 sec at f/5.6 | ISO 1250

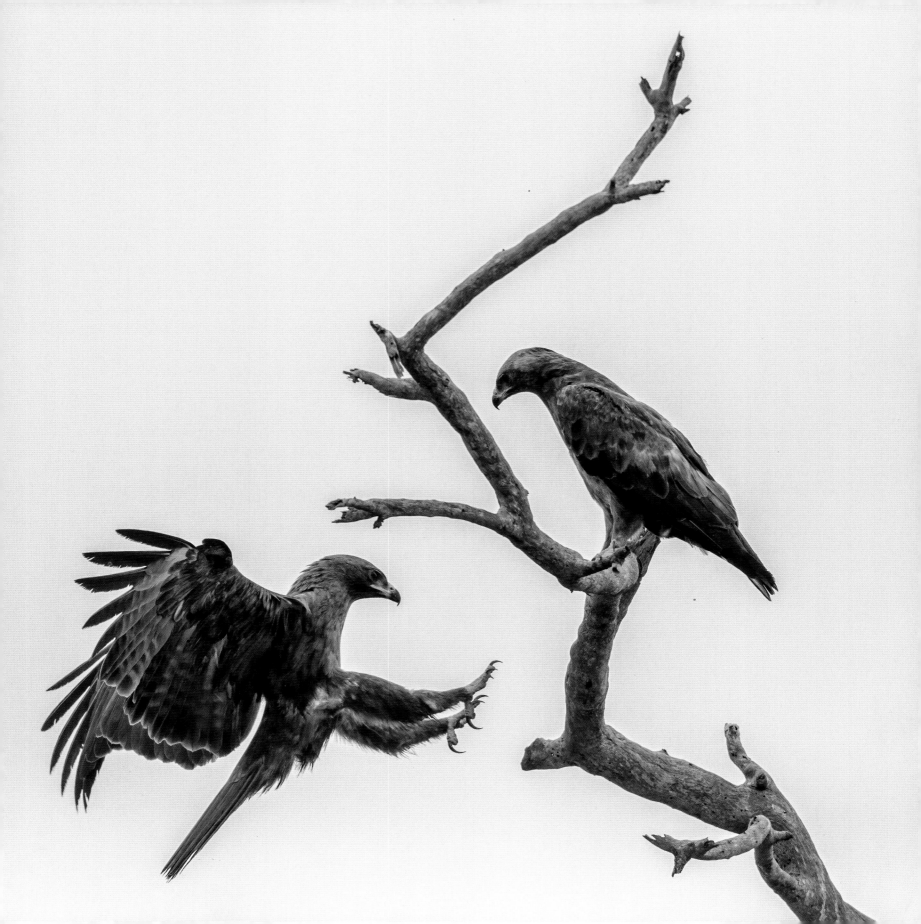

Bald Eagle

Species
Haliaeetus leucocephalus

Length
2.3–3.0 ft. (70–90 cm)

Wingspan
5.2–7.9 ft. (160–240 cm)

Weight
Male: 7.1–11.5 lb. (3.2–5.2 kg)
Female: 8.8–13.7 lb. (4.0–6.2 kg)

Conservation Status
Least concern

Population
Approximately 250,000 breeding birds; increasing

A bird photographer's dream is to look through his or her viewfinder at an iconic bird against a clear blue sky and with the sun and a brisk wind in its face. Having the sun behind the photographer ensures an even illumination of the bird, without shadows that can saturate the blacks and give the image too much contrast. The right wind direction provides the best chance of seeing a frontal view of the bird in flight.

Birds take off into the wind whenever possible because lift depends on the velocity of the airflow across their wings. In fact, lift increases as the square of that velocity. In terms of relative velocity, wind counts just as much as airflow from forward movement. And so, if the photographer is upwind of the departing bird, conditions are optimal for a full-frontal flight shot like the one shown here.

The Bald Eagle in this image had just leapt upward into the wind. The "venetian blind" configuration of its flexed wings indicates that the bird it quickly moving them upward, soon to be followed by a powerful down thrust. Remarkably, studies in other birds have shown that the upward movement can result in lift; so lift generation is not just a product of the downstroke.[4] Unlike human fingers, which are controlled by individual muscles, the primary feathers at the end of a bird's wings are mainly rotated by tension in a stretched membrane called the patagium, rather than by muscle action on individual feathers. Tugging on the membrane is just like pulling the cord to open a venetian blind; it reduces the drag on the wing during the upstroke.

An added joy in this image for me is that it was taken within sight of my home, which reminds me of how fortunate I am to have such elegant neighbors!

Lopez Island, Washington (March)
Canon EOS-1D Mark IV | EF 500 mm f/4L IS USM | 1/8000 sec at f/5 | ISO 640

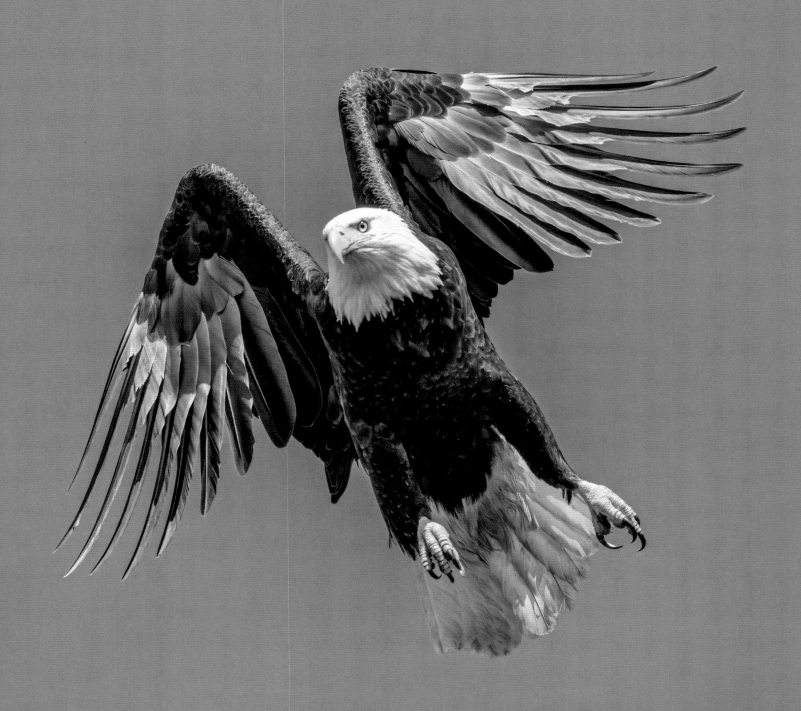

White-tailed Eagles

Species
Haliaeetus albicilla

Length
2.4–3.0 ft. (74–92 cm)

Wingspan
6.3–8.0 ft. (193–244 cm)

Weight
Male: 6.8–11.9 lb. (3.1–5.4 kg)
Female: 8.2–15.2 lb. (3.7–6.9 kg)

Conservation Status
Least concern, but locally threatened

Population
20,000–49,999 birds; increasing

I love to photograph young eagles. Their color and patterning are so spectacular that I often value photographs of sub-adults over those of adults. But catching a range of ages in the same image is indeed the best of both worlds. The younger bird (right) had been aggressively competing for food, and it is likely the older (but not completely mature) White-tailed Eagle (left) was teaching the young bird a lesson. Although such interactions are not life-threatening to young birds, other threats await: An eaglet's journey to maturity is long and uncertain, despite adults being near the top of the food chain. Bald Eagle chicks, for example, have only a 50 percent chance of living through their first year. Causes of mortality include poisoning, electrocution, wind turbine strikes and human predation.

The White-tailed Eagle is a success story that stands out in the seeming endless procession of globally threatened species. White-tails disappeared from many locations during the 19th and 20th centuries, but they have been successfully reintroduced in several European countries, including Scotland and the Czech Republic. In the summer of 2019, six eaglets were released in southern England, where the species had been absent for 240 years.

Shooting images of birds in aerial combat is a tough assignment, primarily because such flight is erratic and unpredictable. Combat is also rare and often not preceded by warning signs. All of these factors imply that a handheld rig is most likely to be successful, although this image was taken with a gimbal-mounted 500 mm lens.

Akan Crane Center, Hokkaido, Japan (February)
Canon EOS-1D X | EF 500 mm f/4L IS USM | 1/3200 sec at f/7.1 | ISO 640

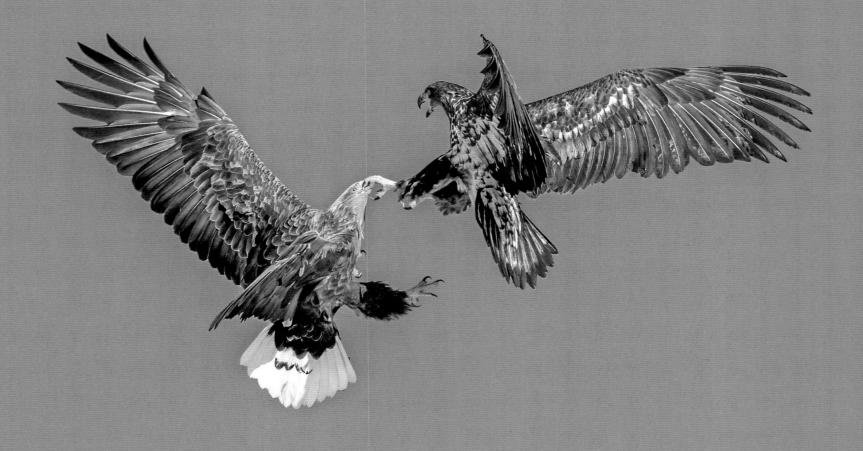

Bateleurs

Species
Terathopius ecaudatus

Length
22–28 in. (55–70 cm)

Wingspan
6.1 ft. (186 cm)

Weight
4.4–5.7 lb. (2.0–2.6 kg)

Conservation Status
Near threatened

Population
10,000–100,000 birds; decreasing

Eagles love perching in standing dead trees. Snags, as they are called, provide an unobstructed view of potential food sources and also allow a safe takeoff path without the wing feather wear and tear that can occur in dense foliage. Snags are also great for the photographer, since the birds are usually unobstructed. This particular tree is a Leadwood, which has the remarkable characteristic of living over 1,000 years and then having a second life by standing upright for another 80 years or so.

When I first arrived at the site, the pair of Bateleur eagles were sitting quietly watching life unfold on the bushveld beneath them. After about half an hour of waiting, with my finger on the shutter release, the male bird at the right flew, and I captured a really nice departing flight shot. His flight, however, turned out to be a brief bout of exercise, and I had the opportunity to capture this image on the return landing.

The next 90 minutes of observation proved to be equally rewarding. A steady procession of very photogenic White-backed Vultures (*Gyps africanus*) arrived to occupy various perches on the tree, to the obvious consternation of the Bateleurs. When the total number of vultures reached 15, the Bateleurs had had enough! They both departed, allowing me to take several other flight shots and interesting vulture images.[5] The lesson for me from this encounter was to stick with an evolving scenario, rather than move on to seek new opportunities. This speaks to the difference between birding and bird photography: In a locale with more than 500 species of birds, the birder would likely move on to extend their "Life List," but the photographer prefers to dwell in anticipation of further action.

Satara, Kruger National Park, South Africa (January)
Canon EOS-1D X |
EF 500 mm f/4L IS USM |
1/3200 sec at f/5.6 | ISO 2000

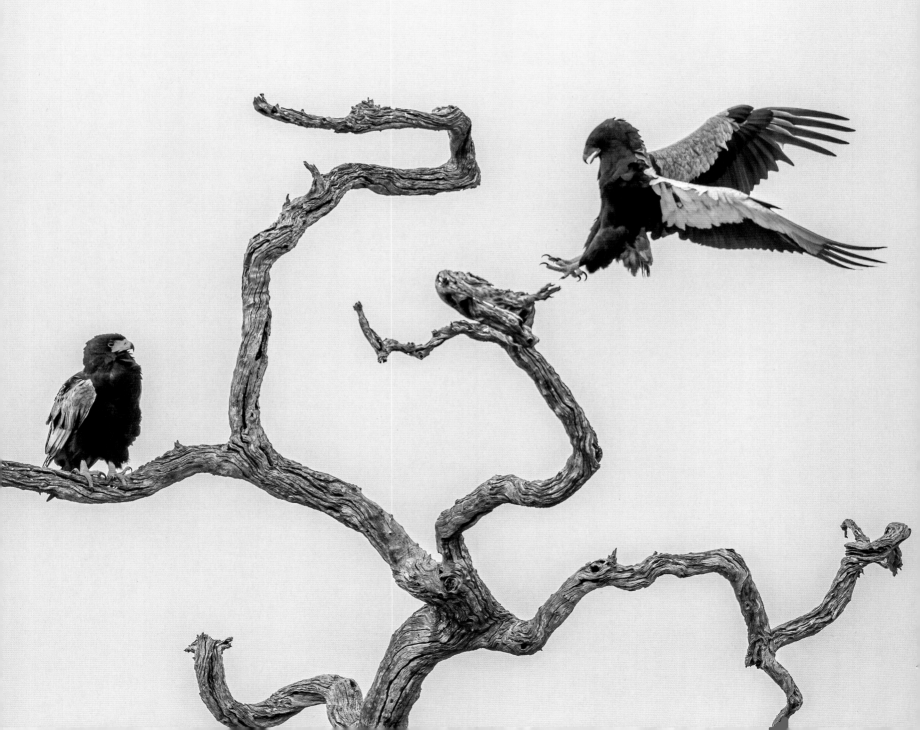

Golden Eagle

Species
Aquila chrysaetos

Length
2.2–2.9 ft. (66–90 cm)

Wingspan
5.9–7.7 ft. (180–234 cm)

Weight
Male: 6.2–10.0 lb. (2.8–4.6 kg)
Female: 8.0–15.9 lb. (3.6–7.2 kg)

Conservation Status
Least concern

Population
100,000–200,000 mature birds; stable

Golden Eagles are at the very top of the avian food chain. I have seen an adult and juvenile Golden Eagle eating their fill from a deer carcass while Bald Eagles, followed by Turkey Vultures and then ravens and crows, waited in a noisy, impatient chorus for their turn at the table. Goldens also defend extremely large territories of up to 100 square miles (256 km^2), so one rarely gets the chance to photograph multiple birds in their own habitat on a given day.

By successfully taking quite large animals as prey, Golden Eagles have found themselves in conflict with farmers. In 2016, a law was passed in Norway to allow culling of up to 200 Golden Eagles in order to protect lamb and reindeer. This is ironic, since Norway has been at the forefront of helping other nations reintroduce populations of White-tailed Eagles from Norwegian stock (see pages 26–27).

Occasionally, the bird in this picture perched in a large tree overlooking a field full of rabbits, but this shot captures the only time when I was in the right place at the right time. The gray day and lack of context combine to put this image into my least favorite category, but it does give me motivation to plan a future visit to a migration site where I can do better! Aesthetics apart, this image highlights the striking anatomical feature of the Golden Eagle: large rectangular wings, perfectly designed for soaring. A common way to express the stress on the wings of a bird (or an airplane) is "wing loading," which is the bird's weight divided by the total wing area. It is very advantageous for soaring birds to have low wing loading. A Golden Eagle has approximately one-third the wing loading of a Canada Goose, showing how specialized the species is for soaring compared to the goose, whose preferred mode of locomotion is flapping flight.

Lopez Island, Washington (April)
Canon EOS-1D Mark IV | EF 500 mm f/4L IS UM | 1/3200 sec at f/4 | ISO 400

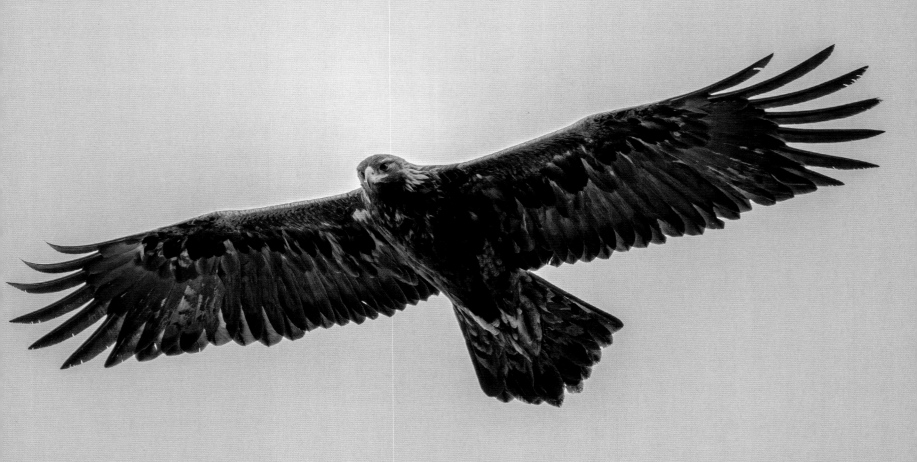

African Hawk-Eagle

Species
Aquila spilogaster

Length
22.0–24.4 in. (55–62 cm)

Wingspan
4.3–4.9 ft. (132–150 cm)

Weight
Male: 2.5–3.1 lb. (1.1–1.4 kg)
Female: 3.1–3.8 lb. (1.4–1.8 kg)

Conservation Status
Least concern

Population
Unknown; decreasing

Letaba River, Kruger National Park, South Africa (January)

Canon EOS-1D X | EF 500 mm f/4L IS USM | 1/6400 sec at f/5.6 | ISO 1600

The safari vehicle turned abruptly to the right and stopped dead on the dusty rutted road along the Letaba River in South Africa's Kruger National Park. By now, I knew the drill: My guide, Bruce Lawson, had spotted a young eagle and positioned us perfectly. My tripod was fastened to the frame of the open vehicle, and I swung the camera and lens around searching for the target. The young bird waited long enough for me to position a single focus point on its neck and then, unsettled by our presence, it flew as my shutter rattled off a quick-fire series of images.

My eye moves in this image from the beautifully delineated, barred primary and secondary feathers to the silhouettes of the hunting equipment the bird is displaying: Its almost semicircular talons and deeply hooked bill are the weapons of a raptor. This entire encounter lasted less than one minute, a stark contrast to the many hours that are sometimes required to get a flight shot.

But there was a lot more excitement to come. The young bird was briefly joined by its parents for some formation flying. Adults, who outgrow the chestnut color of this bird's underparts, often hunt together, weaving in and out of the trees. For a few exhilarating moments, the youngster joined the adults in flight and then peeled off to explore the area around the nearby nest. Like any kid out on its own, it did some risky things, including landing on a branch that was too small to hold its weight. This led to a bill-over-talons tumble down the tree, from which it recovered after impacting a few branches.[6] It was a rare privilege to watch and photograph a young bird finding its wings!

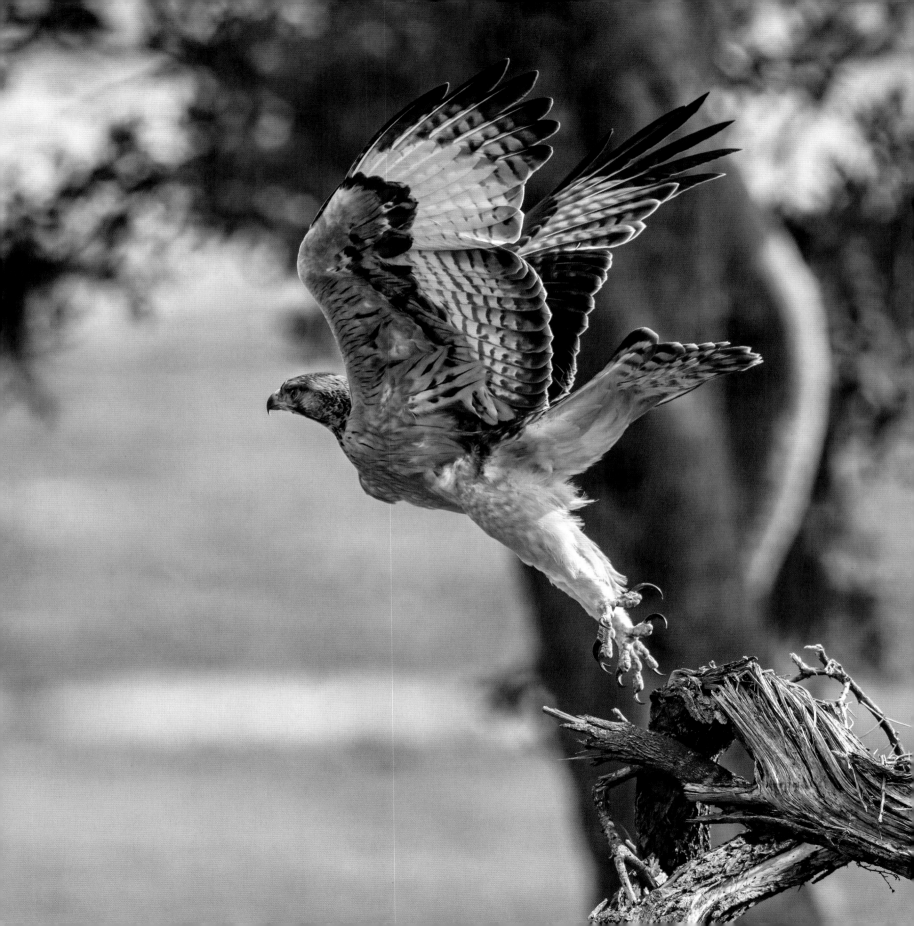

African Fish-Eagle

Species
Haliaeetus vocifer

Length
2.1–2.5 ft. (63–75 cm)

Wingspan
6.6–7.9 ft. (200–240 cm)

Weight
4.4–7.9 lb. (2.0–3.6 kg); female is larger than male

Conservation Status
Least concern

Population
More than 100,000 adult pairs; stable

Pafuri, Kruger National Park, South Africa (January)
Canon EOS-1D X | EF 500 mm f/4L IS USM +1.4x | 1/4000 sec at f/5.6 | ISO 3200

The afternoon temperatures topped 100°F (38°C) as our safari vehicle bounced along the rutted dirt track beside the chocolate-brown Luvuvhu River in the Makuleke Concession of Kruger National Park, South Africa. We had not seen a single bird for a very long time, when my guide looked over his shoulder and spotted an African Fish-eagle perched majestically in a dark alcove on a broad, shady tree limb from which the river was in full view. The white excrement covering the limb showed it to be the bird's regular hangout. The driver made a sharp left turn toward the riverbank to bring the perch into camera view. I attached a 1.4x extender to the 500 mm prime lens to get more pixels from the bird and waited about 20 minutes as it alternately preened and looked intently down into the water.

Without any warning or preparation, the bird thrust itself into the air, showing the full extent of its almost 8-foot (2.4 m) wingspan. Flying in a straight line to a point about 50 yards (46 m) upriver, the eagle extracted a large, writhing silver fish. It was an amazing demonstration of the superiority of raptor vision compared to that of humans (see pages 159 for a discussion of raptor vision).

When staking out a perching bird to capture a flight shot with a camera that does not have electronic buffering, the photographer's attention must be absolutely riveted on the task at hand.[7] Human reaction time to a visual stimulus is about 16/100 of a second, and in less than half a second the bird can be gone. The margin for error is very small! I find it best to continue looking through the viewfinder during the entire stakeout, although this can be taxing on the neck. My unsubstantiated theory for why this works best is that more of my retinal cells fire when the bird moves, since the image is larger than if I was looking at the bird with my naked eye and taking in a consequently larger field of view. Holding a shutter release cable and looking through binoculars also work well.

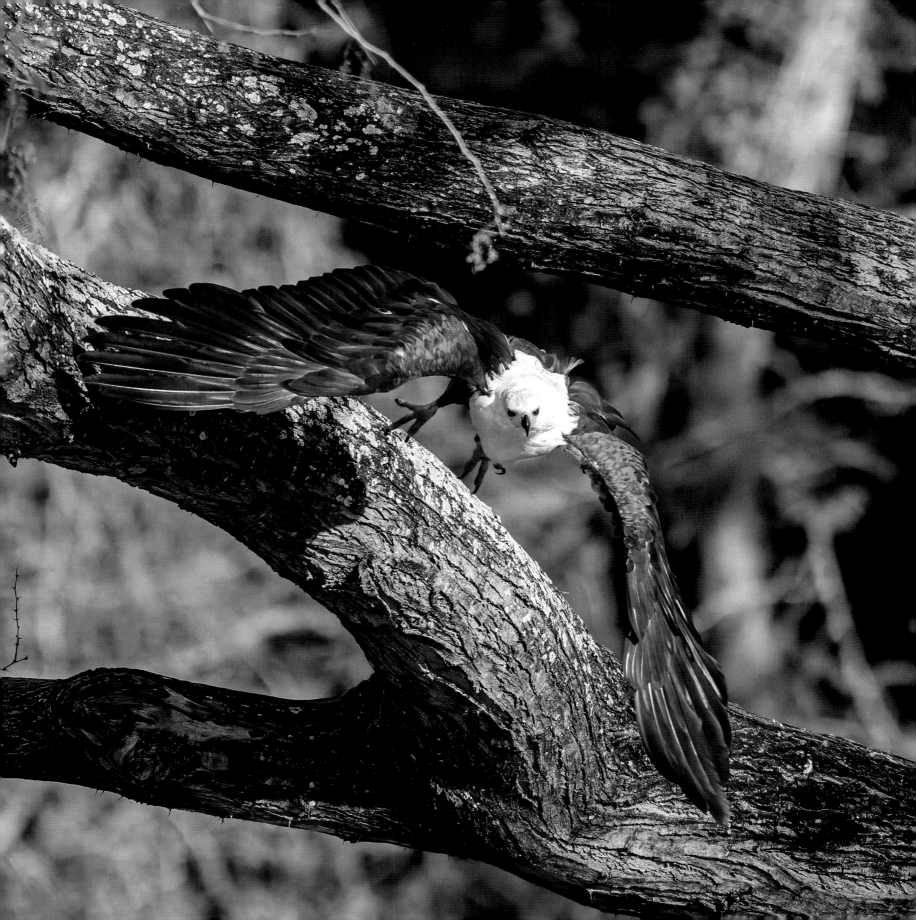

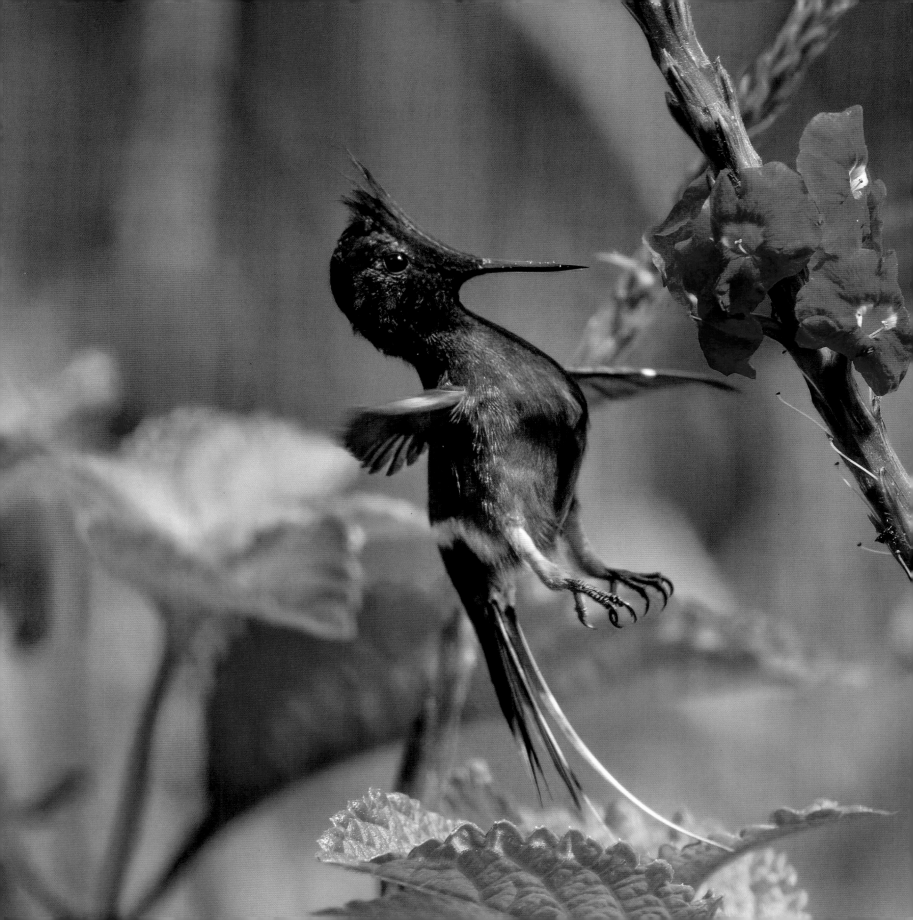

2
Hummingbirds

Previous Spread

Species

Wire-crested Thorntail (*Discosura popelairii*) (Immature)

Location

Pilcopata, Peru (April)

Settings

Canon EOS-1D X | EF 100–400 mm f/4L IS USM at 400 mm | 1/4000 sec at f/10 | ISO 5000

A hummingbird and its preferred flowers are partners in a finely tuned evolutionary dance. Over the last 20 million years, certain flowers have evolved to suit certain birds, and certain birds have evolved to suit certain flowers. Recent studies suggest that new plants emerged after the ancestor to all of the 338 known species of hummingbird arrived in South America and that new species of hummingbirds evolved to exploit the new habitat.

My favorite example of the close link between the morphology of a hummingbird and its primary food sources is the Sword-billed Hummingbird and what scientists describe as its "guild of flowers," one of which is the Red Floripontio (*Brugmansia sanguinea*). The Sword-billed has an extraordinary bill that, at 3.2 to 4.7 inches (8–12 cm), is long enough to probe deep inside these flowers to drink the nectar. The sword-billed "owns" this food source because it is out of reach of other species of hummingbirds that live in the same area.

Hummingbirds are distinguished from all other birds by their ability to fly to a precise location and maintain their bill perfectly still in relation to a flower, even if the flower is moving in the wind. Other birds can certainly hover in a clumsy sort of way, including kingfishers, terns, ospreys and some raptors. None, however, can match the almost robotic precision of a hummingbird as it executes small positional adjustments — forward, backward, up and down — in front of a flower. A number of anatomical, neurological and physiological adaptations enable this unique behavior. The anatomy of the hummingbird's shoulder and upper limbs allow it to generate approximately 33 percent of its lift on the backward wing stroke. Hummingbird brains also have specialized circuitry that uses the visual field to stabilize the bird's position. Laboratory studies have shown that hovering control is adversely affected if objects in the bird's field of view are moved. Curiously, given the

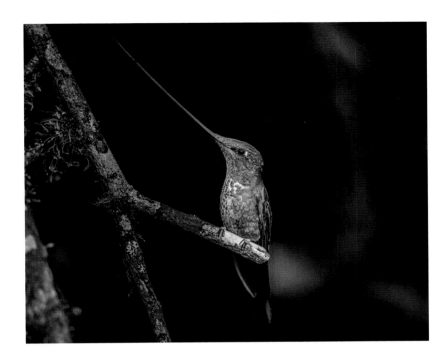

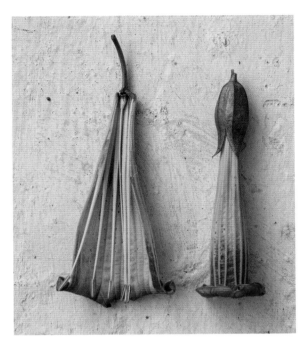

A Sword-billed Hummingbird (*Ensifera ensifera*), Yanacocha, Ecuador, and Red Floripontio (*Brugmansia sanguinea*), one of its favorite flowers (left: in cutaway; right: intact flower).

uniqueness of hummingbird wings, wingspan measurements for most species are missing from the standard sources, and I have omitted them in the headers for this chapter.

The muscles that drive a hummingbird's wing movement are exclusively fast-twitch fibers, enabling wing flapping rates that are so fast that the human eye or a camera with a medium shutter speed can only see them as a blur. Another distinctive feature of hummingbird anatomy is that the primary feathers contribute about 75 percent to the total wing area. As such, when the "hand" wing is swept backward by a flick of the wrist, the bird has an almost completely reversed airfoil to generate lift. Hummingbirds also win another biological gold medal: They use more energy each day (per unit of body weight) than any other living vertebrate. Powering their energetic lifestyle of many thousands of wing flaps a day requires a huge caloric intake. To compensate for this high-energy expenditure during foraging, hummingbirds at the nest can enter a state called "torpor," in which metabolic rate, and body temperature, is markedly reduced.

Photographers who capture images of hovering hummingbirds are divided into two camps: the naturalists and the constructionists. The naturalists seek a place where flowers preferred by their target bird

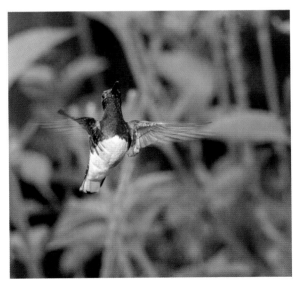

White-necked Jacobin (*Florisuga Mellivora*) Tandayapa, Ecuador

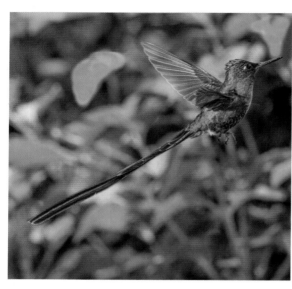

Violet-tailed Sylph (*Aglaiocercus coelestis*), Tandayapa, Ecuador

grow, and they sit and wait until the bird appears. Images taken with this approach often show a head and body that is sharp, but a blurring of the wings even with shutter speeds as fast as 1/4,000 of a second. Such blurring is actually preferred by many viewers because it expresses fast movement in an otherwise still image.

The constructionists leave nothing to chance in their pursuit of ultra-sharp images of every part of the bird. They create an outdoor "studio" with four or more strobes (flash guns) and invite the birds in. The lure is usually either a hummingbird feeder or a flower that has been laced with sugar solution. A card containing an abstract pattern is often used as a background. Paradoxically, the exposure for this form of image capture is very slow and the aperture very small, such as 1/250 of a second at f/22 with ISO 400. If strobes were not used, these settings would produce an almost black image in which the bird could not be seen. However, when a photographer uses synchronized strobes, he or she can adjust the flashes of light so they last for extremely brief periods say 1/12,000 of a second. The sensor thereby only records the reflections of this light from the bird. Wing movement during this instant in time is not discernible, and the resulting image shows the wing in perfect focus.

I have photographed hummingbirds in Costa Rica, Ecuador, Peru and in my backyard on Lopez Island, Washington. For 90 percent of my shots, I have used the studio approach, or at least a nectar feeder, to attract the birds, but I always do this with a touch of guilt because I cannot find a satisfactory answer to the question "How can I be sure that 'baiting' the birds to come in front of my lens will not alter their behavior, feeding habits and geographical distribution?" There is evidence that the northward spread of winter habitat for Anna's Hummingbirds in the United States is a direct result of people on the fringe of the distribution deploying hummingbird feeders. Several eco-lodges in Costa Rica

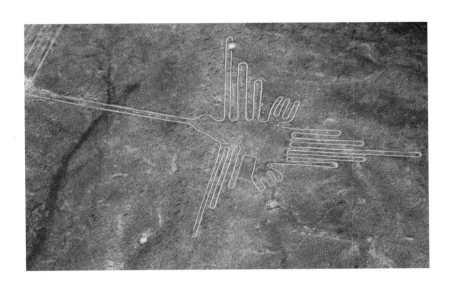

Rufous-tailed Hummingbird (*Amazilia tzacatl*) Tandayapa, Ecuador

A 300-foot (91.4 m) long hummingbird geoglyph in southern Peru's Nazca Lines.

have already decided on the best approach and have no feeders on their property, only flowers that hummingbirds like to feed on. (I am aware that the logical extension of this argument is that backyard bird feeders should be eliminated, but I am not ready to espouse this view.)

Hummingbirds have long been revered by humans. For example, in pre-Columbian cultures in Mexico and Peru, it was believed that fallen warriors were reincarnated as hummingbirds, and the Aztec god Huitzilopochtli is sometimes represented as a hummingbird. The famous Nazca Lines in southern Peru show a huge hummingbird geoglyph.

These birds are unquestionably members of nature's evolutionary elite. They have adapted relatively rapidly to environmental changes. They are also great ambassadors for conservation — people love them! This can only be good for the stewardship and conservation of birds in general.

White-whiskered Hermit

Species
Phaethornis yaruqui

Length
5.1 in. (13 cm)

Weight
0.14–0.25 oz. (4.0–7.0 g)

Conservation Status
Least concern

Population
Unknown

On a short trip to Ecuador, I drove down to Milpe from Tandayapa late in the afternoon — a descent of about 2,600 feet (800 m). Different hummingbird species occupy different elevation niches in the Andean foothills. The White-whiskered Hermit was new to me because I had never ventured far from the lofty elevations around Quito. The common name "white-whiskered" refers to the thin white facial stripe under the bird's eye.

This male bird was feeding on a cluster of pink and yellow flowers in a rather dark location under the tree canopy. My flash gear was not yet unpacked, so I shot in available light with a wide-open aperture, high ISO and a rather slow shutter speed. These settings give the image a sense of motion in the wings and tail, but the sharpness of the thorax, head and bill shows that these body parts are being maintained absolutely stationary in relation to the flower.

Hummingbirds often approach flowers at high speed and then come to a screeching halt a short distance away, stabilizing their head before moving in to feed. In terms of feeding, all that really matters is that the bill contacts the nectar-producing regions of the flower for as long as possible. Scientists have found that the bird can maintain its head position in relation to a flower even in turbulent airflow. In effect, the bird will react to the wind by rotating the rest of its body around its fixed head, arranging its body parts to dynamically balance the beating of its wings and the movements of its tail. It is an exquisite dance that has proven so successful that hummingbird evolution appears to be continuing to generate new species.

Milpe, Pichincha, Ecuador (March)
Canon EOS-1D X | EF 500 mm f/4L IS USM | 1/1000 sec at f/4 | ISO 3200

Koepcke's Hermit

Species
Phaethornis koepckeae

Length
5.1 in. (13 cm)

Weight
Male: 0.14–0.21 oz. (4.0–6.0 g)
Female: 0.14–0.19 oz. (4.0–5.5 g)

Conservation Status
Near threatened

Population
6,000–15,000 birds; decreasing

The Manú Road, which runs from the ancient Incan capital of Cusco, Peru, is a legendary birding route that ornithologists have traveled for years. It climbs through mountain passes at 13,000 feet (3,962 m) and then drops to 1,640 feet (500 m) above sea level at the junction of the Tambo and Urubamba Rivers. For long stretches, it is a single-track dirt road on which trucks carrying bananas and coca leaves from the Amazon basin squeeze through primitive passes. After five days along this road, we arrived at the small port of Atalaya for the brief transfer by motorized canoe to the Amazonia Lodge. The fall floods had left the grounds waterlogged, ankle-deep with black mud. However, within minutes of our arrival, this beautiful endemic hummingbird livened up the dampness with its high-speed aerobatic maneuvers.

Hermits are low-key hummingbirds. They dress in greens and browns, and generally don't have the iridescent bling of some of their relatives, but I like their long tail feathers, extruded bills and classy flight moves. Astonishingly, this bird was only identified in 1977. It is named for ornithologist Maria Koepcke, who broke the glass ceiling of male-dominated ornithology. She died tragically after her pilot flew into hazardous weather conditions. The story of her daughter's survival of the crash after a 10,000-foot (3,048 m) free fall into the Peruvian rain forest has been celebrated in several movies.

The three telltale white dots in this male bird's eye are evidence of the strobes I used to freeze the rapid motion. The brief strobe flashes provided the only light that was effectively recorded by the camera's sensor. Incidentally, what seems like a scratch on the image is actually a cobweb being carried on the bird's tail!

Amazonia Lodge, Manú National Park, Peru (April)

Canon EOS-1D X | EF 500 mm f/4L IS USM | 1/200 sec at f/32 | ISO 1250 | 3 strobes

Peruvian Booted Racket-tail

Species
Ocreatus peruanus

Length
4.3–5.9 in. (11–15 cm), including tail feathers

Weight
0.09–0.1 oz. (2.5–2.7 g)

Conservation Status
Least concern

Population
Unknown; stable

As I stood in the lodge, the rocket-launcher-sized lens tucked underneath my arm was a dead giveaway that I was a photographer, but I was still surprised when an authoritative voice said, in perfect if colorful English, "Come with me, and we will photograph the most beautiful f...ing bird in the valley together."

The speaker turned out to be the iconoclastic Peruvian filmmaker Daniel Winitzky, who was making a documentary about the destruction of rain forests. Our meeting turned out to be very influential in my photographic direction, pushing me toward potentially impactful filmmaking, and he was certainly right about the bird.

The Peruvian Booted Racket-tail is a wondrous bird: shining emerald-green body, orange boots above its feet and 2- to 3-inch (5.1–7.6 cm) long outer tail feathers that extend like thin vanes and end in royal-blue heart-shaped disks. Similar birds in Ecuador have white boots, and a group of taxonomists have recently proposed that the bird in the picture is, in fact, a separate species after analyzing its size, color and movements. They named it the Peruvian Racket-tail (*Ocreatus peruanus*).[1]

This image was taken late in the day with available light (no strobes) using a shutter speed that did not completely freeze the wing motion. An intriguing feature of the shot is that it shows the male bird's wings clearly moving backward. The straight line on top of the wing is usually called the leading edge because it is in front of the feathers. However, at this instant, the feathers are lined up in front of the leading edge as the bird generates lift during its backward wing movement.

Cock of the Rock Lodge, Manú National Park, Peru (April)
Canon EOS-1D X | EF 100–400 mm f/4–5.6L IS USM at 400 mm | 1/2000 sec at f/5.6 | ISO 5000

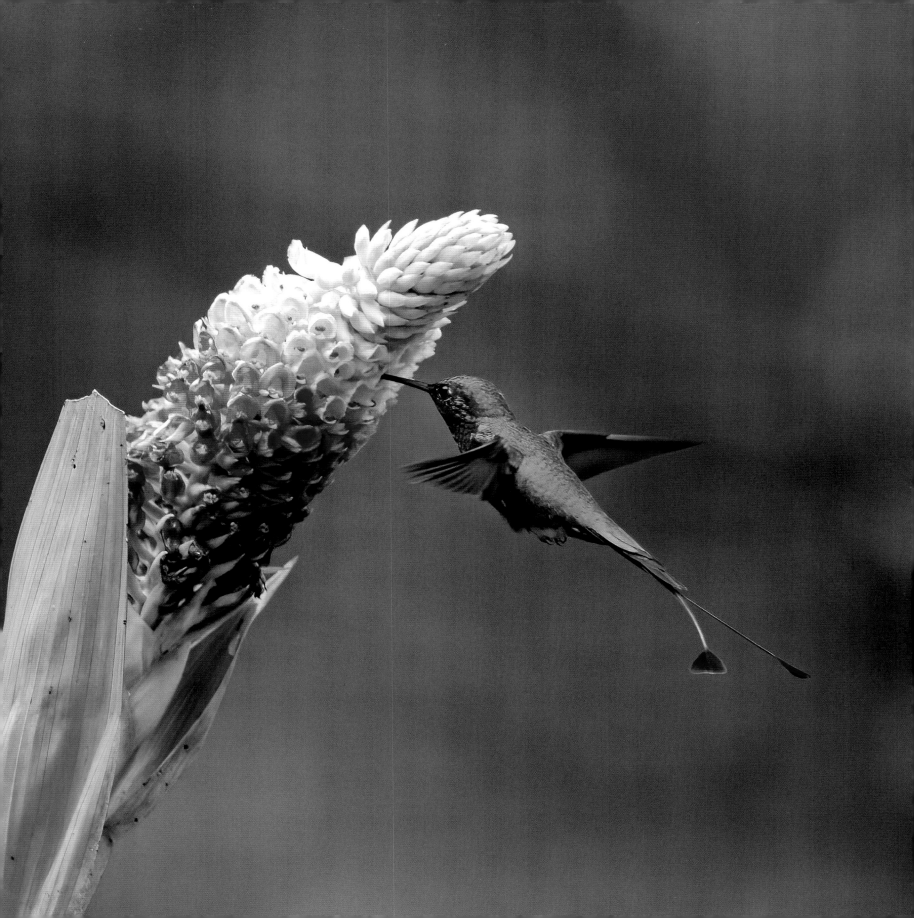

Marvelous Spatuletail

Species
Loddigesia mirabilis

Length
Male: 5.9–7.0 in. (15–17 cm), including 4.3–5.1 in. (11–13 cm) tail
Female: 3.5–3.9 in. (9–10 cm), including 2.0–2.8 in. (5–7 cm) tail

Weight
0.11 oz. (3 g)

Conservation Status
Endangered

Population
250–999 birds; decreasing

Charles Darwin formulated the notion of sexual selection to explain extreme morphology or behavior that makes males attractive to females, even though these features are not overtly advantageous to survival. Think of the ornate train of the peacock or the large antler racks in elk. The long rackets on the tail of this male Marvelous Spatuletail fall into this category. Even though they are attractive to females, they must be a burden to carry around all day and are surely a major aerodynamic hindrance! They remind me of the banners towed by small airplanes above ballparks, which slow these planes down to near stall speed.

Marvelous Spatuletails need all the reproductive success they can muster because there are fewer than 1,000 of these birds alive today. To try to reverse this trend, the American Bird Conservancy has established the Huembo Reserve in Peru's Rio Utcubamba Valley, which is the Marvelous Spatuletails' only habitat.

On the day I visited, the skies were gray and the rules were strict — no flashes. I had to use an ISO setting of 10,000, right in the zone where color noise and luminance noise can wreck an image. The maximum available shutter speed with a wide-open aperture was only 1/2,000 of a second, barely enough to prevent blur in the bird's body. With the help of some pretty aggressive noise filters in post-production, however, an image of this magnificent male bird shone through the noise like a pastel painting.

It is heartbreaking to stand watching a species that is on the edge of survival. We have the resources and skills to turn the tide. Why do we continue to be complicit in this species's march toward extinction?

Huembo Reserve, Peru (May)
Canon EOS-1D X | EF 500 mm f/4L IS USM | 1/2000 sec at f/4 | ISO 10000

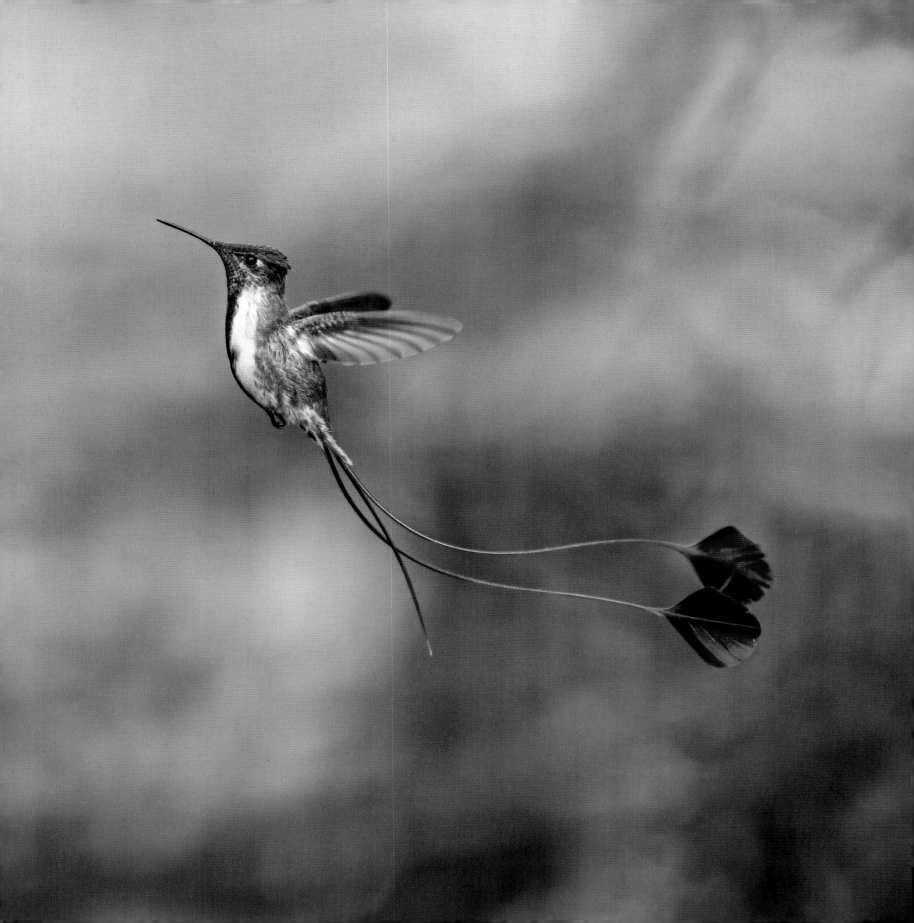

Sword-billed Hummingbird

Species
Ensifera ensifera

Length
6.7–9.0 in. (17–23 cm), including 3.4–4.3 in. (9–11 cm) bill

Weight
0.3–0.5 oz. (10–15 g)

Conservation Status
Least concern

Population
Unknown; stable

I like to think of the Sword-billed Hummingbird as the giraffe of the bird world. In the same way that the giraffe, because of its 6-foot (1.8 m) long neck, has the choice of the juiciest leaves and shoots on its favorite Acacia trees, the Sword-billed has evolved a distinctive bill that is as long as its body, which allows it to feed at flowers that are inaccessible to all other birds. The fit between the Sword-billed and its favorite flowers is known as coevolution. A recent study has shown how local coevolutionary regions exist where there is the dual presence of many long-stemmed flowers and many Sword-billed Hummingbirds with extra-long bills.[2] These places are likely the hot spots of evolutionary adaption, where plant and bird alike have been molded to match each other's morphology.

The Sword-billed Hummingbird is not uncommon on the western slopes of the Andes, but in several previous visits I had only managed a single glimpse of the bird performing a courtship display dive, which I was unable to photograph. As such, my day trip to the Yanacocha Reserve outside Quito, Ecuador, at elevations of 10,500 to 12,120 feet (3,200 to 3,700 m) was all about photographing the Sword-billed in flight. The early going was promising when, at the trailhead, we saw a beautiful female bird feeding in the crown of a large Red Floripontio (*Brugmansia sanguinea*) tree, but the long hike up to a feeder station ended at a grotto, where little light penetrated. Although the bird was present, my flight shots were just a hair off acceptable sharpness. I am left with this image taken at the trailhead. Although it shows the bill and flower together, it represents a meager haul after a journey specifically undertaken to photograph this unforgettable bird. I will definitely return to Yanacocha!

Yanacocha, Ecuador (October)
Canon EOS-1D X | EF 500 mm f/4L IS USM +1.4x | 1/2500 sec at f/5.6 | ISO 1000

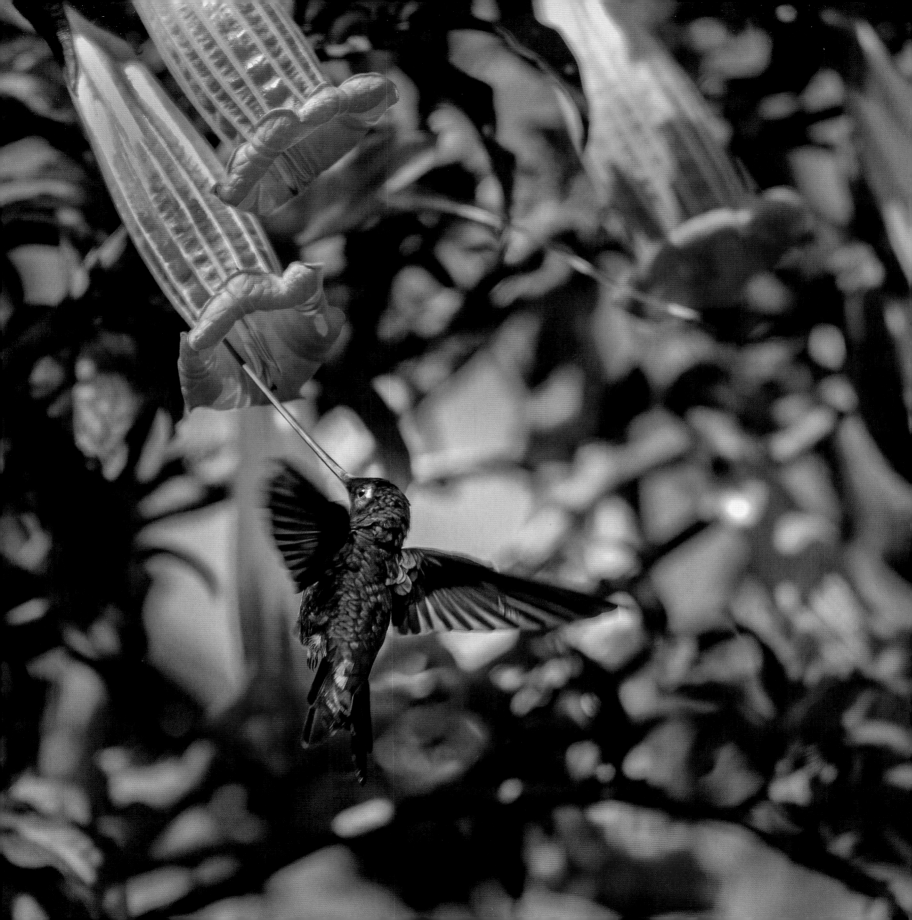

Rufous-crested Coquette

Species
Lophornis delattrei

Length
2.5–2.7 in. (6.4–7.0 cm),
not including 0.8-in. (2 cm) crest

Weight
0.1 oz. (2.8 g)

Conservation Status
Least concern

Population
Unknown; anticipated loss of 13.3–15.1% of habitat over three generations

After crossing the Andes in northern Peru from west to east with a group of birders, I dropped down to Moyobamba. This sleepy city was once a settlement used by the Spanish conquistadors as a base for their annihilation of the Incas in Amazonia. The small grove of trees where I sat provided some shade from the afternoon sun, but I was still overheated after carrying cameras, a tripod and flash gear up a steep path. I was not only drenched in sweat, but also swimming in insect repellent because I knew that mosquitoes in the area could carry dengue and Zika viruses.

Only one bird was on my mind, the Rufous-crested Coquette, which is known to live in the area. I caught a fleeting glimpse of it and then nothing! After a long wait, a series of insectlike, muffled chirps caught my attention, and as I looked to the left, there it was — a male perched on a twig just 12 inches (30 cm) away, looking right at me.

This is one tiny, spectacular bird: It's just about the size of a thumb and weighs less than a sugar cube. It has an iridescent green throat, a fan of black-tipped rufous streamers blowing back from its head and delicately mottled lime-green and brown feathers on its body and tail. The first sighting leaves one with a sense of incredulity that all the necessary avian functions can be crammed into such a glorious, miniature package.

As the coquette took off from the wire-thin branch, the sound of its small wings oscillating at high frequency was more reminiscent of a bee than a bird. It flew right across the broad banana leaf set up behind my four strobes. With a press of my shutter release, the strobes blazed, freezing the image of one of nature's wonders on the waiting sensor.

Moyobamba, Peru (May)
Canon EOS-1D X | EF 500 mm f/4L IS USM | 1/60 sec at f/20; ISO 400 | 4 strobes

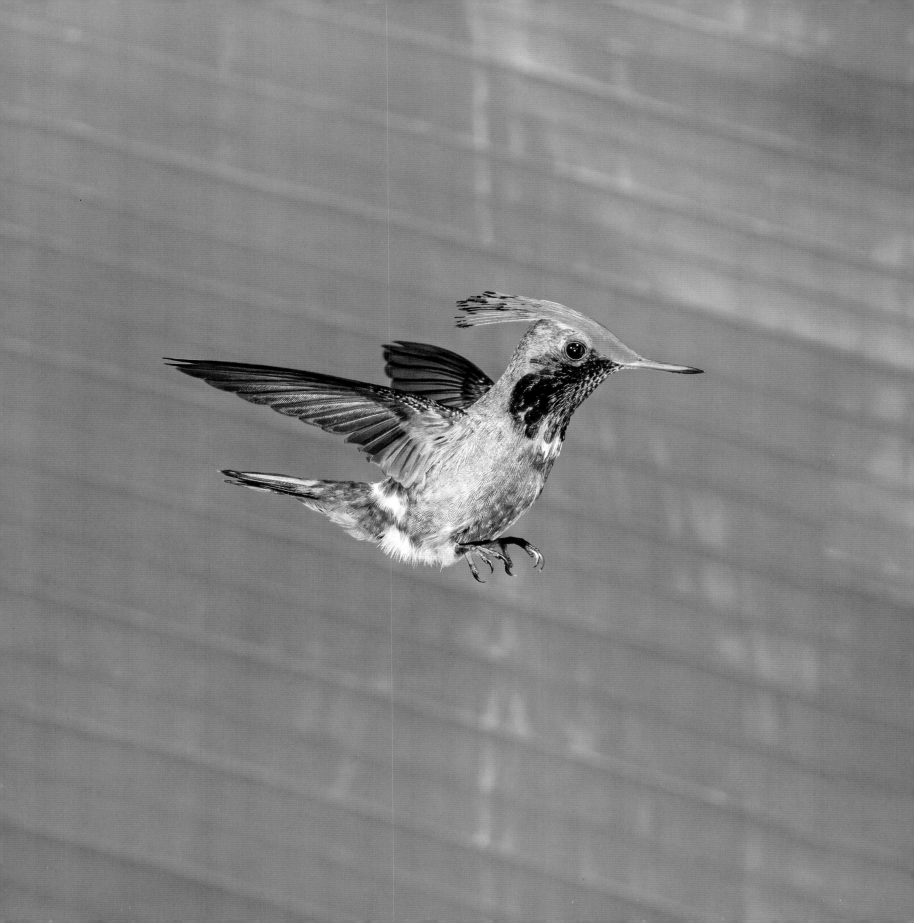

Purple-throated Woodstar

Species
Philodice mitchellii

Length
2.7–3.0 in. (6.8–7.5 cm)

Weight
0.11–0.12 oz. (3.0–3.3 g)

Conservation Status
Least concern

Population
Unknown; stable

Purple has long been associated with royalty (well before the late rock star Prince made it his signature color). As a child, I remember seeing the queen of England's crown jewels in the Tower of London. It was the purple cap of the imperial state crown and not its 317-carat Cullinan II diamond that left an impression on me. Purple whispers to us of creativity, luxury, mystery and magic — perhaps because there are so few plants, animals and birds that are purple.

So when a purple-throated bird that I had never seen before appeared in my viewfinder on the western slopes of the Andes, it was indeed a moment of great magic. This is a small creature. It was not quite as tiny as the Rufous-crested Coquette (see pages 52–53), but the arrival of the male pictured here was accompanied by the same loud, buzzing noise. Perhaps we should call these small editions "buzzingbirds" not hummingbirds! Remarkably, scientists do not know exactly why these birds buzz. Hummingbird expert Chris Clark told me that one part of the answer is that Purple-throated Hummingbirds flap with a wing frequency (80 cycles per second) that is at least 30 percent greater than would be expected based on their body size.[3] Another piece of the puzzle is wing feathers. Dr. Clark's group have observed that Allen's Hummingbirds generate "wing trill" through wing feather interactions using a subtle rotation at their "wrists." The trill can be aimed to some extent, either at rivals or a potential mate. They have theorized that the Purple-throated Hummingbird can do likewise.

The fact that this diminutive bird holds secrets that even dedicated minds have not yet unraveled is somehow deeply satisfying. Royalty is, after all, entitled to certain confidential privileges!

Tandayapa, Ecuador (March)
Canon EOS-1D X | EF 500 mm f/4L IS USM | 1/250 sec at f/16; ISO 800 | 4 strobes

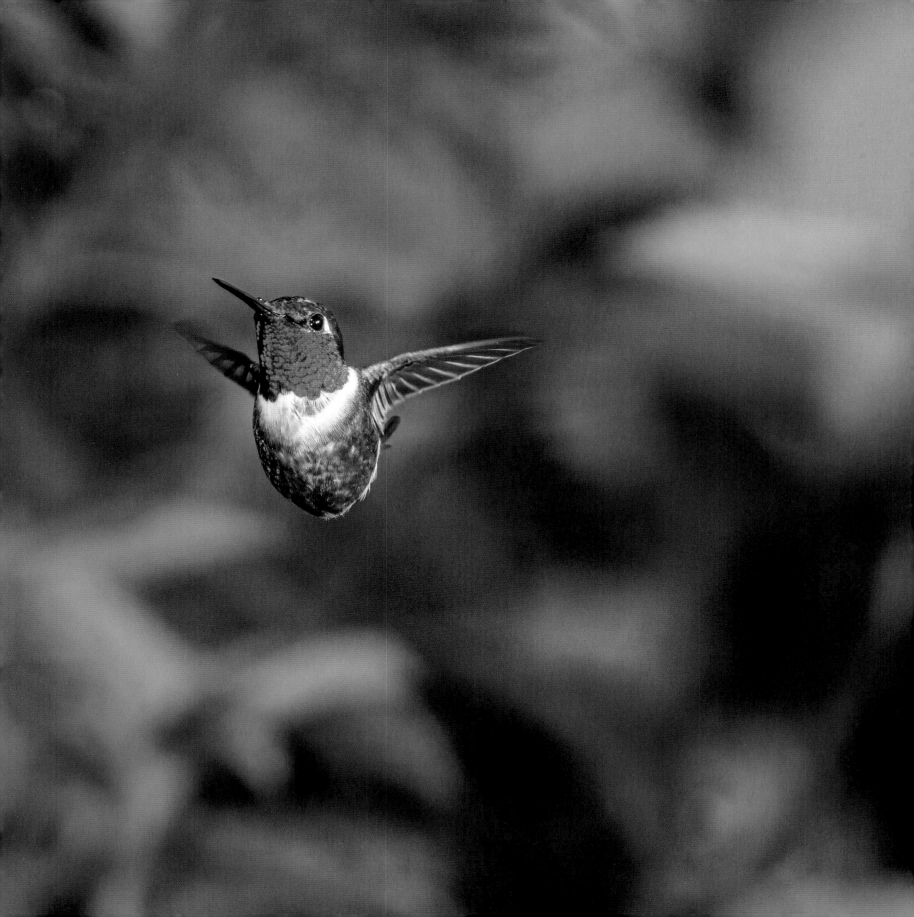

Rufous-tailed Hummingbird

Species
Amazilia tzacatl

Length
3.9–4.7 in. (10.0–12.0 cm)

Weight
0.2 oz. (5.2 g)

Conservation Status
Least concern

Population
Unknown

For many hummingbird species, great beauty is a cloak for extreme aggression! Photographers know this well, particularly those who have set up their cameras to focus on a nectar feeder in the hopes of capturing images of multiple species present in a given locale. Often, one dominant bird will decide that he "owns" the feeder (and it usually is a male!). He will perch within sight of the feeder and launch a dive-bombing attack on any other bird that visits, whether from his own species or from others. This is obviously not great for photography! Only rarely will the attacker actually stop to feed. His major goal is to prevent others from feeding. Not surprisingly, studies have found that both the attacker and the intruder are flying right at the limit of their available speed and aerobatic envelopes during the interaction. Some evidence also suggests that the most aggressive defenders of wild food resources, such as a bank of flowers, make the most desirable mates.

All of which brings us to the male Rufous-tailed Hummingbird in this image. Off camera at right is a nectar feeder, and this bird has just started to hover after moving in to assert his rights. The outside section of the wing (the "hand wing") is being moved backwards in a process which generates lift to hold the bird in place relative to a food source: Several other interesting features are also displayed in the image: the gaping downward curve of the lower bill, the warping of the wings, the clear delineation of the short feathers (called coverts) on the tail and wings, and the exquisite fanning of the tail. Since tail use is such a feature of maneuvering in hummingbirds, I try, when possible, to choose images in which the tail is deployed.

Tandayapa, Ecuador (October)
Canon EOS-1D X | EF 500 mm f/4L IS USM | 1/200 sec at f/29 | ISO 320 | 4 strobes

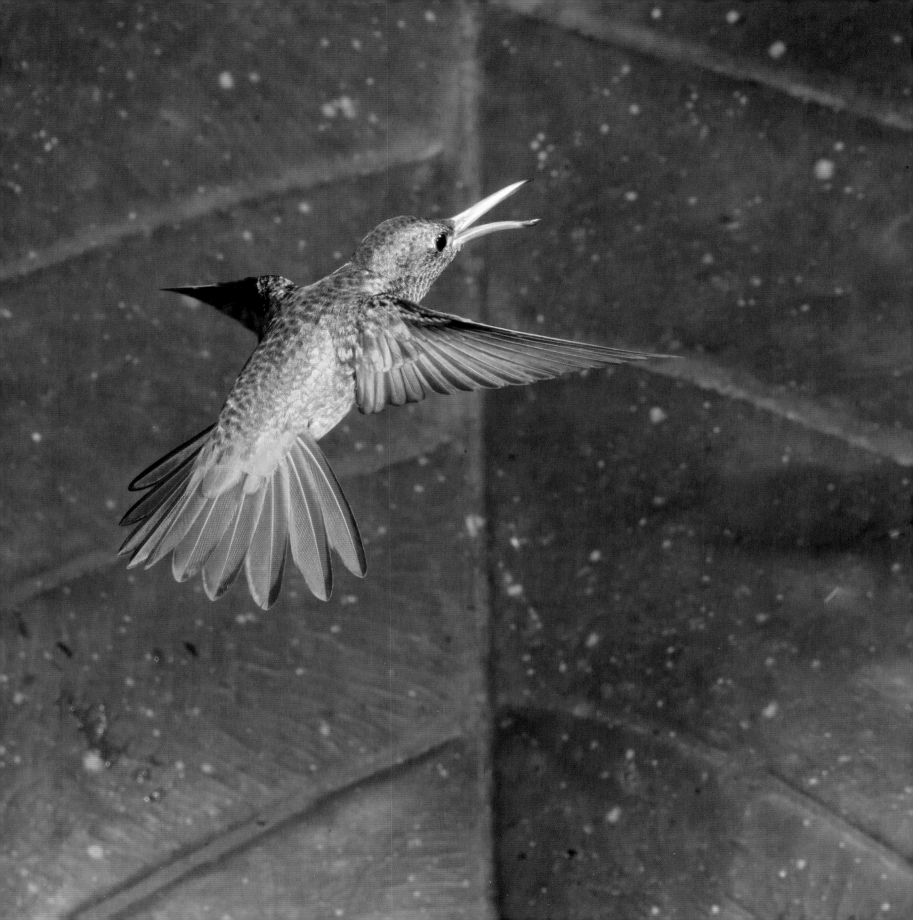

Shining Sunbeam

Species
Aglaeactis cupripennis

Length
4.7–5.1 in. (12–13 cm)

Weight
0.27–0.29 oz. (7.6–8.1 g)

Conservation Status
Least concern

Population
Unknown; stable

The air in Quito, Ecuador, at 9,200 feet (2,804 m) is extremely thin. Fresh off the plane, the hike up to my room after dinner required several rest stops. But in the morning light, it was clear that the many resident species of hummingbirds thrive at this elevation, cutting and diving to defend the nectar feeders placed around the terrace of the lodge. Most of the birds had showy heads, iridescent gorgets or colorful tails, but this male Shining Sunbeam was an exception: His flecked iridescent lilac-and-green rump contrasted vividly with his otherwise plain tan plumage.

I could not see it through the lens, but in the image it is just possible to make out the tip of the bird's tongue as he prepares to feed. In 1833, it was first proposed that the hummingbird's split tongue harvested nectar by capillary action. Imagine thrusting a thin straw into a bowl of colored water and seeing color spread up the tube — that's what capillary action resembles. But in 2011, Alejandro Rico-Guevara and Margaret Rubega looked beyond conventional wisdom and started studying hummingbird tongue movement in clear plastic feeder tubes. What they found is that the tongue acts like a pump, reshaping its contours to suck the nectar into the bird's digestive tract at a much faster rate than would be possible by capillary action. The moral of this story is that nothing should be taken for granted, even if it has been believed for 178 years! It is also humbling to learn that a key physiological system from one of our most beloved groups of birds had resisted discovery for centuries.

Quito, Ecuador (October)
Canon EOS-1D X | EF 500 mm f/4L IS USM | 1/250 sec at f/18 | ISO 320 | 3 strobes

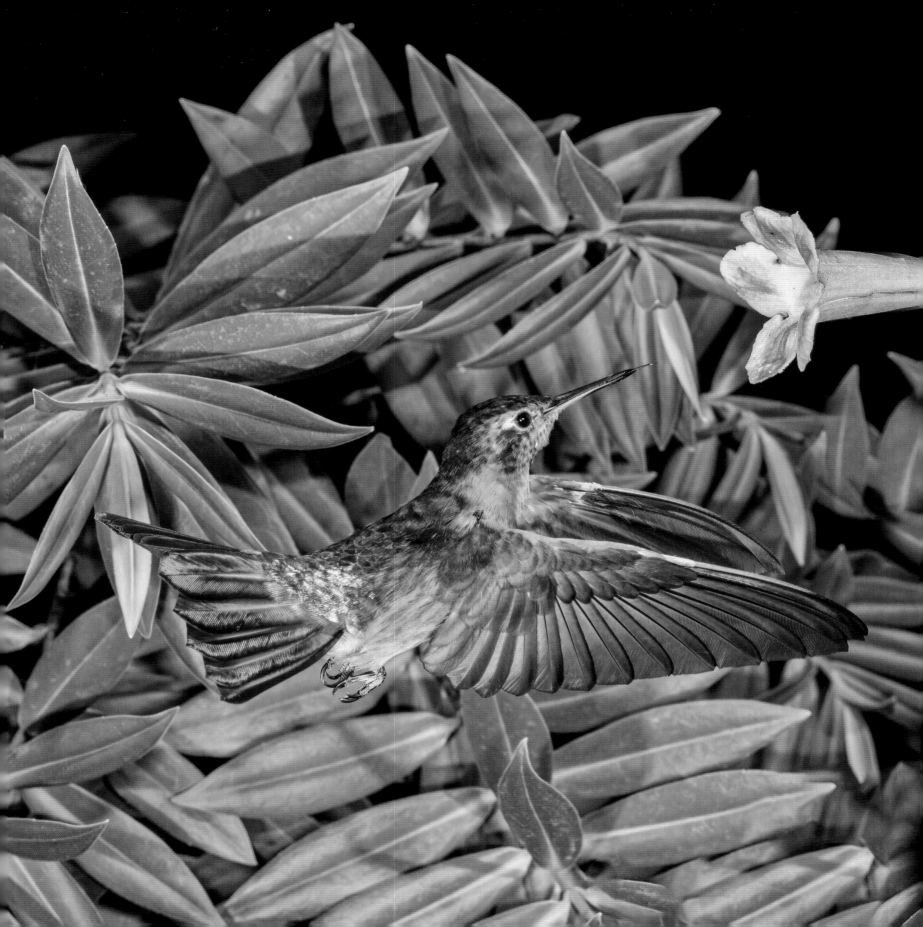

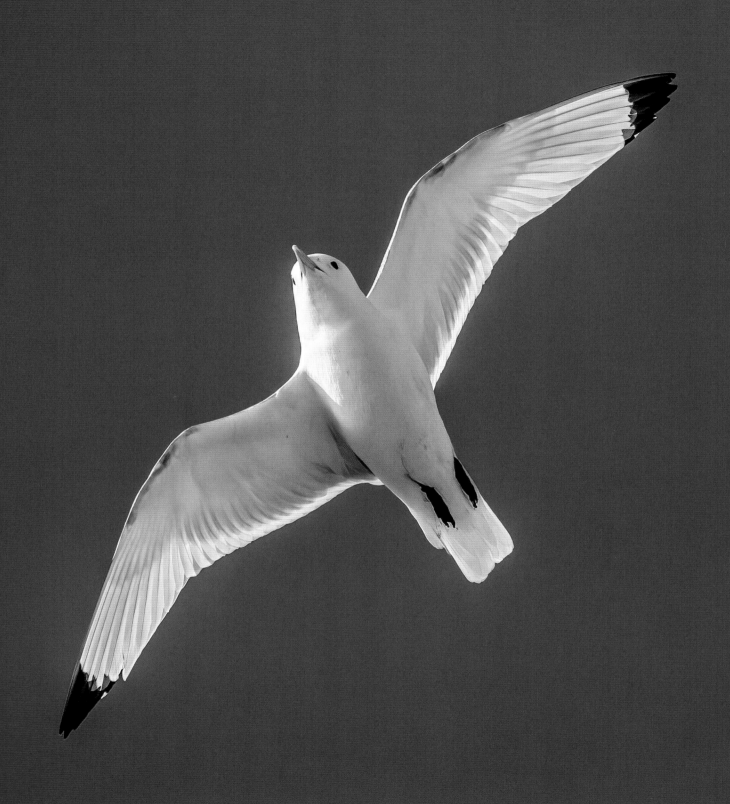

3
Gulls & Terns

Previous Spread

Species
Black-legged Kittiwake (*Rissa tridactyla*)

Location
Látrabjarg, Iceland (May)

Settings
Canon EOS-1D Mark IV | EF 70–200 mm f/2.8L IS II USM at 200 mm | 1/8000 sec at f/4.0 | ISO 640

It is easy to underestimate gulls and terns. They don't appear on any list of the world's most intelligent birds. As the street sign below from Inverness, Scotland, suggests, they are often considered a nuisance by people who have to navigate the mess left behind by a frenzied flock of gulls competing for food handouts. Yet these ubiquitous birds are gregarious, opportunistic, athletic and highly adaptable. Their persistent plaintive cries also inhabit the background noise of many a childhood memory of a seaside vacation.

We should first dispose of the term "seagull." Despite the Scottish sign and 1970s best-selling self-help book *Jonathan Livingston Seagull*, no bird has the word *seagull* as part of its name. And neither are gulls confined to the seashore. Gulls certainly thrive in coastal regions when food sources are plentiful and secure nesting locations are available, but they are also encountered every day by people who live nowhere near the sea. Gulls live above the water and on it, but rarely put more than a head underwater. In contrast, most terns are skilled divers who patrol the shoreline and plunge-dive headfirst into the water to grab prey.

Many gulls can be maddeningly difficult to identify. Adults change their plumage during breeding season, and young birds pass through years of different stages of molt during which they look nothing like their parents.

Most common gulls are omnivores — they will eat anything and everything. This has led some observers to ask if gulls have abandoned the sea since they can be found at landfills and dumpsters eating french fries and other human detritus thousands of miles from the ocean. In their natural habitats, gulls excel at finding sustenance in the form of small fish, crustaceans, mollusks and invertebrates. They are quick to spot fishing boats, and swarms of them can surround boats, waiting for bycatch. This usually includes stealing food from other gulls (known as

kleptoparasitism) and, despite their reputation as dunces, occasionally using ingenious behaviors to access otherwise inaccessible food.

I see one such example on a regular basis. There is a road near my home on a thin strip of land called a tombolo (not to be confused with the game Tombola!). On the west side is a tidal sound, and on the east side is a bay. At low tide, Glaucous-winged Gulls find mollusks in the exposed floor of the bay. They take off with closed shells in the wide gape of their bill. After climbing above the road, they try to hover briefly and then drop the mollusk onto the road so that it breaks open, exposing a morsel of food. Using the road as a proto-tool seems to be a learned behavior because young gulls acquire the skill slowly. It is interesting that the gulls know that the road is the preferred site for the drop, rather than the adjacent rocky beach (the impact is more dependable on a flat, hard surface).

Gulls have also been known to fish using bait: A Herring Gull has been observed using bread scraps thrown to ducks by tourists in the center of Paris. The bird took a piece of bread, broke it into smaller pieces and then scattered the crumbs on the water. It waited motionless and then lunged when a goldfish appeared to feed.

Gulls may also be the group of birds most frequently drawn by children. The simplicity of the two connected arcs representing flying gulls conceals a complex aerodynamic characteristic known as "wing droop," in which the wing tips are lower than the mid-wing "wrist" joint. Engineers have explored this phenomenon and found that it represents an optimum aerodynamic solution to the gull's wing anatomy.[1]

Terns, however, occupy a much more exotic place in the avian pantheon. This high regard is driven by the astonishing athleticism of the Arctic Tern (*Sterna paradisaea*). This small bird spends its entire life in a constant search for daylight, migrating between the Arctic and

A street sign in Inverness, Scotland.

Least Tern (*Sternula antillarum*) South Padre Island, TX

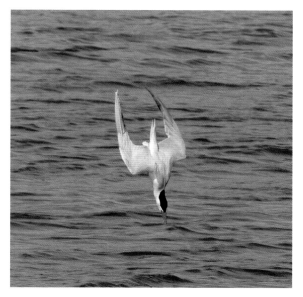

A Glaucous-winged Gull (**left**) feeds on the surface, and a Caspian Tern (**right**) plunge-dives for food. Both images were taken on Lopez Island, WA.

Antarctic. Over its lifetime, it accumulates nearly 1.5 million miles of flight distance. Terns also tend to be more specialized feeders: Like gulls, they sometimes enlist the help of marine mammals that bring their chosen food closer to the surface.

Because of the notion that gulls and terns are numerous and omnipresent, it can be hard to accept the reality that many species are facing challenges to survive in the Anthropocene age. In 2016, a special issue of the journal *Waterbirds* was devoted to the status of gulls around the world. American ornithologist John Anderson and his colleagues from Canada and the United Kingdom noted "….dramatic drops in regional numbers of Herring Gulls (*Larus argentatus*) and Great Black-backed Gulls (*L. marinus*), as well as similar trends in Ring-billed Gulls (*L. delawarensis*)". In New Zealand, the Red-billed Gull (*Larus novaehollandiae scopulinus*) is now less common than the endangered kiwi. Many species of terns are threatened due to declining food stocks, pollution, encroachment and their casual nesting behavior close to human habitation. This story is all too familiar, but it is compounded by the lack of concern — or even by outright antagonism — for this varied group of interesting and vital birds. It is hard to imagine a seashore devoid of gulls, but such is the vision in some dystopian accounts of our environmental future.

Heermann's Gull (*Larus heermanni*)

Belcher's Gull

Species
Larus belcheri

Length
17.7–21.2 in. (45–54 cm)

Wingspan
47.0 in. (120 cm)

Weight
1.2–1.6 lb. (560–725 g)

Conversation Status
Least concern

Population
Less than 10,000 birds; increasing

The Humboldt current sweeps a torrent of cold, subantarctic water up South America's Pacific coast. As this cold water mixes with warmer Peruvian waters, the upwelling carries food to the surface, which attracts a rich ecosystem of invertebrates, fish, marine mammals and birds. This Belcher's Gull, one of the animals that lives off the Humboldt current, exudes "gullness" in its breeding plumage: yellow legs and bill contrasting boldly with a snow-white body, almost 4 feet (123 cm) of deep black upper wings, banded tail, black eyes, and red and black bill spots. Bird photographers try to capture these important "field marks" that identify a species, but they also want to give a sense of the bird's habitat, which is what I really like about this image. One senses that this bird is completely at home among the crashing waves that carry its food to the shore.

The story behind this gull's name exposes a fascinating link between 19th-century British explorers and politics. Sir Edward Belcher was a real-life captain in the British Royal Navy who surveyed the Pacific coast that his namesake gull inhabits. Among Belcher's other exploits was the command of a rescue mission that included five ships to search for Sir John Franklin's lost expedition to find the Northwest Passage. In 1854 Belcher abandoned his ships, including the HMS *Resolute*, when they were trapped in ice. This led to a court martial that ended Belcher's career, but the *Resolute* was later to drift free and be returned to the British by an American whaler. After its subsequent salvage, oak timbers from the *Resolute* were used to make the Resolute Desk that is still used in the Oval Office by U.S. presidents. So there it is, less than six degrees of separation between a Belcher's Gull and the seat of American political power!

Paracas, Peru (June)

Canon EOS-1D X | EF100–400 mm f/4.5–5.6 IS II USM at 400 mm | 1/5000 sec at f/5.6 | ISO 800

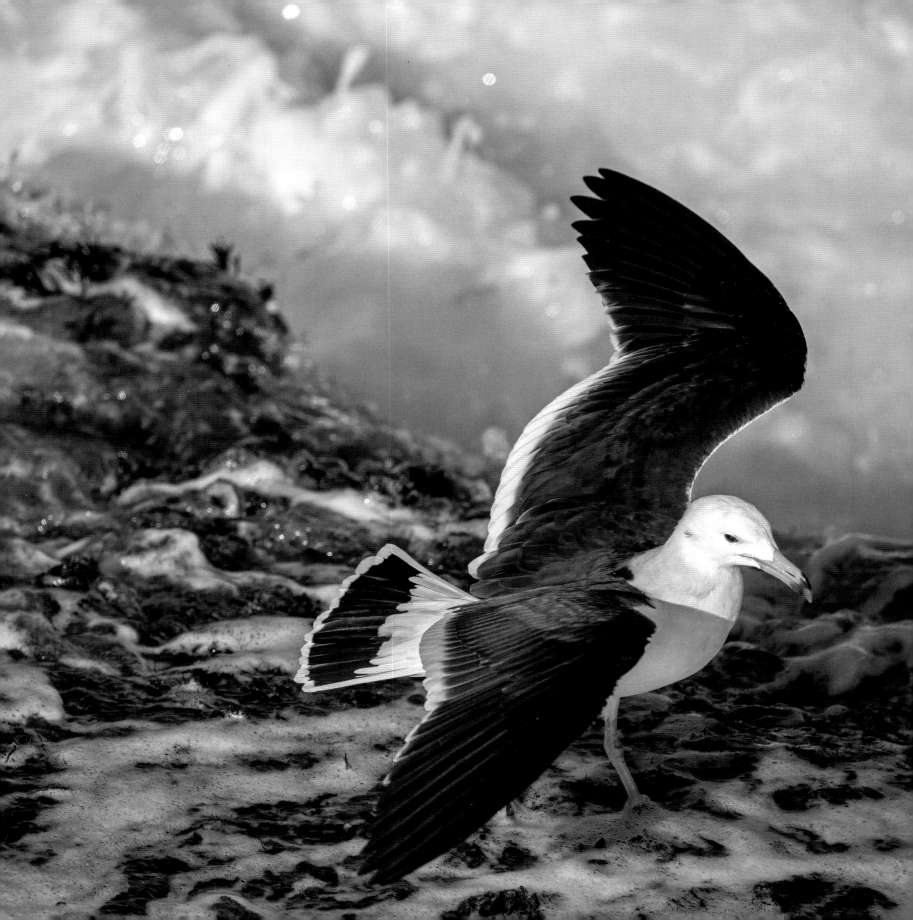

Caspian Tern

Species
Hydroprogne caspia

Length
18.5–21.3 in. (47–54 cm)

Wingspan
3.9–4.2 ft. (120–135 cm)

Weight
1.3–1.7 lb. (590–771 g)

Conservation Status
Least concern

Population
240,000–420,000 birds; increasing

The exotic Greco-Latin name of this bird, which translates to "water swallow of the Caspian Sea," belies its wide distribution throughout the world. I am fortunate to have a small colony of Caspian Terns in the bay outside my house. They mark the changing seasons, arriving in spring and leaving in early fall. They are the largest tern, about the same size as large gulls, but are easily distinguishable by their bright coral-red bills, heronlike croaks, and characteristic and very purposeful flight paths. Caspian Terns prefer a fish diet, and they search for food with the discipline of a pilot approaching an airport. Following a racetrack path, they fly the upwind segment with their head down, using their keen water-adapted eyesight to search for fish. Flying into the wind reduces ground speed and provides additional time to scan the water. The downwind leg is flown quickly and with deep wing beats, ignoring the water below. The path around the racetrack continues thus, until they locate a fish, whereupon they plunge-dive after a brief period of hovering. About half the time, the result is what you see in the adjacent image: They capture a small fish. The bird either devours it on the fly or makes a beeline back to its nest.

Some notable aerodynamic features are displayed in this image. The bird's wing tips are turned up like the winglets of a jet plane. This has been shown to be energetically efficient, increasing the lift-to-drag ratio. Note also the wonderfully streamlined shape of this bird in flight: The bill and head run seamlessly into the contoured body, and the bird is tucking its legs tightly into the base of its tail.

Lopez Island, Washington (August)
Canon EOS-1D Mark IV | EF 600 mm f/4L IS USM | 1/3200 sec at f/5.6 | ISO 400

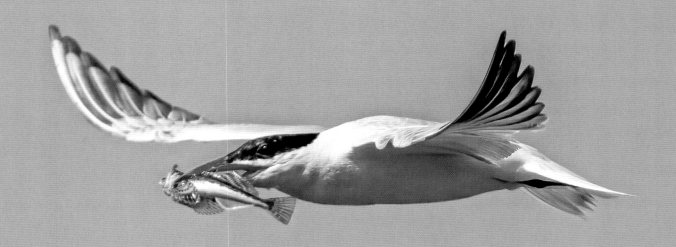

Lava Gull

Species
Leucophaeus fuliginosus

Length
20.0–22.0 in. (51–55 cm)

Wingspan
4.3 ft. (130 cm)

Weight
13.0 oz. (380 g)

Conservation Status
Vulnerable

Population
Estimated to be 600–800 birds; stable

This is what vulnerability looks like. As the rarest gull in the world, the Lava Gull is believed to have an estimated population of only 600 to 800 individuals. It is endemic to the Galápagos Islands, and even within this relatively small protected enclave, the population shows little sign of expanding. Surprisingly, there are no concerted conservation campaigns to safeguard this species. There are only a handful of scientific studies that describe its hardscrabble life, which depends on stealing the eggs of other birds and retrieving food caught and regurgitated by other birds.

When there are so few members in a population, a small disturbance in the ecosystem can drive the species to extinction. For example, a virulent avian virus called Newcastle disease has been detected in the Galápagos in domestic chickens, and Lava Gulls are believed to be at risk. The gull's vulnerability is increased by its apparent unwillingness to travel far from its nest to forage, so food scarcities at home affect its reproductive success.

The Galápagos Islands are a photographer's dream location. Unique endemic species live in highly photogenic settings, and most of the wildlife (gulls excluded!) are entirely unconcerned about humans because they are not perceived as a threat. I have seen a finch frustrate an eager photographer by perching on his lens! My own time was enhanced by visiting with local photographer Tui de Roy, who has documented these islands extensively with her exquisite images.

Mosquera Island, Galápagos Islands, Ecuador (November)
Canon EOS-1D X | EF 100–400 mm f/4.5–5.6 IS II USM at 200 mm | 1/600 sec at f/5.6 | ISO 1250

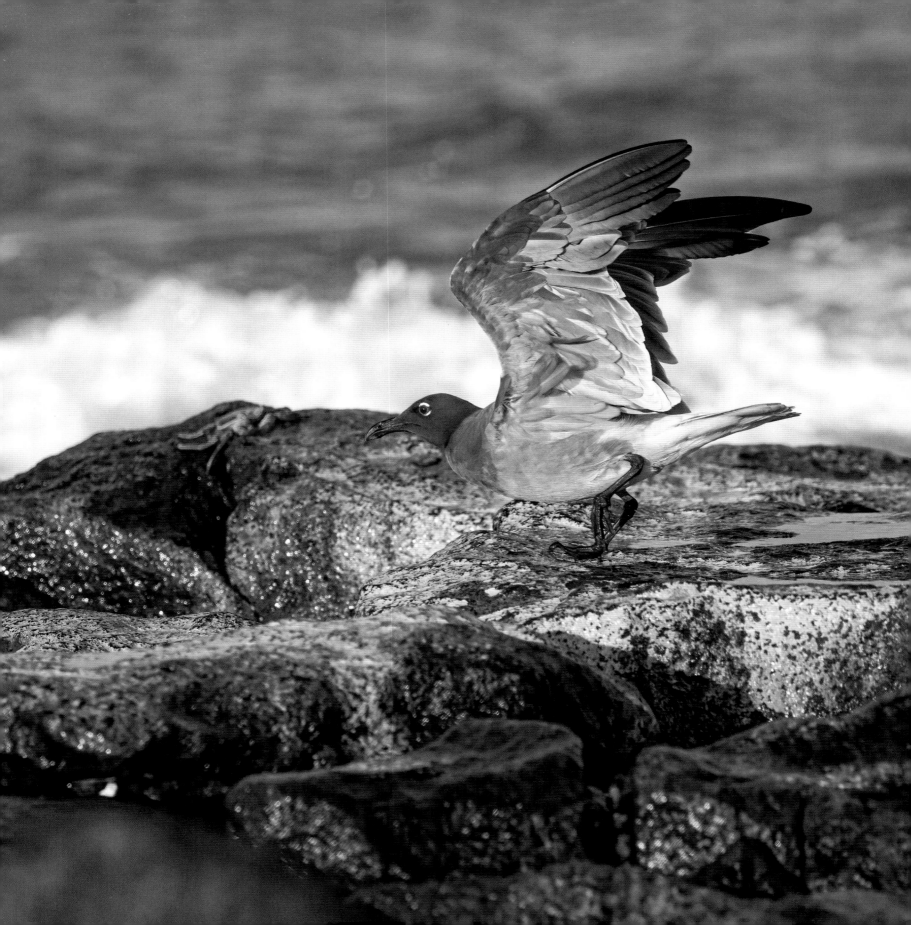

Glaucous-winged Gull

Species
Larus glaucescens

Length
19.7–23.2 in. (50–59 cm)

Wingspan
3.9–4.7 ft. (120–143 cm)

Weight
1.9–2.6 lb. (900–1,200 g)

Conservation Status
Least concern

Population
Approximately 250,000–300,000 pairs; increasing

At the end of a crisp winter afternoon, I set up my tripod at Weeks Wetland and focused on a small group of foraging Northern Pintail ducks (*Anas acuta*), hoping they would fly, but something more interesting intervened: A dusky-headed adult Glaucous-winged Gull was standing in the shallows ingesting what looked like the detached arm of an Ocher Sea Star (*Pisaster ochraceus*). In a flash of pearl gray and brown, an immature Glaucous-winged Gull landed next to the stranded echinoderm to claim a leg of his own. When no amount of pulling produced the desired result, the young bird took flight with a powerful down thrust of its wings, hoping to separate a limb from its owner with the help of gravity. The resulting shot makes the wings appear like a clamshell of feathers above the isolated body of the bird. The water streaming from the bird's feet adds additional dynamics.

This shot would be very difficult to obtain in 2021. Sea stars have suffered from a devastating wasting disease that has killed many species from Alaska to the Baha Peninsula. Since some sea stars are keystone predators, the effects of their loss have rippled down the food chain. A virus was initially implicated, but more recent studies suggest that a more complex mix of environmental factors and infection may be involved. One comprehensive study has revealed a convincing association between abnormally high near-shore temperatures and peak decline in sea stars. Now six years after the outbreak, recovery among many species is limited, and a complete understanding of the causes of the epidemic remains to be elucidated.

Lopez Island, Washington (December)
Canon EOS-1D Mark IV | EF 500 mm f/4L IS USM | 1/1250 sec at f/5.6 | ISO 800

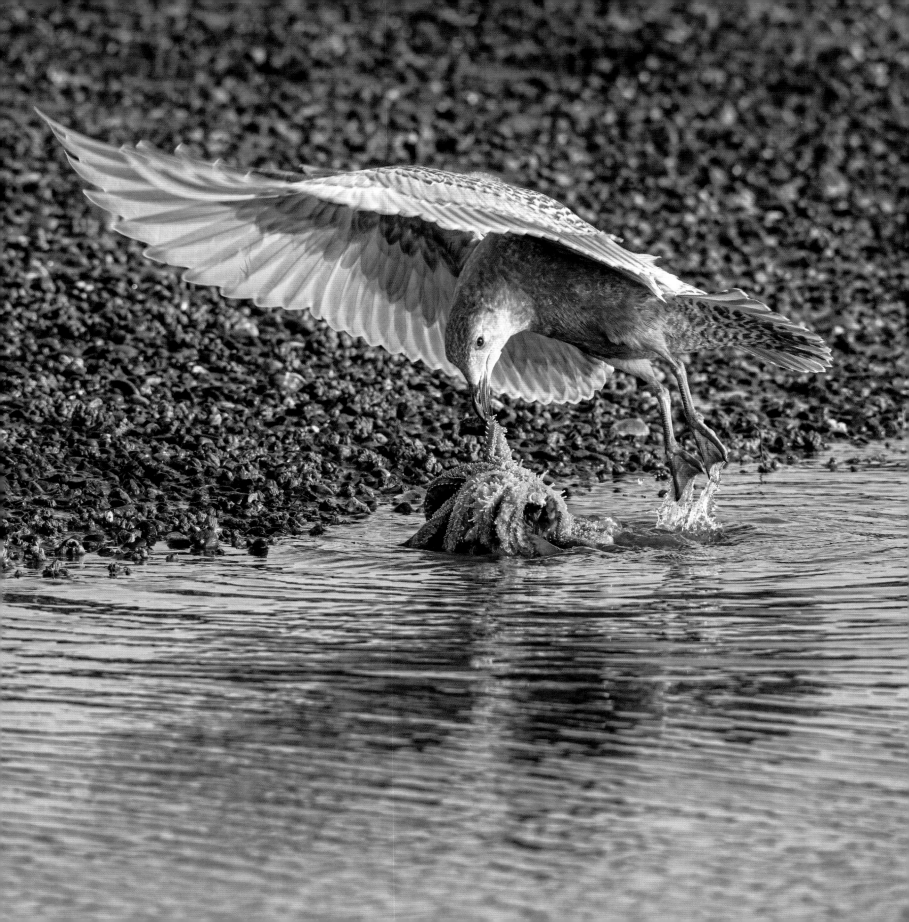

Inca Tern

Species
Larosterna inca

Length
16.0 in. (40 cm)

Wingspan
2.6 ft. (80 cm)

Weight
6.3 oz. (179 g)

Conservation Status
Near threatened

Population
More than 150,000 birds; decreasing

At its zenith, before the arrival of the Spanish in 1526, the Incan empire stretched for more than 3,600 miles (5,800 km) from what is today southern Colombia to central Chile. It is fitting that this striking bird, whose territory occupies a significant proportion of that range, is named after a civilization that valued beauty, color and ceremony.

The Inca Tern is famous among bird lovers for its unique trailing handlebar moustache, deep red bill and legs, and white-tinged charcoal-gray wings. Its aerobatic mating rituals include in-flight food exchanges. As I stood with a handheld rig on the cliffs above the raging Humboldt current in Paracas, Peru, my first sight of the Inca Tern was entirely joyful: one of those jaw-dropping moments of amazement that such great natural beauty exists.

But what are the prominent white circles in the lower part of the image? These were not actual objects in the field of view. They are artifacts of the camera optics called "bokeh" — a name derived from a Japanese word for blur or haze. My camera was about 20 feet (6 m) from the bird, and at the settings used (focal length of 400 mm with an aperture of f/7.1), the available depth of field in which objects were in focus was only about 4 inches (10 cm). The bright reflections off the waves in the background were therefore well out of focus, and the lens rendered them as circles. Personally, I really like this effect, but I know there are those who find it distracting. However, some people like it so much that there are a large number of apps that add bokeh to images where none was generated by the lens.

Paracas, Peru (June)

Canon EOS-1D X | EF 100–400 mm f/4.5–5.6 IS II USM at 400 mm | 1/2500 sec at f/7.1 | ISO 1000

Sandwich Tern

Species
Thalasseus sandvicensis

Length
13.4–17.7 in. (34–45 cm)

Wingspan
2.7–3.0 ft. (84–90 cm)

Weight
6.3–10.6 oz. (180–300 g)

Conservation Status
Least concern

Population
300,000–500,000 birds; stable

At first glance, this Sandwich Tern looks as though it is executing a barrel roll! However, a closer examination reveals that the wings are in the usual position and the maneuver is, in fact, a momentary 180-degree neck swivel. It is self-evident that water birds get wet, and they have developed a number of strategies to ensure that excess water does not weigh them down in flight.

This bird had been bathing and preening in the surf. Shortly after taking off, it executed a whole-body shake to rid itself of on-board water. This might have been a comfort measure rather than a necessity, but I have seen Ospreys emerging from a plunge dive grasping a large fish struggle to gain height because they were waterlogged. Typically, they will stop flapping, despite losing height, while vigorously shaking off excess water.

The diagnostic feature of a Sandwich Tern is its black bill with a small yellow tip. In 1787, British ornithologist John Latham described the Sandwich Tern as being "generally seen in the neighborhood of Romney about the 17th of April."[2] Romney is just southwest of the town of Sandwich in Kent, England, hence the bird's name, but this bird has a worldwide distribution. My encounter occurred during a late morning walk along Sanibel Island's idyllic Bowman's Beach. This beach is a frenzy of gulls and terns, most of whom are quite accustomed to human passersby. The lens I was using is very fast (meaning it has a large maximum aperture of f/2.8), which allows fast shutter speeds (like the 1/8000 of a second used here) and low ISO settings.

Sanibel Island, Florida (January)
Canon EOS-1D Mark IV | EF 70–200 mm f/2.8L IS II USM at 200 mm | 1/8000 sec at f/4.5 | ISO 250

Yellow-legged Gull

Species
Larus michahellis

Length
20.0–27.0 in. (52–68 cm)

Wingspan
3.9–5.0 ft. (120–155 cm)

Weight
1.2–3.5 lb. (550–1,600 g)

Conservation Status
Least concern

Population
Approximately 409,000–534,000 pairs in Europe; increasing

Texel is the largest of the West Frisian Islands, a chain of natural barrier islands that buffer the northeastern coast of the Netherlands from the belligerence of the North Sea. The peaceful dunes of the national park belie the history of the many battles that have been fought on Texel over the centuries. The island is visited by many avian migrants, including the Eurasian Spoonbill (*Platalea leucorodia*), which drew me there.[3] Surprisingly, since the Dutch are avid builders of bridges, the only way to get to Texel is by a short ferry ride from the small mainland city of Den Helder. This image was taken on that ferry.

People love to feed gulls. The ferry passengers on my ride held out their snacks to share with the Yellow-legged and Black-headed Gulls that formed a scrum in the sky above us. The birds circled the stern of the boat and then turned in our direction of travel as they jockeyed with their neighbors for a pole position close to the passenger deck. Their strategy to snatch the food was to fly at full speed toward an outstretched hand and then apply the brakes full-on to minimize contact speed. The bird pictured here is far from the sleek, streamlined vision of gulls that we often have. The ruffled feathers on the underside of the wings indicate a turbulent airflow as the bird stalls to bleed off speed. This image is a dramatic reminder that birds can morph and position their wings to fly almost anywhere and anyway they want in a manner that airplanes cannot.

Texel, the Netherlands (May)
Canon EOS-1D Mark IV | EF 70–200 mm f/2.8L IS II USM at 140 mm | 1/3200 sec at f/6.3 | ISO 800

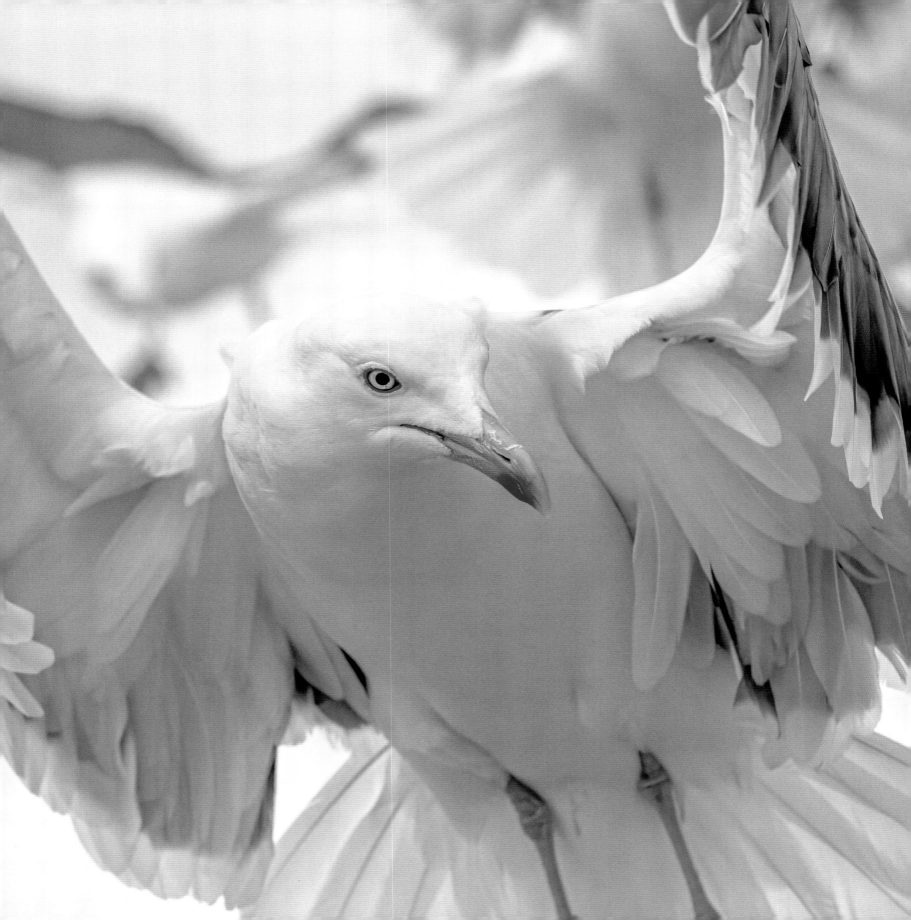

Swallow-tailed Gull

Species
Creagrus furcatus

Length
20.1–24.0 in. (51–61 cm)

Wingspan
4.0–4.6 ft. (124–139 cm)

Weight
1.3–1.7 lb. (610–780 g)

Conservation Status
Least concern

Population
10,000–15,000 pairs; trend unknown

The Swallow-tailed Gull is a bird superhero. While it doesn't have X-ray vision like Superman, it has characteristics that are much more useful to a bird that searches for small items of food at night: large eyes with enhanced night vision and a hooked bill. The Swallow-tailed Gull's eyes have a light-reflective layer behind the retina that effectively increases the gain of its retinal cells. In the early evening, Swallow-tailed Gulls leave the nest to hunt for squid and small fish that only surface after dark. Some of this prey is fluorescent, which helps the gull's targeting.

This species nests almost exclusively in the Galápagos Islands, if a small scrape on a rocky shore can be distinguished as a nest. I have watched a Swallow-tailed Gull fiercely defending its egg lying on the shore in full view of a marauding Nazca Booby (*Sula granti*).[4] An endearing feature of Swallow-tailed Gull's courtship is food sharing, during which the male offers the female whole or regurgitated squid.[5]

I have also photographed Swallow-tailed Gulls on North Seymour Island. This is the first stop for many visitors to the Galápagos Islands because it lies right next to the main airport at Baltra. Nothing can prepare the photographer for the sheer intensity and in-your-face impact of life that inhabits this tiny island: Magnificent Frigatebirds (*Fregata magnificens*) inflate their bulbous blood-red gular pouches and Blue-footed Boobies (*Sula nebouxii*) strut and weave just 3 feet (1 m) from the narrow path. Darwin's finches cling to prickly cacti, while marine and land iguanas stare at the visitors with haughty, statuesque indifference. It is hard to know which of these myriad animals to photograph first. In a few brief hours there, I took more than 2,200 images.

Tower Island, Galápagos Islands, Ecuador (February)
Canon EOS-1D Mark IV | EF 500 mm f/4L IS USM | 1/1000 sec at f/14 | ISO 800

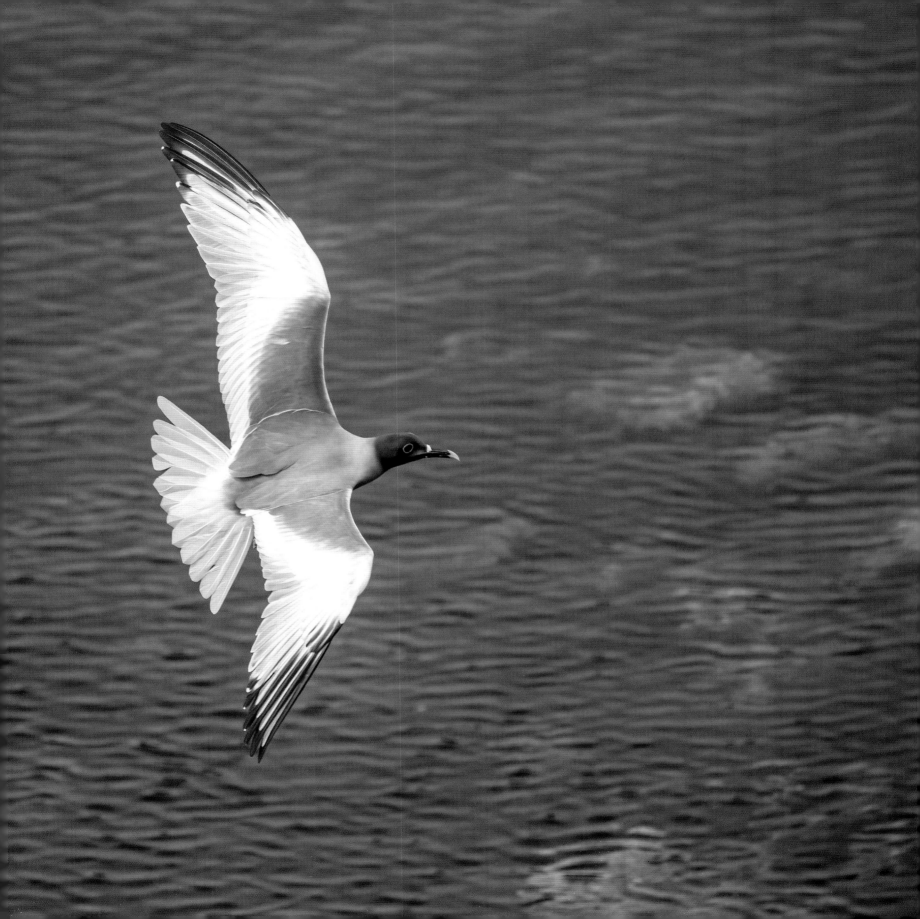

Antarctic Tern

Species
Sterna vittata georgiae

Length
13.8 in. (35–40 cm)

Wingspan
2.4–2.6 ft. (74–79 cm)

Weight
5.3–6.3 oz. (150–180 g)

Conservation Status
Least concern

Population
9,450–17,700 for this subspecies (132,000–145,000 birds total for all subspecies, including 45,000 breeding pairs); trend unknown

Godthul, South Georgia (November)
Canon EOS-1D X | EF 100–400 mm f/4–5.6L IS II USM at 400 mm | 1/1600 at f/5.6 | ISO 2500

A wet landing on a rugged, isolated beach is always a supremely exciting moment.[6] In the Antarctic, the photographer is a tolerated guest into the private worlds of animals who continue their daily battle to survive in almost complete indifference to human intrusion. This day was no exception, despite skies that were slatey gray and the light rain that was spitting onto nearby gleaming icebergs. As our boots slid down the wall of the Zodiac into the water on the narrow rocky beach at Godthul, a diverse cast of elephant seals, Gentoo Penguins (*Pygoscelis papua*), and endemic and common birds decorated the landscape. I decided to concentrate on a pair of Antarctic Terns that were patrolling the beach.

Compared to its cousin the Arctic Tern (*Sterna paradisaea*), the Antarctic Tern is positively lazy! While Arctic Terns relentlessly oscillate between the northern and southern polar regions, many Antarctic terns are quite happy to stay put in their own neighborhoods or, at the most, make a short trip to the Atlantic coasts of South America or Africa. It is, however, dangerous to overwinter in such an inhospitable climate: Chicks may not survive during brutal weather, particularly when predators such as Brown Skuas (*Stercorarius antarcticus*) may be nesting less than 100 yards (91 m) away.

The challenge with this shot from the beach was to capture an image of the bird against something other than the gray water or sky or the pure whiteness of an iceberg.[7] It is easy to be mesmerized by the first sighting of a bird and to immediately start shooting. Sometimes that is the only option when a bird unpredictably appears, but terns are creatures of habit: They fly a dependable racetrack pattern when fishing, slowing into the wind while looking down into the water and quickening their pace downwind as they prepare to start searching for food again. By moving upwind, I was able to place the bird against a moss-covered cliff and capture a frontal image with outstretched wings and tail. The mottled appearance of the out-of-focus background had the added benefit of highlighting raindrops, transforming difficult weather conditions into a positive feature.

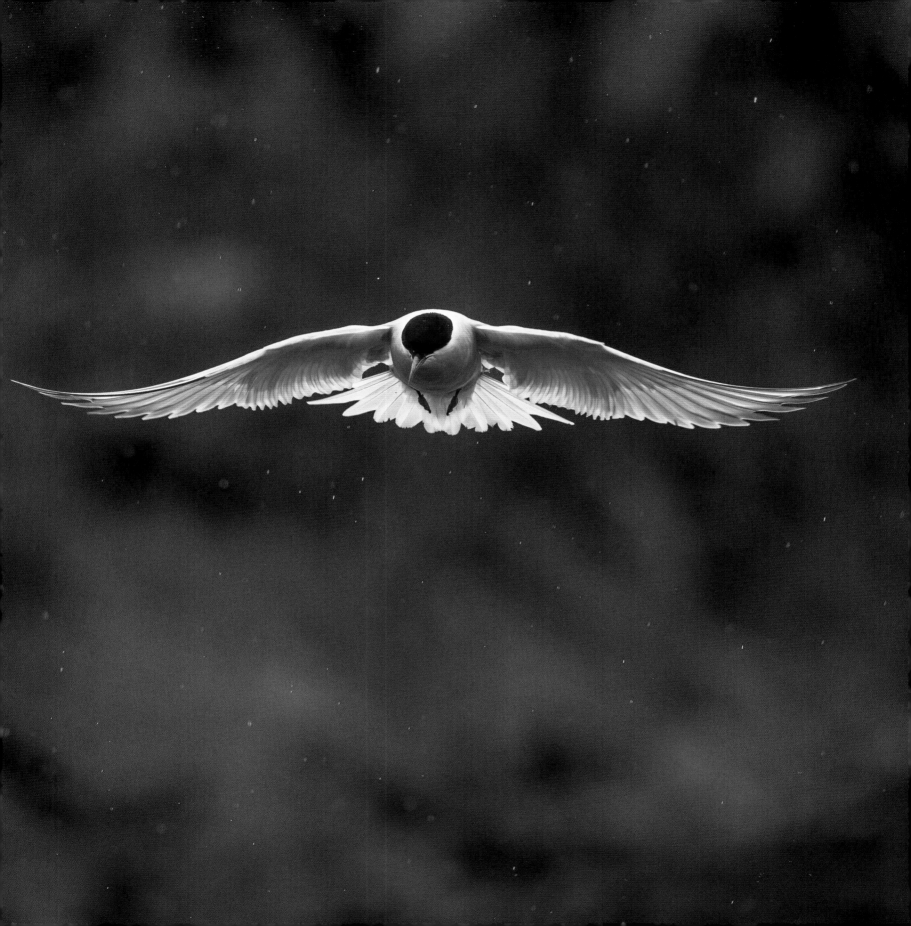

4
Small Waterbirds

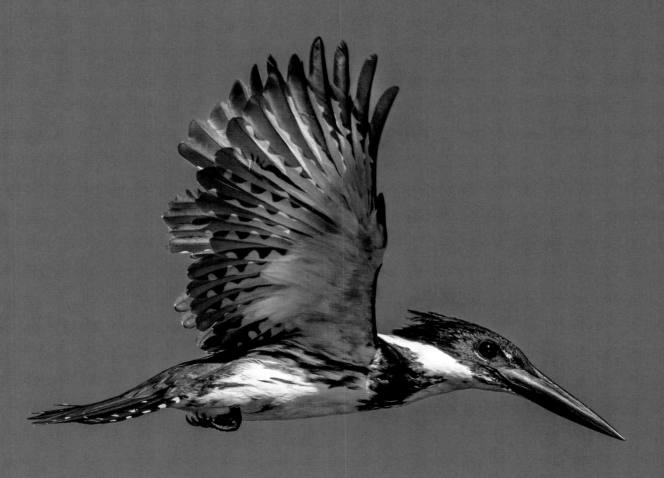

Theodore Lamont Cross II is one of my heroes. After a stellar career in publishing, law, government and civil rights, Cross, in his sixth decade, found inner peace as a bird photographer. His second book of bird photographs, *Waterbirds*, was published in 2008 to broad critical acclaim. I was given a copy soon after I moved to the Pacific Northwest, a region that is rich in waterbirds. Cross's book provided a road map for my own photographic explorations. He showed me that one could leave behind a professional career without regret to pursue the passion we both shared. His focus on islands led me to understand the importance of isolation in the evolution of species; now I live on an island! His images, many of which show birds in flight, motivated me to improve my own photographs, and I have visited several of his favorite islands to shoot waterbirds.

Ted Cross died in 2010, aged 86. His obituary in the March 3, 2010, issue of the *New York Times* recounted that he wished his epitaph to read as follows:

> *He Passed on*
> *To a Better World*
> *Still Waiting for*
> *A Perfect Picture*
> *Of a Reddish Egret.*

My non-perfect flight picture below of Ted Cross's favorite waterbird, the Reddish Egret (*Egretta rufescens*), taken on Green Island, Texas (where he often visited), is offered in celebration of a life well lived by a polymath and master photographer of waterbirds.

There is a Waterbird Society and a journal called *Waterbirds*, but no bird actually includes the word *waterbird* in its name, and there is

Previous Spread

Species
Amazon Kingfisher (*Chloroceryle amazona*) (female)

Location
Rio Claro, Pantanal, Brazil (July)

Settings
Canon EOS-1D Mark IV | EF 500 mm f/4 ISM | 1/8000 sec at f/5.6 | ISO 800

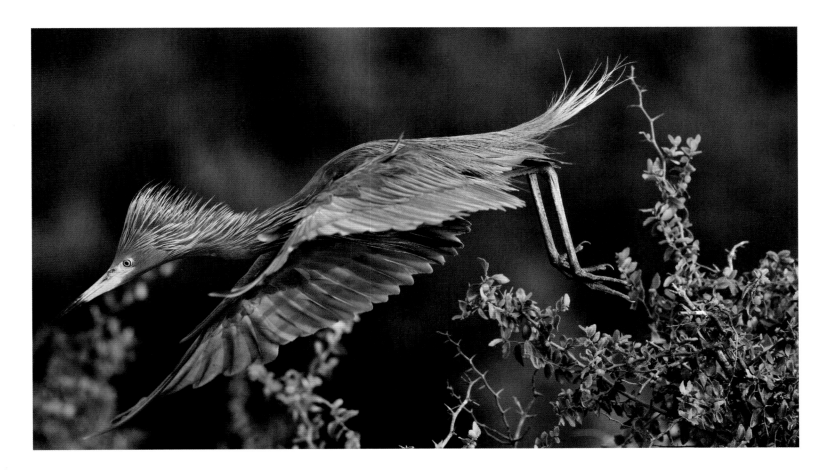

A Reddish Egret (*Egretta rufescens*) on Green Island, Texas, shoots from its perch in search of food.

no taxonomic order or family of waterbirds. Yet the term is widely, if loosely, used to refer to birds that feed in, nest by, swim in, wade in, depend on or otherwise frequent fresh or salt water. It also embraces other slightly more restrictive subcategories, such as shorebirds, waders, seabirds and waterfowl.

My classification of "small" for this group of waterbirds and "large" for the next group is entirely arbitrary. All the birds in this chapter weigh less than about 2.2 pounds (1 kg), but the range is quite wide, from the diminutive Dunlin (*Calidris alpina*) at 1.2 ounces (33 g) to the substantial Red-footed Booby (*Sula sula*), which can weigh up to 2.2 pounds (1 kg). Small waterbirds are an excellent target for the photographer because they are somewhat predictable in their movements and usually very gregarious. This means that time can be spent getting the right shot, rather than searching for the bird. Mass migration of

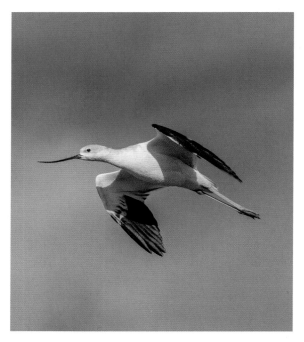

The upcurved beak and long legs of the American Avocet are adaptations that facilitate "scything" and wading feeding behaviors. Great Salt Lake, UT

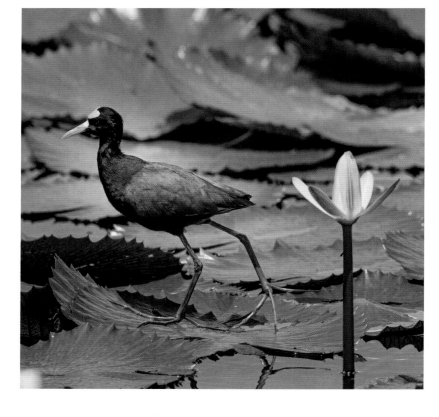

The extended foot segments of the Northern Jacana allow this bird to walk on water lily pads. Turrialba, Costa Rica.

small waterbirds also offers tremendous opportunities for dramatic images of a huge biomass of birds.

Waterbirds are attracted to water because it generally contains a reservoir of their chosen foods. Many of these birds are specialized for living off the water by anatomical adaptations, such as long legs, webbed or extended feet and bills that help them capture specific prey. The Northern Jacana (*Jacana spinosa*) walks comfortably across lily pads, loading a large area with its extruded toes. The upward curvature of the American Avocet's (*Recurvirostra americana*) bill is nicely adapted to side-to-side sweeping across the water's surface, known as "scything," to capture insects and larvae.

The downside of a small-sized target bird is that the photographer either needs to use stealth techniques, such as a hide or blind, or a large lens to capture an image that has enough pixels for the end-use of the photograph. Let's take the example below of an Atlantic Puffin (*Fratercula arctica*) landing on the Látrabjarg bird cliff in Iceland. This image,

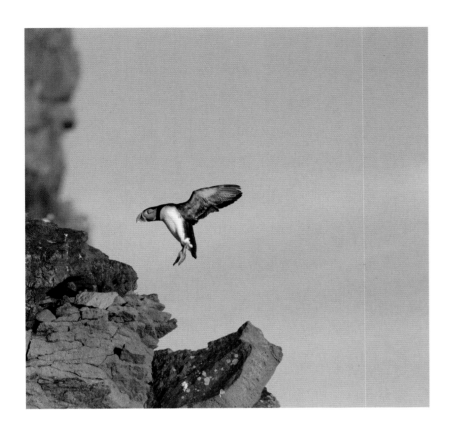

Small birds often occupy just a small part of the image, particularly if the focal length of the lens used is also small (**left**). Enlargement of the bird in post-processing will lead to loss of quality (**right**). Látrabjarg, Iceland

which was taken with a 70–200 mm zoom lens that is best used for a much closer subject, is not cropped and has dimensions of 4,896 x 3,264 pixels. The second image has been tightly cropped around the bird and now has dimensions of just 902 x 725 pixels. At this small size, digital noise and the individual pixels in the image can become visible. While the image may be acceptable for posting as a small icon on a website or on social media, it would not make a satisfactory print.

We were born from water, and many of us strive to be near water whenever possible. One of the great joys of photographing waterbirds is that the photographer is working in an environment that is a sought-after space at some deep level of the human psyche. The landmark *Apollo 17* blue Earth photograph reminds us that, as Arthur C. Clarke pointed out, planet Earth should really be called planet Ocean. There is something transcendent about being alone at sunset on the water's edge, watching the descendants of dinosaurs live and thrive. It is the ultimate retreat from 21st-century madness.

Dunlins

Species
Calidris alpina

Length
6.3–8.7 in. (16–22 cm)

Wingspan
13.0–15.7 in. (33–40 cm)

Weight
1.2–3.0 oz. (33–85 g)

Conservation Status
Least concern

Population
Several million (450,000–600,000 in Pacific); decreasing

Along the west coast of the United States, the swing of the celestial pendulum toward the spring and fall equinoxes is marked by an unparalleled movement of biomass. At one end of the size spectrum, more than 20,000 Gray Whales (*Eschrichtius robustus*), each weighing in at 60,000 pounds (27,216 kg), migrate between Baja California and Alaska. At the other end, millions of shorebirds turning the scales at just a few ounces head north to their Alaskan breeding grounds in the spring and south to milder climes in the fall. These long-distance migrations are hazardous undertakings that are enabled by physiological adaptations. They also require the right resources of food and habitat along the way.

The Dunlin is one of the many species of shorebirds that pass through my home turf. They can be found by the tens of thousands at major refueling centers such as the Grays Harbor National Wildlife Refuge and in smaller flocks at just about any coastal wetland, such as this river delta on Camano Island, Washington. Seeing so many birds flying together in formation raises two immediate questions: "Who's in charge?" and "How do they avoid bumping into each other?" More progress has been made on the second question than the first. While several complex solutions have been explored, a simulation called *BOIDS* that involves just three simple rules that control separation, alignment and cohesion produces realistic flocking behavior. This topic has received renewed interest recently because humans want to control "flocks" of robots, satellites and unmanned aerial vehicles (UAVs).

Camano Island, Washington (April)
Canon EOS-1D X | EF 100–400 mm f/4.5–5.6L IS II USM at 390 mm | 1/2500 sec at f/9 | ISO 2000

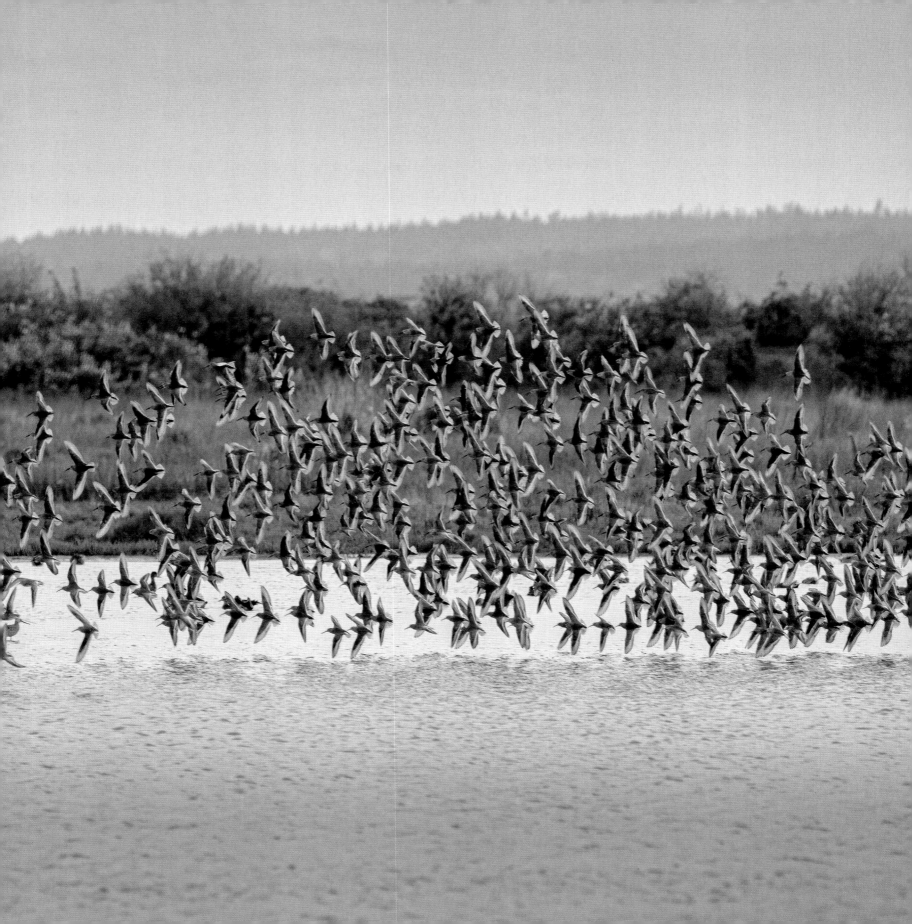

Band-rumped Storm-Petrels

Species
Oceanodroma castro

Length
6.9–7.7 in. (17–20 cm)

Wingspan
17.3–19.3 in. (44–49 cm)

Weight
1.4 oz. (39.3 g)

Conservation Status
Least concern

Population
Approximately 150,000 mature birds; decreasing

The story goes that Saint Peter was invited to join Jesus as he walked on water. Peter was apparently not very successful. Quite to the contrary, storm-petrels, who are named after Peter, perform a great show, appearing to walk on water. They are actually using wing lift to stay just above the water and pattering their webbed feet to reveal food on or below the disturbed surface. The "storm" part of the name is a reference to old sailing lore that associated the arrival of storm-petrels with bad weather.

Fortunately, the appearance of these birds did not affect the idyllic weather I was enjoying while traveling by small boat. We had spent the morning photographing penguins and flightless cormorants at Punta Moreno on Isabella Island in the Galápagos. During a lunchtime transit to Urbina Bay, it is likely that some food waste had found its way from the boat to the water, and the petrels arrived out of nowhere to feed. They are also known to attend the kills of marine mammals to feed off the detritus. It seems we were just another mammalian food provider.

Land-based opportunities to photograph small pelagic birds such as petrels and shearwaters are often quite limited because they spend so much time at sea. These birds are members of the order known in English as tubenoses. The small appendage on the bill (just visible on the front bird in this image) is an external nostril that, while often said be involved in salt excretion, may be most important in heightening the birds' sense of smell.

Urbina Bay, Galápagos Islands, Ecuador (October)
Canon EOS-1D X | EF 100–400 mm f/4.5–5.6L IS II USM at 100mm | 1/1250 sec at f/9 | ISO 800

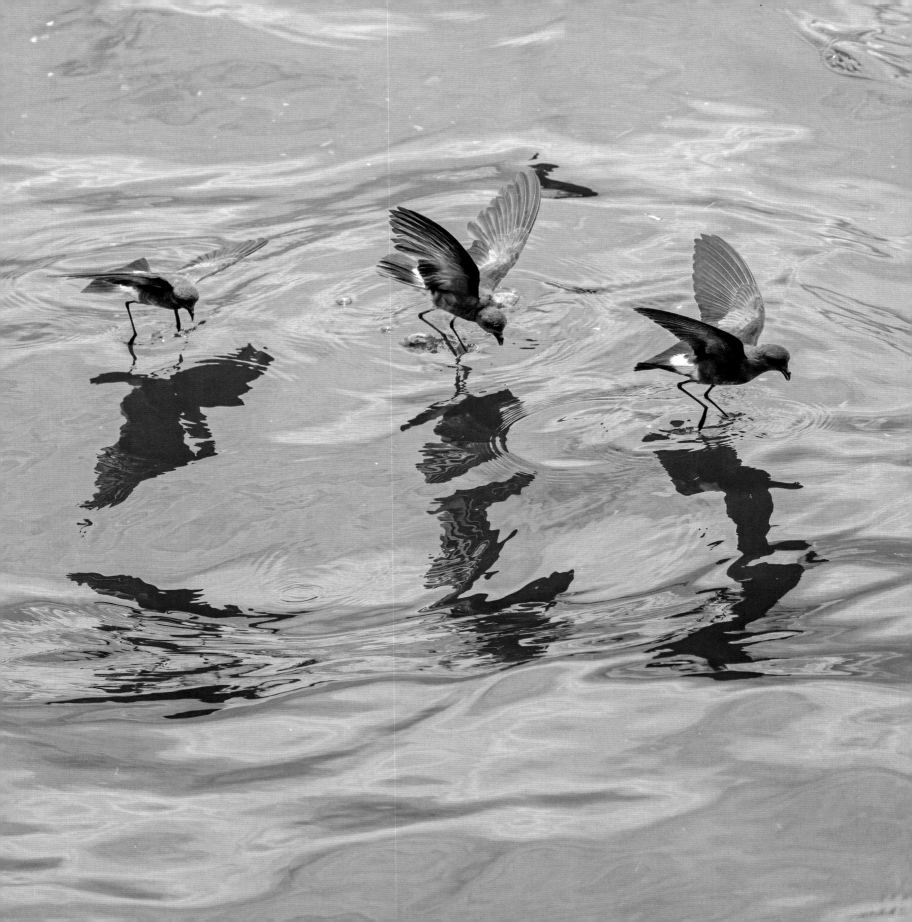

Hawaiian Stilt

Species
Himantopus mexicanus knudseni

Length
13.8–15.7 in. (35–40 cm)

Wingspan
26.4–32.7 in. (67–83 cm)

Weight
5.9–7.2 oz. (166–205 g)

Conservation Status
Least concern

Population
Unknown; locally threatened (worldwide population of all subspecies is 450,000–780,000 and increasing)

The history of western contact in the Hawaiian Islands is a case study in annihilation. More than 70 species of birds have become extinct across the islands, and 31 additional species are federally listed as threatened or endangered. The latter category includes the bird shown here, which is a Hawaiian subspecies of a bird known to the islands' Indigenous People as the Ae'o. This bird's relatives, however, are doing well in other parts of the world. The primary reasons for the loss in the Hawaiian islands are introduced predators and competing species, non-native diseases and loss of habitat. Belatedly, significant conservation efforts are underway to provide stewardship for the remaining flora and fauna.

This bird is all legs — as you might expect from an accomplished wader that finds its food in the water. Biologists interpret this as an adaption to a preferred environment, rather than an exploitation enabled by anatomy (a chicken and egg question answered?). The legs also trail behind in flight, like the towline on a banner-towing plane. Neck length and leg length are correlated in birds, and the stilt can extend its neck a long way if required.

Birds can make beautiful water patterns during an explosive takeoff or crash landing that are lost to the naked eye. Manipulation of shutter speed can either freeze (as in this image) or blur these patterns and enhance the sense of the bird's relationship with the water.

Hanalei Valley, Kauai, Hawaii (February)
Canon EOS-1D X | EF 500 mm f/4L IS USM | 1/5000 sec at f/4 | ISO 800

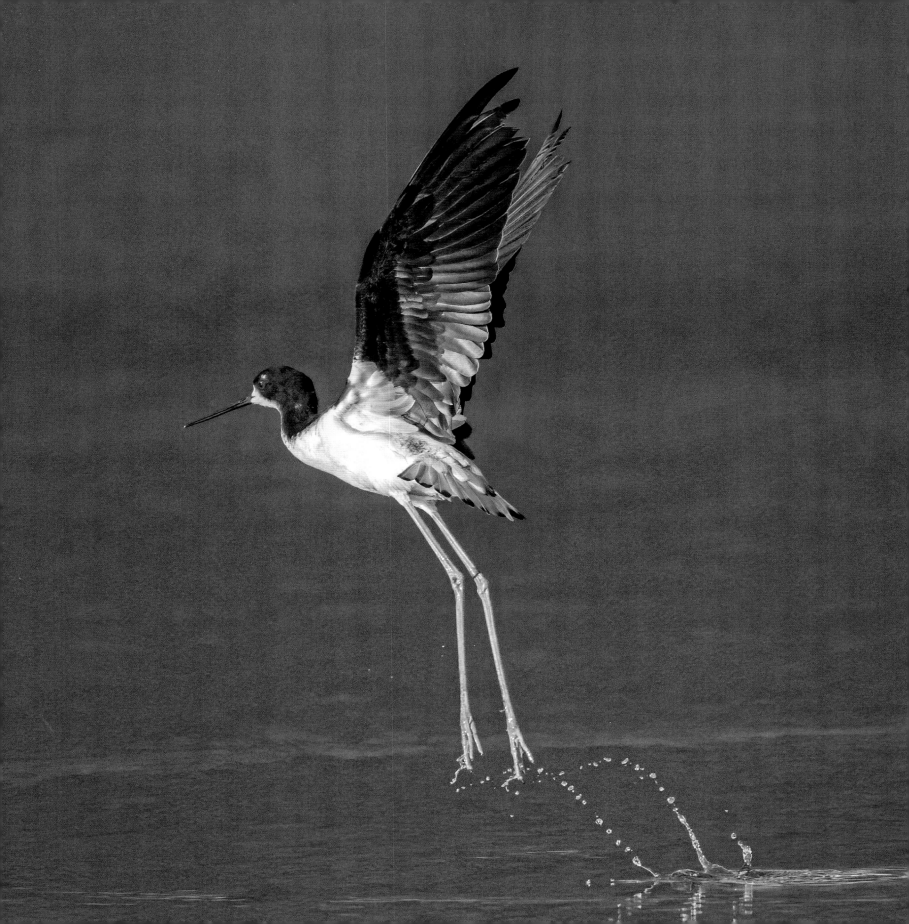

Black Skimmer

Species
Rynchops niger niger

Length
16.1–18.1 in. (41–46 cm)

Wingspan
3.5–4.2 ft. (107–127 cm)

Weight
Male: 10.7–13.2 oz. (308–374 g)
Female: 8.2–10.4 oz. (232–295 g)

Conservation Status
Least concern

Population
93,000–101,000 birds; decreasing

The Galveston-Bolivar ferry plies its relentless path around the clock, every single day of the year. For the bird photographer, it is a nexus between two nirvanas: a place where migrants from Central and South America first make landfall during the spring in Galveston Island's scrub trees, and the breeding sites of many waterbirds in the wetlands of the Bolivar Peninsula. The exposure to the Gulf of Mexico's massive weather systems bring feast and famine — blue sky and hurricanes — to the avian inhabitants of this rich and diverse region.

On a March afternoon, well outside hurricane season, I set up my tripod at Rollover Pass, a narrow cut across the width of the peninsula about 20 miles (32 km) east of the ferry landing at Port Bolivar. The sky and water were overflowing with bird life: gulls, terns, egrets, avocets, Brown Pelicans and restless flocks of my target bird for the day, the Black Skimmer.

This fish-eating bird is an expert flier that is uniquely adapted to its feeding habits. The advanced flying skill is a level, arrow-straight flapping flight at a precise height of about 6 inches (15 cm) above the water. Its anatomical adaptation is a 3-inch (7.6 cm) bill that is longer on the bottom than the top by about 1 inch (2.5 cm).[1] This combination allows the skimmer to repeatedly fly a transect across water in which potential prey is swimming while keeping its lower mandible submerged. When the bill collides with a fish, it snaps shut, and the bird dips its head to consume the fish while on the wing. There is some debate about whether the search process is driven by visual cues or somewhat random with sensory organs in the bill triggering it to close. Regardless of how navigation is achieved, the bird's straight and level flight is perfect for securing multiple shots using a camera mounted on a gimbal, which was the case for this image.

Rollover Pass, Bolivar Peninsula, Texas (March)
Canon EOS-1D X | EF 500 mm f/4L IS USM | 1/6400 sec at f/4 | ISO 800

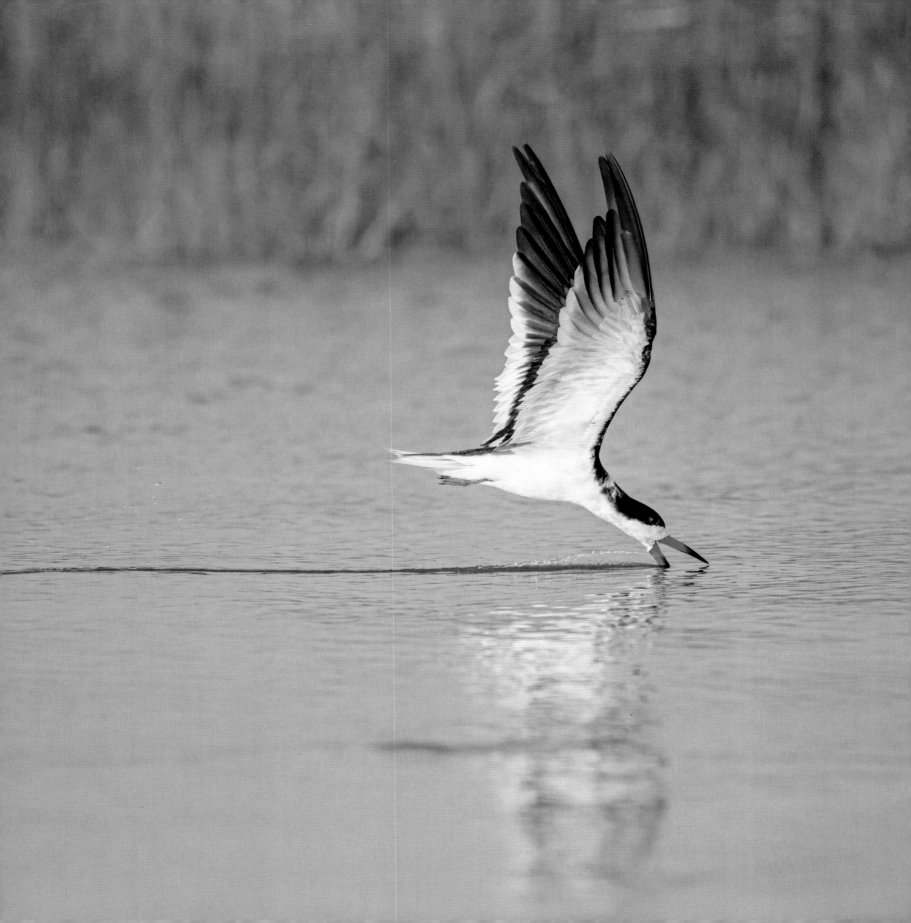

Black Skimmer

Species
Rynchops niger intercedens

Length
16.1–18.1 in. (41–46 cm)

Wingspan
3.5–4.2 ft. (107–127 cm)

Weight
Male: 10.7–13.2 oz. (308–374 g)
Female: 8.2–10.4 oz. (232–295 g)

Conservation Status
Least concern

Population
25,000–100,000 birds; trend unknown

Cuiabá River, Pantanal, Brazil (July)

Canon EOS-1D X | EF 500mm f/4L IS USM | 1/6400 sec at f/4.5 | ISO 640

Arriving in a new part of the world and encountering a familiar bird is like an unexpected meeting with an old friend. Granted, this subspecies is different from the bird profiled on the previous page, and there are minor, almost indistinguishable, color differences. However, the unmistakable bill and feeding behavior of this Black Skimmer welcomed me back to common ground.

This image was taken at the end of a particularly rich and exciting day, starting at Porto Jofre, a small community at the southern end of the Transpantaneira Highway in Brazil's Pantanal. After photographing iconic Toco Toucans (*Ramphastos toco*) in the early morning, our day had included close-range sightings of jaguars (*Panthera onca*), Giant Otters (*Pteronura brasiliensis*) and the world's largest living rodents, Capybaras (*Hydrochoerus hydrochaeris*).[2] As the late afternoon sun turned the Cuiabá River into a strand of liquid gold, we guided our small boat into a calm eddy to end the day photographing skimmers feeding.

The magical light seemed at first to be its own reward, but as I continued to shoot, adjusting my settings for the decreasing light, it soon became obvious that several of the birds were pushing the envelope too far and wiping out, cartwheeling bill over tail and crashing into the water. I do not know if these were young birds just learning the trade or experienced adults who felt that the benefits of deep exploration with their bills outweighed the risks. This encounter reminded me that we observe so much flawless flight behavior in birds that it comes as a real shock when they make a mistake, and something goes radically wrong.

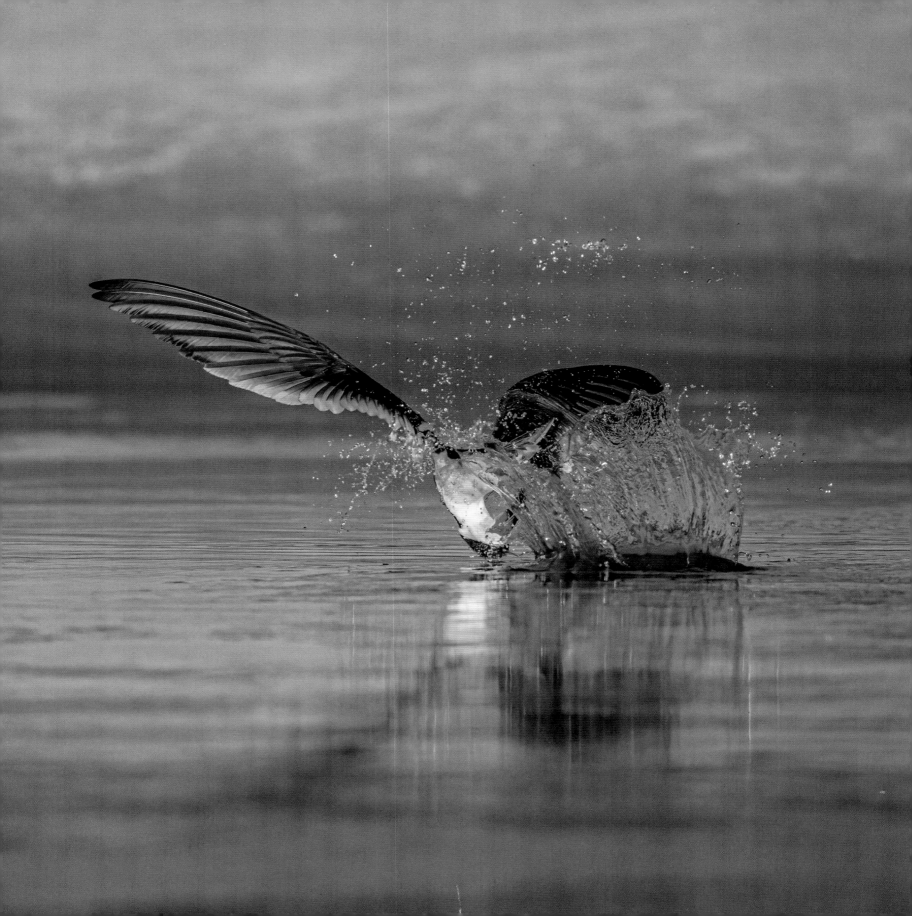

Black-tailed Godwits

Species
Limosa limosa islandica

Length
14.2–17.3 in. (36–44 cm)

Wingspan
2.3–2.7 ft. (70–82 cm)

Weight
Male: 5.6–15.5 oz. (160–440 g)
Female: 8.6–17.6 oz. (244–500 g)

Conservation Status
Near threatened

Population
64,000 birds; increasing

Flói Bird Reserve, Árborg, Iceland (May)

Canon EOS-1D X | EF 500mm f/4L IS USM | 1/4000 sec at f/4 | ISO 1000

We spent a gray morning on the lava cliffs of southwestern Iceland, buffeted by southerly winds. The bird life was rich: shorebirds, gulls, guillemots and the occasional skua looking to steal a meal from an exhausted bird that it had been pursuing. By lunchtime, a respite from the wind was in order.

Traveling with a guide in unknown territory can dramatically increase the probability of locating a target species. That was particularly true on this day, when my guide was Jóhann Óli Hilmarsson, who literally wrote the book on Icelandic birds. When I suggested photographing Black-tailed Godwits, a new bird for me, Jóhann Óli knew just where to go. Within the hour, we had arrived at the Flói Bird Reserve, and I captured this image five minutes later.

If I were a judge, the Black-tailed Godwit would get my vote in the avian concours d'elegance. This pair, in full breeding plumage, are showing off their long javelin bills that flow smoothly from slender chestnut necks. The black and white of the wing stripe and tail, and trailing undercarriage complete an exquisite design. They are also fast, attractive fliers with high-frequency wing beats. These birds flew erratic circles around us, landing frequently to forage, plunging their bills full length into the soft, moist undergrowth or under the water.

In this image, the softly blurred background hints at the bird's preferred inland wetland habitat, and the pair seem at first glance to be the crisp reflection of a single bird in silent water. Their fortuitous positioning, almost in the same vertical plane, ensured that both birds were in focus. It was still a challenge to keep the single focus point centered on one of the birds.

Red-billed Tropicbird

Species
Phaethon aethereus mesonauta

Length
2.9–3.5 ft. (90–107 cm), including 18.0–22.0 in. (46–56 cm) tail streamers

Wingspan
3.2–3.5 ft. (99–106 cm)

Weight
24.7 oz. (700 g)

Conservation Status
Least concern

Population
3,000—13,000 birds; decreasing

The entrance to Great Darwin Bay on Genovesa Island is a lesson in volcanic geology: The entire southwestern wall of a caldera has collapsed into the Pacific Ocean, which has flooded in to fill the void. A Zodiac ferries the visitor to shore, where a short climb up Prince Phillip's steps leads to a relatively level rocky plateau packed with interesting life. My Zodiac detoured along the base of cliffs where the red gular pouches of Magnificent Frigatebirds (*Fregata magnificens*) fluttered from high perches, Nazca Boobies (*Sula granti*) clattered their bills together in displays of earnest affection and Swallow-tailed Gulls (*Creagrus furcatus*) floated on ridge lift.

My objective for the ride was an isolated image of a Red-billed Tropicbird trailing its 20-inch (51 cm) tail streamers. I wanted an image of the bird against its cliff-nesting habitat. The Latin genus name *Phaeton* recalls the son of Helios, who was slain by his father for crashing the chariot of the sun into the ground. This has some relevance to the landing behavior of tropicbirds. Their legs are almost useless for perching, so the bird has to approach its rocky nest very precisely and land right on target, almost crashing into its front porch. Two or three trial passes are often needed to get the approach right, particularly in windy conditions. This is very useful for the photographer. I noticed that the bird pictured here had made an initial aborted landing, and I was able to get well positioned, aim toward the nest and not the bird and shoot the second pass with both cliffs and sky as a backdrop.

Bird flight is often unpredictable, but when the photographer can benefit from advance knowledge of the destination, the probability of success in the brief window of available time is increased. This is particularly true when shooting handheld from a rolling Zodiac.

Genovesa Island, Galápagos Islands, Ecuador (October)
Canon EOS-1D X | EF 100–400 mm f/4.5–5.6 IS II USM at 220 mm | 1/4000 sec at f/8 | ISO 1250

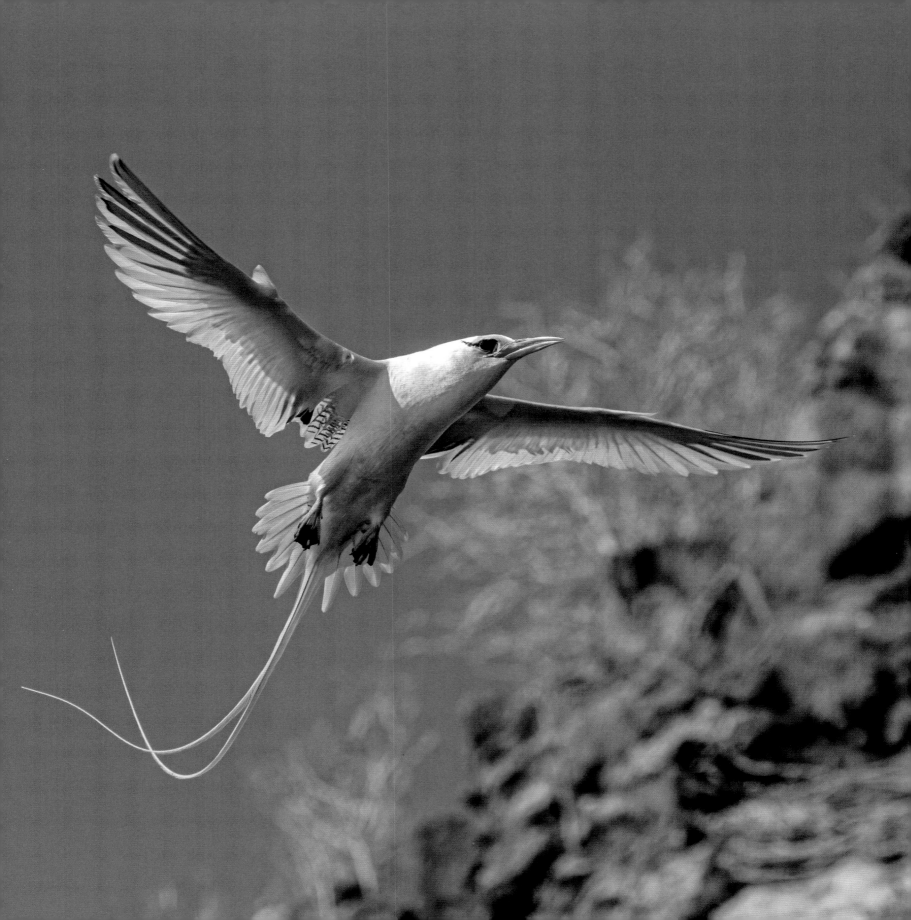

Whimbrel

Species
Numenius phaeopus rufiventris

Length
15.7–18.1 in. (40–46 cm)

Wingspan
2.5–2.9 ft. (76–89 cm)

Weight
Male: 9.5–19.4 oz. (268–550 g)
Female: 11.1–21.2 oz (315–600 g)

Conservation Status
Least concern

Population
1,000,000–2,300,000 birds; decreasing

The most striking feature of the Whimbrel is its long, downward-curved bill, seen in duplicate in this image as the bird pipes its repetitive, monotonic alarm call. The bird's genus (*Numenius*) evokes the Greek word for the shape of a new crescent moon. The Whimbrel's bill is curved due to the tunneling behavior of its favorite winter food, the fiddler crab (*Uca* species). What we see on the surface of the beach as a round hole is actually the top of an L-shaped tube with the foot of the L extending horizontally.[3] As the Whimbrel probes the tunnel, the curvature of its bill allows it to access the horizontal section of the tunnel, where the frightened crab may be taking refuge from the determined intruder.

This was an opportunistic image taken during a walk along the beach in the Galápagos Islands. The Whimbrel is a long-distance commuter to these islands, traveling from its breeding ground in the Arctic tundra. My most frequent mode of bird photography is to decide in advance what species I am interested in on a given day and then to stake out the nest or habitat where that bird can be found, usually with a tripod and a 500 mm lens. This is often more productive than random walks with a camera, but there are always surprises. Having a camera at the ready with a lens that can be handheld will allow the well-prepared photographer to capture unexpected shots such as this one. Note that I increased the ISO setting to maintain a high shutter speed for the flight shot on this somewhat gray afternoon. Each photographer will have to find the threshold for their own camera, where further increases in the ISO setting result in unacceptable digital noise.

Santiago Island, Galápagos Islands, Ecuador (October)
Canon EOS-1D X | EF 100–400 mm f/4.5–5.6 IS II USM at 400 mm | 1/2000 sec at f/5.6 | ISO 2000

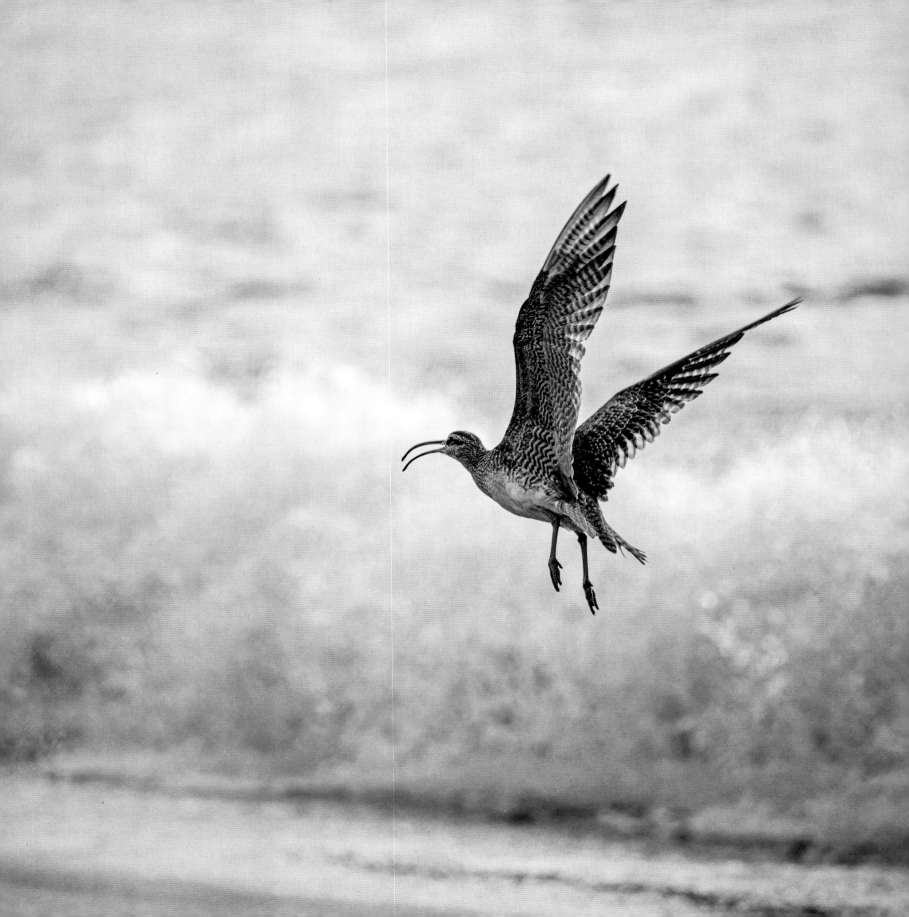

Boat-billed Heron

Species
Cochlearius cochlearius panamensis

Length
17.7–21.1 in. (45–54 cm)

Wingspan
2.5 ft. (76 cm)

Weight
Male: 1.5–1.7 lb. (680–770 g)
Female: 1.1–1.6 lb. (503–726 g)

Conservation Status
Least concern

Population
Unknown; decreasing

Convergent evolution confirms that a particular structure, characteristic or behavior is definitely a great idea. It describes something that has evolved quite independently in different species as a solution to a common problem. Flapping flight itself is a wonderful example: Over a broad swath of evolutionary time, insects, pterosaurs, birds and bats all evolved the ability to fly. The problems of escaping predators, extending the range for food and seeking out a warmer climate were all solved by the emergence of flight, but evolution has provided the Boat-billed Heron with its own approach to catching prey that, as far as I know, has not appeared in any other animal.[4]

The body of this bird is similar in size and shape to other medium-sized herons, such as the Black-crowned Night-Heron (*Nycticorax nycticorax*), but the bills of these two birds could not be more different. The Boat-billed Heron generally feeds by lunging toward its prey and gathering a giant scoop of water in its aptly named, ebony-colored bill. The contents are then filtered for fish and small crustaceans. Pelicans have a similar modus operandi, but their soft gular pouch is absent in this bird, which has a wide, rigid lower mandible.

Herons are generally very skittish. This one was gathering nesting material in the trees of the Turrialba Botanical Garden when my presence disturbed it. I like the dynamic posture of the bird as it thrusts off laterally to avoid flying though branches. The relatively slow shutter speed shows that I should have used a higher ISO setting as the aperture was wide open at f/4. The result is a slight blur of the left wing.

Turrialba, Costa Rica (March)
Canon EOS-1D X | EF 500 mm f/4L IS USM | 1/1000 sec at f/4 | ISO 2000

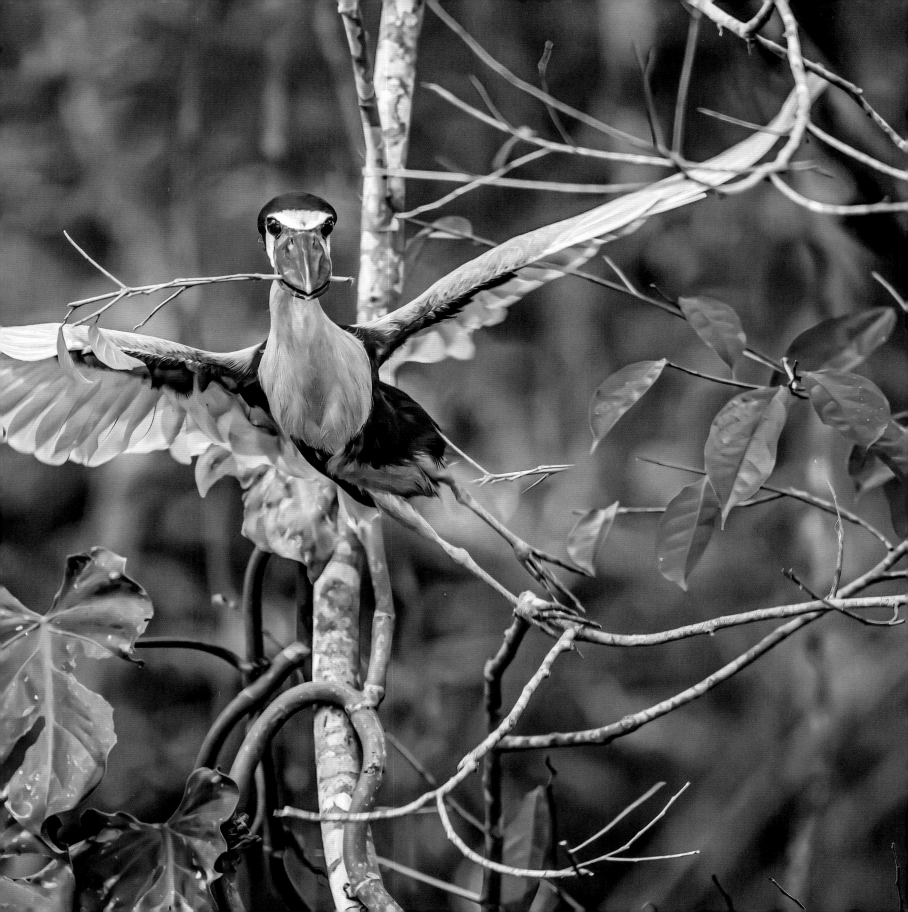

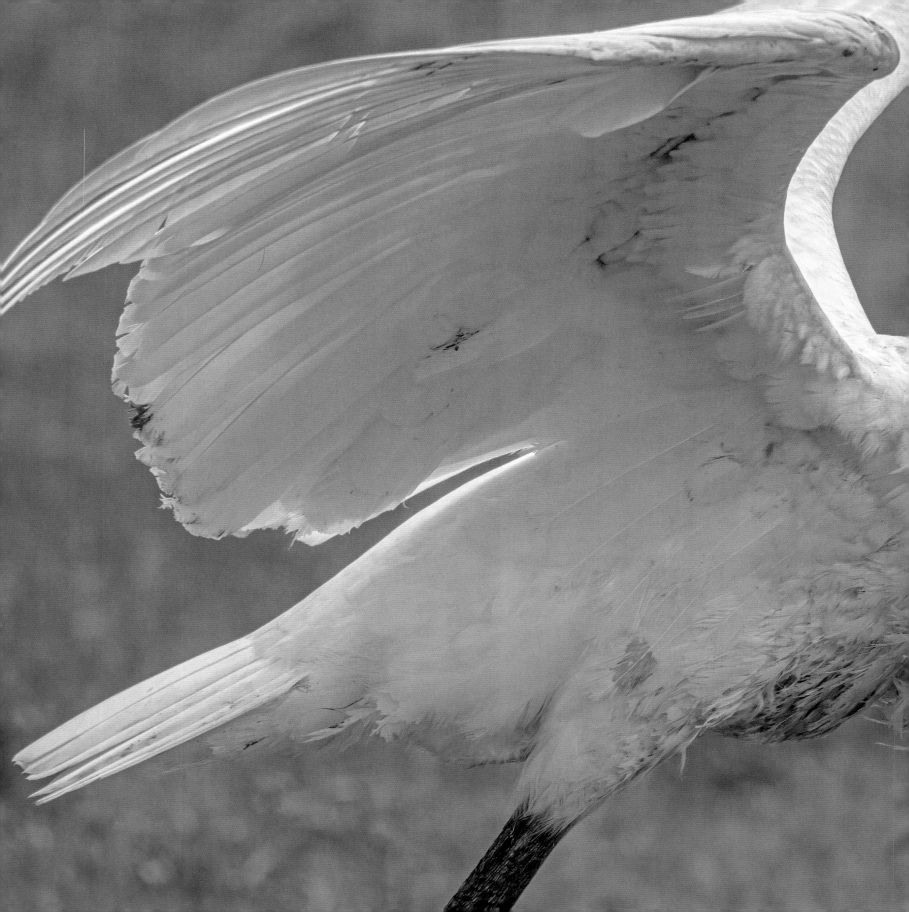

5
Large Waterbirds

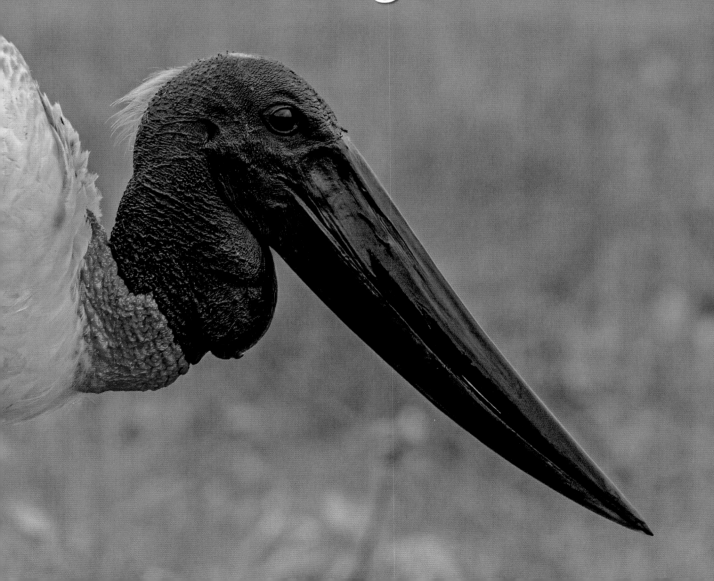

Humans are fascinated with large creatures: whales, elephants, giraffes, bears and the perennially popular dinosaurs never lose their childhood appeal. Perhaps this affection is an expression of our subconscious fear of being attacked by something larger than us. Photographers love shooting images of large birds for much more prosaic reasons: their ponderous wing beats, their predictable flight paths and the ease with which focus can be held on their large bodies. Another benefit is that the photographer does not need to be close to a large bird to capture a good image. And, of course, the frame is often crammed full of active pixels, so cropping during post-processing still leaves a large image.

The physiology of large animals is also engaging, partly because the visual yardsticks that we typically use to estimate size are completely misleading. Take, for example, two hypothetical birds with the same basic shape, except that bird A is twice as tall as bird B. Using "tallness" as our measure, we make the implicit assumption that *everything* about bird A (not just height) is twice as large as everything about bird B. However, this is not correct: reasonable assumptions suggest bird A will have a wing area four times greater than that of bird B and will weigh eight times as much. Let's see how this concept applies to two birds we have already met: the Bald Eagle (*Haliaeetus leucocephalus*) and Belcher's Gull (*Larus belcheri*). The eagle is only 53 percent taller than the gull but weighs six times as much. These seemingly odd results are due to the fact that area and mass scale as the square and cube of length, respectively (strictly speaking, mass is a surrogate for volume). The science of size even has a name, allometry, which is defined as "the study of how [biological] processes scale with body size and with each other, and the impact this has on ecology and evolution."[1]

Large birds are, of course, unaware of the math involved, but they are

Previous Spread

Species
Jabiru (*Jabiru mycteria*)

Location
Pantanal, Brazil (July)

Settings
Canon EOS-1D X | EF 500 mm f/4L IS USM | 1/1000 sec at f/6.3 | ISO 800

very aware of the implications of their disproportionately large weights: high metabolic rates, the need for high caloric intakes and the large energetic cost of just getting around. The implication for flight is that the load on the wings of a large bird will be greater because the wings' area does not scale to match the increased weight. It is perhaps no surprise that seven of the 10 heaviest birds in the world are flightless, with the Common Ostrich (*Struthio camelus*) topping the list at a gargantuan 340 pounds (154 kg). Once the need for flight is removed, the imperative to minimize weight at liftoff disappears.

Large waterbirds who feed while wading usually have extremely long necks and legs, so they can access prey in deeper water. This poses a challenge for flight, since the tight streamlining and stowed undercarriage seen in many smaller birds is not possible. In different circumstances, the neck may be either rod straight or retracted in a serpentine form, and the legs may be trailed behind or carried below the body.

Over the course of history, several large waterbirds have been revered by a number of different civilizations. The African Sacred Ibis (*Threskiornis aethiopicus*) was worshiped as an incarnation of the Egyptian God Thoth, who graduated from a moon god to, among many other responsibilities, being a god of wisdom, writing, science and the dead. This deification was very bad news for the population of African Sacred Ibises between the 26th Dynasty (664–525 BCE) and the Greco-Roman Period (30 BC–300 CE). Over four million mummified African Sacred Ibises have been discovered as votive offerings at tombs throughout Egypt. Some believe that an industrial-scale farming operation existed to provide birds for mummification.

One of the most persistent myths involving large waterbirds is enshrined in Hans Christian Andersen's fairy tale *The Storks*. This 1838 retelling of the myth that White Storks (*Ciconia ciconia*) bring newborn

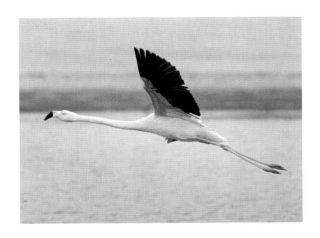

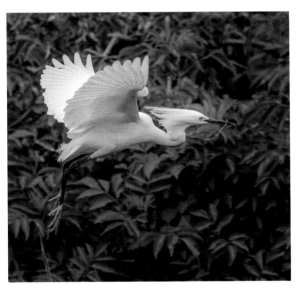

Different styles of neck and leg carriage during flight.
Top: This Chilean Flamingo (*Phoenicopterus chilensis*) is flying to escape, with straight neck and legs. Paracus, Peru.
Bottom: This Snowy Egret (*Egretta thula*) is on a short freight delivery with a retracted neck and hanging legs. High Island, TX.

babies is actually extremely malevolent and cruel, involving young boys singing a song about storks being hanged, stabbed, burned and slapped, as well as storks bringing dead babies to human mothers in revenge. The more family-friendly versions of this story have ancient roots, possibly as far back as ancient Greece. The picture to the left shows a close relative of the fairy-tale stork seen in the amazingly bird-rich Brazilian Pantanal. I took this photograph shortly after the photograph of the massive Jabiru in this chapter's introductory panel.

The birds featured in this chapter all have body masses greater than 2.2 pounds (1 kg). The size of some of the larger birds — such as the American White Pelican (*Pelecanus erythrorhynchos*), which can weigh in at 18.7 pounds (8.5 kg) — is a reminder of the huge diversity of size in the class Aves. Several of the hummingbirds featured in this book weigh one-tenth of an ounce (2.8 g), which is only a little heavier than a penny and 3,000 times less than the pelican. The challenge for the photographer is to render the largest and smallest birds with equal insight, clarity and context.

Left: An African Sacred (*Threskiornis aethiopicus*) Ibis photographed on the Chobe River in Botswana. **Right**: A representation of the God Thoth in the form of a human with the head of an African Sacred Ibis.

Red-footed Booby

Species
Sula sula rubripes

Length
26.0–30.3 in. (66–77 cm)

Wingspan
4.0–5.0 ft. (124–152 cm)

Weight
2.0–2.2 lb. (0.9–1.0 kg)

Conservation Status
Least concern

Population
Likely more than 1 million birds; decreasing

Kilauea Point on the north shore of the island of Kauai is a superb locale for bird photography. A cudgel of steep cliffs thrusts out defiantly into the Pacific Ocean, which fights back row after row of crashing waves. Red-tailed Tropicbirds (*Phaethon rubricauda*), Laysan Albatrosses (*Phoebastria immutabilis*) and Great Frigatebirds (*Fregata minor*) fight with, or float on, the powerful wind past the century-old lighthouse.

A protected colony of about 2,000 pairs of Red-footed Boobies nests on the neighboring hillside, and they were in a state of constant motion gathering nesting material during my February visit. Boobies are powerful, aerobatic fliers, and they can be challenging to photograph. I had to return to the cliffs six times before I had this shot, which I feel captures the industrious bird's grace and speed. Success required picking up the bird early in the viewfinder and keeping the single focus point centered on the bird with periodic light presses of the shutter release for refocusing. At the same time, I continually dialed down the zoom to ensure that the bird's wing tips were always in the frame. The often busy, broken background resulted in many rejected shots because I wanted a smooth blur of brown and green to highlight the bird's bold colors and reflect the terrain.

Red-footed Boobies are the smallest boobies, and they vary in their coloration.[2] This bird is a white morph; the dark morph birds can be chocolate brown. It was fascinating to watch how, during approach to the nest for landing, it deployed its large claw-tipped red feet as aerodynamic control surfaces. They subtly extend, rotate and retract them, sometimes asymmetrically, like trim tabs on an airplane, to finely nuance the flight path. Birds are so much more capable of altering their shape and configuration than even the most advanced airplane.

Kilauea Point National Wildlife Refuge, Kauai, Hawaii (February)
Canon EOS-1D X | EF 100–400 mm f/4.5–5.6L IS II USM at 165 mm | 1/6400 sec at f/4 | ISO 800

Blue-footed Booby

Species
Sula nebouxii excisa

Length
2.3–2.8 ft. (71–84 cm)

Wingspan
4.9–5.4 ft. (148–166 cm)

Weight
3.3–4.9 lb. (1.5–2.2 kg)

Conservation Status
Least concern

Population
More than 100,000 birds; declining in Galápagos Islands

Love is not blind for a female Blue-footed Booby. It is blue — and the bluer the better. During the courtship dance, the male bird struts his stuff around the female while prominently displaying his turquoise feet.[3]

A fascinating study has shown that there are good reasons for her color fixation, and that color continues to be an indicator throughout a pair's relationship. Biologists sometimes talk about an "honest signal" and "truth in advertising" in relation to markers of sexual selection such as foot color. This means that bluer feet really are an indication of a healthier mate because they are a marker, in this case, of good nutrition and immune system function.

This bird has feeding on his mind. Blue-footed Boobies are plunge divers: They execute an aerobatic change of direction, diving from level flight upon seeing prey, such as their favorite meal of sardines, and closing their wings just before impact. Their nostrils are concealed to prevent water from thundering through their sinuses. After the dive, the problem to be solved is getting airborne while waterlogged. The feet help with this, as you can see in this photograph: The bird is "pattering" on the water, not as storm-petrels do in order to disturb food (see pages 92–93), but more like a heavy swan getting some additional forward speed from its feet when taking off from water.

To capture this image, I was wading with a handheld camera in 18 inches (46 cm) of luxuriously warm water on a shallow beach. The bird seems to be looking directly at the lens and wondering what is invading his private domain. The full extent of the large wingspan is also striking.

San Cristóbal, Galápagos Islands, Ecuador (November)

Canon EOS-1D X | EF 100–400 mm f/4.5–5.6 IS II USM at 400 mm | 1/1250 sec at f/10 | ISO 1250

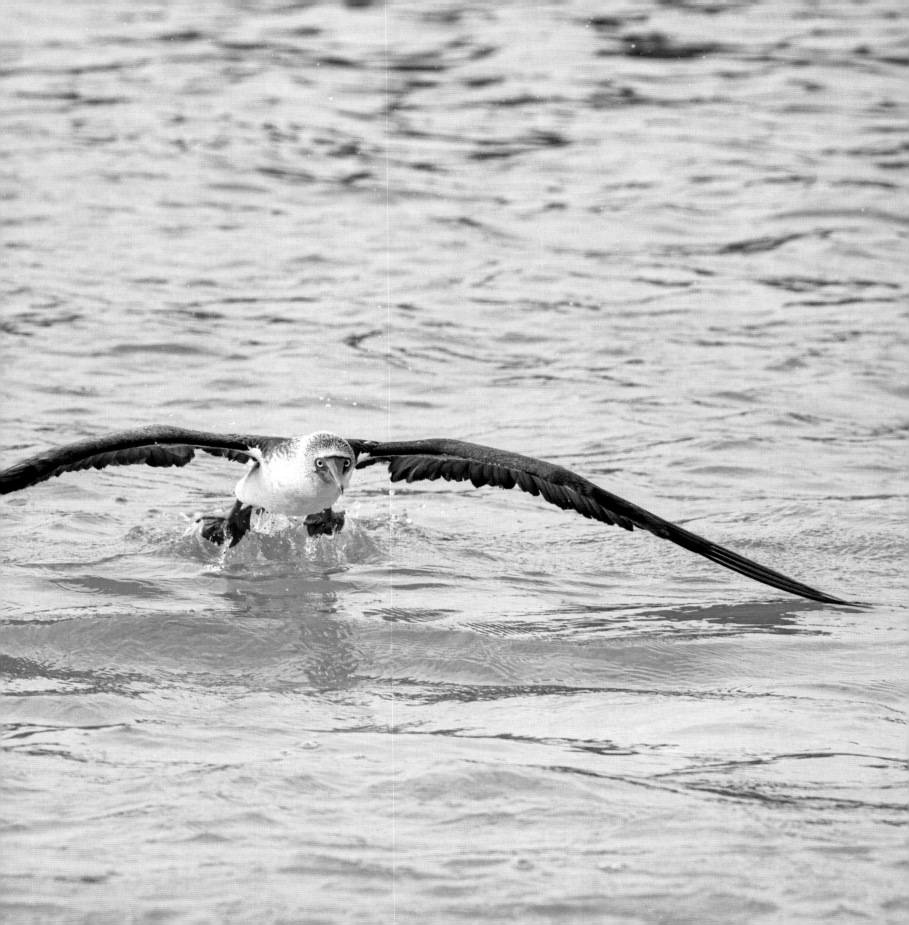

Magnificent Frigatebird

Species
Fregata magnificens

Length
35.0–44.9 in. (89–114 cm)

Wingspan
7.1–8.0 ft. (217–244 cm)

Weight
2.4–3.5 lb. (1.1–1.6 kg)

Conservation Status
Least concern

Population
100,000–499,999 birds; increasing

Frigatebirds have a bad reputation. They are widely regarded by their neighbors as thieves and vagabonds: birds to avoid, particularly when the neighbor might be carrying food back to the nest. This image captures the typical frigatebird modus operandi. They patrol the skies above areas where Blue- and Red-footed Boobies are fishing. When the boobies emerge with a fish, the pirate will swoop down and try to harass the booby so they can recover the catch, even if it requires the booby to regurgitate its catch of already-swallowed food. This happens so frequently that it comes as a surprise to learn that the success rates of this kleptoparasitic behavior are remarkably low. A study in Mexico found that females and juveniles were the main aggressors and that they were only successful in forcing a release of food about 5 percent of the time. If a group of frigatebirds attacked together, they were three times more successful. All of this seems like a lot of energy expenditure for little caloric reward.

 I took this image of a male bird handheld from a Zodiac, and the fast shutter speed compensated for the instability of the platform. The key to this image's composition was getting the bird aligned with the notch in the cliff top ridge. I took several photos just before and after this one, and the bird simply gets lost in front of the cliff or floats too high in the sky to give the image a feeling of unity. In many images, composition can be adjusted successfully by cropping in post-processing, but in this case the bird really needed to be positioned correctly for the shot to work.

San Cristóbal Island, Galápagos Islands, Ecuador (February)
Canon EOS-1D X | EF 70–200 mm f/2.8L IS II USM at 70 mm + 1.4x | 1/5000 sec at f/5.0 | ISO 1000

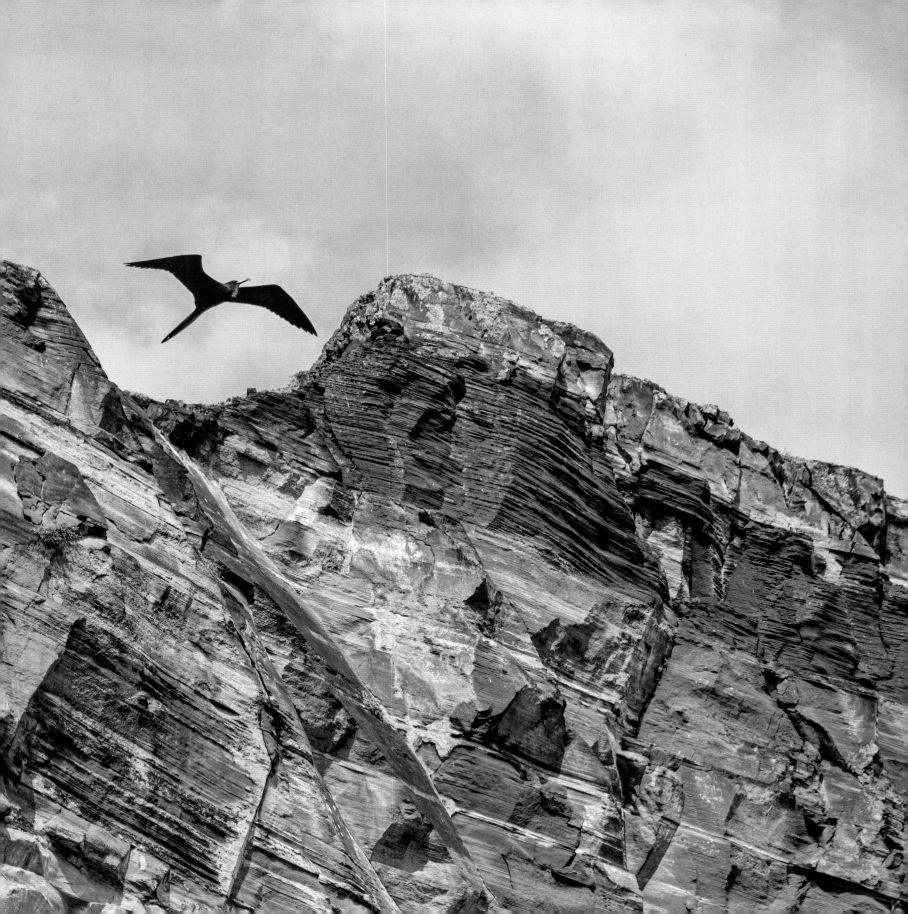

Saddle-billed Stork

Species
Ephippiorhynchus senegalensis

Length
4.7–4.9 ft. (145–150 cm)

Wingspan
7.9–8.9 ft. (240–270 cm)

Weight
13.6 lb. (6 kg)

Conservation Status
Least concern

Population estimate
Approximately 25,000 birds; possibly declining

The Saddle-billed Stork ranks high among the birds that have appeared in my viewfinder. It is a massive, bold, colorful animal with an enormous saber of a bill and long black drainpipe legs with red garters. Its black, red and yellow coloring has led to the nickname the "German flag bird."

I made several trips to Africa before getting a flight shot of this female bird, including a long stakeout beneath a nest in Botswana's Okavango Delta. After several hours, all I had to show before darkness approached were images of the bird "periscoping" its head above the nest and then making a slow, gaping yawn. I whooped with joy when I captured a sequence of more than 25 usable images of this bird transiting a small river valley in the Greater Kruger National Park, proudly thrusting its straight neck forward. I was able to crank up the ISO setting just in time, preserving high shutter speeds on this cloudy day, and add a 1.4x extender to my lens to generate substantially more pixels in the bird than my 500 mm lens would have provided.

This bird's preferred domain is wetlands, which is not a desirable address in the 21st century. Wetlands all over the world are being drained, agriculturalized, polluted and encroached upon. Even in the Kruger, loss of habitat has made the Saddle-billed Stork uncommon. Recent estimates suggest that there are only 20 to 40 pairs living in this more than 7,000 square-mile (20,000 km²) preserve. However, the bird's immortality has already been assured in one sense, since it is believed that an image of the Saddle-billed Stork was used for an Egyptian hieroglyph.[4]

Klaserie Sands River Camp, South Africa (January)

Canon EOS-1D X | EF 500 mm f/4L IS USM +1.4x | 1/2500 sec at f5.6 | ISO 3200

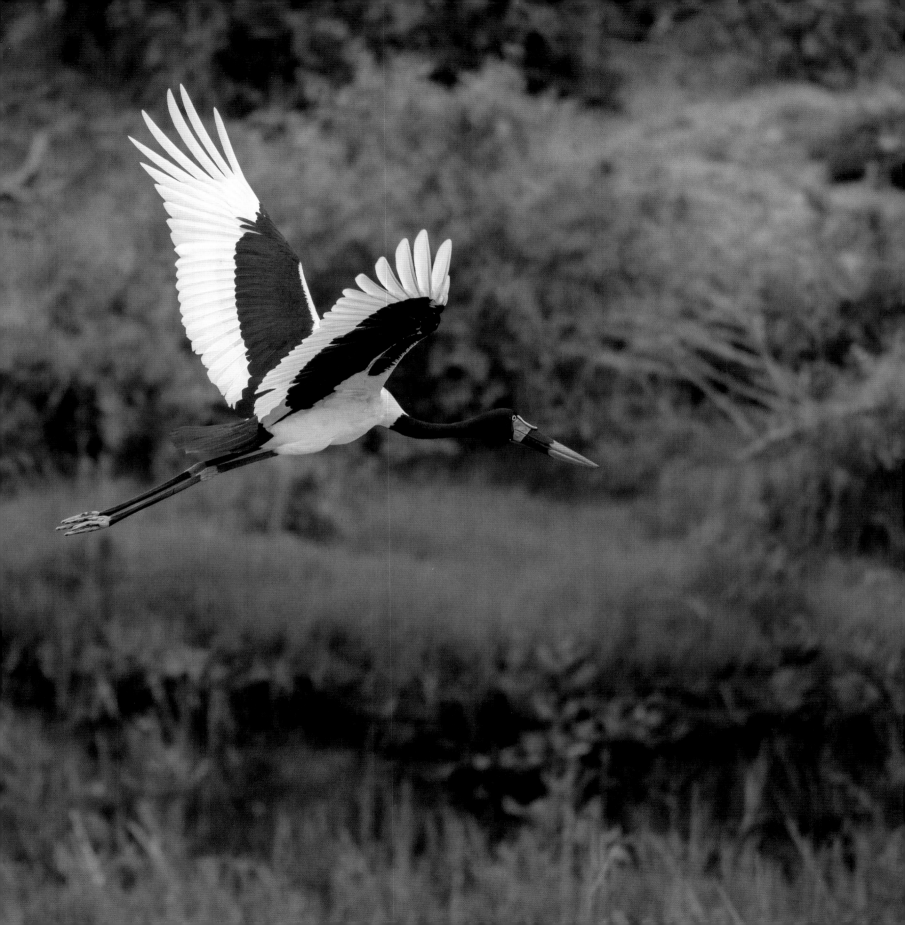

Roseate Spoonbill

Species
Platalea ajaja

Length
2.2–2.8 ft. (68.5–86.5 cm)

Wingspan
3.9–4.3ft. (120–130 cm)

Weight
2.5–3.1 lb. (1.1–1.4 kg)

Conservation Status
Least concern

Population
100,000–250,000 birds; stable

Green Island, Texas (March)
Canon EOS-1D Mark IV | EF 70–200 mm f/2.8L IS II USM at 182 mm | 1/3200 sec at f/6.3 | ISO 500

Most wildlife illustrators today work from photographs, but this was not the case for the most famous bird illustrator of all: John James Audubon. In the text accompanying plate 321 of his landmark 1827–1838 book *Birds of America*, Audubon described his hunt for Roseate Spoonbills as follows:

> After having seen three of these precious birds alight on their feeding grounds, about a quarter of a mile from where I stood, I managed something short of half an hour, to get within shot of them. Then, after viewing them for awhile unseen, I touched one of my triggers, and two of them fell upon the surface of the shallow water. The other might, I believe, have been as easily shot, for it stood, as I have seen Wild Turkey cocks do on like occasions, looking with curious intensity as it were upon its massacred friends.

As repugnant as killing birds is today, Audubon was following a long-established practice of naturalists and artists. What he did differently was to draw from reanimated specimens, rather than dead "skins." His technique involved mounting the recently killed birds in dynamic, lifelike postures on boards using "wire, skewers, and pins."

This photograph was taken in the afternoon on Green Island, Texas, as the resident birds were returning to roost from a day of feeding, during which they oscillated their eponymous bill rapidly in the water to create turbulence and stir up prey. Historically, this bird has suffered because of its splendid coral-pink, gold and crimson plumage. Roseate Spoonbill wing and tail feathers were described by Audubon as "a regular article of trade [for fans] in St. Augustine, Florida." This trade risked eliminating the bird from U.S. shores until the Migratory Bird Treaty Act (MBTA) of 1918 outlawed such commerce. It is ironic that after exactly a century of protection, changes were proposed to the MBTA that may again threaten the Roseate Spoonbill.

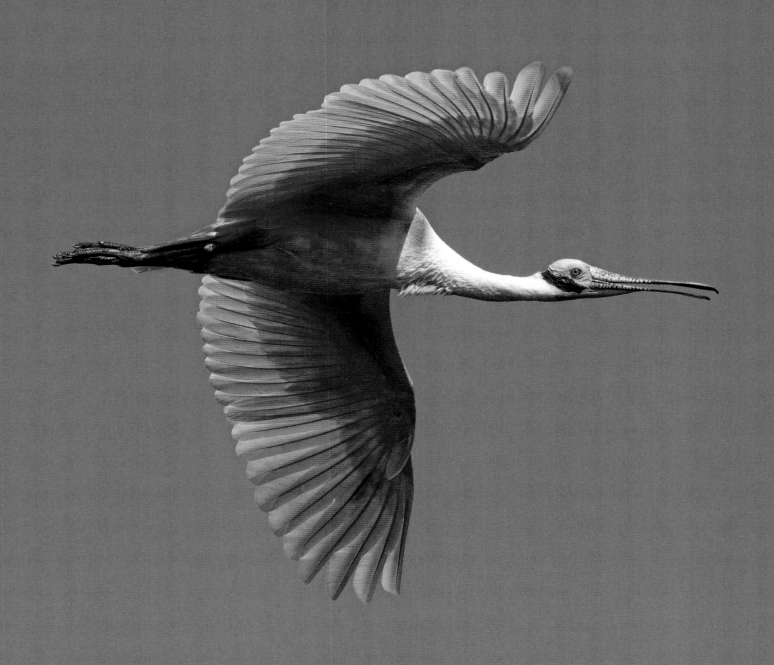

Brown Pelican

Species
Pelecanus occidentalis

Length
3.4–5.0 ft. (105–152 cm)

Wingspan
6.7–7.5 ft. (203–228 cm)

Weight
7.7 lb. (3.5 kg)

Conservation Status
Least concern

Population
300,000 birds; increasing

Most cameras have a rarely visited setting called "exposure compensation" that is designed to cope with a situation where the light on the subject is very different from the average light level in the frame. I use this setting on almost every image that I take! As my feet sunk into the deep beach sand during a walk at sunset in the Galápagos Islands, it was tempting to dial in a few stops of exposure compensation so that the resulting image would show feather detail in this Brown Pelican that was plunge-diving for its evening meal, but correct exposure for the bird would have overexposed the sky. The orange and ocher tones that dominated the mood of the moment would have been lost. I instead exposed for the sky, and the result is a slightly disturbing silhouette with a prehistoric echo.

Fossilized remains of birds with elongated fish-scooping bills from the early Oligocene period, approximately 30 million years ago, that were similar to the Brown Pelican and its relatives have indeed been found in fine lacustrine limestone in France. The French fossils' beaks were even similar in size to the Brown Pelican's massive mandible (11.8–13.7 inches; 30–35 cm). This fossil find is surprising because it suggests that the pelican's evolutionary adaption for collecting large quantities of small fish has been a solved problem for this vast expanse of time. Where better solutions occur by chance, they will be favored by natural selection. However, in this case, it seems that the near-ideal design had already been achieved. Soft tissue from the pelican's huge dangling net — the gular pouch — was not fossilized, but we can be fairly sure that this structure, in which small fish swim their last moments in rapidly draining water, has stood the test of evolutionary time.

Playa Espumilla, Santiago Island, Galápagos Islands, Ecuador (October)
Canon EOS-1D X | EF 100–400 mm f/4.5–5.6L IS II USM at 400 mm | 1/3200 sec at f/5.6 | ISO 2000

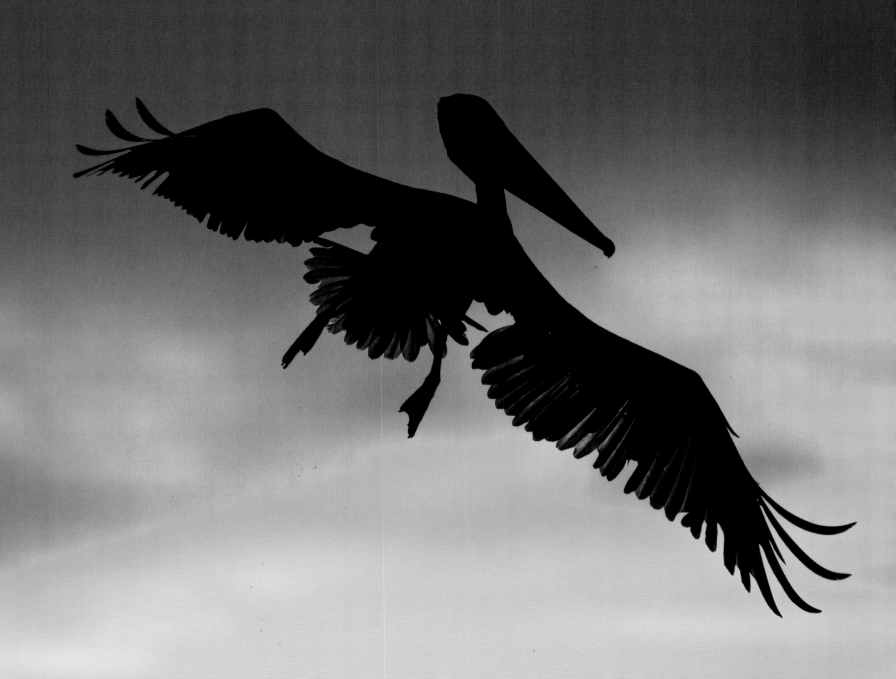

American White Pelican

Species
Pelecanus erythrorhynchos

Length
4.2–5.8 ft. (127–178 cm)

Wingspan
8.0–9.8 ft. (244–299 cm)

Weight
11.0–18.7 lb. (5.0–8.5 kg)

Conservation Status
Least concern

Population
180,000 birds; increasing

We had accomplished our goal for the day: flight shots of the endangered Whooping Crane (*Grus americana*) that overwinters eating Blue Crab (*Callinectes sapidus*) from the shallow waters of the Aransas National Wildlife Refuge (see pages 210–211). But as our boat left the Intracoastal Waterway and swung back toward Rockport Harbor, the brilliant whiteness of a row of half a dozen American White Pelicans roosting like sentinels on a sandbar was hard to ignore. As we passed by, these heavy birds rose into the air with an extensor thrust from their stout orange legs and a single powerful downbeat of their enormous wings, providing us with a close-range lesson in the aerodynamics of lift.

I have held museum specimens of the wings of an American White Pelican, and their lightness is staggering — particularly for such a large span.[5] The total surface area of the two wings (excluding the body in between) is about 10 square feet (0.93 m^2), and the weight of an average adult bird is approximately 15 pounds (6.8 kg). A simple calculation (of force divided by area) tells us that each square foot of a pelican's wing generates at least 1.5 pounds (0.68 kg) of lift force to get the bird off the ground. This lift force comes from the forward and downward sweep of the wings, which creates a lower pressure on the upper wing's airfoil surface. Pelicans are superb fliers: They glide for long distances and expertly detect thermals for soaring. Like cormorants, they also often fly very close to the surface of water, one bird following another, taking advantage of ground effect and the upwash provided by the leading bird's slipstream, both of which minimize their energy expenditure.

Aransas National Wildlife Refuge, Texas (January)
Canon EOS-1D Mark IV | EF 70–200 mm f/2.8L IS II USM at 200 mm | 1/4000 sec at f/6.3 | ISO 400

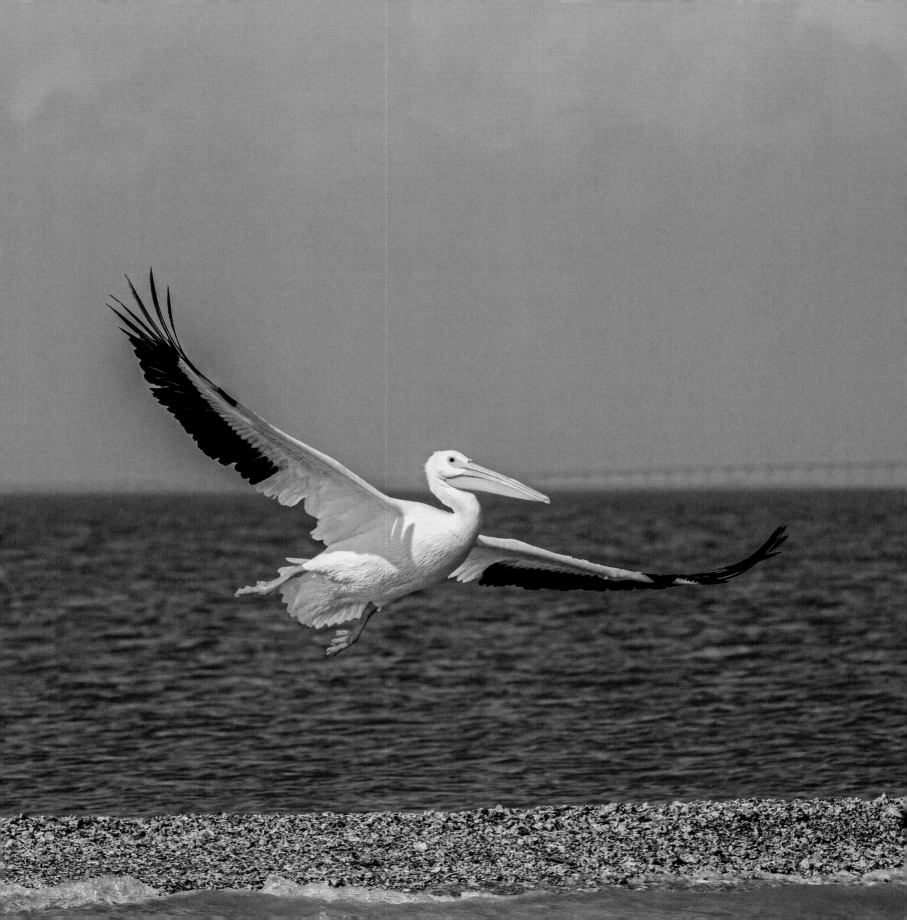

Goliath Heron

Species
Ardea goliath

Length
4.4–4.9 ft. (135–150 cm)

Wingspan
6.9–7.5 ft. (210–230 cm)

Weight
9.5–9.9 lb. (4.3–4.5 kg)

Conservation Status
Least concern

Population
6,700–67,000 mature birds; stable

I was bound and determined to capture a flight shot the very first time I encountered a Goliath Heron along the banks of the Letaba River in South Africa. For more than two and a half hours, in the blistering heat of an early Kruger afternoon, I continued centering this largest of all the world's herons in my viewfinder, fingering the shutter release, waiting for the climactic moment to arrive. The bird foraged and fished, got mobbed by a Blacksmith Lapwing (*Vanellus armatus*), exhibited its full 7-foot (2.1-meter) stature,[6] observed an itinerant African Fish-Eagle (*Haliaeetus vocifer*), stretched and preened, and succeeded in making a passing Squacco Heron (*Ardeola ralloides*) look as small as a sparrow, but it showed absolutely no inclination to fly. I could almost hear a scratchy recording of Noël Coward in my head singing "Mad dogs and Englishmen go out in the midday sun." He would have been correct. Our rightful place was back at the lodge with all the other sensible photographers, not baking in the sun waiting for a bird that never did fly. But there were to be other opportunities, including this one taken a few days later from the southern bank of the chocolate-colored Luvuvhu River as it oozed its way to Crooks Corner, the point where the borders of South Africa, Zimbabwe and Mozambique meet.

Confronting one of nature's extremes, such as the Goliath Heron, begs the questions: "What about the design of this animal is the limiting factor that prevented an even larger species from evolving and becoming successful? Are we looking at the maximum feasible length for a serpentine avian neck? Are such long leg bones prone to fracture? Is the balance between energy expenditure and available food right on the edge for this bird?" Archeological records from Abu Dhabi mention a recently extinct larger heron, but the Goliath is by far the largest of the 64 extant members of the Heron family (Ardeidae), so this indeed may be as large as a successful heron can get!

Kruger National Park, South Africa (January)
Canon EOS-1D X | EF 500 mm f/4L IS USM | 1/3200 at f/6.3 | ISO 2000

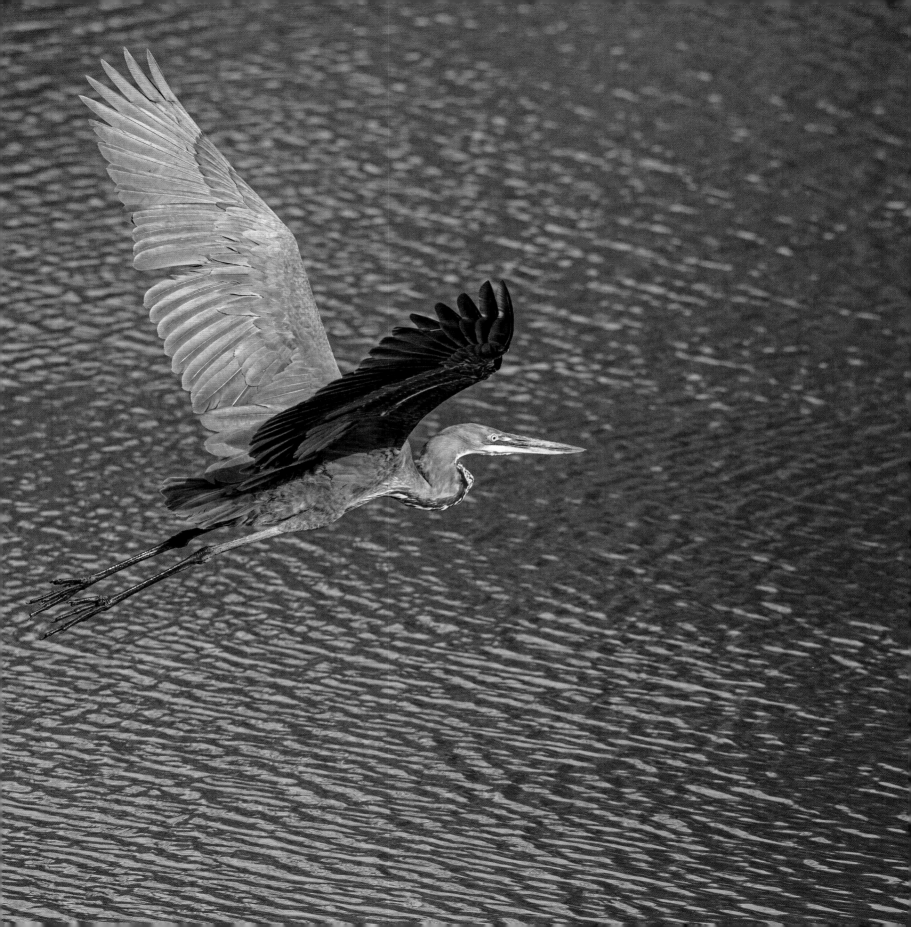

Southern Giant-Petrel

Species
Macronectes giganteus

Length
2.8–3.3 ft. (85–100 cm)

Wingspan
4.9–9.2 ft. (150–210 cm)

Weight
Male: 11.0 lb. (5.0 kg)
Female: 8.4 lb. (3.8 kg)

Conservation Status
Least concern

Population
95,600–108,000 birds; increasing

Bleaker Island, Falkland Islands (January)
Canon EOS-1D X | EF 100–400 mm f/4.5–5.6L IS II USM at 400 mm | 1/2500 sec at f/5.6 | ISO 1000

It is not that Bleaker Island is more desolate than elsewhere. This long ribbon of land off the southeast coast of the Falkland Islands used to be called Breaker Island. It may owe its present name to the poor eyesight of a cartographer who made a new map of this then-uninhabited island in 1859. Today, Bleaker is recognized as an IBA (Important Bird and Biodiversity Area) by BirdLife International, partly for the spectacular writhing colony of thousands of Imperial Cormorant (*Phalacrocorax atriceps*) that can be seen from the window of the island's only guest house.

Transportation around the Falkland Islands is in nine-seater Britten-Norman Islander aircraft that land on designated farmland or dirt strips. I took this photograph while waiting for my flight off the island, where several Southern Giant-Petrels were nesting along the shore. They are fiercely territorial near their rudimentary nests. I kept well away from the nesting site and shot the bird as it patrolled the kelp-strewn shore.

Southern Giant-Petrels are known as the vultures of the southern Atlantic, but this appellation does not begin to describe their aggressive, mean-spirited, murderous personalities. They are attracted to death and dying and always on the lookout for vulnerable mammals and birds. They are not just carrion eaters and will beat or drown their own prey if the opportunity arises. At Ocean Bay in South Georgia, I witnessed a tragic tug-of-war between a Southern Giant-Petrel and a female South American Fur Seal (*Arctocephalus australis*) over a seal pup.[7] Despite the mother's gallant efforts, the bird was soon feasting on the pup's entrails while the mother mourned.

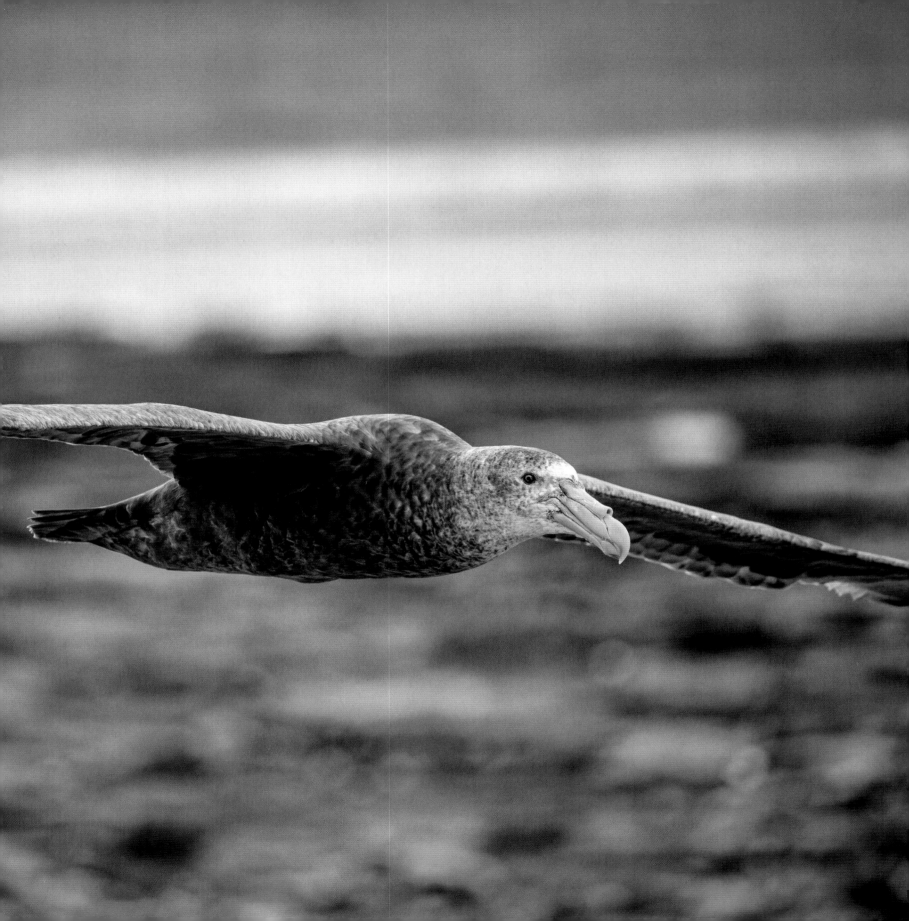

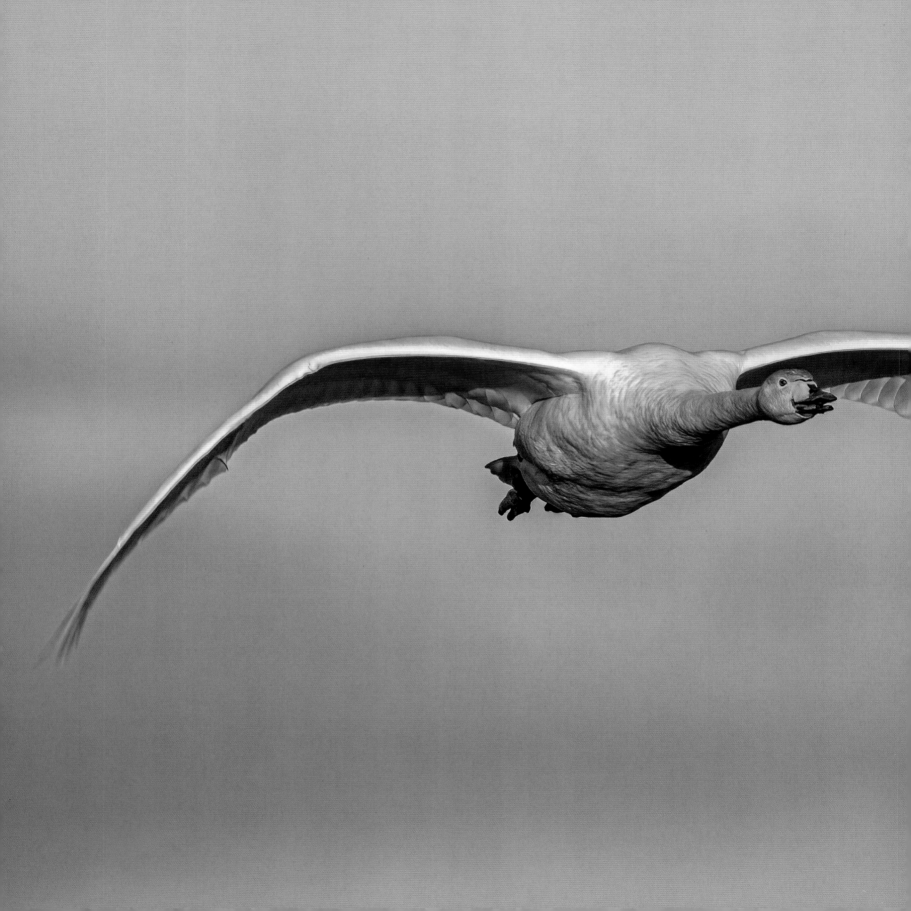

6
Ducks, Geese & Swans

Previous Spread

Species
Whooper Swan (*Cygnus cygnus*)

Location
Iceland (April)

Settings
Canon EOS-1D X | EF 100–400 mm f/4 IS II USM at 400 mm | 1/4000 sec at f/8 | ISO 4000

All the birds in this chapter belong to a single taxonomic family, the Anatidae. It is a cosmopolitan family of water-loving birds. It contains both commoners and royalty. Geese are the most likely candidates for the proletariat; several species of geese are so successful, so adaptable and, consequently, so numerous that population control measures have been considered or implemented to protect habitat and food for less successful species.

The royalty are undoubtedly the swans. They appear in the art and mythology of many cultures and are considered the epitome of grace and beauty. Their royal pedigree is demonstrated by the anachronistic charter that gives the British monarch absolute ownership of all unmarked Mute Swans (*Cygnus olor*) swimming in open waters in Britain. This decree was originally intended to procure a dependable supply of swan meat for the royal dinner table and enable the monarch to bestow rights to swan ownership on royal supporters, such as the Vintners' Company. In modern times, it has devolved into an annual count and marking of swans and cygnets on the River Thames in a process known as "swan upping." Ironically, introduced Mute Swans (*Cygnus olor*) on the east coast of North America are themselves considered a disruptive species and, just like geese, have been subject to a "management" plan. Fealty to royalty, it seems, is strictly local.

Curiously for a group of birds that we invariably associate with flight, ducks incapable of flight do exist. I have seen one such bird: the Falkland Steamer-Duck (*Tachyeres brachypterus*). This bird thrives in coastal regions of the Falkland Islands, where the adults have no predators other than marine mammals. A closely related — and virtually indistinguishable — Falkland steamer can fly and occupies the same territory, but it travels to fresh water for mating. Darwin saw these birds during his brief visit to the Falklands in 1833. In *The Voyage of the Beagle*, he

observed that "Their wings are too small and weak to allow of flight, but by their aid, partly swimming and partly flapping the surface of the water, they move very quickly."

On the next page, in a moment of integrative rumination, he wrote: "So that there are three sorts of birds which use their wings for more purposes than flying; the Steamer as paddles, the penguin as fins, & the Ostrich spreads its plumes like sails to the breeze."

Bird lovers and photographers share their attraction to this family of birds with a group that has more deadly intentions. Historically, uncontrolled hunting has driven certain species of Anatidae to the brink of extinction. In the America of the late 1930s, Wood Ducks (*Aix sponsa*) were thought likely to become extinct, and Trumpeter Swans (*Cygnus buccinator*) had almost vanished. Even recently, the once ubiquitous Ruddy-headed Goose (*Chloephaga rubidiceps*) has been relentlessly hunted down to small numbers in continental South America. European tour groups in the early 21st century proclaimed to their potential customers that "Bird hunters from all over the world come to Argentina for a shooting holiday without limit." (The website has now been taken down.) I totally appreciate those who enjoy sustainable hunting and supplement their diets with the take, but I shall never understand the need to pose for a photograph in front of mountains of dead birds, particularly since the carcasses are likely to be discarded.

Until the late 1800s, nature in North America was considered boundless. For example, the select committee of the Ohio Senate confidently stated in 1857 that the passenger pigeon needed no protection. By 1914, the bird was extinct. A turning point in the survival of U.S. ducks, geese and swans (and many other birds) was the Migratory Bird Treaty Act signed by the United States and Canada (represented by Great Britain) in 1918. Originally designed to curb the trade in feathers for apparel (see

The Emblem of the Worshipful Company of Vintners, an ancient livery company in the city of London that has been granted the right to own swans since at least 1609. The Latin motto reads "Wine gladdens the spirit" (Reproduced with permission of the Vintners' Company).

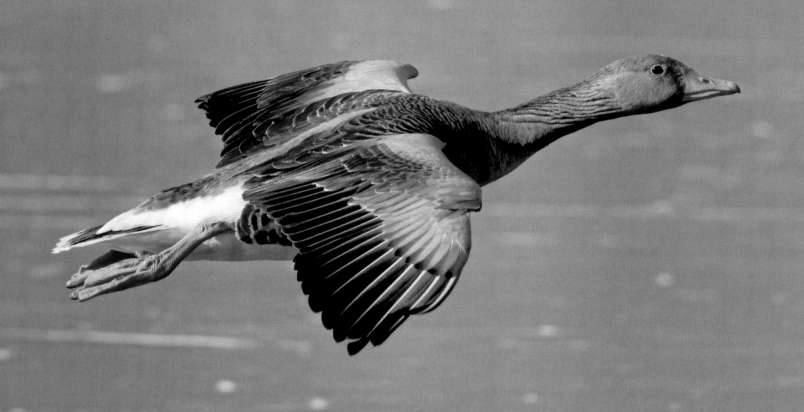

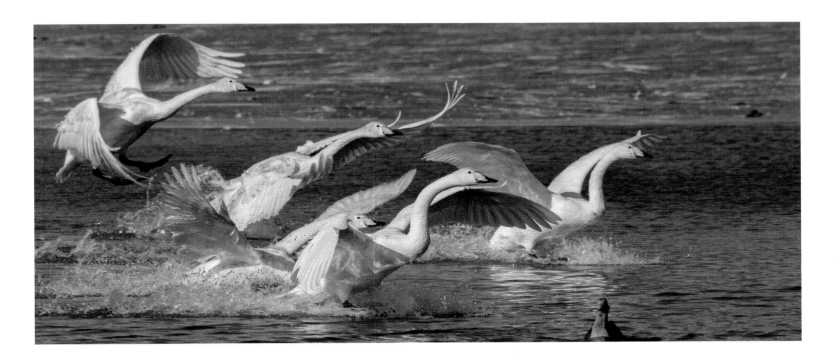

Whooper Swans (*Cygnus cygnus*) Reykjavik, Iceland

page 280), it prohibits the harming of birds, nests and eggs. The treaty has grown and now includes Japan, Russia and Mexico and covers a total of 1,026 species, many of whom are not migratory in the usual sense. There are, of course, seasons in the United States during which certain birds can be hunted. The duration and frequency of these open seasons are based on detailed assessments of the viability of populations as assessed by the U.S. Fish & Wildlife Service.

Because the Anatidae are accustomed to being hunted, they can be very difficult to photograph on the ground or water. Just like hunters, photographers of ducks, geese and swans must use stealth and deception to get close to their quarry. Camouflage, hides, floats, sleds, boats and chest-level waders are all useful. Flight photography of this group is actually somewhat easier than capturing portraits: positioning oneself upwind increases the likelihood of a close pass when the birds flush. Because they are so gregarious, isolating single birds in an image can be difficult, but the inclusion of a male-female pair in the same shot can be captivating. Similarly, massive flocks of geese can provide images that emphasize the teeming biomass that nature sometimes offers up.

Graylag Goose (*Anser anser*). Reykjavik, Iceland

Northern Pintail

Species
Anas acuta

Length
19.7–29.9 in. (50–76 cm), including tail

Wingspan
2.6–2.8 ft. (80–95 cm)

Weight
Male: 1.9–2.9 lb. (850–1,030 g)
Female: 1.6–1.9 lb. (735–871 g)

Conservation Status
Least concern

Population
Less than 5 million mature birds; decreasing

Millions of people around the world think of the handsome Northern Pintail as a neighborhood bird, since it is broadly distributed across a vast swath of the northern hemisphere. In reality, pintails are birds on the move, and they move very quickly. During migratory flights, pintails carrying satellite tags have been measured at maximum ground speeds of a furious 75 miles per hour (122 km/h). Even the average speed relative to the air was a crisp 34 miles per hour (55 km/h). These high speeds are a combination of smart flying, using tailwinds to maximize speed and distance, and genuine athleticism. The latter is also a characteristic that has attracted hunters, eager to match their skill against an able foe. Hunting and loss of habitat have put pressure on this species that, despite its large global population, is in decline.

Since pintails associate humans with the crack of the hunter's rifle, they are understandably skittish. They have been observed in some locations feeding at night, presumably to avoid predation. A photographer without subterfuge (such as a hide) or a long focal-length lens is likely to accumulate many shots of these birds retreating on the water (they are dabblers, not divers) or flying directly away. Despite the fact that there are pintails in my home environment, I caught up with the drake in this image at a national wildlife refuge in New Mexico on a visit that principally targeted Sandhill Cranes (*Antigone canadensis*) that also winter there. In addition to freezing bird motion, high shutter speeds show and preserve water movement in ways the human eye cannot see. Part of the attraction of this image is that the viewer can follow the bird's multiple interactions with the water before it finally got airborne.

Bosque del Apache National Wildlife Refuge, San Antonio, New Mexico (December)
Canon EOS-1D Mark IV | EF 500 mm f/4L IS USM | 1/3200 at f/8 | ISO 800

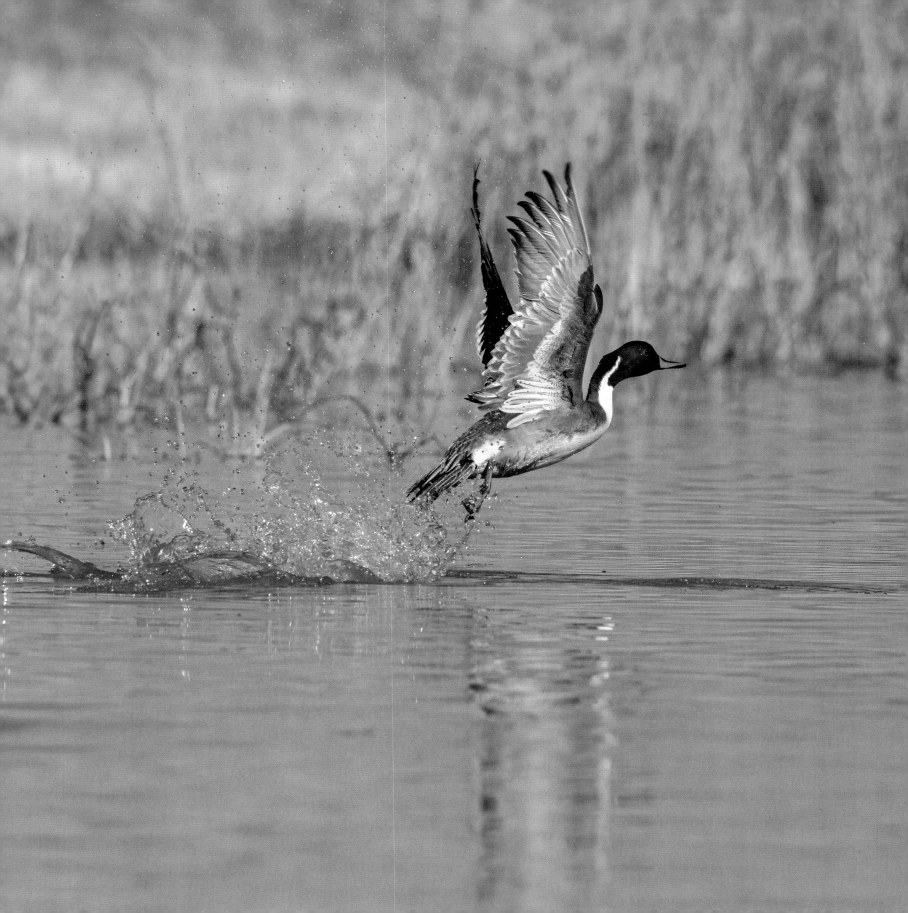

Buffleheads

Species
Bucephala albeola

Length
12.6–15.7 in. (32–40 cm)

Wingspan
20.9–24 in. (53–61 cm)

Weight
Male: 11.8–21.2 oz. (335–600 g)
Female: 8.0–16.6 oz. (230–470 g)

Conservation Status
Least concern

Population
Approximately 1,200,000 birds; increasing

Lopez Island, Washington (November)
Canon EOS-1D Mark IV | EF 600 mm f/4L IS USM | 1/2000 sec at f/9 | ISO 600

Winter is by far the most productive season for bird photography in the Pacific Northwest of the United States. The relatively mild climate attracts migrating birds that have summered in Alaska and the Canadian tundra. Mergansers, grebes, pintails, loons and Mallards are among the birds that overwinter in the waters near my home. The white-helmeted male Bufflehead in this image is leading his five female companions into a water-ski landing on the glassy surface of Fisherman Bay on Lopez Island, Washington. The birds are using their wings as air brakes, bleeding off speed from the flight in.

It is not hard to identify the females, which are noticeably smaller and have darker plumage with just a dab of grayish-white highlighting their under-eye stripe. The term biologists use to describe differences in size, shape or color between male and female animals of the same species is sexual dimorphism. Ducks usually exhibit a high level of sexual dimorphism. Drakes are larger and more brightly colored, while hens are often smaller and drab. Bright and distinctive males are demonstrably more attractive to females (see page 48), but there is another evolutionarily sound reason for female drabness: Many ducks nest in the open, and when the female is incubating eggs on the nest, she is hidden in plain sight from predators by her camouflaged plumage. Buffleheads are cavity nesters, so it makes sense that the female should not have a large white signpost on her head to indicate the location of the nest, particularly since the male disowns her for the first 20 days of incubation.

In order to capture a good group landing shot, the photographer must identify the incoming birds as early as possible and continually keep a focus point centered on the lead bird. In a camera without automatic tracking a shot like this will not work using a focus mode that allows the camera to choose the point of interest (e.g., 61-point Automatic Focus Point Selection on the Canon 1D X). The camera will often choose a point that is not where the photographer wants to focus.

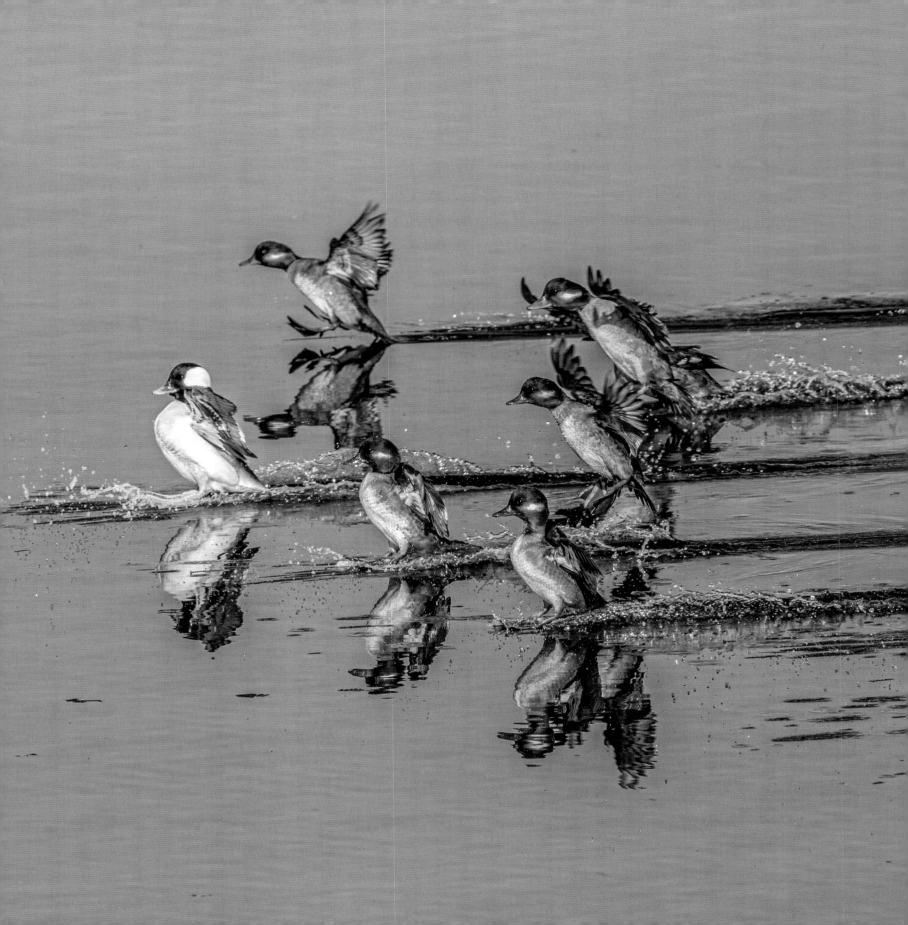

Snow Geese

Species
Anser caerulescens

Length
2.2–2.7 ft. (66–84 cm)

Wingspan
4.3–5.1 ft. (132–165 cm)

Weight
Male: 3.5–5.1 lb. (1.6–2.3 kg)
Female: 5.0 lb. (2.3 kg)

Conservation Status
Least concern

Population
More than 5,000,000 birds; increasing

Snow Geese love to hang out with a few thousand of their closest friends, as this image of a flock in Skagit County, Washington, demonstrates. In the late fall, tens of thousands of migrating birds travel the Pacific Flyway from their Arctic summer home to forage on agricultural leftovers in western Washington. They stand shoulder to bill, chattering noisily, their connected mass letting no light pass to the ground. Imperceptibly, the entire flock inches forward as the land beneath them is cleared of nutrients. More birds arrive and join the feeding party. On this day, the sentinels at the edges of the group suddenly detected an incoming Bald Eagle (*Haliaeetus leucocephalus*). The lookout birds took flight, and the entire flock followed, leading to this blizzard. What the image can't convey is the cacophony — it seemed like every single bird was screaming their alarm call. The sound wrapped around everything until my eardrums rang.

Snow Geese are highly successful breeders. A real concern is that, as their numbers increase, they are displacing other species from Arctic breeding grounds. Federally approved steps encourage hunters to increase their catch. So far, this has not dented the onslaught.

Snow geese are so omnipresent, and their habits so predictable, that a photographer can almost guarantee a "snow globe" flight shot within a couple of hours of arriving at a field where Snow Geese are feeding. The flocks are often so large that one can take the time to move around in order to find a good composition, anticipating how the foreground and background might complement the impending whiteout. In this case, I was able to use the line of wintering trees to show the transition between ground and sky.

Skagit County, Washington (January)

Canon EOS-1D Mark IV | EF 500 mm f/4L IS USM | 1/1000 sec at f/11 | ISO 800

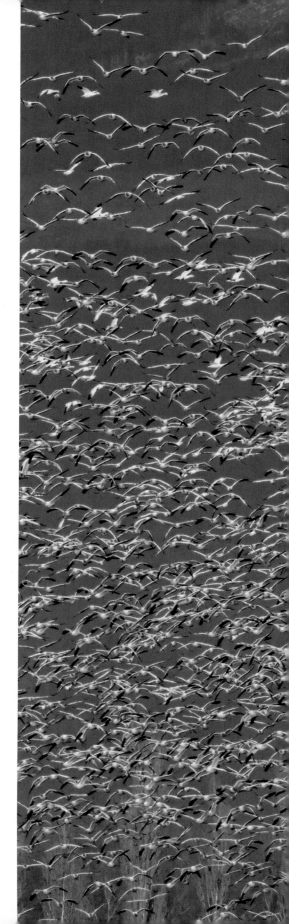

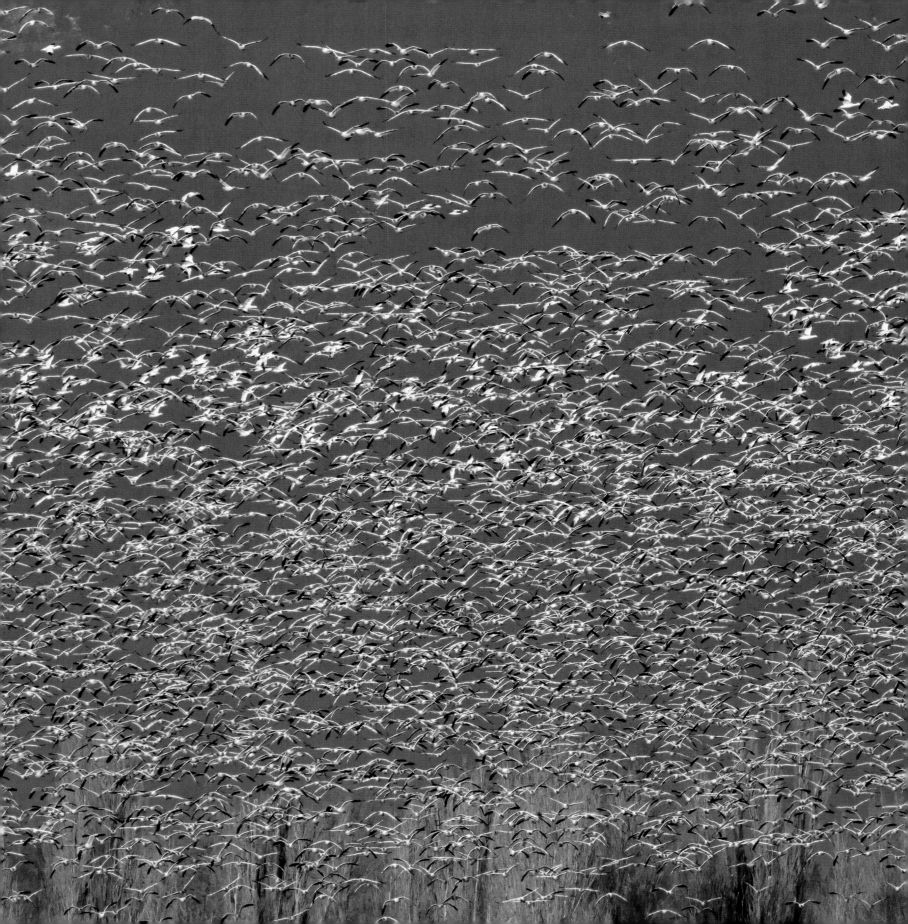

Ruddy-headed Goose

Species
Chloephaga rubidiceps

Length
17.7–20.7 in. (45.0–52.5 cm)

Weight
Male: 3.64–4.45 lb. (1.6–2.1 kg)
Female: 2.6–3.3 lb. (1.2–1.5 kg)

Conservation Status
Least concern

Population
43,000–82,000 birds; decreasing

Let me count the 14 reasons why this male Ruddy-headed Goose should not be flying: eight missing primary feathers on the right wing, five missing primaries on the left wing and one primary covert feather that has just been jettisoned. But it is flying because avian flight equipment has a great deal of redundancy. This handheld image was taken right in the middle of the annual molting season, when many Ruddy-headed Geese are stranded, flightless, on the ground, being at a more advanced stage of shedding last year's feathers and beginning to show their new plumage.

This species is seen in pairs most of the year, but during molt the birds cluster together on the ground, probably for safety from predators. This flight outing is certain to have been energetically costly for the bird. While an intact wing is perfectly designed for smooth, laminar airflow across the wing surface, it is easy to imagine what turbulence there is in the flow across and through the missing feathers, even though we cannot see the circulating air. This is going to increase the drag and decrease the lift of the wing — both negative factors — requiring more energy from the bird to stay aloft.

Ruddy-headed Geese in Argentina have been decimated by hunters. The government of Argentina actually declared this bird an "agricultural plague" in the 1930s. Despite more recent protections, there is still a tradition of shooting these birds as game. Surprisingly, the species is listed as "least concern," mainly because of the robust population in the Falkland Islands. The two populations do not appear to mix, and recent research suggests they may soon be designated as separate species.

Carcass Island, Falkland Islands (January)
Canon EOS-1D X | EF 100–400 mm f/4.5–5.6L IS II USM at 188 mm | 1/2500 sec at f/5.6 | ISO 1000

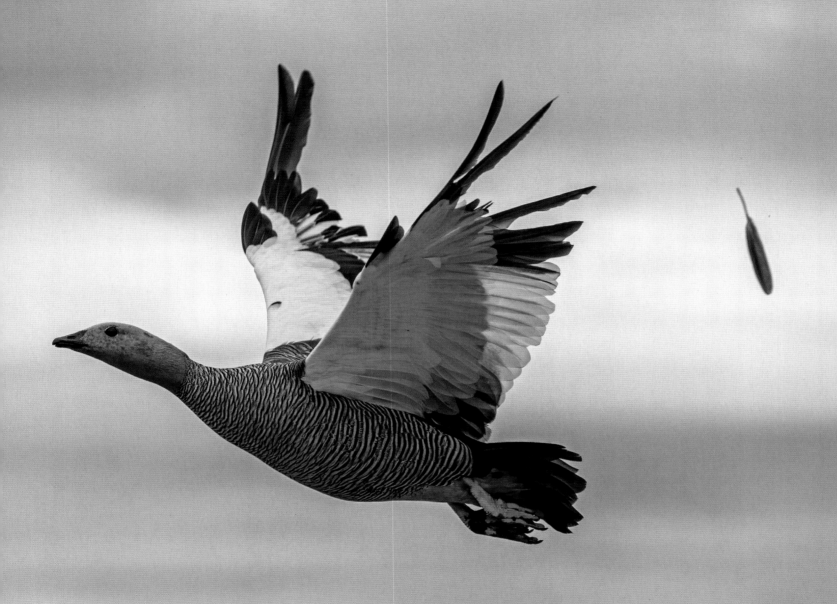

Canada Goose

Species
Branta canadensis

Length
1.8–3.6 ft. (55–110 cm)

Wingspan
4.0–6.0 ft. (122–183 cm)

Weight
2.9–14.4 lb. (1.3–6.5 kg)

Conservation Status
Least concern

Population
5 million–6.2 million birds; increasing

Some years ago, I dispatched the proof of a bird poster that I had designed for a local nonprofit conservation group to seek their approval before printing. The message came back loud and clear: We love the poster, but please delete the image of the Canada Goose. It was not that the picture was technically or aesthetically bad, but that the Canada Goose is a hated bird by conservationists and pilots of jet aircraft. For the latter, U.S. Airways Flight 1549 from La Guardia on January 15, 2009, is firmly implanted in the memories of many flight enthusiasts. With Captain "Sully" Sullenberger in the left seat, the Airbus 320-214 flew into a flock of Canada Geese at an altitude of 2,800 feet (853 m) just two minutes after takeoff. The ingestion of geese into the engines resulted in a fire, engine failure and the subsequent "Miracle on the Hudson," in which all 155 people on board were safely rescued from the ditched airplane. The *New York Times* reported that in response to the accident, 2,000 Canada Geese were exterminated in an act that seemed more like revenge than a serious attempt at preventing further accidents.

Canada Geese are victims of their own resilience and hyper-adaptability. Conservation groups dislike these birds because they seem able to commandeer any feeding or nesting habitat, driving less resilient, and often more threatened species, from their former environments. In Europe, where some vagrants have established colonies, they have been described as the most harmful alien bird species present.

Ironically, this image was taken from a boat trip sponsored by the Friends of the San Juans, an environmental advocacy group that, to date, has not taken a position opposing Canada Geese.

Spieden Island, Washington (March)
Canon EOS-1D X | EF 100–400 mm f/4.5–5.6L IS II USM at 400 mm | 1/5000 sec at f/8 | ISO 2000

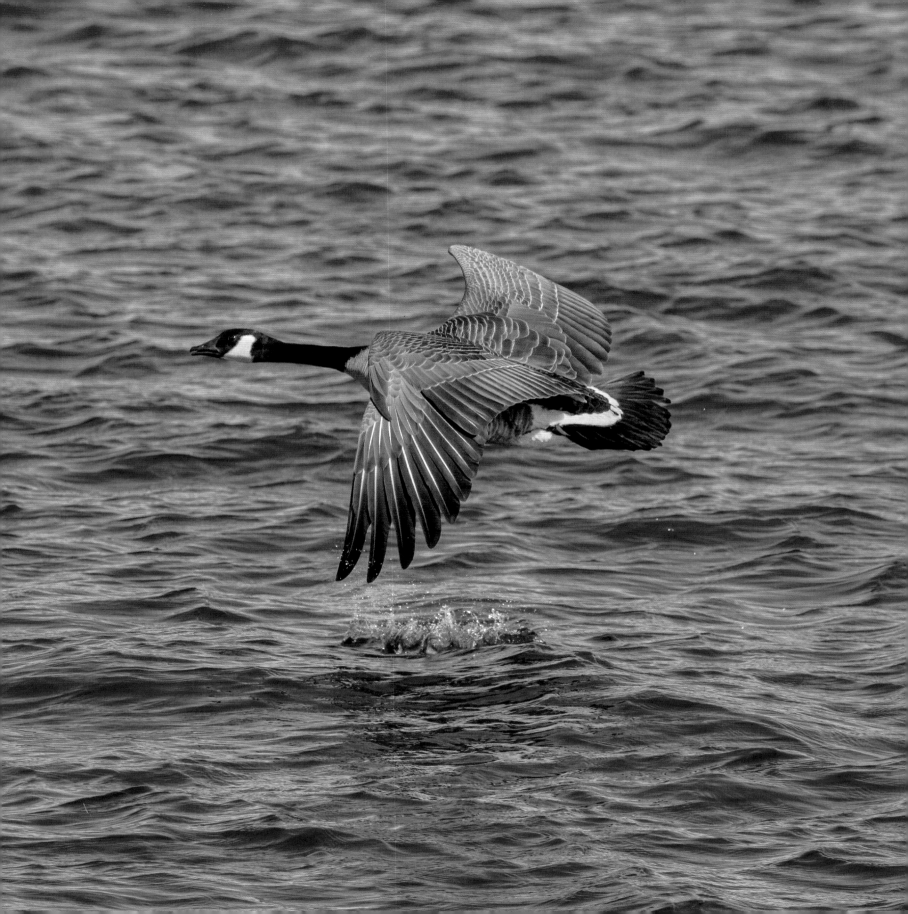

Trumpeter Swans

Species
Cygnus buccinator

Length
4.9–5.9 ft. (150–180 cm)

Wingspan
7.5–8.5 ft. (230–260 cm)

Weight
Male: 20.1–30.0 lb. (9.1–13.6 kg)
Female: 15.4–27.6 lb. (7.0–12.5 kg)

Conservation Status
Least concern

Population
More than 23,000 birds; increasing

Skagit County, Washington (January)
Canon EOS 50D | EF 500 mm f/4L IS USM | 1/1250 sec at f/6.3 | ISO 400

At the end of the 19th century, Trumpeter Swans were on the verge of extinction because their much sought-after feathers could be legally traded, and swan skins were prized for clothing and accessories. In the 20th century, protections for migratory birds saved the species, which continues to rebound today.

These birds are known to be faithful mates; only one instance of a polygamous Trumpeter Swan has ever been reported. The balletic synchrony of the two bird's wing movements in this image is evocative of that fidelity: They are flying beat for beat in perfect unison against an evergreen background. A small group of Trumpeters had been foraging in the fallow winter fields; suddenly one took flight — likely wary of the distant interloper. The rest followed, pairing up before starting their departure runs.

At the moment the photograph was taken, the birds were at the end of their downward and forward propulsive thrust. The tips of the primary feathers, which are bent upward during the downstroke and downward during the upstroke, are now straight, indicating that reversal for the upstroke is about to begin. When kids are asked to demonstrate how birds fly, they usually raise and lower their arms in line with their bodies. In fact, wing movements during flight are downward and forward. This forward motion directs a component of the wing force forward to generate propulsion. This is apparent in the photograph when the position of the wing tip in relation to the bill is examined: The wing tip is much closer to the line of the bill than a simple up and down wing movement would produce. This forward wing stroke, relative to the body, is needed to generate thrust because of the bird's overall forward motion. We can also just see that the birds have their tails deployed to provide additional lift for the departure. With a wingspan of over 8 feet (244 cm) and a weight of up to 30 pounds (13.6 kg), these birds would have been an easy target for the hunters who nearly caused their demise.

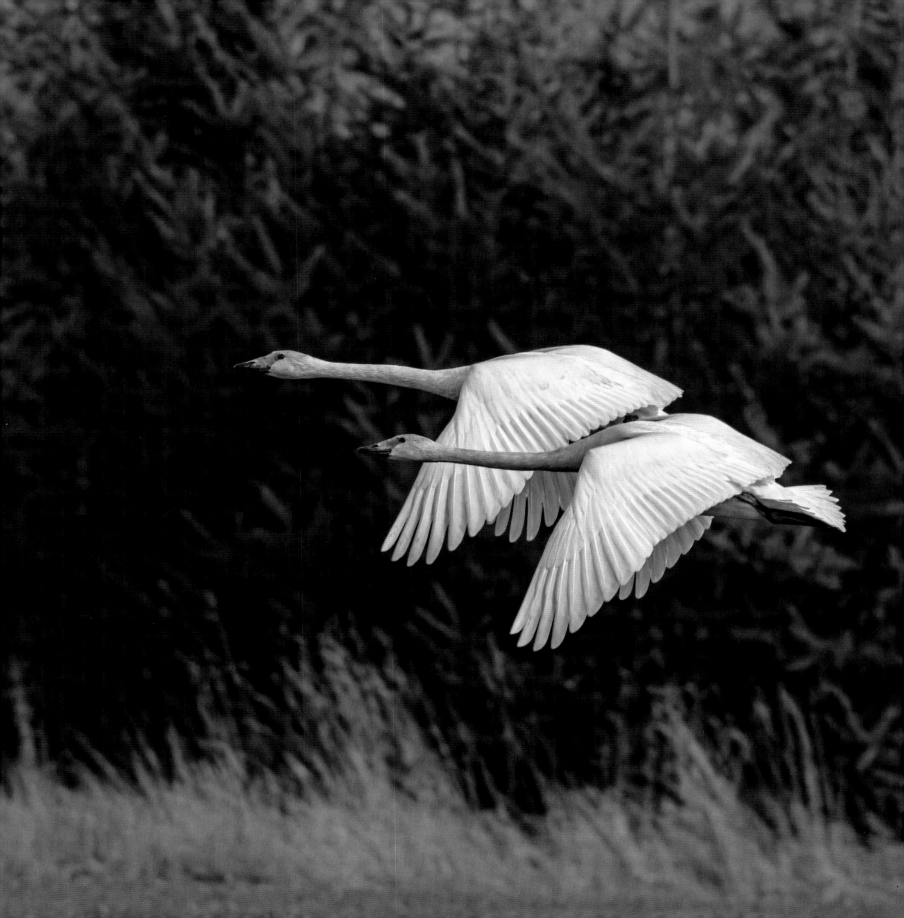

Whooper Swans

Species
Cygnus cygnus

Length
4.6–5.4 ft. (140–165 cm)

Wingspan
6.7–8 ft. (205–243 cm)

Weight
Male: 15.9–34.2 lb. (7.2–15.5 kg)
Female: 12.3–28.9 lb. (5.6–13.1 kg)

Conservation Status
Least concern

Population
More than 180,000 birds; trend unknown

Launching a mass of over 30 pounds (13.6 kg) into the air with minimal metabolic energy expenditure is a monumental task that requires perfect conditions. For the Whooper Swan, those conditions include a strong headwind and a long stretch of ground they can use as a runway.

This image shows three Whoopers running flat-out along a beach in Iceland. The sand flying from their feet reflects the importance of leg thrust in this process. The goal is to use the runway to maximize ground speed. It is perhaps counterintuitive that a strong headwind is favorable for takeoff, but wing lift is proportional to airspeed across the wing, where the square of airspeed is the combined effect of the ground speed created by the swan and the headwind created by the moving air mass.[1] The greater the headwind, the less the bird's ground speed needs to be to achieve liftoff. Theoretically, in an extremely strong wind, the swans could simply spread their wings and take off with a ground speed of zero; gulls frequently do this when facing a high onshore wind. Of course, swans can, and do, take off from water; they try to "run" across the water, pattering their huge feet as if they were on land, but you can see from this image that where there was a choice of land or water, the birds chose land for their takeoff roll.

This was an unplanned shot taken from the road as I was driving back from the famous Látrabjarg bird cliffs. I keep my camera switched on and close by when traveling. It is also wise to choose and enter settings for ISO and shutter speed that would be suitable for the ambient weather conditions. I have missed good shots while making exposure adjustments.

Rauðasandur, Iceland (May)
Canon EOS-1D Mark IV | EF 500 mm f/4L IS USM | 1/3200 sec at f/9 | ISO 800

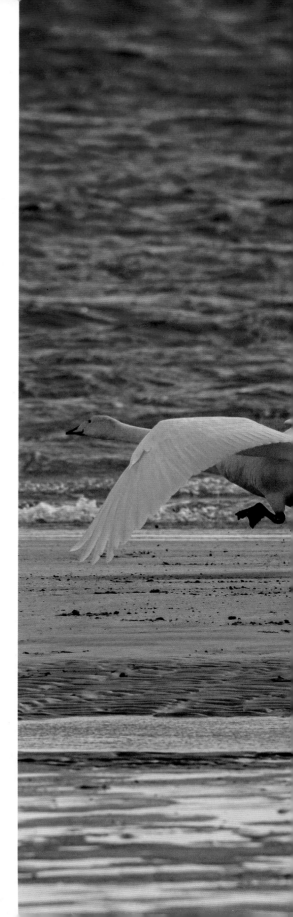

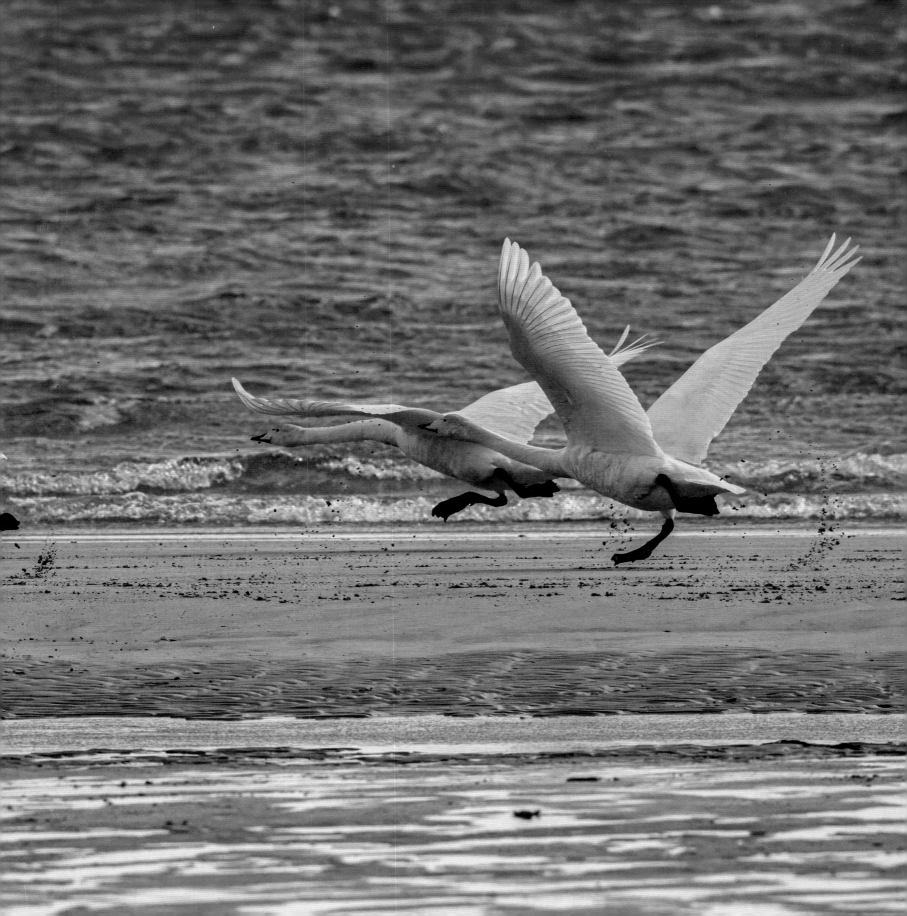

Yellow-billed Pintail

Species
Anas georgica

Length
16.1–21.7 in. (41–55 cm)

Wingspan
27.6 in. (70 cm)

Weight
Male: 1.2–1.5 lb. (540–655 g)
Female: 1.0–1.1 lb. (460–495 g)

Conservation Status
Threatened

Population
1,000–1,500 pairs; increasing

When the seal and whale hunters came to the subantarctic island of South Georgia, they carried items from the old country as an antidote to home sickness. The Norwegians brought reindeer, and the British hung the Union Jack. Both groups also inadvertently brought rats and mice that escaped from ships to colonize the low-lying coastal margins of the island. When left alone, nature eventually finds an uneasy equilibrium between the hunter and the hunted, but when an outside predator is introduced, the results can be catastrophic. On South Georgia, the ground-nesting and burrowing birds were the big losers as the rodents ate their eggs and devoured their young. The populations of birds such as the South Georgia Pipit (*Anthus antarcticus*), the most southerly songbird in the world, and the South Georgia subspecies of the Yellow-billed Pintail plummeted, and these birds almost disappeared from the island.[2]

In a bold attempt to restore the balance, the South Georgia Heritage Trust spent more than five years and U.S. $13 million in a campaign that crisscrossed the infested zones with helicopters that laid down baited poison. The story, told in the book *Reclaiming South Georgia*, has a fairy-tale ending: On May 9, 2018, after extensive reconnaissance that included rat-sniffing dogs, South Georgia was declared rodent free after two centuries of infestation. The rebound of threatened species was immediate.

I visited South Georgia in 2019, and sightings of South Georgia Pipits (*Anthus antarcticus*) and Yellow-billed Pintails were almost a daily occurrence. This image celebrates that success story. The two birds in the photograph were members of a small flock of more than 15 birds that was circulating rapidly on a rainy day in a snow-laced inlet that the Norwegians named Godthul (which means "good cove"). Today, *Godthul* is a safe harbor for birds and not for the whaling ships that carried the stowaway rodents to South Georgia those many years ago.

Godthul, South Georgia (October)
Canon EOS-1D X | EF 100–400 mm f/4.5–5.6L IS II USM at 400 mm | 1/2500 sec at f/5.6 | ISO 2000

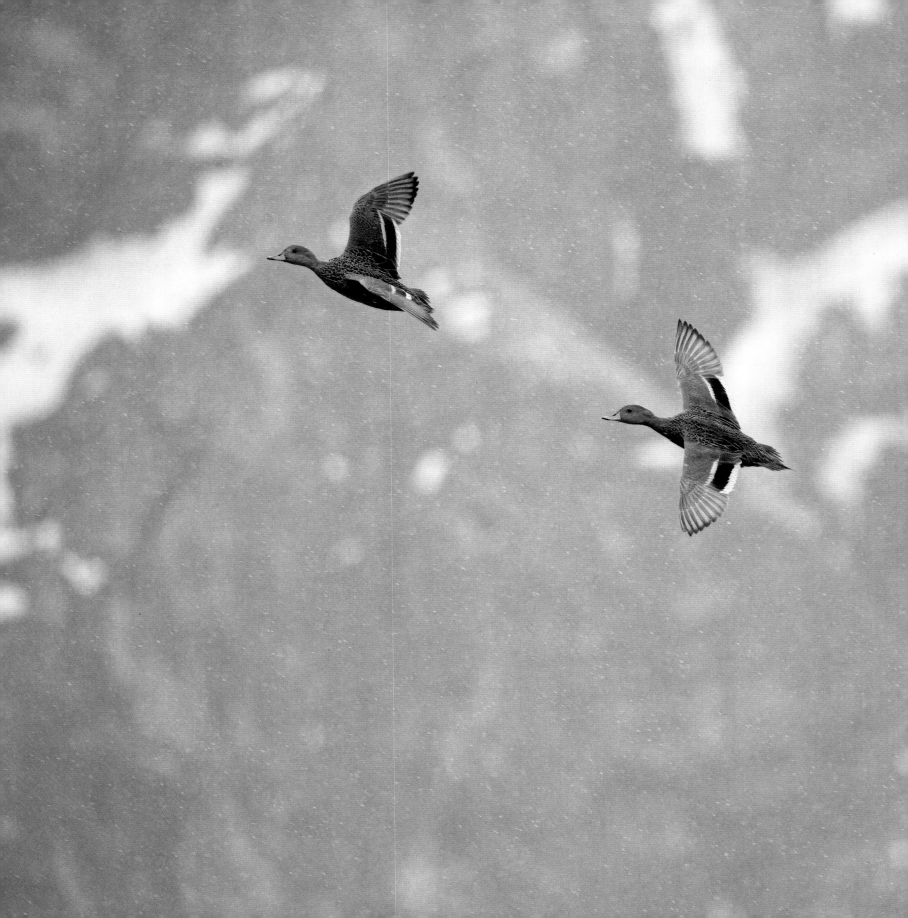

Upland Goose

Species
Chloephaga picta leucoptera

Length
23.6–28.5 in. (60–72 cm)

Wingspan
Data not available

Weight
Male: 5.8–7.8 lb. (2.6–3.6 kg)
Female: 5.4–6.7 lb. (2.4–3.1 kg)

Conservation Status
Least concern

Population
Approximately 1,200,000 birds; decreasing

New Island is a small, spectacular place on the western fringe of the Falkland Islands archipelago. Among the many wildlife attractions is a large sculpted amphitheater that is home to a colony of Southern Rockhopper Penguins (*Eudyptes chrysocome*). After landing in a sandy cove framed with yellow gorse bushes in front of the picturesque settlement (replete with a shipwreck), visitors follow a path to the colony that trends slowly uphill over a stretch of marshy grassland. Normally, the magnetic pull would have been so strong that I would have marched, head down, to the penguin colony, but on the day that I visited, I knew that I needed one final photograph of a duck, swan or goose to finish this book, so I lingered on the grassy plain that was dotted with geese. This image was my reward.

Aggression seems to be baked into the genes of Upland Geese. They are just feisty birds, rarely minding their own business, more often lunging at, and chasing, conspecifics to establish dominance and ownership of terrain. When there are eggs in the nest, male birds like this one notch up the frequency and amplitude of their attacks, as was apparent during my late October visit. Many females lay pancaked on nests in the deep grass, their chestnut-colored heads protruding from an elegantly barred breast.[3] All around them, the monochromatic males were in full attack mode, like the bird in this image. They attacked male and female birds that had wandered into their undefined territories and others that were far away but heading in the general direction of their mate's nest. While the chase usually ended without contact, I did witness a long-drawn-out fight in which two males battled in a stand-up fight for over five minutes, biting and beating each other as their agitated mates looked on.[4]

New Island, Falkland Islands (October)
Canon EOS-1D X | EF 100–400 mm f/4.5–5.6L IS II USM at 400 mm | 1/4000 sec at f/5.6 | ISO 800

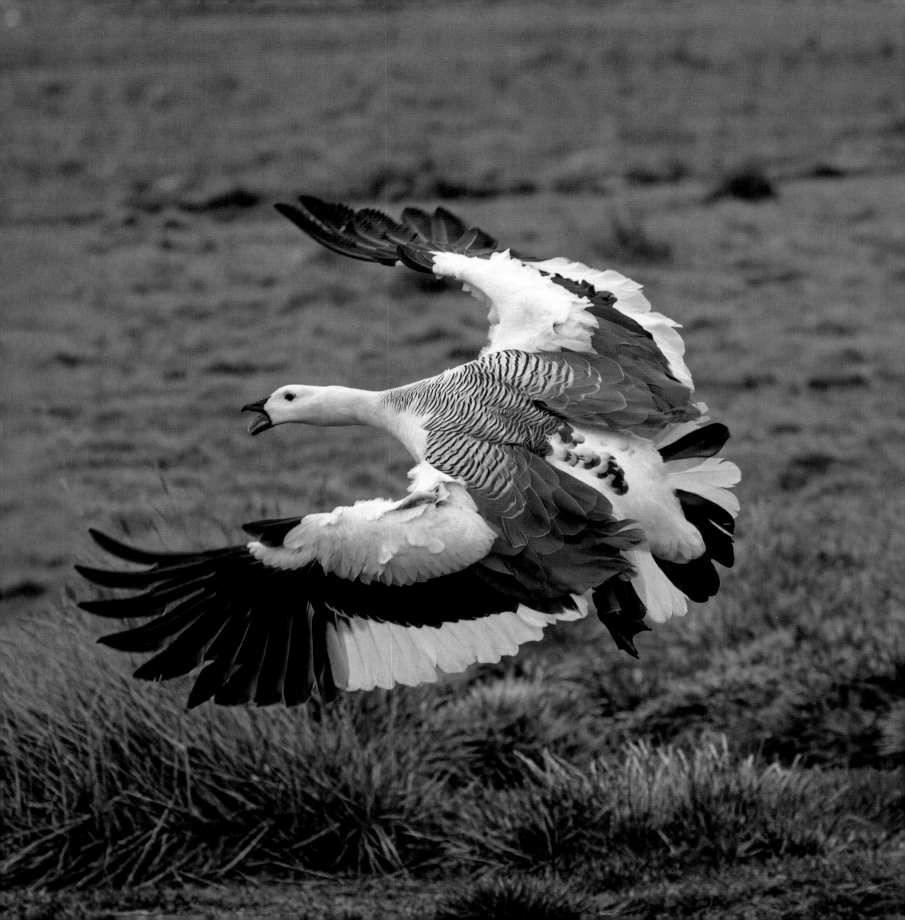

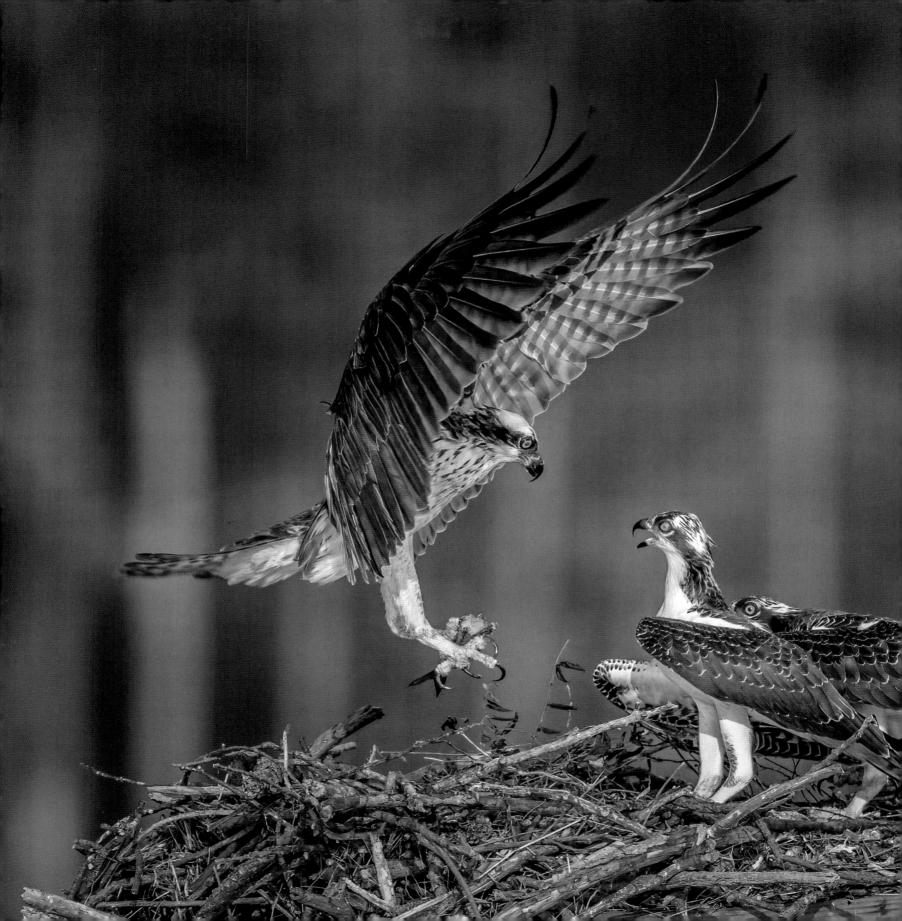

7
Raptors

A radiograph of the talons of an Osprey (*Pandion haliaetus*). The dense white material is the bony tip of the digit (the toe), and the surrounding shadow is the keratin sheath. The single arrow indicates the flexor tubercle, and the double-headed arrow indicates the approximately 0.4-inch (1 cm) extension of the keratin beyond the end of the bone. (Image courtesy of Brandon Hedrick.)

Previous Spread

Species

Osprey (*Pandion haliaetus*) (Adult female flying)

Location

Blackwater National Wildlife Refuge, Dorchester County, Maryland (August)

Settings

Canon EOS 50D | EF 600 mm | 1/800 sec at f/5.6 | ISO 500

There are almost 450 species of raptors in the world, and they are all killers. This group — named from the Latin *rapio*, meaning to take by force — hunt and kill vertebrate animals, although they are not averse to alternative fare. They have both the equipment and the temperament that serves their calling: penetrating eyesight, razor-sharp claws, flesh-tearing hooked bills, rapid aerobatic flight and endless patience.

You have already met nine members of this notorious band (the eagles in Chapter 1), and here I introduce nine more raptors from around the world. The label "raptor" does not belong to any single taxonomic group, although the dazzlingly diverse family to which eagles and hawks belong (the Accipitridae) contributes 248 species to the raptor roll call. Various falcons, vultures, owls, the Osprey (*Pandion haliaetus*) and the Secretary-bird (*Sagittarius serpentarius*) round out the list.

The most sinister instruments in a raptor's arsenal are its menacing, curled talons. The foreboding shape and sharpness of these weapons speak to the abduction and destruction that is a raptor's daily trade. The exterior of the talon is actually a sleeve of β-keratin that fits, like a curling thimble, tightly over the base of underlying bone and then extends into a sharp, scalpel-like tip. The bump at the talon's bony base (indicated in the image to the left) is a tubercle that provides a long lever arm where powerful flexor muscles, which can hold prey in a vicelike grip, attach to the main structure.

Raptor claws have provided fascinating insights into the culture and cognitive abilities of a Neanderthal civilization from over 130,000 years ago. A cache of eight White-tailed Eagle (*Haliaeetus albicilla*) talons recovered from the Krapina Neanderthal site in Croatia by archeologists between 1899 and 1905 has recently been reinterpreted and reanalyzed. Although it is not known how these relatively rare birds (at the time) were captured, it is now believed that the talons were used as jewelry

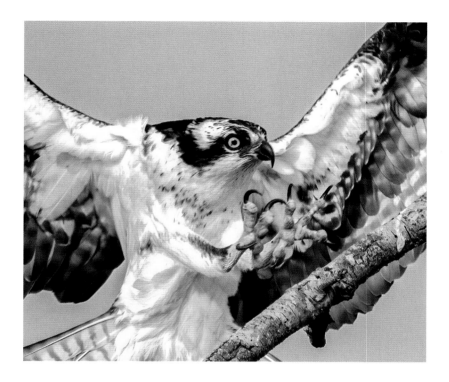

A fossilized White-tailed Eagle (*Haliaeetus albicilla*) claw, one of eight found at a 130,000-year-old Neanderthal site. The arrows (b) and (c) point to evidence of ornamentation. Arrow (a) indicates the presence of an animal fiber presumably used to bind the talons together into a piece of personal or symbolic jewelry.

for ornamentation or ceremonial purposes. What makes this finding so important is that it pushes back the onset of personal ornamentation and symbolism to the Neanderthals. It is remarkable that reverence for the talons of a raptor have provided evidence that challenges the view that this kind of activity, and the cognitive development it requires, is a modern human characteristic.

Raptors' bills are specialized for tearing the tissues of their prey. The bony parts of the bill (the upper and lower mandibles) are, like the talons, covered in sleeves of keratin. The upper bill curves steeply downward into a sharp tip. After a kill, it is common to see raptors wipe off their bills by rubbing them against a tree or washing them off in water.

I was awed by the importance of raptors' vision when I first held the skeleton of a Great Horned Owl (*Bubo virginianus*) at the University of Washington's Burke Museum. The cavities that contain the eyes (the orbits) are huge cylinders of forward-facing bone. It is readily evident why the owl moves its entire head to shift its visual focus. Owls are known to have extremely complex specializations and connections between their eyes and the visual regions of their brain, including a

The bill and talons of an Osprey. The spiny pads on the underside of the feet help prevent fish from slipping out of the bird's grasp. Lopez Island, WA.

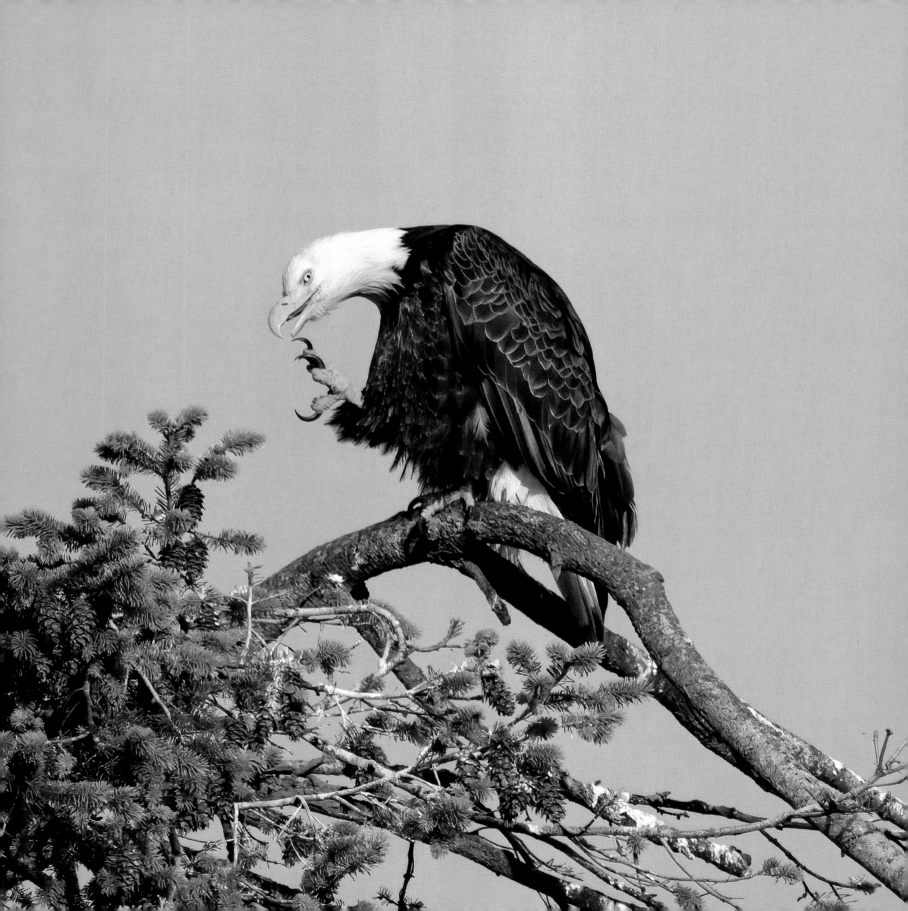

somewhat unique double crossing of left and right visual neurons, which provide low-light stereoscopic vision.

In many raptor species, females are larger than males — a characteristic that is so unusual in the animal kingdom that it is called "reverse sexual size dimorphism." A female Bald Eagle (*Haliaeetus leucocephalus*) can weight 20 percent more than her partner, while the differences in the Verreaux's Eagle-owl (*Bubo lacteus*) can be almost 60 percent. Since the within-sex size variation is often one of the few ways to distinguish male from female birds, it is generally easiest to sex raptors when viewing them together.[1]

It is no surprise that most photographs of raptors show the birds perching. Many of these birds spend long hours in patient vigilance, continuously scanning the landscape for feeding opportunities. Some hard-working owls (such as the Short-eared Owl [*Asio flammeus*], see pages 162–163) and Ospreys are notable exceptions, and their foraging patterns are very accessible to photographers. There are so many photographs of Ospreys carrying fish back to their young that a scientific study of handedness in Ospreys used open-access photographs on the Internet as their primary data source.

Once perching raptors do decide to strike, their movements are swift and purposeful, making photography challenging. Many of the published photographs of raptors striking at prey are baited, such as images of Snowy Owls (*Bubo scandiacus*) recovering rodents from underneath deep snow. The violent raptor lifestyle continues to fascinate photographers, who justify the use of bait as a necessary evil to obtain an otherwise difficult image.

This skull of a Great Horned Owl shows the huge cylindrical orbits that enclose its eyes.

A Bald Eagle (*Haliaeetus leucocephalus*) shows off both its talons and bill. Lopez Island, WA.

Short-eared Owl

Species
Asio flammeus

Length
13.4–16.5 in. (34–42 cm)

Wingspan
37.4–43.3 in. (95–110 cm)

Weight
Male: 7.3–14.0 oz. (206–396 g)
Female 9.0–16.8 oz. (260–475 g)

Conservation Status
Least concern

Population
Approximately 3 million birds; decreasing

Throughout recorded history, owls have been alternately regarded as either sages or harbingers of doom. The wisdom we ascribe to owls is likely derived from their solemn, judicial disposition and their ability to penetrate darkness better than a solider with night-vision goggles. That Athena, the Greek goddess of wisdom, was always accompanied by an owl has also enhanced their reputation for erudition. Prophesy, however, may be the dark side of wisdom: Shakespeare wrote that an owl predicted the death of Julius Caesar.[2]

For me, the Short-eared Owl has been a signpost species directing my passions toward bird photography. I still remember almost every detail of the January day on Fir Island, Washington, when I made my first serious foray into the field with a long lens: Short-eared Owls and Northern Harriers (*Circus hudsonius*) fought continuous aerial battles for territory, occasionally disengaging to snatch up a small mammal. I was hooked, despite the tempered warning of my guide that "It is almost never as good as this."

The Short-eared Owl is a magnificent bird to photograph. It is obligingly crepuscular — that is, it hunts in the twilight — offering good chances for flight shots like few other owls. The bird's hunting pattern is a fascinating combination of intensive surveillance and random search. It patrols a territory just above the tallest vegetation, wheeling and turning, almost butterflylike on large flapping wings. It identifies prey by both vision and hearing. Studies have shown that Short-eared Owls are not particularly efficient hunters: Only about one in nine pounces or touchdowns end with a successful capture. The penetrating gaze of the owl in this image seems like a rebuke of my intrusion into its private domain.

Samish Flats, Skagit County, Washington (January)
Canon EOS-1D X | EF 500 mm f/4L IS USM +1.4x | 1/1250 sec at f/5.6 | ISO 800

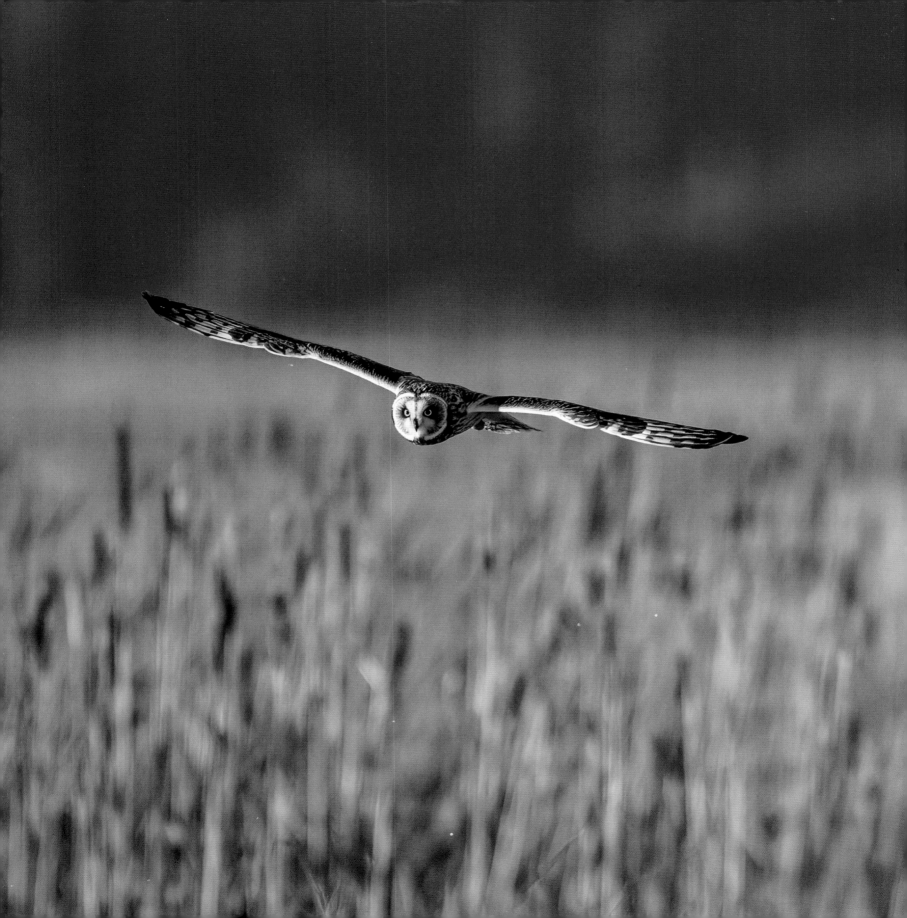

Snowy Owl

Species
Bubo scandiacus

Length
Male: 20.9–25.2 in. (53–64 cm)
Female: 23.2–26.0 in. (59–66 cm)

Wingspan
4.1–5.5 ft. (125–166 cm)

Weight
Male: 1.6–5.5 lb. (710–2,500 g)
Female: 1.7–6.5 lb. (780–2,950 g)

Conservation Status
Vulnerable

Population
28,000 birds; decreasing

Boundary Bay, British Columbia (December)
Canon EOS-1D Mark IV | EF 500 mm f/4L IS USM | 1/5000 sec at f/6.3 | ISO 800

My passion is flight photography, but I also take bird portraits. When approaching perched birds, I usually employ the incremental "shoot and move, shoot and move" technique. The alternative, moving into the optimal position before taking the first image, risks leaving the photographer with no portrait shot at all if the bird decides to fly. At the start of the December day when this image was taken, I learned the now rather blatantly obvious lesson that moving forward while looking only through the viewfinder has its risks. On this occasion, the marshland that I assumed to be level was actually crisscrossed with narrow drainage ditches. In between approach shots with the camera pressed hard to my eye, I suddenly found myself lying horizontally in a ditch of icy water, desperately trying to keep my camera and lens dry.

The Internet birding sites had been buzzing for several days with news of a Snowy Owl "irruption" along the marshy shore of Boundary Bay, just north of the point where the U.S.-Canadian border enters the Salish Sea. Irruption is a term that biologists use for a sudden, unexpected increase in the numbers of a given species, usually brought about by altered environmental conditions. In this case, the driver was a lack of this bird's preferred prey of lemmings and other voles in more northernly latitudes. This beautifully barred female bird was winging her way silently across the marsh as only owls can do. At least four distinct design features of owl morphology attenuate flight noise, so that their prey are unaware of an attack. The most interesting of these are the spiny leading (front) edges and fluffy trailing (back) edges of the owl's wing feathers. These appear to be specialized noise-reducers for when the bird dives toward its prey.

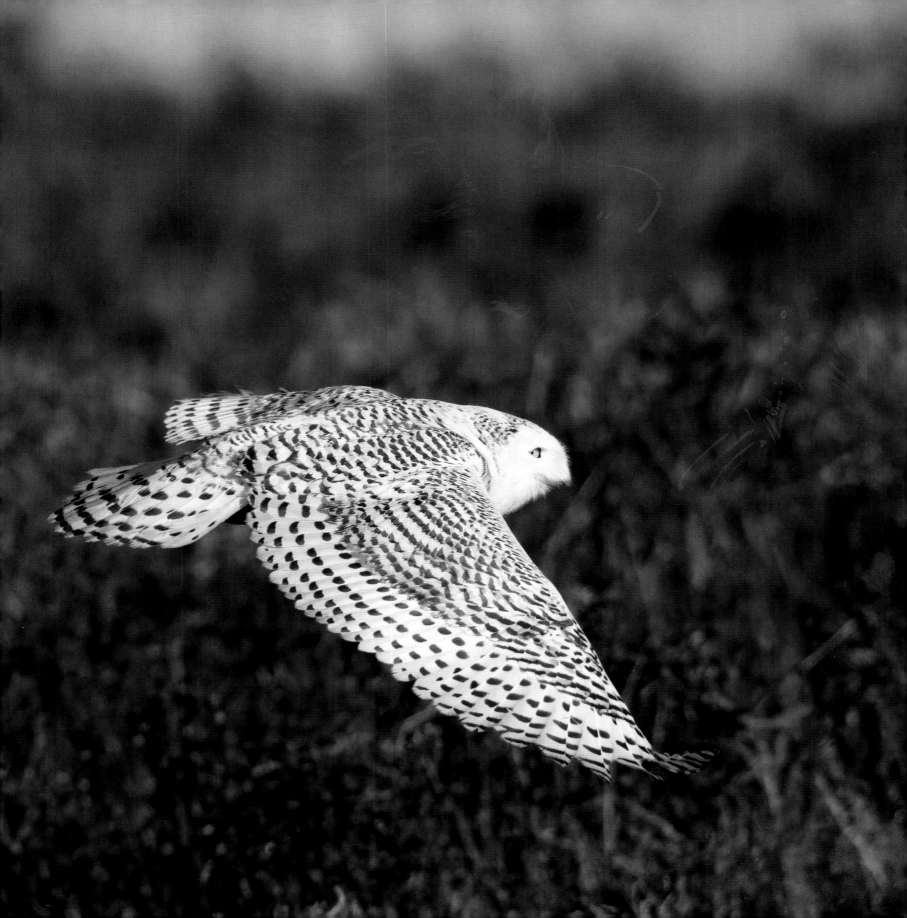

Red-tailed Hawk

Species
Buteo jamaicensis

Length
17.1–22.8 in. (45–58 cm)

Wingspan
3.5–4.6 ft. (107–141 cm)

Weight
Male: 1.5–2.9 lb. (690–1,300 g)
Female: 2.0–3.2 lb. (900–1,460 g)

Conservation Status
Least concern

Population
Approximately 2,200,000 birds; increasing

A raptor's trademark tools of death and destruction are on full view in this image of a Red-tailed Hawk, the most widespread member of the Buteo genus in North America. The bird's talons shine like stainless-steel suture hooks, and its ominous beak is ideally designed for tearing flesh, often against a restraining force applied by the talons, but these weapons are only engaged once the prey has been caught. What we cannot see is the complex system of sensorimotor coordination that makes this bird a successful hunter.

The simplest strategy — the tail chase, during which the pursuer simply follows the prey's tail — is not the most efficient method to capture prey that makes erratic zigzag turns in terrain full of obstacles. Aerial hunters such as Peregrine Falcons (*Falco peregrinus*) effectively use what is known as a proportional navigation guidance law, which is similar to how guided missiles function. They keep turning in direct proportion to the rate at which their line of sight to their prey is changing, and their super-fast flying speed eventually results in an intersection between predator and prey. A relative of the Red-tailed Hawk has been found to use a combination of both tail chase and proportional guidance, likely using visual and vestibular input to change the controls (the "gains") on both systems. This is a hugely complex guidance system, and one we take for granted when we observe what appears to be a simple, rapid and successful capture in the field.

This bird gave me an unusually long amount of time to prepare for the takeoff shot: I set up my tripod within 20 yards (18 m) of its fence post perch, put on an extender and checked my settings carefully. The hawk remained intensely focused on a disturbance in the grass for several minutes before launching off.

Nisqually National Wildlife Refuge, Washington (July)
Canon EOS-1D X | EF 500 mm f/4L IS USM +1.4x | 1/6400 at f/6.3 | ISO 1000

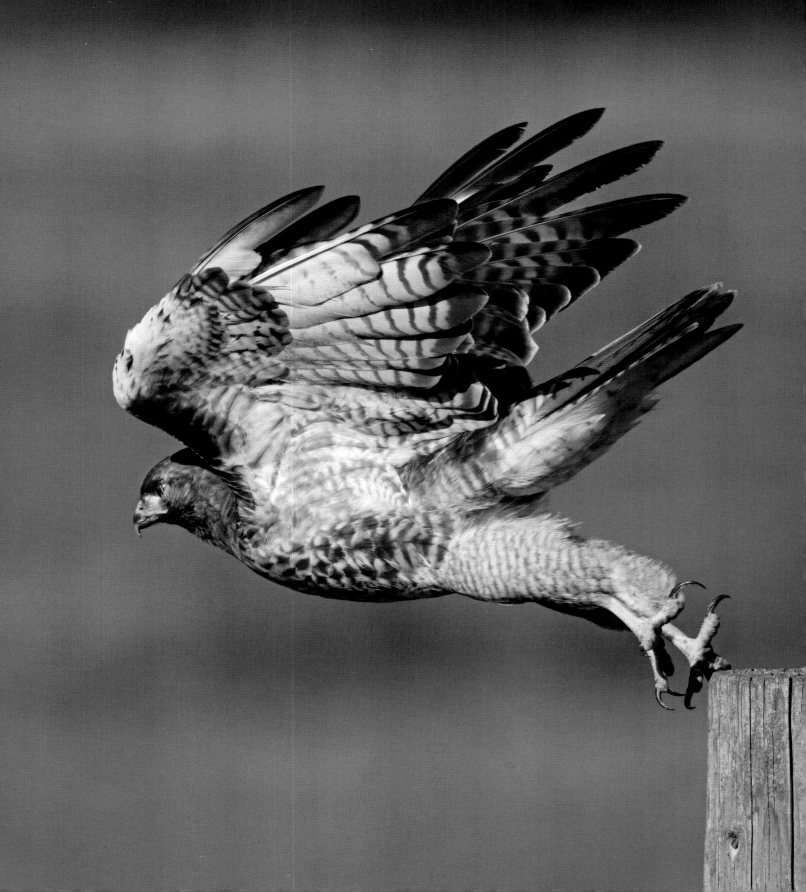

Osprey

Species
Pandion haliaetus

Length
21.3–25.2 in. (54–64 cm)

Wingspan
4.2–5.7 ft. (127–174 cm)

Weight
Male: 2.2–4.0 lb. (1.0–1.8 kg)
Female: 2.6–4.5 lb. (1.2–2.1 kg)

Conservation Status
Least concern

Population
Less than 500,000 birds; increasing

The piscivorous Osprey likes to keep a leg free when delivering a fileted fish from a perch to its nest as long as the catch is not too large. This behavior, displayed by the male bird in this image, has likely emerged because of the need to fight off kleptoparasites, mostly Bald Eagles (*Haliaeetus leucocephalus*), who much prefer stealing food than catching their own. Remarkably, research has shown that most Ospreys are "righties" when it comes to carrying live fish, although they usually use both feet when transporting the whole fish from the catch site to an intermediate perch site. Like surfers, they have a preferred back foot for this carry, and this is the right foot 64 to 78 percent of the time. An Osprey's feet are well adapted for the task of carrying fish securely: The talons are tightly curved, the outer toe can be rotated backward and the skin on the toes has small spicules (pointy structures) to stabilize the catch.

Ospreys are very accessible for photographers because they will nest on platforms placed by humans close to the water's edge. The opening image for this chapter was taken while focusing on such a platform at Blackwater National Wildlife Refuge in Cambridge, Maryland. I spent a fascinating day watching, shooting and learning about the feeding patterns of this three-chick family. First, the parent carried a newly caught fish to a high perch where it devoured the head. As soon as it took off for a one-footed food drop at the nest, like the bird in this image, the young birds became very agitated. The parent dropped the fish remnant right in the middle of the nest where, after a brief food fight, the largest, most aggressive chick claimed the prize.

Later on, the chicks, who had already fledged, tried fishing for themselves, and it was a dismal failure in every case. They crash-landed in the water, always coming up empty-footed! Clearly, these were early trial runs. Adult ospreys are successful on about 62 percent of their feet-first dives.

Ding Darling National Wildlife Refuge, Sanibel Island, Florida (January)
Canon EOS-1D Mark IV | EF 500 mm f/4L IS USM | 1/6400 at f/6.3 | ISO 500

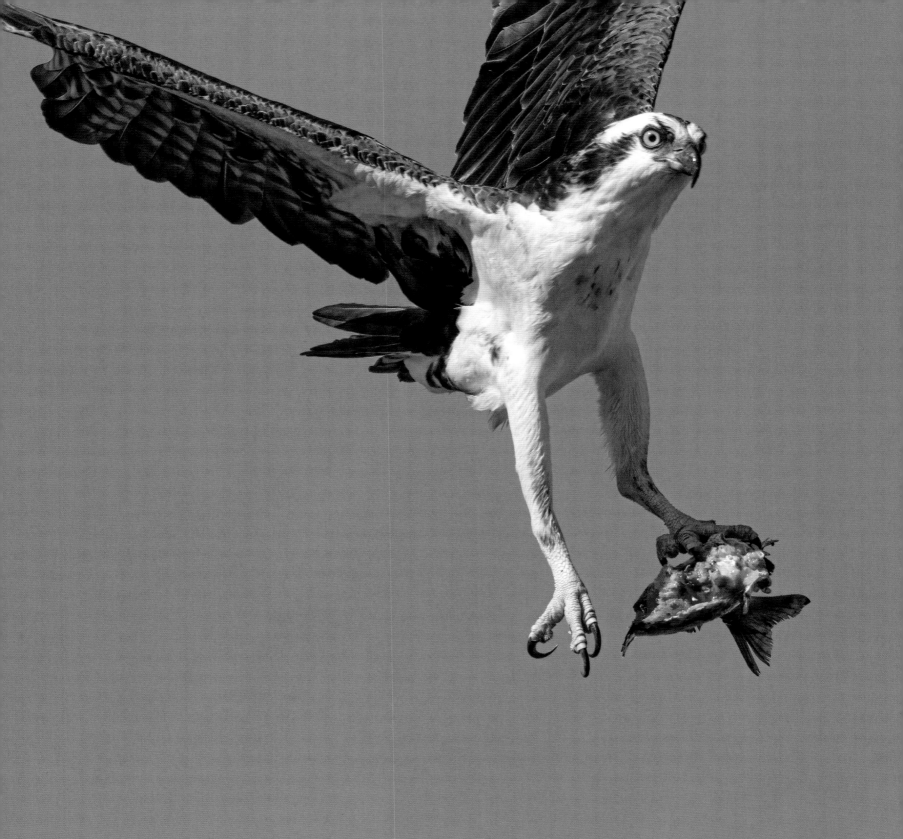

Snail Kite

Species
Rostrhamus sociabilis

Length
15.4–18.9 in. (39–48 cm)

Wingspan
3.2–3.8 ft. (99–115 cm)

Weight
Male: 10.7–15.2 oz. (304–430 g)
Female: 12.8–17 oz (362–480 g)

Conservation Status
Least concern

Population
Unknown; increasing

The needlelike bill tip of the Snail Kite is the perfect tool for quickly extracting its favorite food — amphibious apple snails (Ampullariidae family) — from an otherwise impenetrable shell. Shell-dwelling gastropods move in and out of their mobile fortresses using their spiral columellar muscles. The bird severs these muscles with scything, penetrating sweeps of its sharp pincer, working with the deftness of a cordon bleu chef, and then dinner awaits. As this image of a female Snail Kite shows, these birds will chase other prey when snails are scarce, and land crabs are a particular favorite. The curve of the bird's bill is reminiscent of the picks that we use to extract meat from crab and lobster claws.

If the bill of the Snail Kite is a case study in evolutionary adaption, the struggle that this bird has to find snails across its broad distribution from Florida to Tierra del Fuego exemplifies human's disruption of an otherwise well-tuned ecosystem. In Brazil, where this image was taken, introduced tilapia devour vegetation on which snails thrive. In the Everglades of Florida, the Snail Kite populations are in a cycle of boom and bust. The U.S. Department of the Interior study gave failing grades to ecosystem attributes that are critical to the Snail Kite, highlighting how wetlands critical for maintaining snail populations have been manipulated. In Surinam, pesticides were sprayed on rice fields to kill apple snails. This resulted in many deaths of Snail Kites, as well as other birds and fish. The same story is replicated in other locations and for other species: Human priorities threaten ecosystems.

This was an unplanned, opportunistic shot taken along the Transpantaneira in Brazil. My dominant memory of this trip is the sheer volume of birds accessible for photography. I would frequently be working one bird when my guide would redirect my attention to another spectacular species nearby. For the photographer, there is no other place quite like the Pantanal.

Pantanal, Brazil (July)
Canon EOS-1D Mark IV | EF 500 mm f/4L IS USM | 1/8000 sec at f/4 | ISO 1250

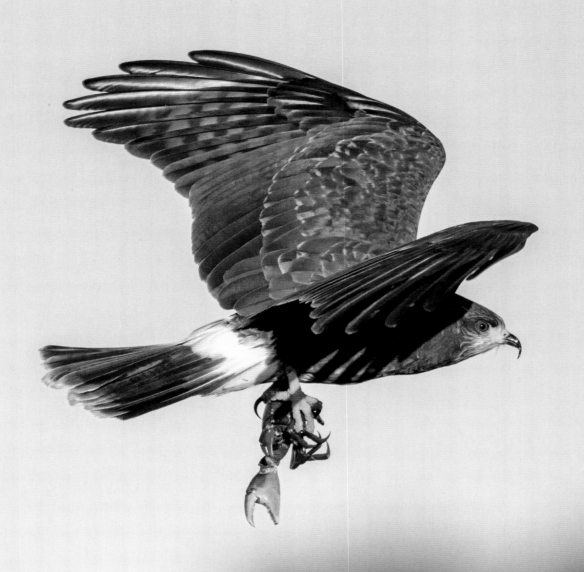

Black Kite

Species
Milvus migrans

Length
17.3–26.0 in. (44–66 cm)

Wingspan
3.9–5.0 ft. (120–153 cm)

Weight
Male: 1.4–2.0 lb. (630–928 g)
Female: 1.7–2.4 lb. (75–1,080 g)

Conservation Status
Least concern

Population
1 million–2.5 million;
trend unknown

When Leonardo da Vinci dreamed of flying, the Black Kite was his inspiration. We know this from the many deft marginal sketches and references to "the kite" in what has become known as the *Codex on the Flight of Birds*. This slender volume attests to the vast breadth of da Vinci's sprawling intellect: It starts with a discourse on the chemistry of casting metals and then races through a consideration of the "noble" science of machines, all of which are overlaid with an exquisite drawing of a human leg. By page five, he directly considers how the kite's flight could inform his goal of human flight. Da Vinci believed that the bird's wings "compressed the air," and he imagined artificial wings to do the same.

Da Vinci's avian muse was the European cousin (*Milvus migrans migrans*) of this bird, which I photographed in southern Japan. In contrast to the hyper-specialized Snail Kite (see previous spread), Black Kites are very versatile eaters, and they have learned to take full advantage of whatever humans have to offer. At the port of Akune, women clean and pack the catch by hand next to the fishing boats as they have done for centuries. Black Kites fill the air, pirouetting to gain advantage over their competitors. I love the dynamic torsion in this image, with the tail at 90 degrees to the wings. The narrow terminal primary feathers are spread like trailing streamers, and the neck is inquisitively craning to the left.

Da Vinci's visions of flight were never realized. At the end of the *Codex*, he fantasized about the distinction that the first flying machine would bring him, "filling the Universe with awe, filling all writings with its fame, and eternal glory to the nest where it was born." Such adulation would have to wait another 400 years.

Akune, Kagoshima Prefecture, Japan (January)
Canon EOS-1D Mark IV | EF 500 mm f/4L IS USM | 1/2000 sec at f/7.1 | ISO 640

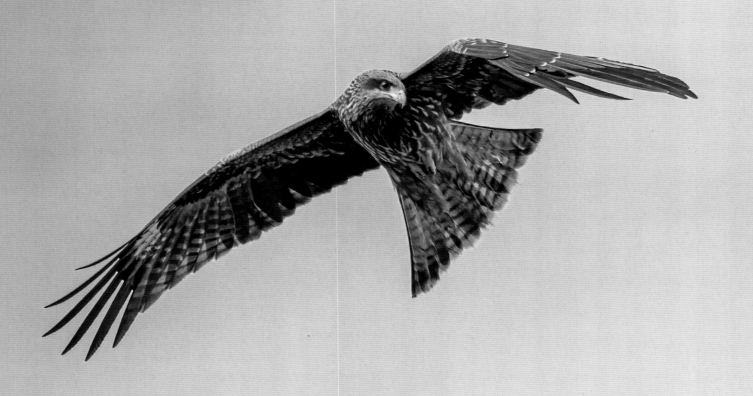

Galápagos Hawk

Species
Buteo galapagoensis

Length
17.7–22.0 in. (45–56 cm)

Wingspan
3.8–4.6 ft. (116–140cm)

Weight
Male: 1.9–2.5 lb. (0.8–1.1 kg)
Female: 2.7–3.5 lb. (1.2–1.6 kg)

Conservation Status
Vulnerable

Population
270–330 birds; stable

Española Island is a pinprick on the map at the southeastern corner of the Galápagos archipelago, but its 22 square miles (58 km²) have an outsized attraction for bird lovers as the breeding site for the world's entire population of the critically endangered Waved Albatrosses (*Phoebastria irrorata*). The island emerged from the sea less than five million years ago, young in geologic time but geriatric for the archipelago as it exists today. Española was likely a staging point for some of the flora and fauna that arrived on the Humboldt current and seeded the many unique species in this evolutionary cauldron.

Scientists working in the field of molecular phylogenetics have been able to pinpoint the precise time at which the evolutionary clock started ticking for the Galápagos Hawk. Less than 300,000 years ago, a small group of Swainson's Hawks (*Buteo swainsoni*) arrived, probably blown off course by adverse weather during their migration between North and South America. From that "single colonizing event," this new species, adapted to the ecology of the Galápagos, has evolved. The bird, in this photograph with its prominent alula winglet deployed, is a descendent of these windblown arrivals.

My travel companions and I were nestled on top of a cliff used by Waved Albatrosses to unfurl their 8-foot (2.4 m) wingspans and rise into the air on the updraft. Our attention was suddenly diverted to a new arrival behind our backs. As the apex avian predator of these islands, the Galápagos Hawk can take anything it wishes, and my stowed monopod obviously looked enough like one of the endemic snakes that form part of its diet. After the immature bird deemed my camera gear inedible, it stayed with our group for more than 30 minutes, seemingly intrigued by the alien contact. This was a typical Galápagos encounter with animals that have no fear of human predation.

Española Island, Galápagos Islands, Ecuador (October)
Canon EOS-1D X | EF 100–400 mm f/4.5–5.6L IS II USM at 234 mm | 1/4000 at f/5 | ISO 2500

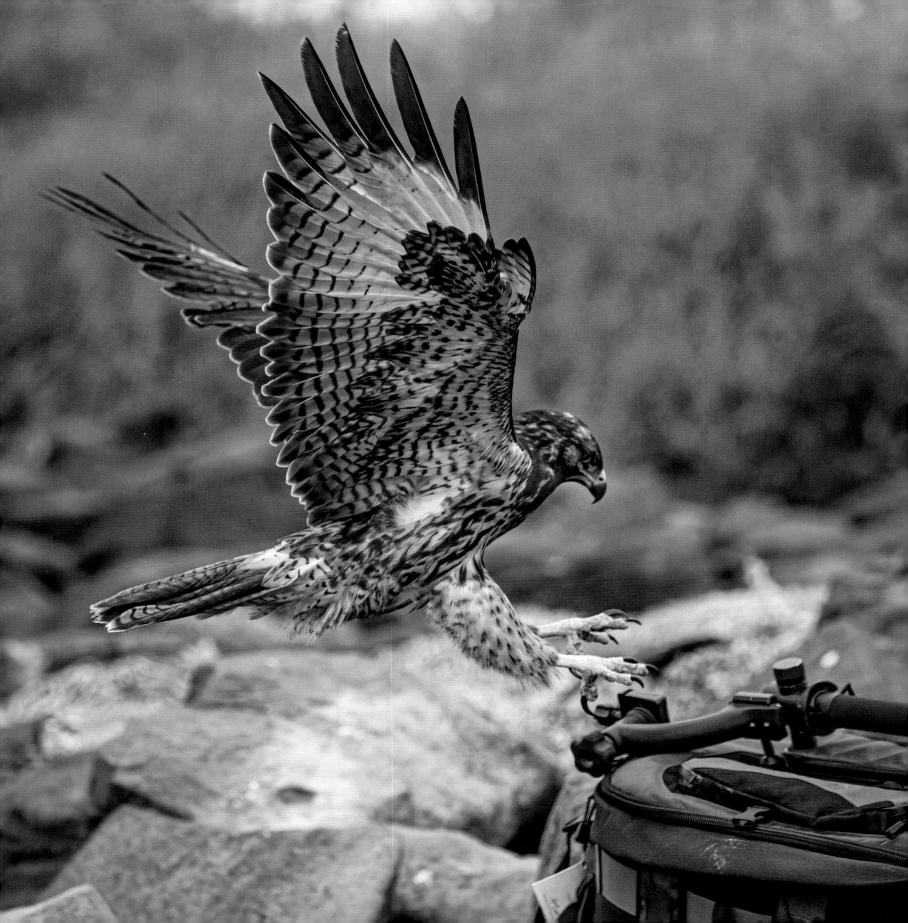

Blakiston's Fish-Owl

Species
Ketupa blakistoni

Length
23.6–28 in. (60–71 cm)

Wingspan
5.7–6.2 ft. (175–190 cm)

Weight
Male: 6.9–7.6 lb. (3.1–3.5 kg)
Female: 7.4–10.1 lb. (3.3–4.6 kg)

Conservation Status
Endangered

Population
1,000–2,499 birds; decreasing

Seafood donburi (a Japanese rice dish) and the endangered Blakiston's Fish-Owl might seem like strange bedfellows, but I encountered this unlikely pairing in a tiny shack that clings tenuously to the hills above Rausu, a hardscrabble Hokkaido port on a finger of land that points northeastward into the Sea of Okhotsk. The Blakiston's cognoscenti arrive at this innocuous eatery hungry and take their place at one of the scattering of tables in the small, dimly lit, shuttered room. For the next hour, the procession of bowls and plates comes and goes without fanfare. Then comes the transformation: Diners become photographers reaching into their gear bags, cleaning their lenses and setting their exposures. After turning on the outside light, the owner props up the wooden window shutters, pushes back the door against a forceful wind and makes her way across a steep snowbank like a mountaineer on the summit ridge. She tosses a few fish into the pool carved out by a stream that is still flowing despite the intense cold and retreats back into the shack. Within minutes, a ghostly fluttering heralds the arrival of the object of our attention: Perching first on a branch and then gliding to the edge of the pool, one of the largest and rarest owls in the world makes its cameo appearance and dutifully devours the sacrificial offering.

This bird was named after the much-traveled Englishman Thomas Wright Blakiston (1832–1891), who was one of those paradoxical Victorian explorers/entrepreneurs who saw no conflict between cataloging the wildlife of his adopted country (Japan) and then founding a logging company to lay waste to the habitat of the bird that now bears his name. My meeting with his fish-owl was certainly not wildlife photography in the usual sense. The bird was wild, but the restaurant owner makes her living off people like me who know that the odds of seeing one of the less than 2,500 living members of this species elsewhere are extremely low.[3]

Rausu, Hokkaido, Japan (January)
Canon EOS-1D X | EF 500 mm f/4L IS USM | 1/60 sec at f/4 | ISO 3200

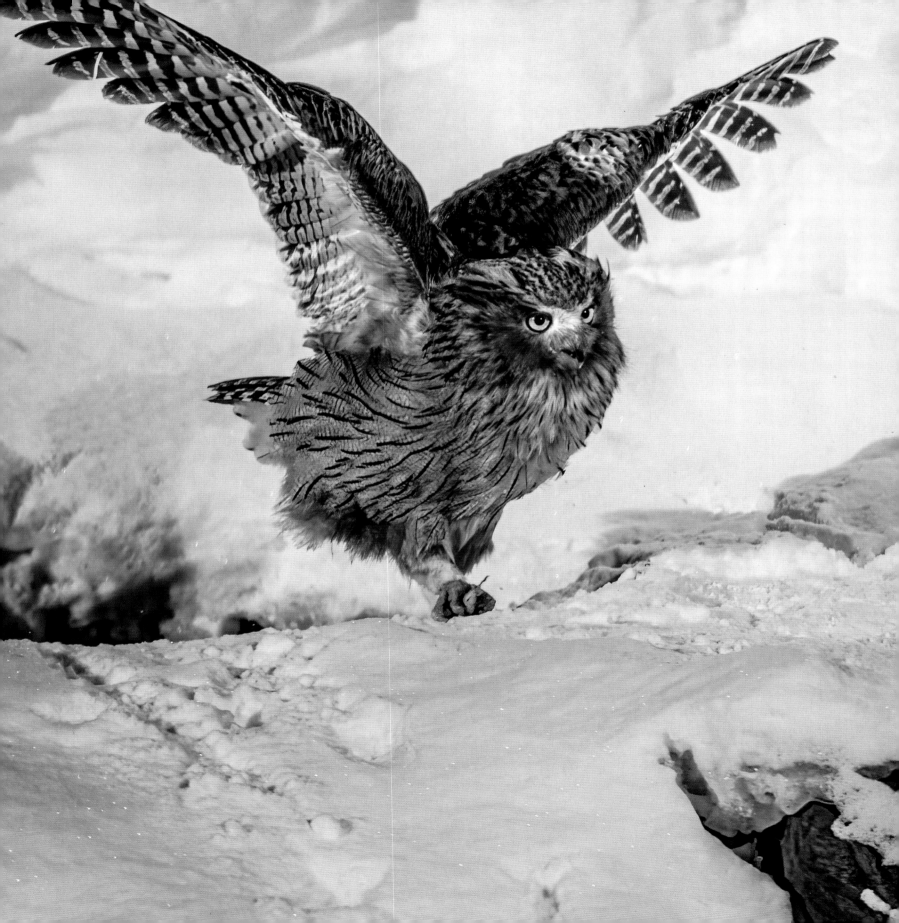

Striated Caracara

Species
Phalcoboenus australis

Length
20.9–25.6 in. (53–65 cm)

Wingspan
3.8–4.1 ft. (116–125 cm)

Weight
2.6 lb. (1.2 kg)

Conservation Status
Near threatened

Population
1,000–2,499 birds; stable

Carcass Island, Falkland Islands (January)

Canon EOS-1D X | EF 100–400 mm f/4.5–5.6 IS II USM at 360 mm | 1/3200 sec at f/10 | ISO 1000

Life in a penguin colony is a constant struggle between predator and prey. Adult penguins fiercely guard their eggs and chicks against the skuas and Southern Giant-Petrels (*Macronectes giganteus*) that patrol overhead. Striated Caracaras prefer the margins of the colony, where they can target dead or nearly dead animals. This bird had located a dead, partially eaten Gentoo Penguin (*Pygoscelis papua*) chick along the broad sandy beach at Dyke Bay on the appropriately named Carcass Island, but the prize was too heavy to lift, and the bird's main goal was to drag it to a protected location where others would not see it and expect their share. I was able to kneel in the sand and take a series of close handheld shots without affecting the outcome of the event. On open ground, these handsome birds prefer to run. At one point in this shoot, a pair raced some distance in front of me across the windblown sand like turbocharged chickens.

When carrion is scarce, the Striated Caracara pecks out the eyes of lambs to wound, disable and eventually devour them. In the Falkland Islands, where sheep outnumber people by 320 to 1, an assault against sheep is a near-capital offence. Historically, this led to open hunting of Striated Caracaras, and their numbers were drastically reduced. The bird is now protected, but the rebound is slow. The concentration of any species in a handful of adjacent islands is always concerning, since disease, introduced predators and weather events can devastate the entire remaining gene pool. A few Striated Caracaras do venture to islands off the coast of Patagonia. These individuals could possibly rescue the species in the event of a catastrophic event in the Falklands.

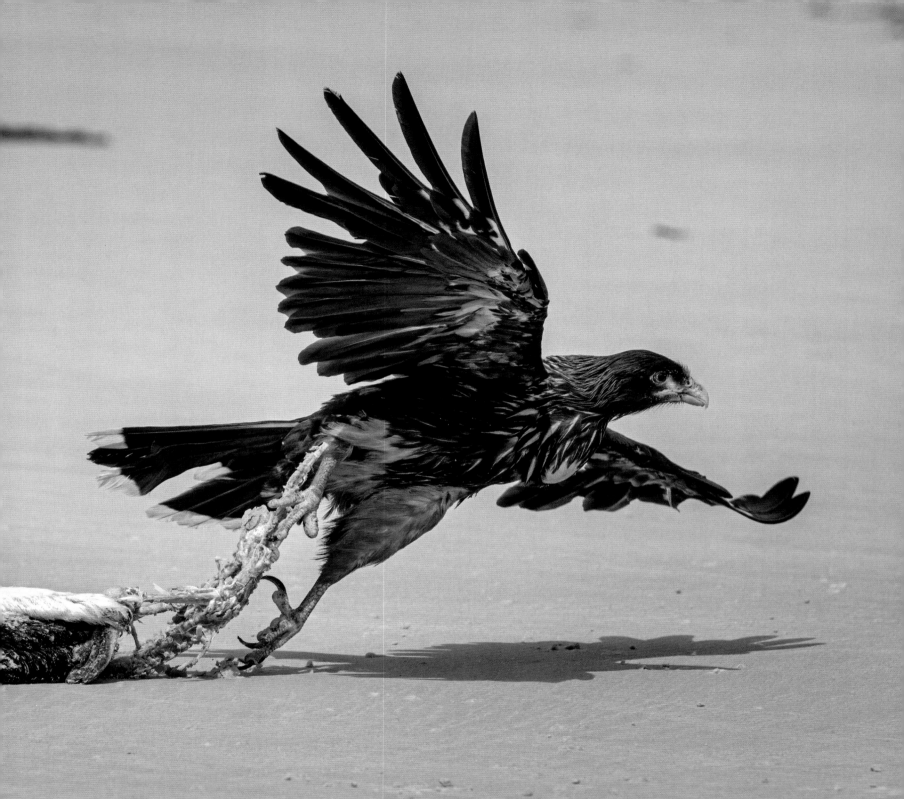

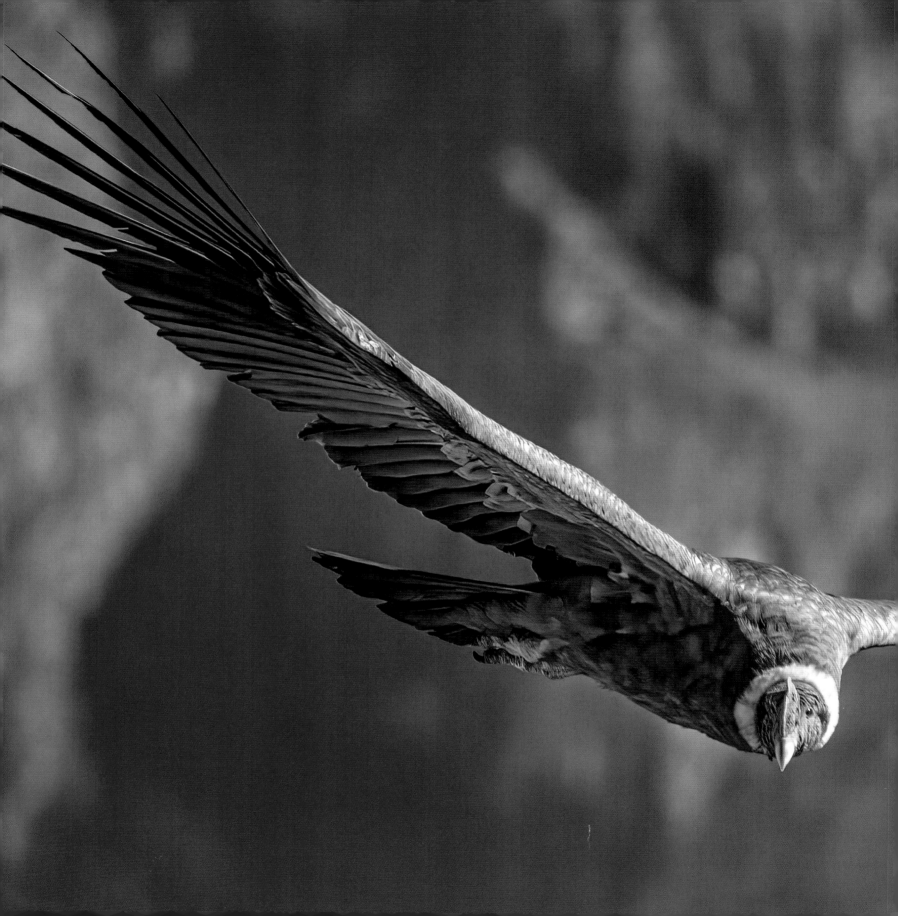

8
Condors & Corvids

Previous Spread

Species
Andean Condor (*Vultur gryphus*) (sub-adult male)

Location
Colca Canyon, Peru (June)

Settings
Canon EOS-1D X | EF 100–400 mm IS II USM | 1/1000 sec at f/5.6 | ISO 1000

Most people know that crows are very smart. Despite that, the word "birdbrain," which the Merriam-Webster dictionary defines as a "stupid person," is still an often-used pejorative term. This age-old insult may well be in need of substantial revision. It is, of course, a fact that birds' brains are small in absolute terms, not much larger than a walnut in a large bird, but there is evidence from a number of species that the neurons in a bird's brain are more tightly packed than those in a similarly sized mammalian brain. This suggests that birds have a powerful computer in a small package, and that birdbrain may be more of a compliment than an insult.

The complex behaviors that flow from a bird's concentrated brain power have been illuminated primarily by research on corvids and crows in particular. One bird with star power has emerged, the New Caledonian Crow (*Corvus moneduloides*), which is a glossy, medium-sized crow that lives on islands in the southern Pacific Ocean between Fiji and Australia's Gold Coast. The observation in the early 20th century that this bird used tools to forage was not, in itself, a major finding. More than 30 species of birds are known to use found objects to help extract food, such as the Woodpecker Finch (*Camarhynchus pallidus*) in the Galápagos, which often uses a cactus needle to dislodge insects, sometimes breaking it to the desired length. But almost 100 years later, it was reported that the New Caledonian Crow appears to go to great lengths, expertly fashioning its complex stepped and serrated-edge hook tool from the leaves of the palmlike pandanus tree. The bird sometimes stows the finished tool in a safe place for future use. Before this research, anthropologists would often trumpet tool manufacture and stowage as a hallmark of hominid evolution and behavior. Crows have made such statements seem premature, even pretentious.

After the discovery of tool manufacture, there were a lot more crow surprises to come. We now know that American Crows (*Corvus brachyrhynchos*) have persistent memories allowing them to remember, recognize and harass human "enemies" for up to three years. A toe has also been dipped in the water of that most controversial facet of animal behavior: It has been suggested that New Caledonian Crows can feel emotions, such as "optimism" after solving problems, and American Crows have been observed performing a death ritual for expired members of their own species. Whether these findings are refuted or extended in the future, it is already clear that crows have radically changed the dynamics and direction of the debate about avian intelligence.

We know little about condor intelligence, but the mere appearance of these mighty birds has inspired reverence over the centuries. The awe-inspiring sight of an adult Andean Condor (*Vultur gryphus*) soaring on 10-foot (3-meter) wings seems like a time capsule from prehistory, when huge birds crossed the skies. The stunning soaring skills of the Andean Condor are highlighted by a study that showed flapping occupies only 1 percent of their flight time. One bird in the study traveled more than 100 miles (160 km) without a single wing flap.

The now near-threatened Andean Condor is still revered, appearing, for example, on the coats of arms of five Andean nations and designated as the national bird of Bolivia, Chile, Colombia and Ecuador. The official description of the Bolivian coat of arms identifies the condor's presence as being symbolic of a willingness to defend the nation and its liberty. This is somewhat incongruous, since condors are actually scavengers that eat carrion and rarely attack anything! To the Inca Peoples of Peru, the Andean Condor was a sacred animal that carried the spirits of the dead aloft. Today in Peru, some of that reverence has evaporated; a

A schematic of the type of tool cut by New Caledonian Crows to extract insects. The bird preserves the hooked side of the pandanus leaf and fashions the flatter side to have a pointed tip and two oblique cuts that maintain its rigidity, while allowing it to be thin enough to be inserted into small openings. (Redrawn from Hunt 1996.)

The coat of arms of Ecuador: the Andean Condor is said to "symbolize the power, greatness and strength of Ecuador."

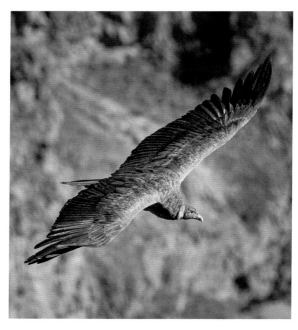

Immature Female Andean Condor (*Vultur gryphus*) Colca Canyon, Peru

condor is tethered to the back of a bull during the gruesome Yawar fiesta as a symbol of the victory of the Indigenous peoples over the Spanish.

The two groups of birds in this chapter, corvids and condors, are far apart in the avian tree of life, having diverged more than 60 million years ago. Their pairing here is a matter of convenience and alliterative association. The Corvid family consists mostly of crows, jays and ravens. With some notable exceptions, these birds are, like condors, primarily black, which brings its own challenges for the photographer. Typical single-lens reflex (SLR) and mirrorless cameras incorporate exposure meters that measure the brightness of every pixel in the chosen metering area and then calculate the average brightness to set the exposure. More specifically, pixels are measured on a scale from bright white to jet black with the middle point set at a level known as "middle gray," which will appear as 50 percent gray on your displayed image. If the choice of exposure is left to the default settings, the imaging of feather detail in a black bird will likely disappear, and the bird will look like an undifferentiated black mass.

Most photographers override the default exposure settings in one of two ways. The first is by changing the area that is metered. By default, the entire sensor is evaluated for exposure calculations: This is called Evaluative, Matrix and Multiple metering on Canon, Nikon and Panasonic cameras, respectively. In reality, other factors are also taken into account, such as where the user has set the focus point and the results of an algorithmic assessment of brightness in different zones. The result is basically an overall average that will be fine when there are not extreme differences in brightness in different regions of the image, such as a black bird against a bright sky. This is where spot-metering or center-metering becomes useful. The photographer can set the camera's exposure meter to assess only a subset of all the pixels in the image, such

as the center of the image, or a spot of adjustable size where the focus point is targeted. It is definitely worth learning about these metering modes in your specific camera.

Spot-metering, however, has its limitations for flight photography. It is very hard to keep the spot on a moving bird, and metering can easily shift to a bright area of the sky, defeating the purpose of the restricted metering area. That is why I almost always combine exposure compensation with evaluative metering when taking flight shots of black birds. This brightens the image a defined amount above the meter reading. For example, if I am shooting in aperture priority mode at, say, f/5.6 and 1/2000 of a second, the addition of +1 stop of exposure compensation will set the final exposure as f/5.6 at 1/1000 of a second. I occasionally need to add up to three stops of compensation, and I invariably take test shots before deciding on a final setting for the compensation. (This process is easier in mirrorless cameras because the image and its histogram are available before shooting).

While waiting for a bird to fly, I am often struck by what, at first, seems like an asymmetrical intellectual power balance: The large human brain calculates the factors needed for a perfect shot, and the small bird brain computes the probability of a successful food foray from the many environmental signals it receives. The asymmetry will often actually favor the bird brain as the bird flies to successfully capture its prey, and the human is left shaking their head, having captured a less-than-optimal image.

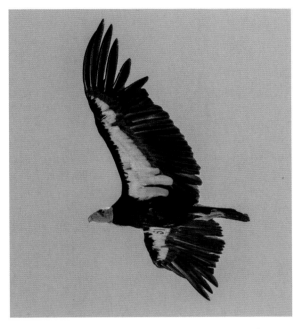

California Condor (*Gymnogyps californianus*) Big Sur, CA

California Condor

Species
Gymnogyps californianus

Length
3.6–4.4 ft. (109–134 cm)

Wingspan
8.2–9.8 ft. (249–300 cm)

Weight
17.6–30.9 lb. (8.0–14.0 kg)

Conservation Status
Critically endangered

Population
Approximately 250 birds in the wild; increasing

Big Sur, California (June)
Canon EOS-1D Mark IV | EF 500 mm f/4L IS USM | 1/2000 at f/7.1 | ISO 800

The California Condor has been wrenched back, feather by feather, from the edge of the black hole of extinction. In 1982, only 22 California Condors remained. A controversial capture program was initiated: Chicks were bred in captivity and, a decade later, released into the wilds of California and Utah. By the summer of 2019, conservationists in Zion National Park were celebrating the birth of the 1,000th chick and a total wild population of 250 surviving birds. There is still, however, lingering doubt over the long-term viability of this magnificent species. Mortality of birds in the wild is high, primarily because of the lead they ingest from bullets lodged in the carrion that is their primary source of food. California now has legislation that forbids the use of lead bullets, but they are still for sale in gun shops, and enforcement of the law is limited.

Before I left San Francisco, rumors of whales being stranded along the coastline south of Monterey, California, were bubbling up on the Internet. About three hours later, just south of Big Sur State Park on the beguiling Highway 1, I spotted a large whale carcass washed up on a distant, inaccessible beach. More than a dozen California Condors were ripping into the exposed guts of the animal after slicing open its leathery skin with their knifelike bills. Periodically, some of the birds returned from the beach and flew close by, but I was in no shape for photography; feverish and chilled by the unexpected spring cold, I was aware that I was not on my game. Some of my camera settings were wrong, and I had trouble holding focus, even on the 10-foot (3-meter) wingspan of this largest of all avian targets. Back in front of my computer screen at the end of the day, the news was not good: coal-black dust spots, some as large as the bird's' bill, were scattered across the sky from a dirty sensor that I had failed to check and clean.[1] Only the magic of spot removal software rescued this image of one of the world's rarest birds in flight.

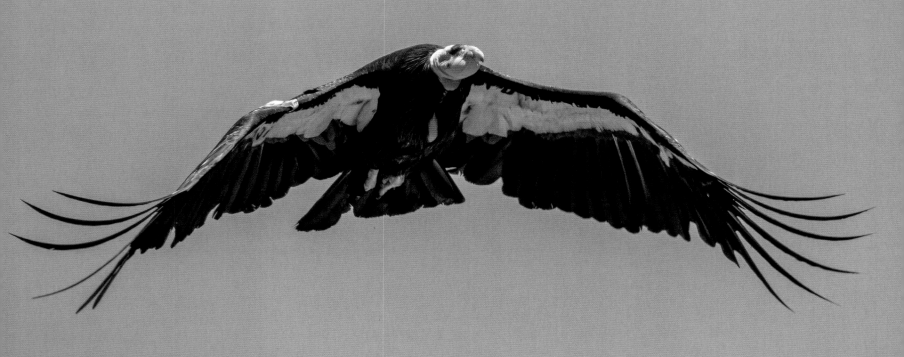

Andean Condor

Species
Vultur gryphus

Length
3.3–9.8 ft. (100–300 cm)

Wingspan
8.5–10.5 ft. (260–320 cm)

Weight
Male: 24.3–33.1 lb. (11.0–15.0 kg)
Female: 17.6–22 lb. (8.0–10.0 kg)

Conservation Status
Near threatened

Population
6,700 birds; decreasing

Mirador Cruz del Cóndor is a mere rocky outcrop crowned by a stone cross overlooking the unfathomably deep Colca Canyon in southern Peru, but it is a place of pilgrimage for the hundreds of thousands of tourists who come annually to catch a glimpse of a soaring Andean Condor and perhaps hear the wind rushing over its wings. As the sun warms the canyon walls, visitors jostle for space along the low stone walls on a broad terrace carved from the rock. Pairs of condors are sometimes visible, waiting impatiently in their nests for rising air to give them free passage to the flight lanes.

On this visit, after a tense hour of waiting, a roar finally erupted from the crowd as the first condor was spotted in the air. Its wingspan is implausibly large, and how it stays aloft without a single wing flap is an enduring mystery. Some visitors leave immediately — their condor box has been checked — but those of us who stay are rewarded with many close encounters with these bird gods. They arrive like a fleet of drones: brownish juveniles, crestless females and adult birds replete with crest and the downy white ruff of an Elizabethan courtier. I decide to move back up to the cross, where the density of birds is greater, but immediately regret the decision as my unacclimated lungs strain to extract oxygen from the thin air. Just in time, I capture this shot of the underside of a jet-black male bird against the distant mountains. Uncharacteristically, his elongated terminal primary feathers are tightly grouped as he maneuvers on an invisible thermal. As suddenly as they came, the birds are gone, soon to be followed by the fleet of buses. Child vendors with their baby Alpacas (*Vicugna pacos*) look forlornly at the departing traffic, but they know the birds will draw another throng of visitors tomorrow.

Mirador Cruz del Cóndor, Colca Canyon, Peru (June)
Canon EOS-1D X | EF100–400 mm f/4.5–5.6 IS II USM at 400 mm | 1/1000 sec at f/5.6 | ISO 1000

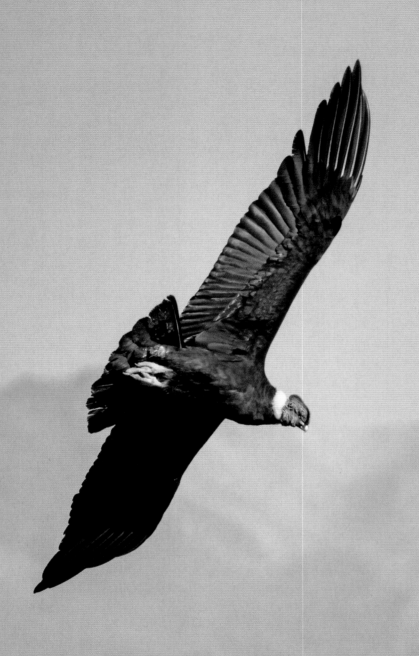

The Temple of the Condor

On the cold, rainy morning of July 23, 1911, Hiram Bingham III hiked up a steep mountainside path 50 miles (80 km) northwest of Cusco, the city in Peru that was the center of the Incan universe. Arteaga, a local innkeeper, had agreed to guide his visitor to "some very good ruins" only when Bingham offered the exorbitant reward of a Peruvian silver dollar. In his book, *Lost City of the Incas*, Bingham recounts how, after a climb that rendered him "completely exhausted" led by a young Quechua boy, he stood "spellbound ... in front of two of the finest ... structures in South America." He pulled out a Kodak 3A Special Camera[2] and took 31 carefully annotated photographs of the exquisite interlocking stonework of towers, temples and terraces covered in moss and choked by tropical vegetation. Machu Picchu, the Lost City of the Incas, had been found again.

What Bingham did not capture that day was a picture of the mystical Temple of the Condor. This is not surprising since, even now, a visitor to Machu Picchu can get lost in the maze of terraces and steps while looking for this sacred shrine. The head of the condor, externally haloed by a white ruff, lies on the floor in abstract two-dimensional relief. Channels around the bill suggest that blood from sacrificial animals flowed from the flat surface of the head into a collection well beneath the ruff. The wings are represented by sweeping, sculpted natural cliffs, augmented by added stonework. The precise use of the temple is much debated, since the Incas had no written language and invading conquistadors never found this site.

Machu Picchu, Peru (May)
Canon EOS-1D X | EF 8–15 mm f/4L fish-eye USM at 14 mm | 1/125 sec at f/20 | ISO 400

American Crow & Bald Eagle

Species
Corvus brachyrhynchos and *Haliaeetus leucocephalus*

Length
16.9–20.9 in. (43–53 cm)

Wingspan
2.8–3.3 ft. (85–100 cm)

Weight
8.8–20.3 oz. (250–575 g)

Conservation Status
Least concern

Population
31 million birds; increasing.

Crows really know how to punch above their weight. Bald Eagles outweigh crows by a factor of 10, but that does not stop crows from regularly mobbing eagles. A dramatic power imbalance exists between these two species when a battle is fought on the eagle's terms. For example, I have heard on good authority that a Bald Eagle was seen taking the head off a crow that was provoking it as the two stood side by side on a perch. The crow in this image, however, has the advantage of speed and maneuverability, while the eagle stays rooted on its perch, contemplating the energy cost of a graceful exit. The crow made at least 10 dive-bombing passes, but the eagle was not to be dislodged. Mobbing is a term usually reserved for a joint assault by several birds on a single larger bird. They do it to protect their territory and to dampen the spirits of a potential bully. Crows are particularly aggressive when they have chicks in the nest, since a moment of inattention can provide the eagle with a live hors d'oeuvre.

The unprocessed image of this shot exemplifies the problem that I mentioned in the introduction to this chapter: Shooting black birds against an otherwise bright scene can lead to an undifferentiated representation of the bird. In post-processing using Adobe Photoshop, I was able to bring out the black detail using adjustment layers without saturating the feathers of the eagle's head.[3] Other key elements in successfully capturing this image were shooting at a high shutter speed and using high-speed continuous drive. During this encounter, I took 479 shots at exposures between 1/5000 of a second and 1/6400 of a second in bursts of approximately 12 frames per second. From all of these shots, this was the only one where the animated conversation between these two birds was visible and the composition was acceptable. It is unlikely that I could have captured this image in single-shot mode.

Lopez Island, Washington (June)
Canon EOS-1D X | EF 500 mm f/4L IS USM +1.4x | 1/5000 sec at f/5.6 | ISO 1250

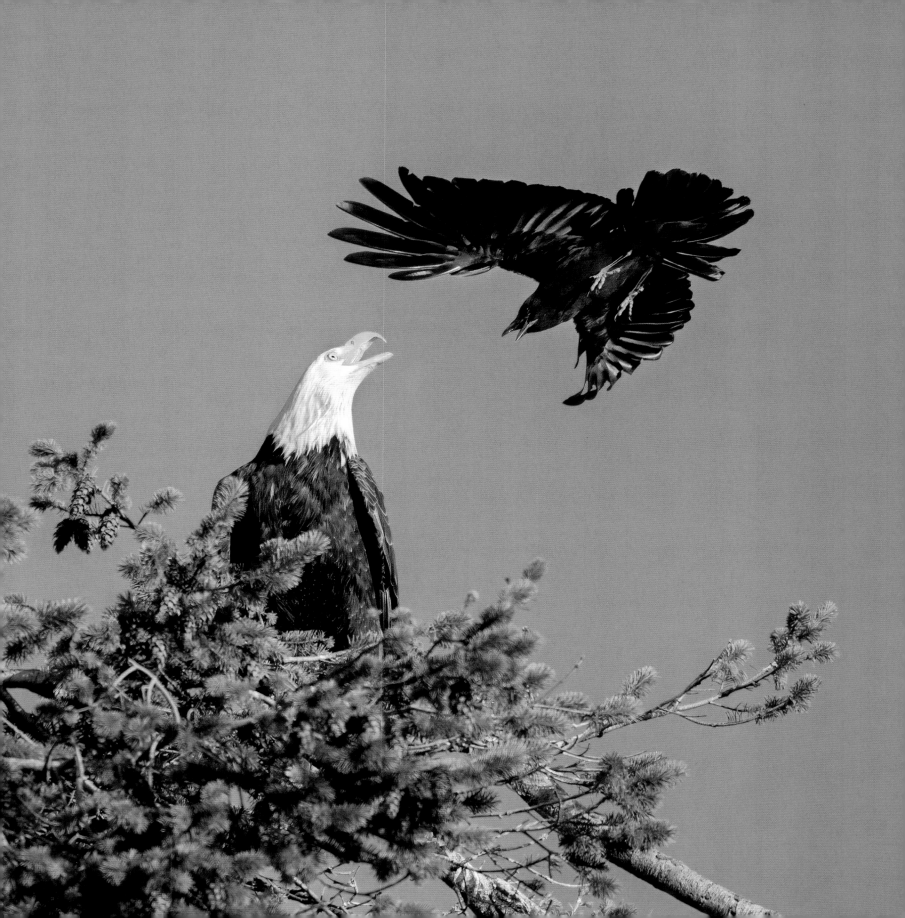

Andean Condor

Species
Vultur gryphus

Length
3.3–9.8 ft. (100–300 cm)

Wingspan
8.5–10.5 ft. (260–320 cm)

Weight
Male: 24.3–33.1 lb. (11.0–15.0 kg)
Female: 17.6–22 lb. (8.0–10.0 kg)

Conservation Status
Near threatened

Population
6,700 birds; decreasing

Estancia Olga Teresa, Patagonia, Chile (February)

Canon EOS-1D X | EF 500 mm f/4L IS USM | 1/8000 sec at f/4 | ISO 2000

Nature's clock is not always synchronized with a photographer's schedule. I landed in Punta Arenas for a four-day stay in Chilean Patagonia, close to an escarpment where Andean Condors were known to be "dependably" present. Everything seemed set for the perfect shoot: My hosts were gracious, my guide was energetic and knowledgeable, and the notoriously unpredictable Patagonian weather was cooperative. As the first day spooled toward sunset without a single image being taken, however, it became numbingly clear that one important component of this trifecta was absent: There were no condors in the neighborhood. Day 2 came and went without the anticipated avian visitors. Even a sheep carcass attracted only a pair of Crested Caracaras (*Caracara cheriway*). Local sages declared that this never happened, and that condors always roost on these cliffs. Late in the afternoon on day 3, their expectations were finally confirmed. The birds returned, first riding the rising air along the ridge and then breaking away to scan the grassy plain laid out like an abstract canvas framed by the cold blue waters fed from the Strait of Magellan.

From my perch on top of the cliff, I followed this slow-moving condor easily using a tripod-mounted gimbal, looking down on his dorsal feathers that were as broad and deep as a pair of cathedral organ keyboards. The terminal primaries were arrayed like the teeth of a giant's comb, the tail was fully spread and the featherless head protruded from the cleric's collar like a turtle from its shell. I have to admit that my opinion of the image is surely biased by my two-day bird-less interregnum, but I do love this photograph!

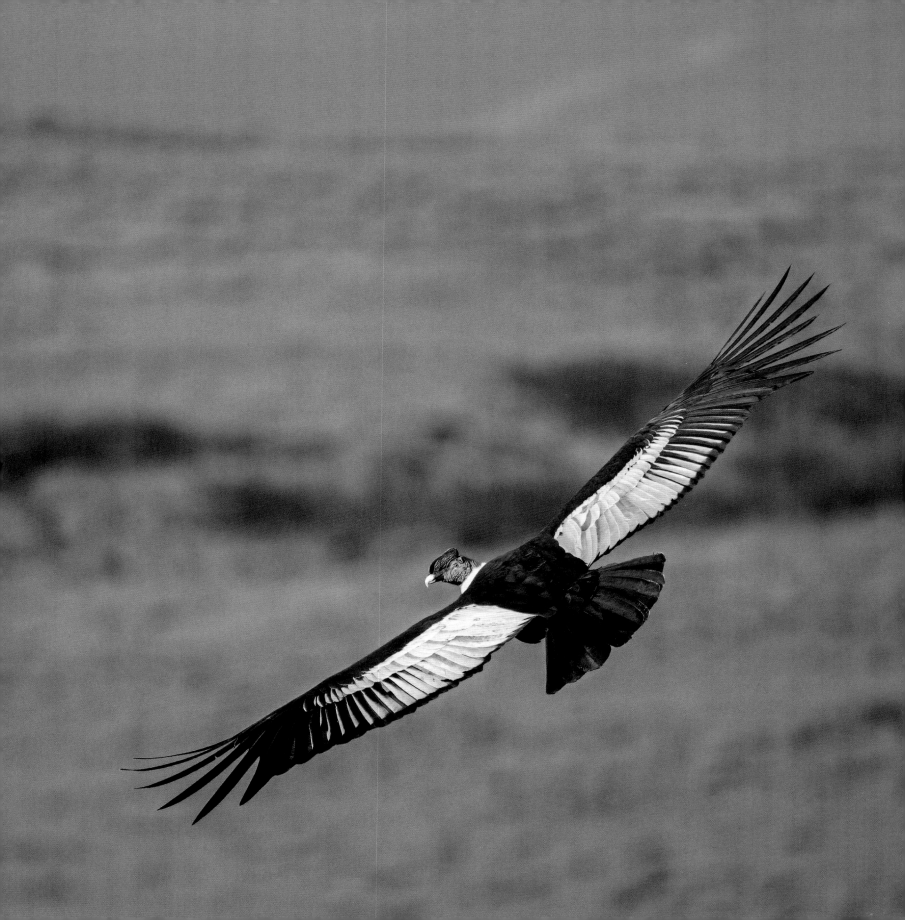

Common Raven

Species
Corvus corax

Length
22.8–27.2 in. (58–69 cm)

Wingspan
3.9–4.9 ft. (120–150 cm)

Weight
1.3–4.4 lb. (585–2,000 g)

Conservation Status
Least concern

Population
More than 16 million birds; increasing

"Reticulate process" and "species reversal" are not terms that easily roll off the bird photographer's tongue, but a study of the genome of the much-mythologized Common Raven has pushed these ideas to the forefront of the debate about how species form. The basic idea is that over 1.5 million years ago, ravens split into two species, the "California" and "Holarctic." At some point soon after the split, renegade birds from these two new branches of the evolutionary tree of life mated and produced hybrid birds, "Caliarctics" if you like. That is the reticulate process part: Instead of the tree of life branching, it turned inward and formed a new middle branch.[4] The "Caliarctics" branch then became so successful that the Holarctic branch all but disappeared, and the Caliarctics became what we know today as Common Ravens, negating the prior split into two species. That's where species reversal comes in. Humans often share the blame for species reversal, since we eliminate or corrupt specialized environmental niches, leaving a more uniform environment in which mixing can occur. In the case of the Common Raven, for once, humans do not appear to be complicit.

The bird in this image, carrying packets of DNA that led to the finding described above, was foraging on my most-frequented beach in the San Juan Islands of Washington State. While the largest of ravens is unlikely to be mistaken for a crow, the wide size range in ravens sometimes makes it difficult to distinguish crow from raven when a solitary bird is encountered. The raven's very large bill is a good field mark, as are the deep, croaky tones of its voice, although it has a large repertoire of different calls that can add to the confusion. I solved the "black bird" problem discussed in the introduction by adding exposure compensation when shooting this image.

Lopez Island, Washington (September)

Canon EOS-1D X | EF100–400 mm f/4.5–5.6 IS II USM at 400 mm | 1/1000 sec at f/6.3 | ISO 800

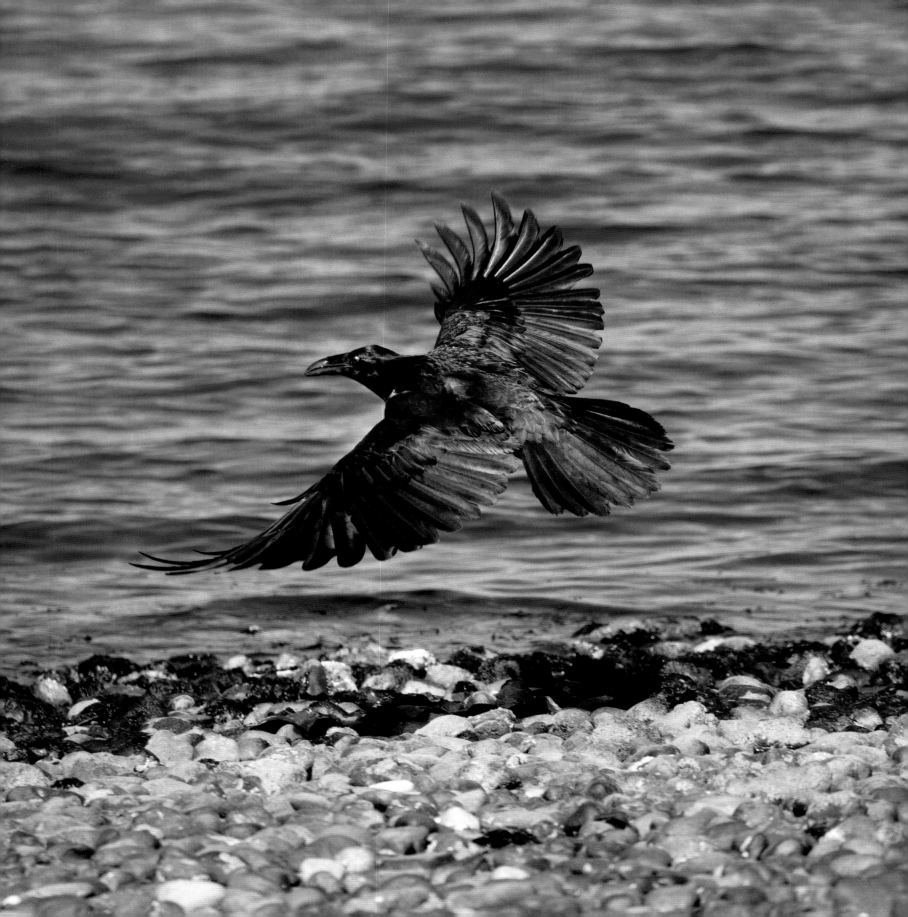

Red-billed Chough

Species
Pyrrhocorax pyrrhocorax

Length
15.0–16.1 in. (38–41 cm)

Wingspan
2.2–2.6 ft. (66–80 cm)

Weight
7.3–13.2 oz. (207–375 g)

Conservation Status
Least concern (vulnerable in Europe)

Global Population
800,000–1,799,999 mature birds (approximately 1,000 pairs on the Isle of Man); decreasing

A down-curving scarlet bill is the essence of this chough (pronounced "chuff"), which is just as well, since that is about the only thing that is sharp in this picture. The image looks like a photograph of a bird's head on which an artist has gone to work with charcoal to add some semiabstract feathers and a few quick aqua brush strokes to suggest the bird's characteristic blue-black feather sheen. The wings are blurred because of the relatively slow shutter speed. I took the shot almost directly into the light and with so much exposure compensation that the sky has been rendered as a featureless canvas.

The starkness of the shot does, however, match the personality of the bird. In the Isle of Man, the Red-billed Chough is a cliff dweller with a liking for insects. Its Asian relative (the subspecies *himalayanus*) has been seen on Everest at a height of 26,000 feet (7950 m), so this is a bird that can live in a monochromatic landscape where its vibrant bill and leg color provide the only color relief.

On the ground, the Red-billed Chough is a conservative bird in the British Isles: It rarely strays far from home, does not migrate, is monogamous and both parents share child-rearing duties. In the air, it is an acrobat. Choughs rarely fly in a straight line, preferring to swoop and soar, and occasionally perform their most distinctive maneuver, when they stop flapping and start tumbling groundward. This may be birds just having fun, since it seems to be unrelated to feeding or reproduction, although "mirror flying" with a partner certainly helps to cement a pair bond.

Their erratic flying behavior is perhaps why I have so few great images of the Red-billed Chough after a couple of visits to the Isle of Man. Flight photographs are easiest when the bird can be located in the viewfinder early and followed smoothly to the point of the final shot.

Isle of Man (September)
Canon EOS-1D Mark IV | EF 500 mm f/4L IS USM | 1/1600 sec at f/6.3 | ISO 1250

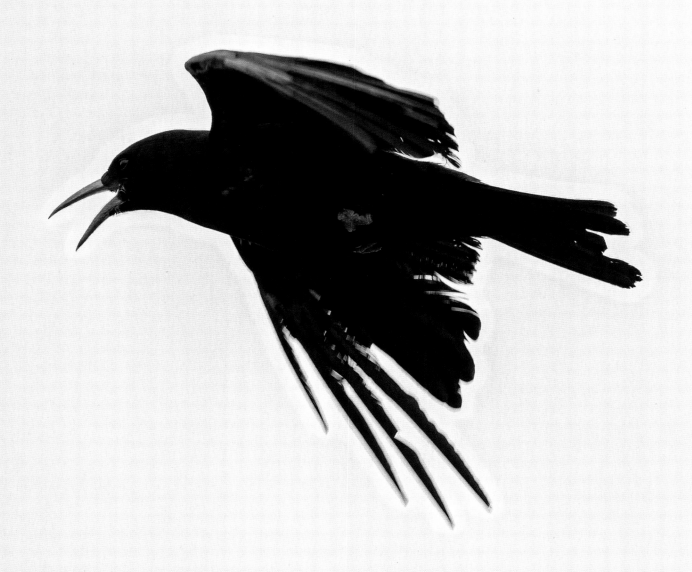

Common Raven

Species
Corvus corax principalis

Length
22.8–27.2 in. (58–69 cm)

Wingspan
3.9–4.9 ft. (120–150 cm)

Weight
1.3–4.4 lb. (585–2,000 g)

Conservation Status
Least concern

Population
More than 16 million birds; increasing

Eagle Beach, Juneau, Alaska (August)
Canon EOS-1D X | EF 500 mm f/4L IS USM | 1/1250 sec at f/4.5 | ISO 5000

This raven in the rain lives in the ancestral home of the Haida First Nation near Juneau, Alaska. More than 13,000 years ago, the first inhabitants of Alaska walked from the Beringia land bridge created during the last ice age and settled into their abundant new homeland. The raven holds an important place in this expansion for the Haida People. In the most well-known version of the Haida creation myth, the ever-hungry and curious raven found the first humans inside a clam shell:

> It wasn't long before one, then another of the little shell brothers, timidly emerged. Some of them immediately scurried back when they saw the immensity of the sea and the sky and the overwhelming blackness of the Raven. But eventually curiosity overcame caution and all of them crept or scrambled out. Very strange creatures they were, two-legged like the Raven. There the resemblance ended. They had no glossy feathers, no thrusting beak, their skin was pale and they were naked except for their long, black hair on their round, flat-featured heads. Instead of strong wings they had stick-like appendages that waved and fluttered constantly. They were the original Haidas, the first humans.[5]

The above retelling of the myth is by Haida descendant Bill Reid, who created a magnificent sculpture, *The Raven and the First Men*, now in the University of British Columbia Museum of Anthropology. Reid and a team of assistants hewed the bird, the clamshell and the first humans from a 4.5-ton (4 t) block of laminated yellow cedar. The museum built a monumental setting for the captivating work, which gives visitors the impression that they are witnessing the moment of human creation.[6] It is a fitting homage to a bird that is inextricably intertwined with northwestern Indigenous cultures.

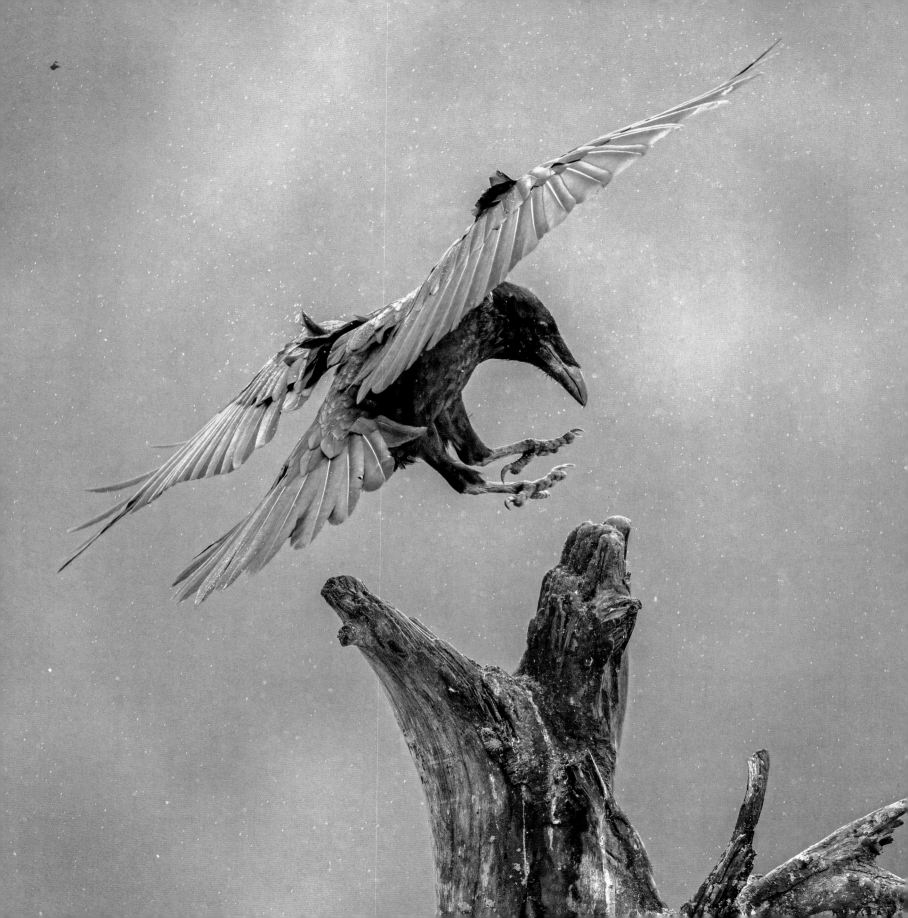

Andean Condor

Species
Vultur gryphus

Length
3.3–9.8 ft. (100–300 cm)

Wingspan
8.5–10.5 ft. (260–320 cm)

Weight
Male: 24.3–33.1 lb. (11.0–15.0 kg)
Female: 17.6–22 lb. (8.0–10.0 kg)

Conservation Status
Near threatened

Population
6,700 birds; decreasing

Any day when you look a bird directly in the eye at camera level is a good day for a bird photographer. If the sun is on your back and the bird is an iconic Andean Condor, then it becomes a spectacular day. In this image, taken on such a day about an hour's drive north of Punta Arenas in southern Chile, the facial features of this singularly South American bird draw the eye. The bird's snow-white ruff, partially framed by the fingers of the long terminal primary feathers on both sides, sharply delineates the boundary between the flying and feeding structures.

As in all vultures, feathers are absent from the facial skin. This is a very functional adaption to the condor's day job of putting its head inside rotting carcasses. The post-feeding cleanup of the head must be complex enough even in the absence of blood-soaked feathers. The pale bill is compact and surgical, allowing the bird to sever the tough skins of terrestrial and marine mammals. Only the male bird has a comb on top of his head, and this likely plays a role in sexual selection, whereby the males with the largest and most striking combs are the most desirable mates.

A closer look at the photograph reveals small swatches of color on the bird's head and neck skin: a dab of red above the eye and a smear of gold across the neck. These colors provide a clue to what appears to be a powerful discriminator of dominance among male birds. Size plays a major role in determining the Andean Condor pecking order, but it is now known that color also matters. Unlike the more long-lasting blue feet of the booby (see page 116–117), the condor's facial color is a more transient phenomenon and is caused by "facial flushing," which is a sudden increase in blood flow through the skin. This happens most frequently in a competitive situation. If two male Andean Condors of equal size are competing, the bird with the brightest facial color at that moment is usually the winner!

Estancia Olga Teresa, Patagonia, Chile (February)
Canon EOS-1D X | EF 500 mm f/4L IS USM | 1/800 at f/18 | ISO 1000[7]

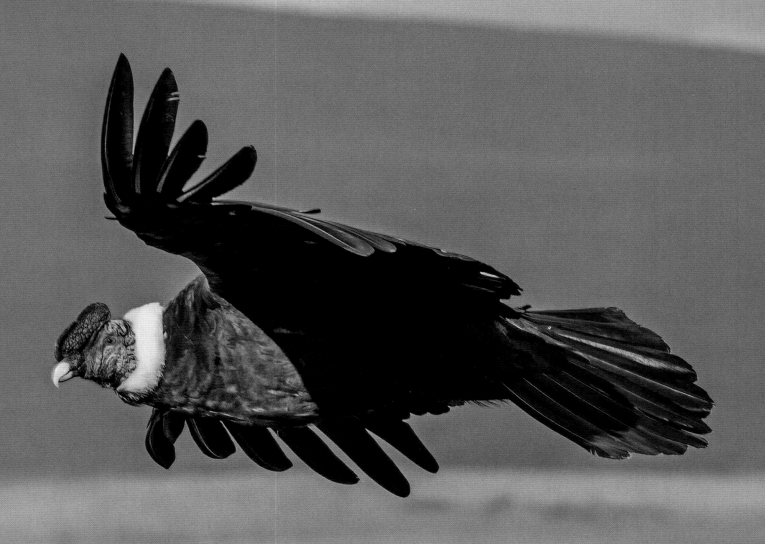

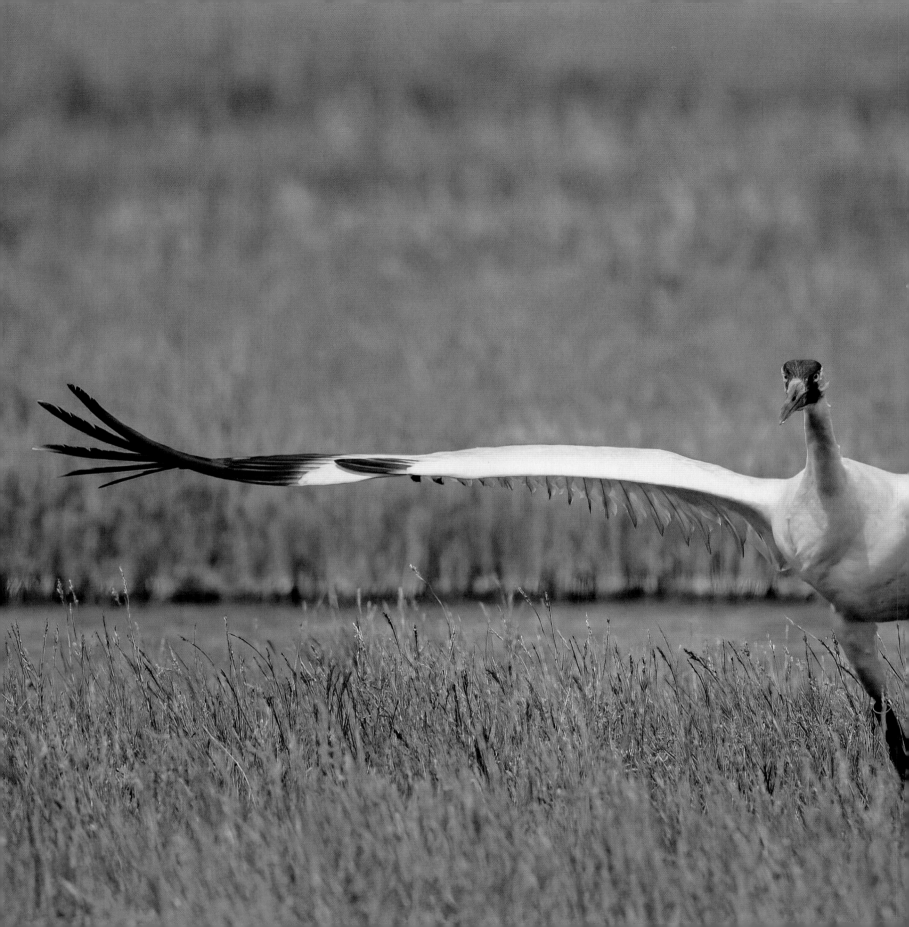

9
Cranes

Previous Spread

Species
Whooping Crane (*Grus americana*)

Location
Aransas National Wildlife Refuge, Texas

Settings
Canon EOS-1D Mark IV | EF 500 mm f/4L IS USM | 1/3200 sec at f/7.1 | ISO 400

A pair of singularly Anthropocene dilemmas frame the complex relationship between cranes and humans. The first is that humans are entranced by cranes, but human activity is pushing cranes to the brink of extinction. The second is that humans have put more extraordinary effort into crane conservation than into any other family of birds, but some conservationists question whether such enhanced care will doom the future of cranes.

Cranes are loved for many reasons: Their large, near-human size allows us to glimpse the intimacies of their life, which other birds can shield from view; their alternately graceful and energetic dances excite our fascination with courtship and athleticism; and their devoted pair-bonding and shared parenting offer animal analogs of the traditional ideal that humans set for their own lives. Cranes are also known for their longevity, something for which humans constantly strive. Finally, we find the consistency of their very visible migration fascinating. The return of the cranes is celebrated by crane festivals around the world from Bosque del Apache to Bhutan.

Reverence for cranes is woven into the fabric of art and culture, particularly in Japan and China. Images of Red-crowned Cranes (*Grus japonensis*) adorn many Japanese and Chinese silk screens and can be frequently seen in works of art that are classified as national treasures in Japan. Cranes were also thought to transport the supernatural Immortals of Chinese mythology. Cranes symbolizing fidelity and longevity explains why they are so often embroidered on wedding kimonos in present-day Japan. A Red-crowned Crane is also the symbol of Japan Airlines, matching the status of the kangaroo on the Qantas logo as a national animal.

Children around the world learn to make origami paper cranes, most without knowing the poignant legacy of Sadako Sasaki, a young girl who

died at the age of 12, suffering from radiation sickness secondary to the explosion of the Hiroshima atomic bomb on August 6, 1945. Sadako is said to have folded 1,000 origami cranes in hope of recovery because legend promised the granting of a wish to anyone completing this task. Statues of Sadako holding a crane aloft have been erected in her honor and as a plea for peace in Hiroshima in Japan and in Seattle in the United States.[1]

Despite so much love and reverence flowing in their direction, cranes continue to suffer greatly from human activities. They are birds that wander, and they need safe and supportive environments at their mid-migration staging areas. Loss of wetlands is a key issue for many crane species, as is human encroachment at both ends of their migration journey. Poisoning and illegal hunting are two additional risks. Janet Hughes gave her important 2008 book about Whooping Cranes the ominous subtitle *A Natural History of a Bird in Crisis*. In the intervening years, the crisis has only worsened.

The crane family (Gruidae) has 15 members, and in her book Hughes provided a table listing the 2008 status and number of each species. I have updated that table on the next page based on the latest data from the International Union for Conservation of Nature's Red List of Threatened Species. It makes depressing reading: Among the 15 species of cranes in the world, only four are listed as being of least concern of risk of extinction. When all 11 vulnerable, endangered and critically endangered crane species are considered, the most pessimistic estimate for the total world population of this group is just over 100,000 birds. Comparing that number with the estimated 31 million crows in the world puts the crane crisis in stark perspective.

A stylized crane is featured in the Japan Airlines logo.

A Red-crowned Crane embroidered onto a wedding kimono.

A summary of the status of each of the world's 15 species of cranes.

Species	Conservation Status	Population Estimate	Trend
Black-crowned Crane	Vulnerable	28,000–47,000 mature birds	Decreasing
Black-necked Crane	Vulnerable	6,600–6,800 mature birds	Decreasing
Blue Crane	Vulnerable	17,000 mature birds	Stable
Brolga	Least concern	20,000–100,000 birds	Decreasing
Common Crane	Least concern	491,000–503,000 birds	Increasing
Demoiselle Crane	Least concern	230,000–261,000 birds	Increasing
Gray-crowned Crane	Endangered	17,700–22,300 mature birds	Decreasing
Hooded Crane	Vulnerable	6,000–15,000 mature birds	Increasing
Red-crowned Crane	Endangered	1,830 mature birds	Decreasing
Sandhill Crane	Least concern	More than 600,000 birds	Increasing
Sarus Crane	Vulnerable	13,000–15,000 mature birds	Decreasing
Siberian Crane	Critically endangered	3,500–4,000 birds	Decreasing
Wattled Crane	Vulnerable	6,000–6,300 mature birds	Decreasing
White-naped Crane	Vulnerable	3,700–4,500 mature birds	Decreasing
Whooping Crane	Endangered	50–249 mature birds	Increasing

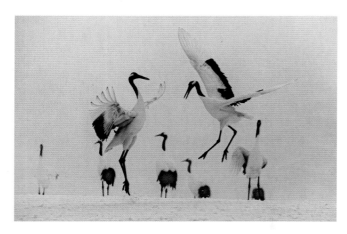

Red-crowned Cranes (*Grus japonensis*) Hokkaido, Japan

The dire situation for the most scarce of the Gruidae, the Whooping Crane, led to an extreme intervention to try to save the species. Birds reared in Wisconsin — apart from their parents —bonded to humans, who eventually piloted ultralight aircraft that led the young cranes to a new winter home in Florida. That new migratory population now numbers more than 100 birds, but the group is still strongly supported by human intervention, and the new challenge is to render the birds self-sustaining in the face of declining habitat and a limited gene pool. A similar dilemma exists in Japan, where the feeding of Red-crowned Cranes has created a dependent population, and the migrant communities of White-naped Cranes, Common Cranes and Hooded Cranes at the Izumi Crane Observation Center derive a large portion of their food intake from human handouts (see page 212).

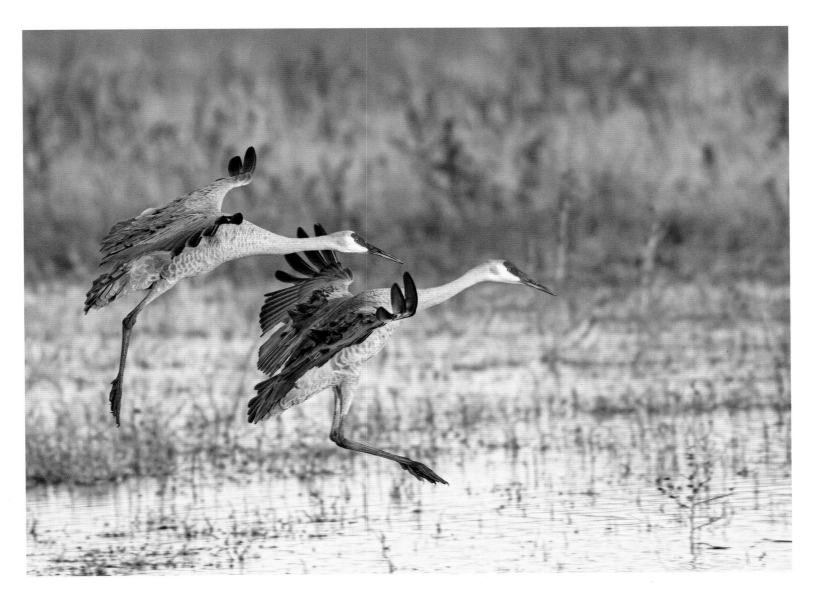

Sandhill Crane (*Antigone canadensis*) Bosque del Apache National Wildlife Refuge, New Mexico.

Photographers can play an important role in preserving this inspirational group of birds. Images displaying the beauty of cranes on the one hand and the devastation of their habitat on the other can provide the visual dots that those unaware of the crisis can connect. In this chapter, I will endeavor to represent the exquisite elegance of cranes in flight, but there is an urgent need for someone to show photographs that expose the underbelly of human destruction of the wetland habitats that cranes need to survive.

Whooping Cranes

Species
Grus americana

Length
4.3–5.2 ft. (130–160 cm)

Wingspan
6.6–7.5 ft. (200–230 cm)

Weight
9.9–18.7 lb. (4.5–8.5 kg)

Conservation Status
Endangered

Population
50–249 mature birds; increasing

This photograph of a family on winter vacation is one that many experts thought would never be taken in the 21st century. It shows two majestic adults and a sandy-headed young Whooping Crane thriving in their winter retreat at the Aransas National Wildlife Refuge on the Texas Gulf Coast. Biologists were understandably pessimistic in the 20th century, since in 1941 the entire migrating flock of Whooping Cranes numbered only 15 individuals. Extinction of the species seemed inevitable, but that meager gene pool became the basis for a slow, human-aided recovery that has few parallels in the history of wildlife conservation.

Loss of habitat, size-similarity to a more populous cousin and focused long-distance travel habits are among the factors that continue to place this tallest of American birds on the endangered species list. Hunters have mistaken Whooping Cranes for the smaller Sandhill Crane, which can be legally hunted in at least 15 flyway states. Historically, the existing flock of Whooping Cranes, including their young offspring, left nesting grounds in north-central Canada on a 3,000-mile (4,828 km) thermal-riding journey to the location where this image was taken. Like many human travelers, they came for the food, in particular the Blue Crabs (*Callinectes sapidus*). With the entire population concentrated in a single location, there is obviously a huge risk that a food shortage, disease epidemic or weather catastrophe could exterminate the flock. This led to an attempt to split the breeding population in the now legendary Operation Migration, in which an ultralight aircraft led cranes reared in Wisconsin by humans in Whooping Crane costumes to a new wintering site in Florida. Unfortunately, the human actors have squabbled over the effectiveness of the program, and the established Florida cohort is now aided by more conventional conservation strategies.

Aransas National Wildlife Refuge, Texas (February)
Canon EOS-1D Mark IV | EF 500 mm f/4L IS USM | 1/400 sec at f/18 | ISO 400

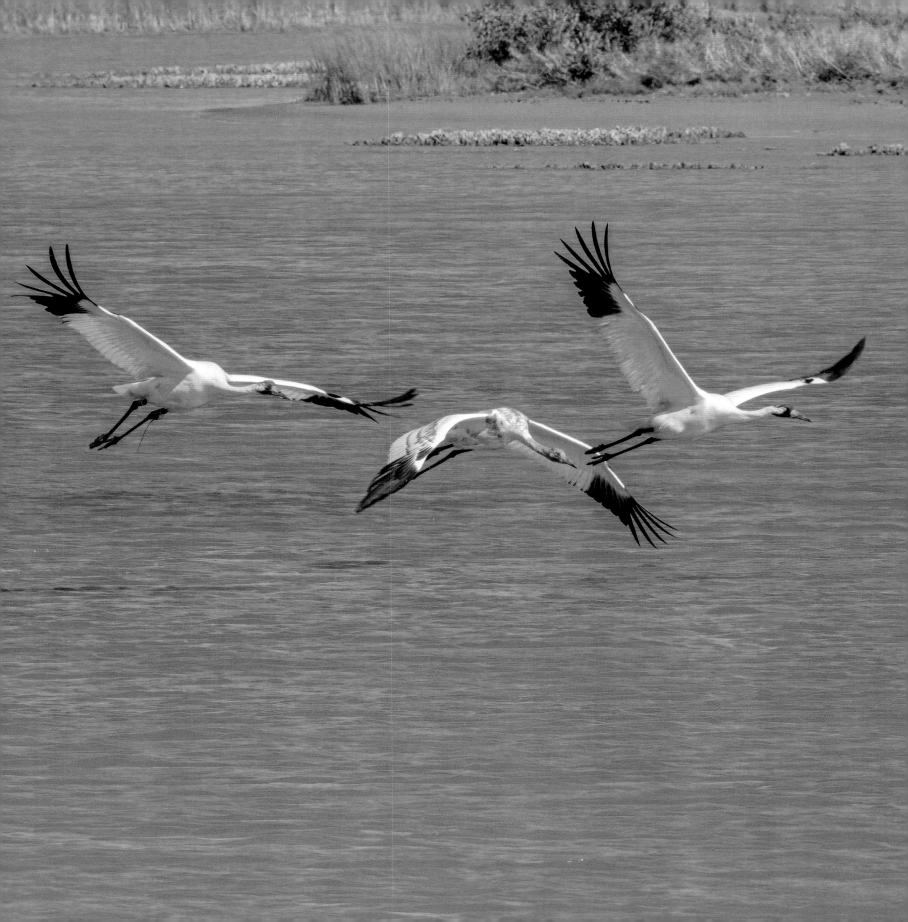

White-naped Cranes

Species
Antigone vipio

Length
3.9–5 ft. (120–153 cm)

Wingspan
5.2–6.9 ft. (160–210 cm)

Weight
10.5–14.3 lb. (4.7–6.5 kg)

Conservation Status
Vulnerable

Population
3,700–4,500 mature birds; decreasing

I had never seen such a vast, writhing avian biomass. It was mid-morning at the Izumi Crane Observation Center in southern Japan, and the day's ration of crane food of rice, wheat and soybeans had just been emptied from a truck onto the middle of an enormous paddy field. Paradoxically, the scene was both chaotic and choreographed. The chaos ensued as thousands of waiting cranes — primarily elegant White-naped Cranes — raced on foot toward the mountain of food. Momentarily, most of them stood proudly erect, with their handsome, tubular gray and white necks extending skyward in a broad arc topped by a gray and red patch and long bill. Next came the curious choreography: All the bobbing birds thrust their heads down to the ground almost simultaneously, leaving behind a billowing field of feathers like waves in a foaming ocean.[2] A minute or so later, on some unknown stimulus, the necks emerged from the feathery carpet, and the whole process repeated until the food was exhausted. The soundtrack for this scene was a penetrating cacophony of cries that sounded like fans at a soccer stadium disputing a penalty.

This image is a post-feeding shot of a pair of White-naped Cranes flying low over a field of rice stalks at the Izumi Crane Observation Center. The long, tapering dart on the neck gives the bird an unmistakable look, and its many shades of gray plumage add to the allure. The black and red facial patch is, in fact, a vulturelike area of bare, roughened and pigmented skin, the intensity of which may determine the male bird's attractiveness to the female.

I like the synchrony in the wings of this pair because it evokes the monogamy of this and other crane species. Curiously, a group of White-naped Cranes has found a way to mock the absurdities of human politics by wintering in the demilitarized zone between North and South Korea. This species has thus become a symbol of peace for the divided people of the Korean Peninsula.

Izumi Crane Observation Center, Kagoshima, Kyushu, Japan (January)

Canon EOS-1D X | EF 500 mm f/4L IS USM | 1/1250 sec at f/9 | ISO 800

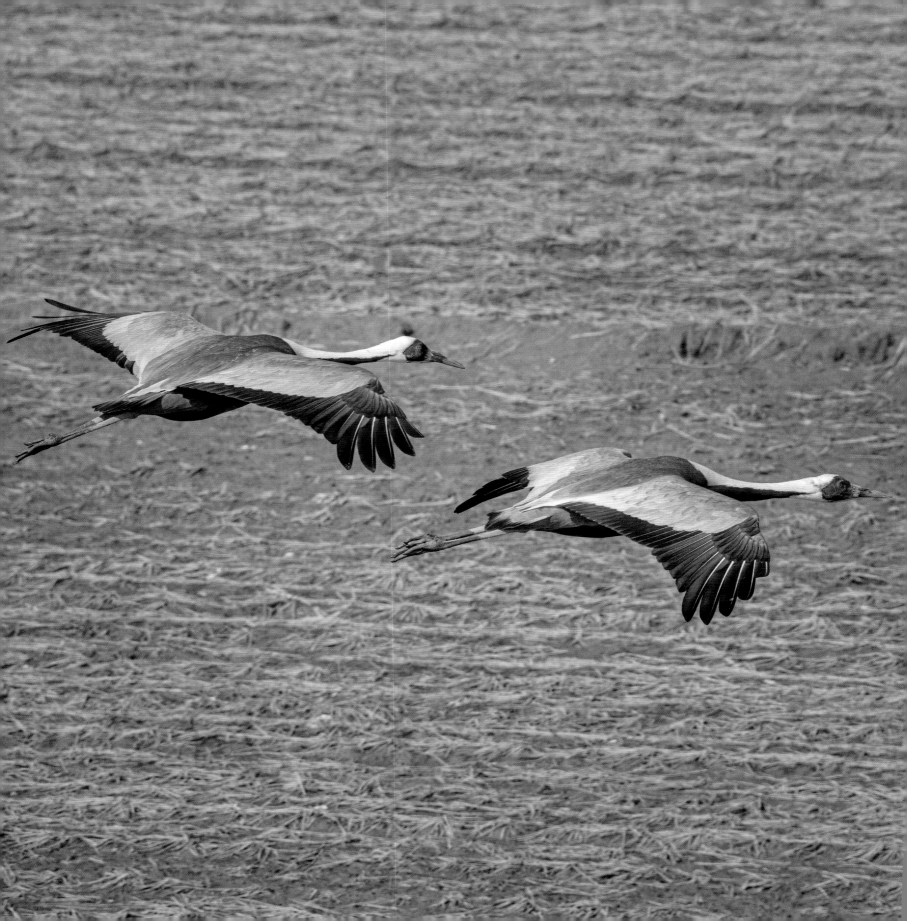

Hooded Crane

Species
Grus monacha

Length
3.0–3.3 ft. (91–100 cm)

Wingspan
5.2–15.0 ft. (60–180 cm)

Weight
Male: 7.2–10.7 lb. (3.2–4.9 kg)
Female: 7.5–8.2 lb. (3.4–3.7 kg)

Conservation Status
Vulnerable

Population
6,000–15,000 mature birds; increasing

Izumi Crane Observation Center, Kagoshima, Kyushu, Japan (January)

Canon EOS-1D Mark IV | EF 500 mm f/4L IS USM +1.4x | 1/2000 sec at f/8 | ISO 800

The vulnerable Hooded Crane is the Cinderella of the crane species that visit Japan. It is not revered like the much larger Red-crowned Crane and lacks the obvious elegance of the White-naped Crane. Its plumage is rather drab, and the bare skin above its eye can only be generously described as red, but Hooded Cranes love Japan, and the Japanese people return that love. This photograph was taken at a place on the Japanese island of Kyushu where an estimated 80 percent of the remaining global population of this species migrate for the winter. They come from breeding grounds in eastern Russia and northeastern China to enjoy the generosity of their Japanese hosts. A large fraction of the wintering birds are thought to entirely depend on the food supplied at Izumi, while the others roam agricultural fields pecking and foraging for seeds and grains. This has led to conflict with farmers and attempts by conservationists to mediate the disputes.

A single individual Hooded Crane became a star attraction in the United States some years ago when it apparently took a wrong turn and followed a group of Sandhill Cranes to Tennessee, rather than attaching to its own kin who were heading for Japan.[3] It would be fitting to name this bird "Corrigan the Crane" after the notorious aviator Douglas "Wrong Way" Corrigan, who, having been denied a permit for solo Transatlantic flight in 1938, made the flight anyway, telling authorities that he had mistakenly taken a wrong turn. This led to the famous headline in the *New York Post* "NAGIRROC YAW GNORW LIAH" (which is "Hail wrong way Corrigan" printed in da Vinci-esque mirror writing).

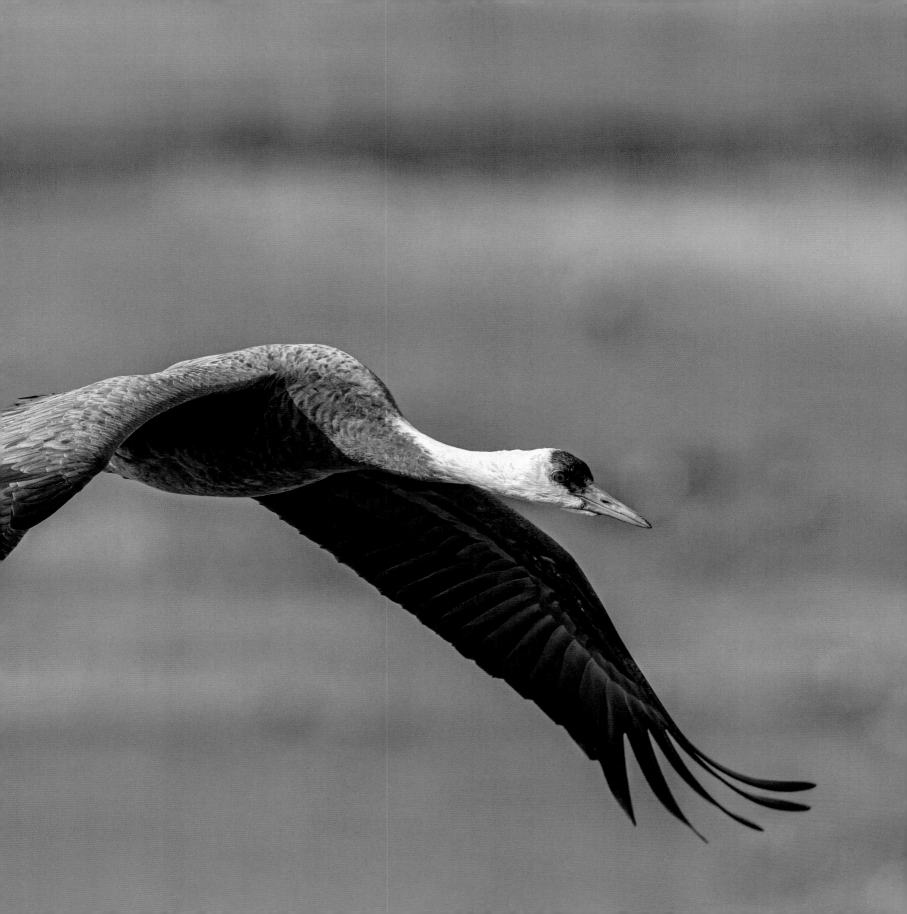

Sandhill Cranes

Species
Antigone canadensis

Length
3.1–3.9 ft. (95–120 cm)

Wingspan
5.2–6.9 ft. (160–210 cm)

Weight
Male: 8.3–11.9 lb. (3.7–5.4 kg)
Female: 7.4–9.5 lb. (3.3–4.3 kg)

Conservation Status
Least concern

Population
More than 600,000 birds; increasing

Bosque del Apache National Wildlife Refuge, New Mexico (December)
Canon EOS-1D Mark IV | EF 500 mm f/4L IS USM | 1/2500 sec at f/4 | ISO 800

It takes a village, and a long runway, to get 10-pound (4.5 kg) cranes up into the air. Cranes are gregarious birds, and they demand company when leaving from an overnight roost in water, a location chosen to protect young birds from predators such as the Coyote (*Canis latrans*).[4] Sandhill Cranes gather in a large congregation for the night, but the morning departure is rarely an exodus — more a steady departing flow of birds over a period of an hour or more. They aggregate into groups of up to 20 birds and start a slow communal shuffle toward shallower water. Eventually, they pause, and one member of the group feels the urgent need to fly. It adopts what I call a ski-jumper's stance, leaning forward precariously like a ski jumper in flight.[5] No sound is made, but the nonverbal communication is a signal to group members that conditions are right. The bird is then off on a mad dash like an aquatic Roadrunner cartoon: It spreads its legs wide with strong extensor thrusts and long forward strides, and it then steps in the water four or five times, increasing its speed and flapping its wings until it achieves liftoff with a final drag of its toes in the water. Close behind are the other members of the group.

There are three small lakes where hundreds of Sandhill Cranes roost overnight along the entrance road to Bosque del Apache National Wildlife Refuge. Attendance at the early morning departure is de rigueur for the small army of photographers who make the pilgrimage to the refuge, despite the often frigid winter morning temperatures. The birds are quite unconcerned by the paparazzi, and the opportunities for takeoff and flight photographs are truly outstanding.

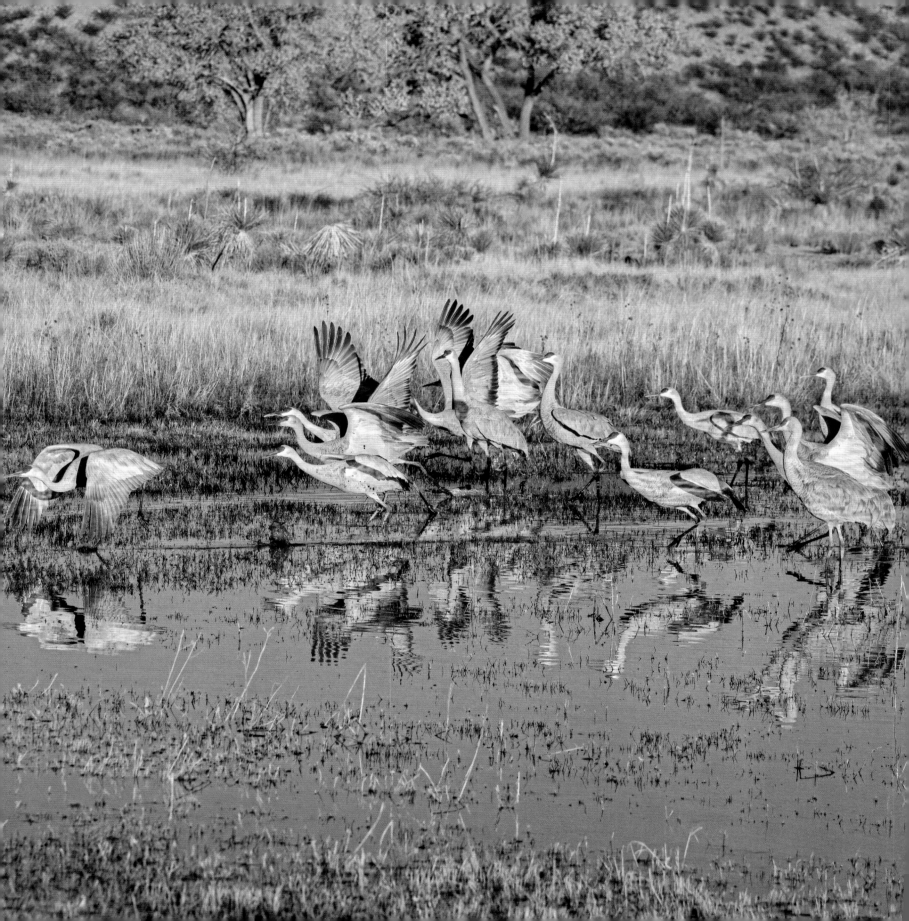

Sandhill Crane

Species
Antigone canadensis

Length
3.1–3.9 ft. (95–120 cm)

Wingspan
5.2–6.9 ft. (160–210 cm)

Weight
Male: 8.3–11.9 lb. (3.7–5.4 kg)
Female: 7.4–9.5 lb. (3.3–4.3 kg)

Conservation Status
Least concern

Population
More than 600,000 birds; increasing

Bosque del Apache National Wildlife Refuge, New Mexico (December)

Canon EOS-1D Mark IV | EF 500 mm f/4L IS USM | 1/2000 sec at f/4 | ISO 800

The canvas on which a bird is portrayed has a major impact on the appeal of a photograph. In order for an image to transcend the basic documentation of a bird's characteristics, the photographer needs to include elements of the environment that enhance a viewer's experience, ideally adding to the aesthetics and informing the content. A cloudless blue sky can convey the sense of the infinite space in which a migrating bird sails, a marsh or shoreline may indicate the habitat in which it forages and a blur of layered background colors can contrast with the bird's plumage and give the photograph the appearance of a watercolor painting.

The most important tool in the photographer's armamentarium for evaluating the range of possibilities at each site is his or her feet. It is tempting to set up for the shot as soon as one locates the bird, usually out of concern that it will fly away and the opportunity will be over. Once a tripod is set up, it is easy to feel rooted and committed to a particular shot, but changing location, sometimes only by a small distance, can make all the difference between a good shot and a great one.

Hewing to this principle, I walked along the lakeshore at Bosque del Apache as the stragglers of a flock of Sandhill Cranes made their morning departure. I already had enough shots of birds running in the water and departing in squadrons against the nearby Magdalena Mountains. Walking upwind in the departure direction, I encountered a patch of vegetation that offered a promising backdrop. The wintering grasses smoldered with a reddish-brown hue, similar to the patches on the bird's coverlet feathers. The leaves of a small bush echoed the yellow cottonwoods that are so characteristic of the Rio Grande Valley in late fall. At that point, all I needed was a bird at the right altitude. After some minutes, this beautiful adult Sandhill Crane obliged and traversed my chosen canvas, its wings contrasting sharply with the vegetation. Keeping the bird low in my field of view emphasized its early post-liftoff flight path and allowed the lake and its far bank to add layers of color to the *mise-en-scène*.

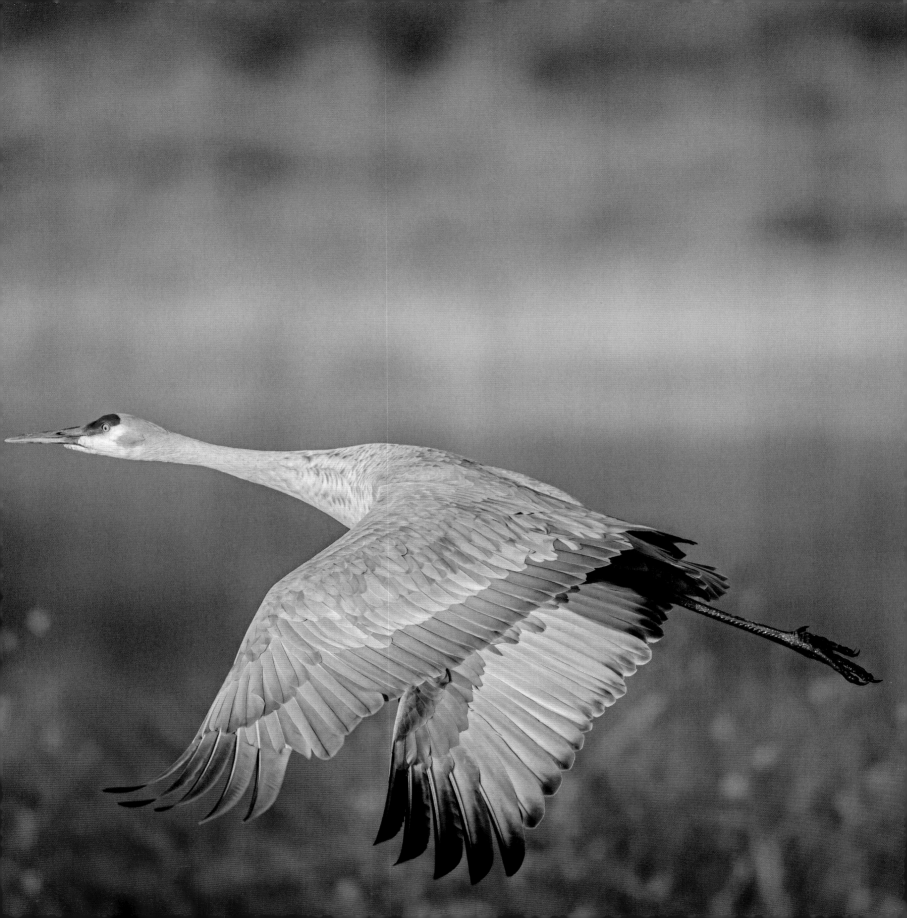

Sandhill Cranes

Species
Antigone canadensis

Length
3.1–3.9 ft. (95–120 cm)

Wingspan
5.2–6.9 ft. (160–210 cm)

Weight
Male: 8.3–11.9 lb. (3.7–5.4 kg)
Female: 7.4–9.5 lb. (3.3–4.3 kg)

Conservation Status
Least concern

Population
More than 600,000 birds; increasing

Bosque del Apache National Wildlife Refuge, New Mexico (December)

Canon EOS-1D Mark IV | EF 70–200mm f/2.8L IS II USM at 200 mm | 1/2500 sec at f/4 | ISO 1000

The voice of the military tower controller crackled through the headphones as I landed my single engine plane at an airport in New Hampshire: "Cherokee Three Eight Quebec is cleared to land. Check gear down." This directive was fortunately unnecessary, since my plane had fixed landing gear, but I assume that the warning had prevented many distracted Top Gun fliers from perilous and expensive belly-flop landings.

Cranes also have their approach-to-landing checklist, which involves the correct positioning of their landing gear. This image shows a small herd of cranes (yes, that is the right collective noun!) on approach to join the early arrivals at an overnight roosting site at Bosque del Apache National Wildlife Refuge. We see birds at various stages of the landing process, including one that is not yet in the landing pattern and is still in streamlined mode, with its long legs trailing to reduce aerodynamic drag. The six birds on their downwind leg have already started to get their "gear down," meaning they have partially rotated their legs forward in a position that will be vertical by the moment of touch down. Some birds with webbed feet actually use their feet as rudders during the approach to landing (see the image of the Red-footed Booby on page 114), but cranes, with their open toes, do not appear to do this.

The nightly return of cranes to roost is an immutable movement of the hands of nature's clock. In New Mexico, where stunning winter sunsets are commonplace, the combination of birds and brilliantly colored light makes shooting the evening's landing activities as rewarding as capturing the morning departures. Exposure management for sunset shots cannot be left to conventional in-camera metering. The light at sunset is still quite bright, and evaluative metering will render everything but the sky dark. That worked to my advantage in this image, and the birds appear as black silhouettes against a vibrant sunset. Exposing for the birds by adding four stops to the metered value would have left a milky white sky, which was not my intent for the shot.

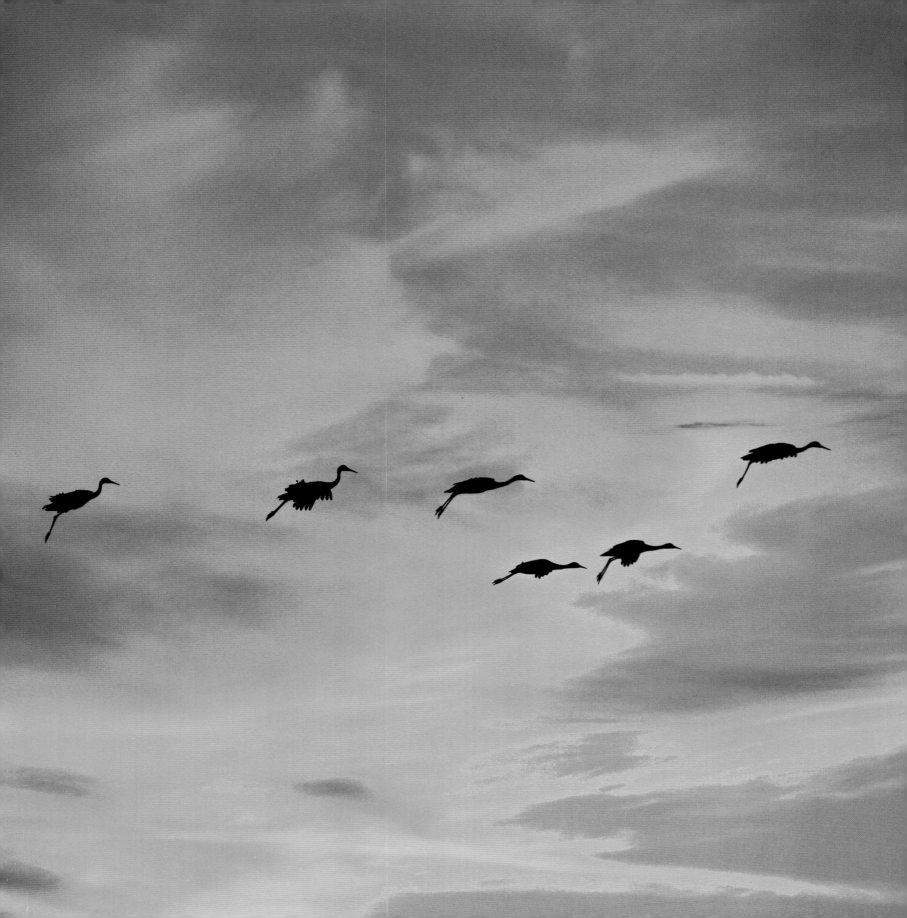

Red-crowned Cranes

Species
Grus japonensis

Length
4.5–5.0 ft. (138–152 cm)

Wingspan
7.2–8.2 ft. (220–250 cm)

Weight
15.4–26.4 lb. (7.0–12.0 kg)

Conservation Status
Endangered

Population
1,830 mature birds; decreasing

Akan Crane Center, Hokkaido, Japan (February)
Canon EOS-1D Mark IV | EF 70–200 mm f/2.8L IS II USM at 70 mm +1.4x | 1/2000 sec at f/11 | ISO 640

"Cranes are coming! Cranes are coming!" The electrified shouts went out in several languages from the large group of photographers sequestered in a fenced enclosure like horses in a paddock at the Akan Crane Center. Already, the early arrivals were pecking at the packed snowfield in front of our enclosing fence, looking for remnants of yesterday's corn. But now the sky was full of cranes, stretched out into the distance like jets stacked up in an airport landing pattern. Except they were never flying alone: pairs, trios and groups of four or five birds cruised in from their overnight roosts on a strong downwind. They carved out sweeping 180-degree turns against the cloudless, cobalt-blue sky to land into the wind. Red-crowned Cranes (sometimes called *Japanese Cranes*) seem to need the proximity of another crane heartbeat to feel comfortable in the air. They don't appear to be taking advantage of aerodynamic assistance — they just want to be close, often flying side by side, like the trio in this image.

I had prepared two camera bodies for the shoot: One was attached to a tripod-mounted fixed focal-length telephoto lens (500 mm), and the other was equipped with a lightweight zoom lens that I could easily hold in my hand. The flight paths of the landing cranes came almost directly overhead, so I soon abandoned the long lens and pivoted around the sky like a searchlight operator, shooting 10 frames per second of as many landing groups as possible with the handheld rig. Attempts at composition in such a frenzied situation are rudimentary — the goal is mostly to keep the entire outstretched wingspan of all the birds in the group within the field of view and to avoid any interference from other groups. I usually hold the focus point on a bird in the middle of the group and keep the aperture as small as possible to keep all the birds sharp.

This image showcases the exquisite plumage of the underwing. Red-crowned Cranes are unique in the crane family for their 10 white primary feathers. The black secondaries are subtly overlaid with a row of graduated-length covert feathers that create a striking diagonal line across the inner wing.

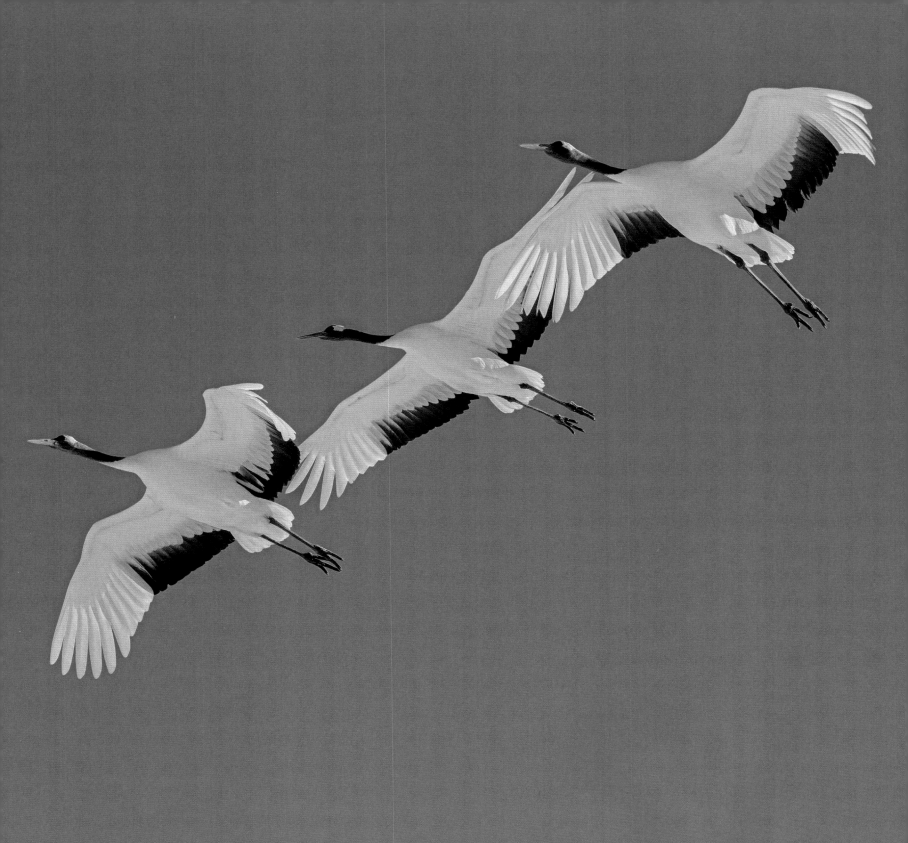

Red-crowned Crane

Species
Grus japonensis

Length
4.5–5.0 ft. (138–152 cm)

Wingspan
7.2–8.2 ft. (220–250 cm)

Weight
15.4–26.4 lb. (7.0–12.0 kg)

Conservation Status
Endangered

Population
1,830 mature birds; decreasing

A winter storm had pounded the tiny village of Tsurui in Japan's northern island of Hokkaido so hard that all roads in and out were closed and all incoming flights to nearby Kushiro Airport were canceled. Our planned road trip to the Shiretoko Peninsula was also a casualty of the weather. Fortunately, the Tsurui Ito Tancho Crane Sanctuary, where Red-crowned Cranes fly in after their nighttime roost, was within walking range. I set off in blizzard conditions carrying a heavy camera rig through the sometimes thigh-deep snow and set up my tripod behind a snowbank.

Choreographed, balletlike movements are part of the enduring allure of watching cranes. Often, it is a pas de deux that can feature a male-female pair interlocking bills and necks or leaping simultaneously into the air.[6] The bird in this image was not dancing to impress a partner, but it was surrounded by several other birds that, incidentally, were balancing on one leg despite the gusty winds. The leap was possibly motivated by a territorial instinct, or perhaps the bird was dancing just because it could. I love the flexed left leg, as if the bird is signaling to the photographer that now is the time to take the picture.

Shooting in snowy conditions offers several technical challenges. So much light is reflected off the snow that metering is not an accurate way to choose exposure settings. The photographer needs to experiment with adding stops of exposure to compensate (see page 287). A very practical issue at this shoot was keeping the lens surface dry from the driving, swirling snowflakes. The lens I used had an 8-inch (20 cm) long hood, but I still had to constantly dab it with a microfiber cloth.

Tsurui Ito Tancho Crane Sanctuary, Hokkaido, Japan (February)
Canon EOS-1D X | EF 500 mm f/4L IS USM | 1/800 sec at f/14 | ISO 1600

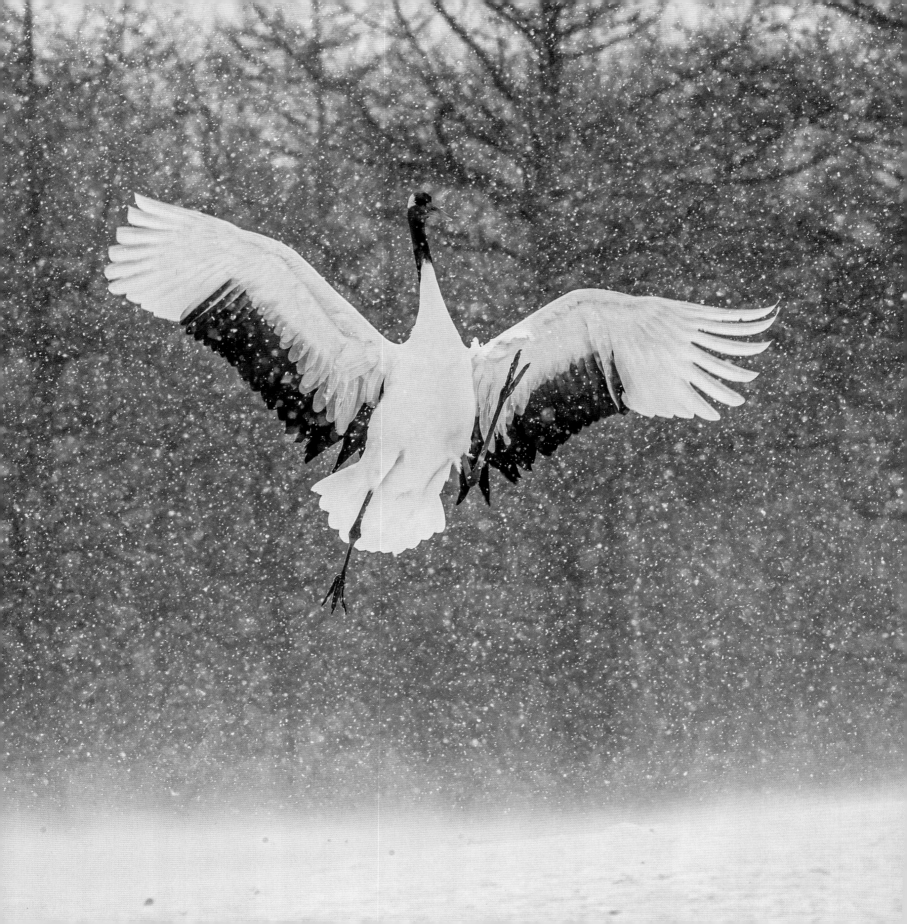

Red-crowned Crane

Species
Grus japonensis

Length
4.5–5.0 ft. (138–152 cm)

Wingspan
7.2–8.2 ft. (220–250 cm)

Weight
15.4–26.4 lb. (7.0–12.0 kg)

Conservation Status
Endangered

Population
1,830 mature birds; decreasing

Otowabashi Bridge, Shimosetsuri, Hokkaido, Japan (February)

Canon EOS-1D X | EF 500 mm f/4L IS USM | 1/3200 sec at f/8 | ISO 1000

There are a handful of locations around the world that birders and bird photographers regard as hallowed ground. I have been fortunate to visit several of these places, including the Látrabjarg Bird Cliff in Iceland, Bass Rock in Scotland's Firth of Forth and Salisbury Plain on South Georgia Island. In most of these locations, a particular species of bird congregates for breeding or migration, and there is a real sense of wilderness where photographers keenly feel that they are alien visitors to a planet more properly owned by wildlife. The Otowabashi (or Otowa) Bridge on Hokkaido Island in Japan has a place in this pantheon of prime birding locations, but my visit there was anything but a wilderness experience.

The early morning scene was enchanting with snow-covered riverbanks, ice-encrusted trees and steam rising in front of a magical orange sunrise.[7] More than 50 Red-crowned Cranes had roosted overnight in the warm water, safe from predators such as the Red Fox (*Vulpes vulpes*). Cranes occasionally leaped into the wispy air in a breathtaking pair-bonding dance. The mercury was hovering close to –20°F (–29°C) when I arrived at the snow-covered bridge just before dawn, but I was late to the party: A scrum of photographers had already lined up six deep against the railing. They jostled, elbowed, shouted back and forth, and abruptly advanced tripod legs in order to maintain locations secured by a 4 a.m. arrival. The stench of diesel fuel filled the air as a flotilla of tour buses ran their engines to ensure that tourists would be welcomed back warmly. Shortly after the sun rose, the bridge cleared as if under a mandatory evacuation order, even though the birds were still in the water. The majority of frozen visitors had stored a "sunrise with Red-crowned Cranes" image in their minds and on their phones, and their thoughts quickly turned to warmth and breakfast. Ironically, about 30 minutes later, all the roosting cranes took off and made a low pass over the bridge to the astonishment and joy of the small group of us left to savor the moment.

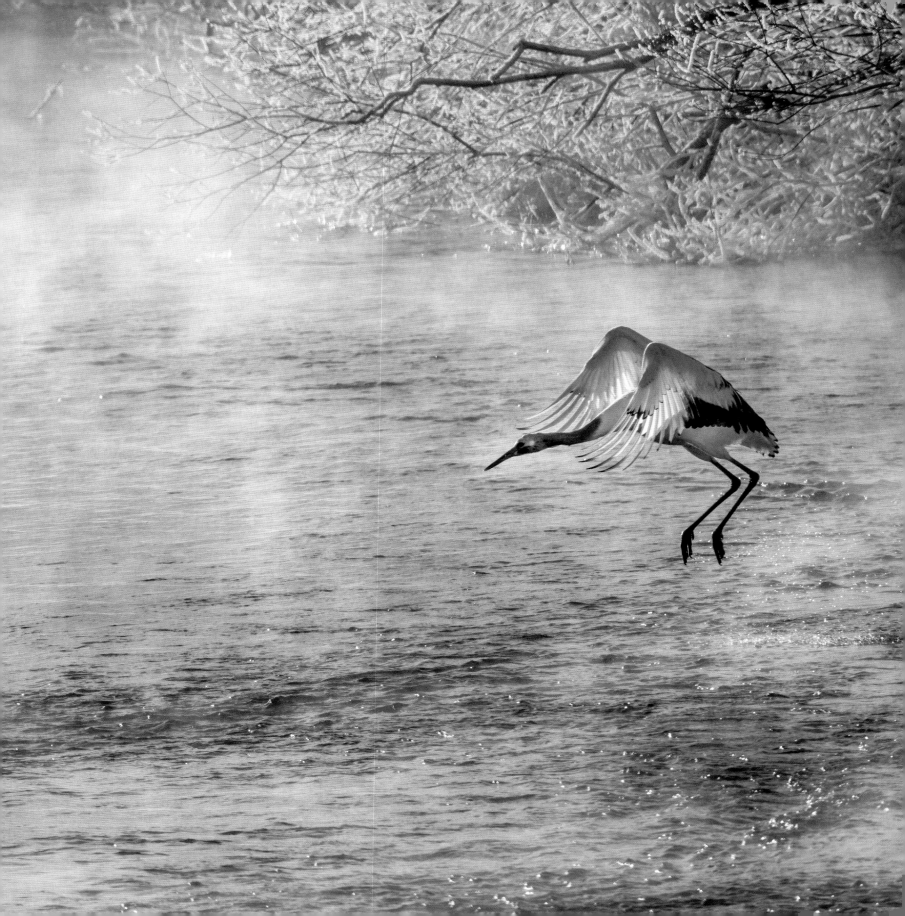

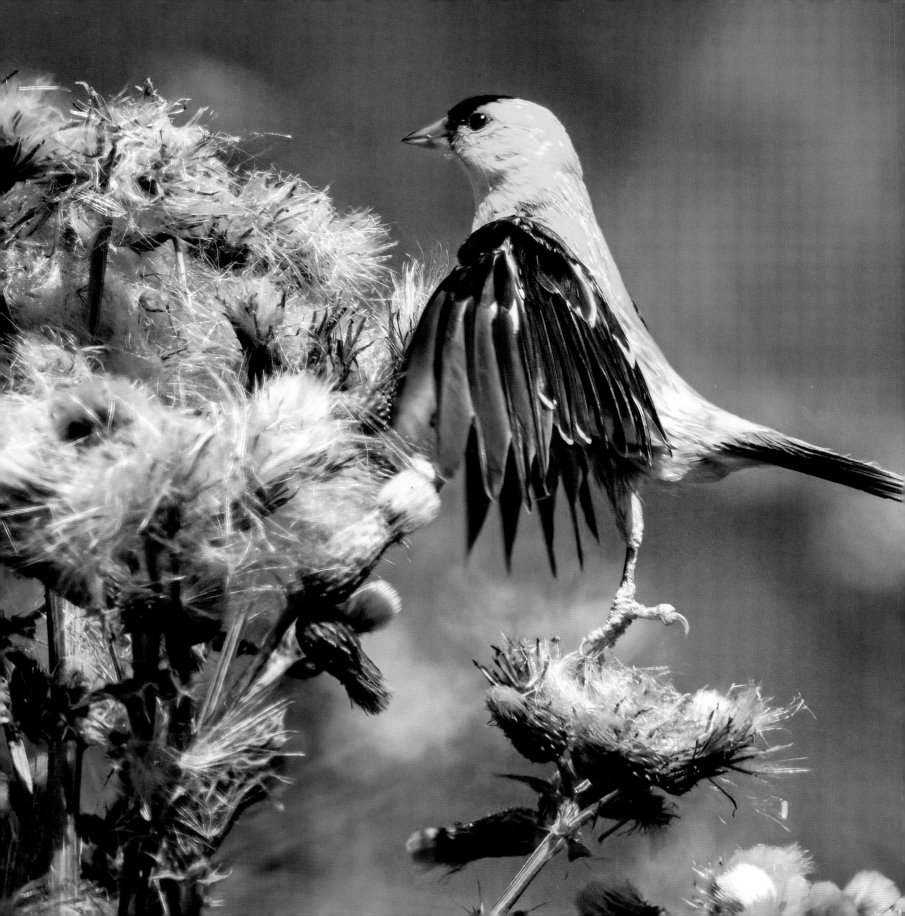

10
Songbirds

Previous Spread

Species
American Goldfinch (*Spinus tristis*) (Male)

Location
Lopez Island, Washington (August)

Settings
Olympus OM-D E-M1X | M 300 mm f/4 + MC-14 (x1.4) (full-frame equivalent: 840 mm) | 1/5000 at f/5.6 | ISO 1000 | Pro Capture

While many despots have espoused eagles as their emblem, artists have more often embraced songbirds for inspiration. Poets John Keats and Emily Dickinson both eulogized songbirds,[1] and William Shakespeare imagined songbirds as a chorus responding to the music of the gods:

Wilt thou have music? Hark! Apollo plays,
And twenty caged nightingales do sing.[2]

Musicologists and ecologists still debate whether or not birdsong is music in the conventional sense of fixed intervals between notes, rhythm, melody, etc. Regardless of the technical answer to this question, it is a fact that many composers have been inspired by birdsong and have incorporated birdsonglike passages into their works. Vivaldi's *Flute Concerto in D* is known as *The Goldfinch* because of its virtuoso trills, and the opening theme of the "Spring" concerto from his beloved *Four Seasons Suite* celebrates the singing of birds. The call of the cuckoo appears in works by Beethoven, Mahler, Dvořák and others, and nightingales abound in the musical canon. Contemporary composer Olivier Messiaen began transcribing bird songs as a child and used the songs of more than 250 species in his music. Birds can also perform music composed by humans: Wolfgang Mozart's caged European Starling (*Sturnus vulgaris*) is said to have sung a passable version of the theme from his *Piano Concerto no. 17 in G*.

While almost all birds vocalize to some extent, there are exceptions. The mostly silent Wood Stork (*Mycteria americana*) only occasionally emits an "airy, low, rasping fizz,"[3] and the Saddle-billed Stork (*Ephippiorhynchus senegalensis*) is virtually mute. Despite its name, however, the Mute Swan (*Cygnus olor*) actually has quite a repertoire of sounds.

Within the vast range of avian vocal sounds, a distinction is made between "calls" and "songs." Calls are conversations about everyday aspects of bird life, such as sounding the alarm or indicating current location, and they are usually fairly modest in their musical scope. Songs, on the other hand, serve a higher purpose, such as attracting mates or proclaiming territorial boundaries. Songs are also usually more complex sound sequences that, with some exceptions (notably crows and ravens!), match a human listener's concept of beautiful sounds.

The anisodactyl foot of a passerine.

Some vocal signals appear to be genetically encoded, but young birds also learn aspects of their song repertoire from adults. The White-crowned Sparrow (*Zonotrichia leucophrys*), a species that we will meet in on pages 238–239, has been widely studied by ornithologists to unlock some of the secrets of vocal learning. If this bird is exposed to a vocal tutor (electronic or avian) between 15 and 50 days after birth, it can learn any of the dialects sung by the species. If the bird is isolated from all the sounds of its kin during this critical period, it will sing an abnormal song. Some song plasticity may also be present in later life. Early learning is not the rule for all species; mimics such as Northern Mockingbirds (*Mimus polyglottos*) can add to their repertoire throughout their life.

Spanning some 4,600 species, the group of birds formally classified as songbirds is astonishingly broad and accounts for almost half of all living bird species. Songbirds are all passerines, meaning they are perching birds, and have three forward-facing toes and one toe facing backward. When the toes are all joined at the same level on the foot, this configuration is called anisodactyl (unequal toe).[4] However, not all passerines are songbirds. The criterion for membership in this elite group is, not surprisingly, that the anatomy of the vocal system is developed to the point where an extended, complex sound pattern can be produced. This specific subgroup of passerines is known as the oscines.

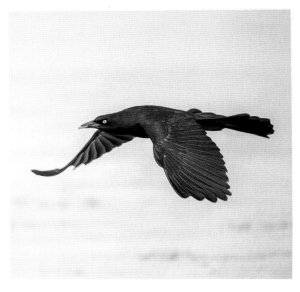

Great-tailed Grackle (*Quiscalus mexicanus*) Bolivar Flats, TX

A diagram of the syrinx and associated anatomy.

Top: The approximate positions of relevant structures in a Lilac-breasted Roller (*Coracias caudatus*): the trachea with the larynx at top (A), the air sacs (B), the lungs (C) and the syrinx (circled). Kruger National Park, South Africa.

Bottom: The syrinx in cross section, showing the trachea (1); membranes and labia, which vibrate to generate sound (2); the external muscles (3); and the bronchi (4).[5]

The anatomical structure that enables birdsong, called the syrinx, is unique to songbirds and has been described by evolutionary biologists as a complete novelty, meaning it has no parallel in the biological universe. It did not evolve from something else; it is a *de novo* occurrence to serve the unique function of singing — a new structure for an old function. The larynx (or voice box), located in the throat at the top of the trachea (or windpipe), is a universal feature of vertebrate anatomy. Birds have a larynx, but it has no vocal function. Instead, the syrinx is a set of vocal folds at the top of each branch of the two tubes, called bronchi, that connect the trachea to the left and right lungs. As air is exhaled across the syrinx, different sounds are generated by the vocal folds, which are tensioned by external muscles and pressure from surrounding air sacs. Birds can generate unique sounds simultaneously from each branch of the system, allowing them to harmonize with themselves! In some species, including non-songbirds, the trachea is folded into elaborate loops like the tubes of a French horn. This extends the frequency range and adds harmonic complexity to the emerging sounds.

Beyond the remarkable anatomy, there are many other fascinating aspects of birdsong. For example, the repertoire of a tiny Californian male Marsh Wren (*Cistothorus palustris*) can exceed 160 distinct songs; both male and female Plain-tailed Wrens (*Pheugopedius euophrys*) loudly sing alternating notes in duets with such precision that the song sounds as if it is from a single bird; a male Northern Mockingbird (*Mimus polyglottos*) lives up to its scientific name (which means "actor of many tongues") by singing over 200 different songs, many of which are copied from other species; and Eurasian Skylarks (*Alauda arvensis*) sing while performing dazzling aerobatic maneuvers that inspired the poet Percy Shelley.[6]

Given the fascination that humans have for songbirds, it is, at first, surprising that there are so few photographs of small flying songbirds

in field guides and bird magazines and on websites. That surprise lasts only as long as it takes to try to capture an image of a small bird taking off from a perch. The usual result is a photo of the perch from which the bird has long departed. Small birds are astonishingly fast compared to a photographer's reaction time. One solution is to use the continuous or burst exposure mode that is a feature of many DSLR cameras and start shooting while the bird is still stationary. However, if the bird lingers, this method will fail because the camera can only write a finite number of images from the memory buffer to the memory card before shooting grinds to a halt. Pulsing in burst mode is also an option, but the bird will often fly between pulses.

A more elegant solution involves using a circular buffer that is a feature of several mirrorless cameras. It is called Pro Capture in the Olympus line and Pre Burst on Panasonic cameras. With a half-press of the shutter release button, images are cycled into an in-camera buffer. They are overwritten once the buffer is full, but when the shutter release is fully pressed, all of the latest buffered images are written to the memory card and new images continue to be saved. The price one pays for such innovation is that images from micro four-thirds sensors are very noisy when the ISO setting is high. Since small birds move so fast, high shutter speeds are needed to "freeze" the wings, so the photographer needs extremely bright light in order to shoot at shutter speeds at or above 1/3000 of a second while keeping the ISO setting at or below ISO 1500.

I have traditionally taken images of large birds such as raptors, waterbirds, cranes and toucans. Focusing on songbirds for this chapter has extended my view of avian beauty into the auditory domain. The poets were there way before me, but I have come around. When browsing bird ID websites and apps, I now find myself clicking to hear the calls and songs of the bird that I am photographing. I encourage you to do the same.

Immature House Finch (*Haemorhous mexicanus*), Lopez Island, Washington

Brewer's Blackbird

Species
Euphagus cyanocephalus

Length
Male: 8.3–9.8 in. (21– 5 cm)
Female: 7.9–8.7 in. (20–22 cm)

Wingspan
14.6 in. (37 cm)

Weight
Male: 2.1–3.0 oz (60–86 g)
Female: 1.8–2.4 oz (50–67 g)

Conservation Status
Least concern

Population
More than 20 million breeding birds; decreasing

Lopez Island, Washington (June)
Olympus OM-D E-M1X | M 300 mm f/4 (full-frame equivalent: 600 mm) | 1/4000th sec at f/4 | ISO 1250 | Pro capture

This male Brewer's Blackbird badly wanted to be in my picture. As I stood about 15 feet (4.6 m) away, it flew repeatedly back and forth between the same two fence posts to make sure I got the shot that I wanted. Such cooperation is rare but extremely welcome!

Distinguished by its elegant, glossy and, in the right light, iridescent plumage and striking yellow eyes, this handsome bird has been listed by *The State of the Birds Report*[7] as a "common bird in steep decline." The species has suffered from shooting, poisoning and trapping at the hands of farmers who believe it threatens their crops. In fact, such aggression has been encouraged by the U.S. government, even though the Brewer's Blackbird is presumably protected by the Migratory Bird Treaty Act. An official USDA publication[8] says "Brewer's blackbirds generally cause minor damage to oats and fruit crops … [and] minor damage to livestock feed in feedlots. [They do, however,] consume large numbers of noxious insects during the summer months."

Despite these disclaimers, the same article goes on to list a variety of lethal and likely painful methods of "management," including "Starlicide, a slow-acting toxicant; birds usually die 1 to 3 days after feeding." It was certainly an eye-opener to me to discover that taxpayer funds are still being used to help poison birds.

The naming of this species in 1843 for Thomas Mayo Brewer, a reluctant Boston physician and highly active ornithologist, was intended as a gift from his friend John James Audubon. Brewer's obituary in the *Bulletin of the Nuttall Ornithological Club* does not mention the naming, but does describe the indebtedness of Audubon to Brewer for "information and rare specimens of birds." As is often the case with a new "discovery," someone else had actually been there first, in this case a young German ornithologist named Johann Georg Wagler, who is credited with the first description of the bird, in 1829. I would credit myself with the discovery that this bird just loves to be photographed, but that too has probably already been determined by another avian paparazzo!

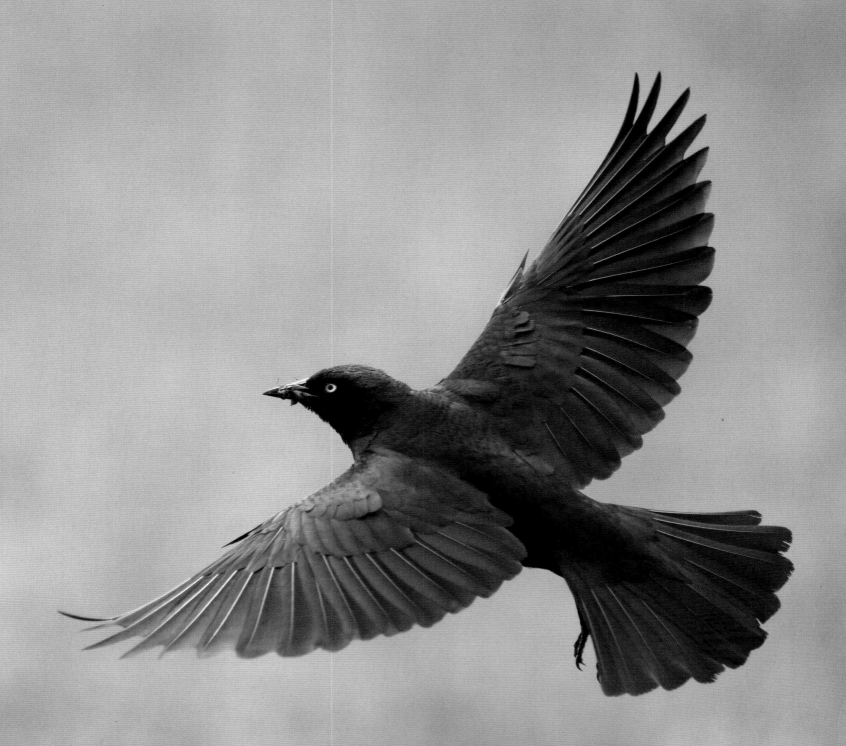

Woodland Kingfishers

Species
Halcyon senegalensis

Length
9.1 in. (23 cm)

Weight
Male: 1.4–2.1 oz. (41–60 g)
Female: 2.1–2.9 oz. (60–81 g)

Conservation Status
Least concern

Population
Unknown; stable

Letaba River, Kruger National Park, South Africa (January)
Canon EOS-ID X | EF 500 mm f/4L IS USM | 1/3200 at f/4 | ISO 1600

Hearing the persistent, melodious trill of the Woodland Kingfisher is a good way to fall in love with Africa. This bird is always there to give a morning wake-up call, offer an invitation to an afternoon siesta or add a comment during an evening of reflection. You hear it before you see it, so when the appearance of a blood-red bill is followed by a flash of turquoise and black wings, it is as if you have just met someone you have only heard on the radio.

I associate this bird with the Satara Rest Camp in Kruger National Park, where I first really listened to its song. Circular thatched guest huts, known as rondavels, are protected from the scorching sun by gangly shade trees that are the stages from which kingfisher arias are sung.

Curiously, this kingfisher doesn't do much fishing. It has a varied diet of flying and ground-dwelling insects and will sometimes take frogs, lizards and small mammals, but fish and crustaceans are occasionally on the menu. This is obviously a bird with keen eyesight, as its typical hunting modus operandi is to perch on a branch, identify potential prey and then swoop down for the kill, sometimes hovering briefly to evaluate the target. The Woodland Kingfishers in this image were making short foraging flights to feed on ants or termites in a nearby dead tree trunk. What I like about this late afternoon photograph is that the striking colors of the birds are set against a hazy backdrop of pastels that remind me of the sandy Letaba riverbank and its occasionally leafy brush. Having listened to the Woodland Kingfisher I find that the image fails to capture what, in my mind, is the dominant feature of this bird: It's song.

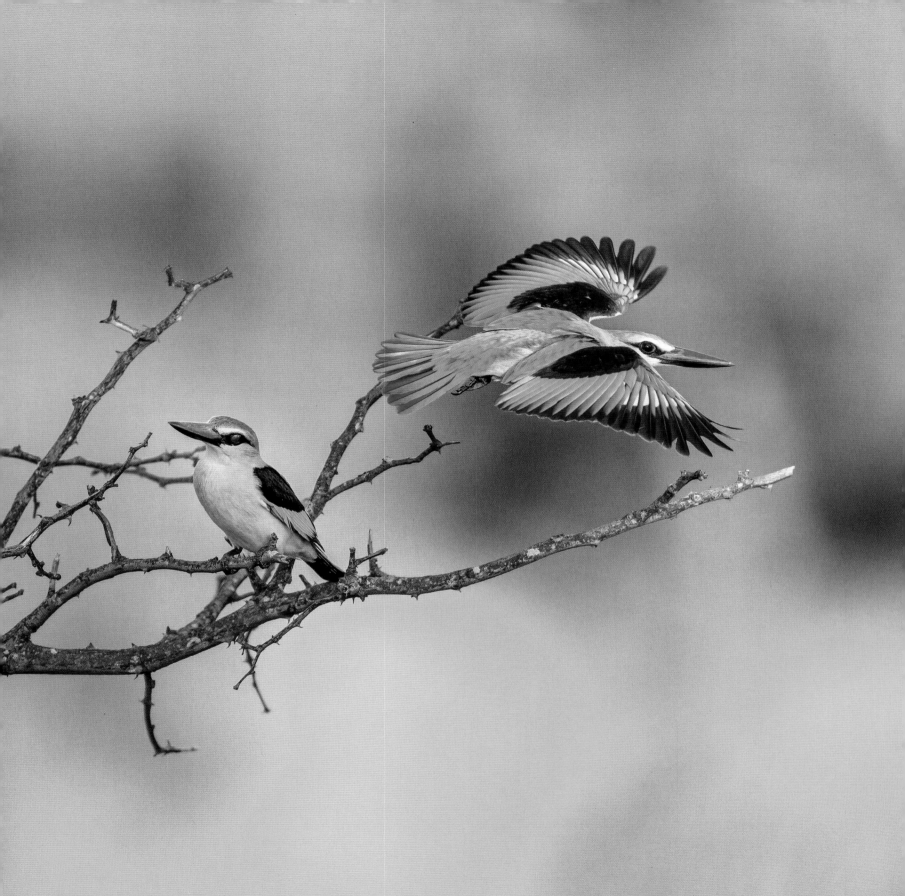

White-crowned Sparrow

Species
Zonotrichia leucophrys pugetensis

Length
5.9–6.3 in. (15–16 cm)

Wingspan
8.3–9.4 in. (21–24 cm)

Weight
0.9–1.0 oz. (25–28 g)

Conservation Status
Least concern

Population
Unknown; stable

Lopez Island, Washington (July)

Olympus OM-D E-M1X | M 300 mm f/4 (full-frame equivalent: 600 mm) | 1/4000th sec at f/4 | ISO 800 | Pro capture

The buoyant, whistling song of the White-crowned Sparrow and that of its relative the White-throated Sparrow (*Zonotrichia albicollis*) are part of the rich aural tapestry of a walk along a hedgerow in much of North America. For the musically inclined, the song of the White-throated Sparrow is described in Cornell's *Birds of the World* as comprising "pure whistled notes without detectable harmonics, arranged in pattern, typically including at least 1 major pitch change after [the] first or second note … followed by a variable number of … triplets."

To the casual birder north of the U.S. border, the two steady notes followed by repeated triplets were remembered as "My sweet Canada, Canada, Canada" until an astute listener realized that it wasn't like that anymore. Biologist Ken Otter and his colleagues reported that, in the second half of the 20th century, birds in western Canada dropped the last note of the triplet and started singing "My sweet Cana, Cana, Cana." These birds from the west coast wintered alongside their Midwestern cousins who, it seems, learned the new doublet song structure and adopted it as their own. This process rolled eastward, and the new song spread virally, so that today many birds across Canada sing the new song. The evolutionary advantage of dropping a song syllable is not yet clear, but the new song is likely a declaration of superior reproductive fitness.

The White-crowned Sparrow in this picture is much too busy to sing as it carries a caterpillar off to its nest. These birds are comfortable in a thicket of twigs and branches, which is conveyed by the dense undergrowth in the image. I don't usually like such complicated backgrounds, but in this case I think it tells the story of the bird's habitat.

The extended posture of the legs shows that the bird has just thrust off the perch that I had been focusing on for about a minute, collecting images into a circular buffer. The bird was well out of the field before I pressed the shutter release fully down one reaction time later, but the image was saved by the camera's electronic wizardry.

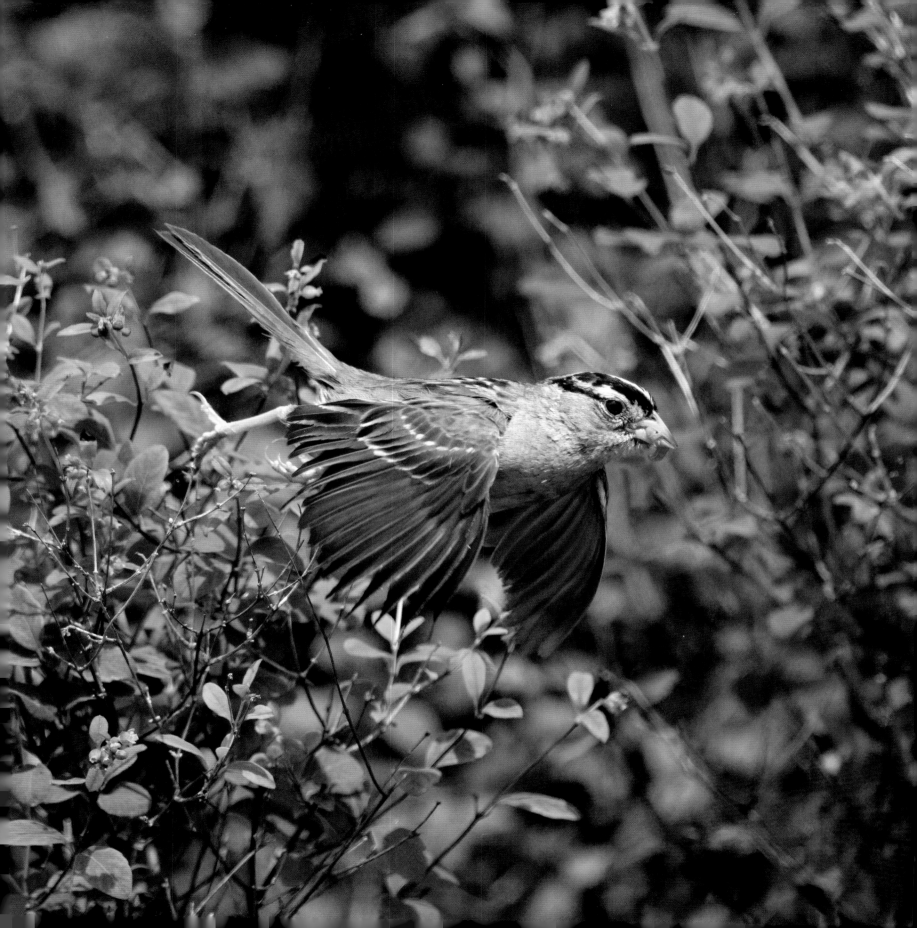

Red-winged Blackbird

Species
Agelaius phoeniceus

Length
6.7–9.1 in. (17–23 cm)

Wingspan
12.2–15.8 in. (31–40 cm)

Weight
1.1–2.7 oz. (32–77 g)

Conservation Status
Least concern

Population
210 million mature birds; decreasing

Lopez Island, Washington (July)
Olympus OM-D E-M1X | M 300 mm f/4 + MC-14 x1.4 (full-frame equivalent: 840 mm) | 1/4000 sec at f/5.6 | ISO 1000 | Pro Capture

Long before I started photographing birds, I met the Red-winged Blackbird through a song. Crowded into the living room of a good friend, nestled in a cleft through the linear ridges of Central Pennsylvania, folk singer Bill Staines sung a David Francey song called "I thought I Heard a Red-winged Blackbird."[9] It is one of those melodies that finds a permanent, resonant space in the brain, and I have hummed it many times in the intervening 40 years. So when I recently found myself in the company of a herd of goats, peering through the cattails, trying (mostly in vain) to find an unobstructed shot of this strikingly well-dressed bird, a verse from the song came to mind:

> Safe as Moses in the rushes,
> Builds his home on the river wide,
> Every time I hear him singing,
> Makes me feel like Spring inside.

With spring already a distant memory, it took approximately 10 visits to the same location before I got the shot I wanted. One or two male birds were always in the vicinity, clinging to the swaying stems, pecking at the furry fruit spikes and occasionally hawking insects in the thick undergrowth. My technique was to establish a fixed focus on the bird with a tripod-mounted camera and to begin collecting images until it flew to another location. This only worked if the bird flew in the plane of focus, but it was the most feasible approach, as the perch moved constantly and caused the focus point to drift continuously between the bird and the background. Invariably, the bird was obscured by vegetation in the handful of in-focus flight images that I captured. Red-wings are expert at flying through a forest of obstacles. Finally, I saw a bird dip down to grab a dragonfly and display it proudly for a few seconds before flying off exactly in the focal plane. Threading my way back very warily through the goat herd, fairly confident that I had my shot, I recalled the bird in the song was also anticipating his next journey:

> He'll be in there singing his heart out
> He'll be telling me stories too
> Of where he went to winter last year
> Of how he's going back there too.

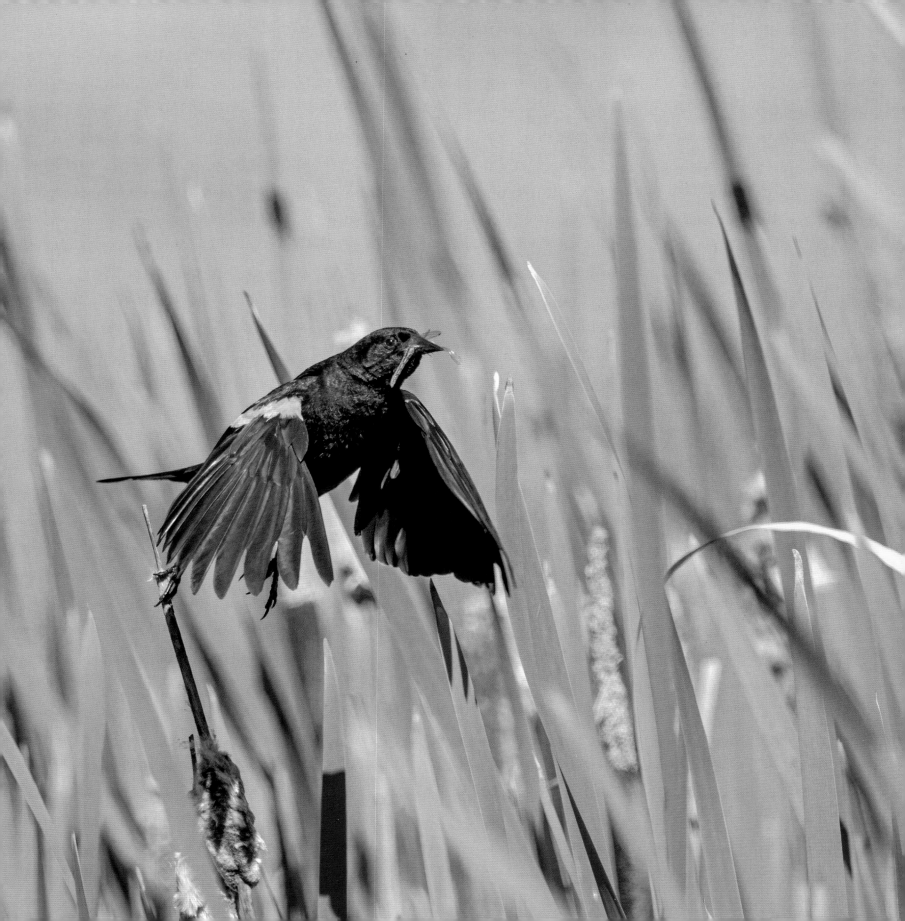

European Starlings

Species
Sturnus vulgaris

Length
7.9–9.1 in. (20–23 cm)

Wingspan
12.2–15.8 in. (31–40 cm)

Weight
2.1–3.4 oz. (60–96 g)

Conservation Status
Least concern

Population
150 million; decreasing

Photographer
Owen Humphries[10]

Gretna, Dumfries and Galloway, Scotland (November)

Nikon D4 | 400 mm f/3.5 | 1/2000 at f/3.5 | ISO 2000

These starlings are murmurating, which is surely a word that sends most of us scurrying for a dictionary. The definition is neither helpful nor evocative of the spectacular display of coordinated, delineated flight shown in this photograph: "murmuration: the act of murmuring. The utterance of low continuous sounds or complaining noises." There is certainly noise, but why do the starlings do this, how do they do it?

Animal behaviorists call this flocking behavior aggregation. This term is used for fish swimming in schools, insects swarming and for the more than one million wildebeests that migrate across the Serengeti. The conventional wisdom is that aggregation is beneficial because it decreases the individual risk of predation and allows vigilance to be relaxed while feeding or caring for young. Others believe that there is some self-organizing principle at work or that aggregation is a result of a complex flow of information between animals.

The underlying choreography of this mass flight of more than 10,000 birds has fascinated mathematicians and biologists alike. We introduced the simple BOIDS' model on page 90, showing that three simple rules could reproduce flocking behavior. Recent studies using fairly complex mathematics have shown that if each bird continuously matches the velocity vector (speed and direction) of only its seven nearest neighbors, the ensemble behavior shown in the photograph will be generated. This "monitoring" likely involves visual, auditory and perhaps even olfactory sampling.[11] Each of those seven neighbors also matches the behavior of their own seven nearest neighbors and so on.

Española Mockingbird

Species
Mimus macdonaldi

Length
10.4–11. in. (26.5–28 cm)

Weight
Male: 2.7 oz. (76.1 g)
Female: 2.3 oz. (64.8 g)

Conservation Status
Vulnerable

Population
600–1,700 birds; trend unknown

Española Island, Galápagos Islands, Ecuador (October)
Canon EOS-1D X | EF 100–400 mm f/4L IS USM at 300 mm | 1/1000 at f/11 | ISO 2500[14]

"Cry 'havoc' and let slip the wings of war!"[12] This bird has just arrived at the scene of a showdown between two rival gangs of endemic Española Mockingbirds on the Galápagos Island of Española. Española Mockingbirds are known to fiercely defend their territory, as I discovered firsthand after a wet, but warm, landing in the late afternoon on the white sand beach of Gardner Bay. Just like prizefighters at a weigh-in, an important preliminary to an avian fight is the intimidation of your opponent by making yourself as large and threatening as possible. This involves extending every feather you own as far from your body as you possibly can. In this image, we see the entire feather structure of the underwings — primaries, secondaries and layers of covert feathers stacked like the petals of a monochromatic flower. The impression on an opposing bird must be daunting.

Reinforcements arrived within seconds of this picture being taken, and the rival gangs lined up as if on either side of a demilitarized zone. I kneeled in the sand, spinning around to record the action as I found myself in the midst of knock-down, drag-out battles in which bills were grasped, heads were pecked and the vanquished were forced into a submissive posture half buried in the sand.[13] The battle ended after a series of these one-on-one duels, and the groups dispersed in different directions. It was not clear to me that either gang had emerged victorious.

The mockingbirds found on the Galápagos Islands do not mimic the songs of other birds or the sounds of insects and frogs like their continental relative the Northern Mockingbird (*Mimus polyglottos*). They appear to have descended from Caribbean vagrants, the Bahama Mockingbird (*Mimus gundlachii*), that are not mimics either, but they hold a place of distinction in the biology of evolution. During his brief visit to the Galápagos Islands in 1835, Charles Darwin saw what are now regarded as three of the four species (he did not see the Española Mockingbird). He realized that different islands were home to mockingbirds with slightly different features, and that all the island birds were different from their mainland relatives. This observation, together with similar findings on finches and giant tortoises, was critical in the development of Darwin's views of speciation and, ultimately, his theory of natural selection.

American Goldfinch

Species
Spinus tristis (Male)

Length
4.5–5 in. (11.4–12.8 cm)

Wingspan
7.5–8.7 in (9–22 cm)

Weight
Summer: 0.4–0.5 oz. (11.0–13.0 g)
Winter: 0.5–0.7 oz. (13.5–20.0 g)

Conservation Status
Least concern

Population
Unknown; increasing

Lopez Island, Washington (August)
Olympus OM-D E-M1X | M 300 mm f/4 + MC 14 (x1.4) (full-frame equivalent: 840 mm) | 1/5000 at f/5.6 | ISO 1000 | Pro Capture

By late summer, the lilac-colored flower heads of Canada Thistles (*Cirsium arvense*) have been usurped by tufts of fine silk hair like the bristles of a white shaving brush. Groups of 30 or more of these gossamer strands are attached to a tiny seed pod, ready to act as a sail to spread this invasive weed far and wide.[15] Unless, of course, a gourmet goldfinch gets there first. These birds land on the thistle heads and create a snowstorm of flying silk, tugging the heads loose to access the seeds that they covet.[16]

And so it was that, in mid-August, I spent several days standing in the middle of a large thistle patch on the shore of San Juan Channel, working to get just the right shot of a goldfinch in flight. The pernicious roots from this patch spread underneath a large Douglas Fir (*Pseudotsuga menziesii*), where I had spent many hours in the spring waiting to photograph Bald Eagles (*Haliaeetus leucocephalus*) landing (see pages 12–13). But now, as I stood among the thistles, I was content to see the eagles come and go without so much as turning my lens in their direction. Photographing these small birds, not much larger than a hummingbird, requires concentration and a confluence of good luck, good lighting and minimal wind. The latter is important because each potential flight series begins with framing the bird as it is perched on a thistle head. When that head sways in the wind, maintaining focus without tracking is challenging. The birds are invariably in an obscured location, and they fly away in the "wrong" direction. The depth of field with a long focal-length lens is punishingly small, and this results in many blurred images. However, each day my technique improved until I captured the image of this male bird flying toward the camera.

This image reinforces the notion of how very different bird wings are from the rigid, planar structure of airplane wings. There is a different torsion in each wing as it flexes during the vigorous downstroke to face the stiff headwind. Birds use various maneuvers for fine flight control, including changing effective wingspan (sometimes asymmetrically), tilting the wing at the shoulder and sweeping back the wings. Biologist Brett Klaassen van Oorschot and his colleagues (see *Further Reading*) have found that this shape-changing or wing morphing "appears to be ubiquitous among flying birds."

Cedar Waxwing

Species
Bombycilla cedrorum

Length
6.1 in. (15.5 cm)

Wingspan
11.8 in. (30 cm)

Weight
1.2 oz. (32 g)

Conservation Status
Least concern

Population
Unknown; increasing

Lopez Island, Washington (August)

Olympus OM-D E-M1X | M 300 mm f/4 (full-frame equivalent: 600 mm) | 1/6400 at f/4 | ISO 1000 | Pro Capture

The skeleton of a homesteader's stone fireplace guards the entrance to Fisherman Bay on Lopez Island, Washington, from behind the remnants of an old orchard. One small tree, a Black Mulberry (*Morus nigra*), stands alone, embarrassed perhaps by its broken limbs and a peach fuzz of foliage clinging to the remaining branches.[17] The tree's forlorn anatomy does, however, make it an ideal setting for photographing the sublime Cedar Waxwings.

I developed a close relationship with this tree during almost 15 hours of shooting over five days. As each session progressed, I moved in a circle around the tree to keep the sun at my back. Cedar Waxwings are not common summer birds in my neighborhood. These birds visited the tree about every 90 minutes on average, and they rarely stayed for more than a minute. I had to concentrate intensely in order not to miss such fleeting opportunities. The male in this image was flying upward from one branch to another, turning his masked head to the side and just showing a glimpse of his yellow-tipped tail feathers, which look dipped in paint.

The apparent absence of vocal signaling between the birds puzzled me until I pulled up a Cedar Waxwing sonogram. The high-pitched sound that these birds emit is centered at about 7,000 to 8,000 Hz (cycles per second) compared, for example, to American Robin (*Turdus migratorius*) chirps that clock in at about 4,000 Hz. Even on the recording, these songs were faint for me. Remorsefully, I realized that too many hours in the pilot's seat of an airplane and on the end of a chain saw have destroyed the hair cells in my cochlea, which respond to high frequencies.

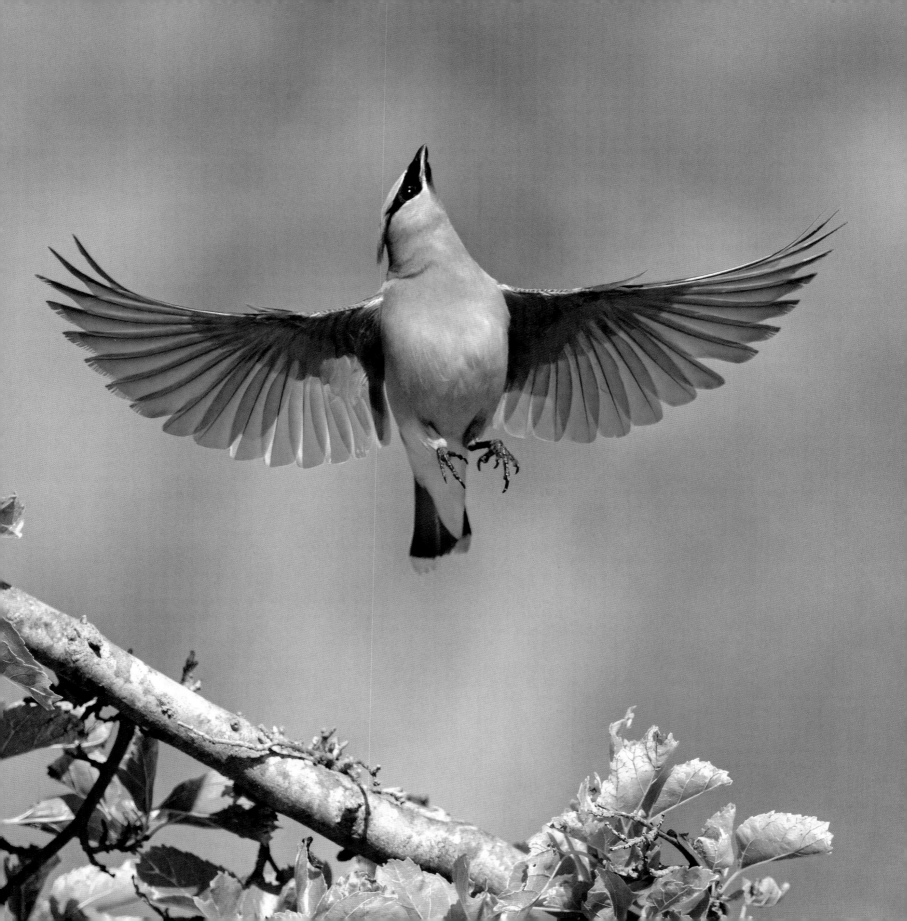

Rufous-chested Swallow

Species
Cecropis semirufa

Length
9.45 in. (24 cm)

Wingspan
12.6–13.6 in. (32–35 cm)

Weight
0.8–1.4 oz. (25–40 g)

Conservation Status
Least concern

Population
Unknown; increasing

Satara, Kruger National Park, South Africa (January)
Canon EOS-1D X | EF 500 mm f/4L IS USM | 1/3200 at f/5 | ISO 2500

I have very few flight shots of swallows, swifts and martins. These birds fly so fast and turn so unpredictably that the typical result of a photography session with them is a lot of out-of-focus images. Even modern, multi-point automatic focus camera systems are often not fast enough to bring the bird into focus before the exposure. The best shots of flying birds are invariably those the photographer was able to plan. That often means shots shortly after takeoff from a perch or a feeding location so that the photographer has ample time to prepare for the bird's flight. The behavior of this Rufous-chested Swallow (also known as a Red-breasted Swallow) allowed me to take the shot with helpful prior knowledge. This swallow was acting very much like a conventional flycatcher: perching on a favorite branch, making a sortie to take food in mid-flight and then, most of the time, returning to the same perch. This enabled me to use single-point focusing on the branch while the bird was away hawking insects and then slightly raise the camera, moving the focus point to the bird as it landed. The entire landing sequence resulted in about seven images, and in four of these the bird was sharp with a wings-spread posture.

Swallows are everywhere in the South African bushveld and, in contrast to some other avian inhabitants, they are doing very well. Some species are migratory visitors from the northern hemisphere with such a large geographical distribution that their global population is not vulnerable to local alterations in habitat or food availability. In an unusual inversion of the typical human impact paradigm, Rufous-chested Swallows appear to have benefited from human presence: They often choose buildings, culverts and bridges over natural sites for their nests. The individual components of Rufous-chested Swallow songs are not particularly melodious. Cornell's *Birds of the World* described them as "a soft gurgling; a plaintive *seeur*, and a short *chip*." When these sounds are combined into a repeated musical phrase, the narrative of a pair of staccato high-frequency notes quickly followed by lower two-toned trilling makes for a beguiling song that seems a perfect fit to this elegant bird's breezy demeanor.

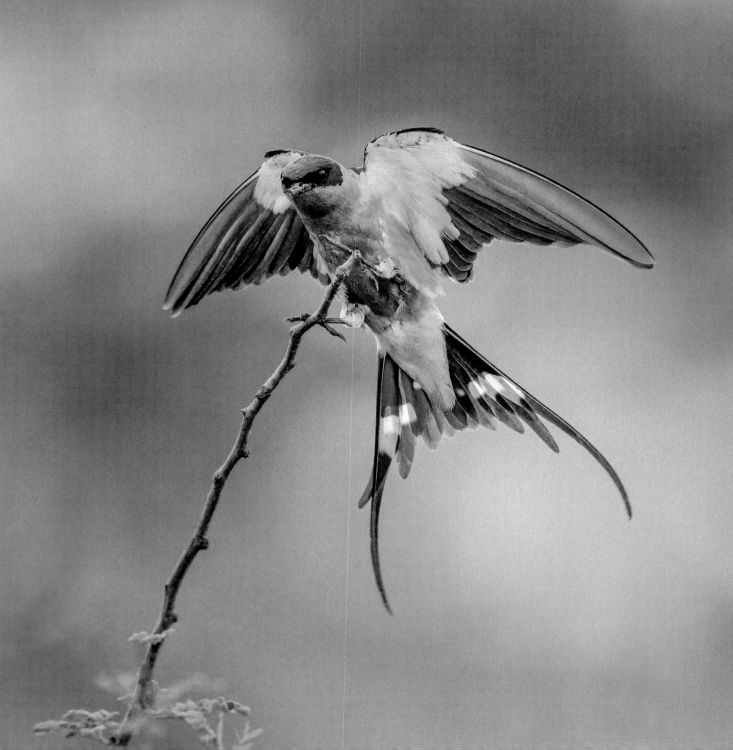

11 Favorites

Previous Spread

Species
Resplendent Quetzal (*Pharomachrus mocinno*) (Male)

Location
Cerro de la Muerte, Costa Rica (March)

Settings
Canon EOS-1D X | EF 500 mm f/4L IS USM | 1/2000 sec at f/4 | ISO 6400

Parents are not supposed to have favorite children, but it is an established fact that they guiltily do. Artists, on the other hand, often have no remorse whatsoever when asked to identify their favorite works. For Paul McCartney, the song "Here, There and Everywhere" comes out on top; architect I. M. Pei's favorite from his portfolio was the Miho Museum in Koka, Japan; Georgia O'Keefe's most inspiring subject was the Cerro Pedernal, a narrow mesa in northern New Mexico; and Ansel Adams considered the 1960 photograph *Moon and Half Dome* his favorite Hasselblad image.

I can tell that a photograph is destined to become a personal favorite when I look at it over and over after first putting it up on my computer screen. The image creates a buzz of excitement that needs to be renewed and validated. However, this is a necessary but not sufficient criterion, since there is another reason that I often binge view an image: I wish it was just a little better than it actually is. Perhaps the bird's posture is not perfect, or the view is partially obstructed or the exposure or focus is too far off to be rescued in post-processing. The danger of this form of viewing is that I am trying to convince myself that an image is good enough to publish when I know in my heart that it is not.

Favorite images are also subject to shifting judgment over time. We all have a tendency to believe that our latest work is our greatest achievement. In an ideal world, this would be the case as each new image builds on the experience and expertise from all those that preceded it. I presume that Claude Monet updated his favorite painting of the Houses of Parliament as each of the 19 variants emerged and as the astonishing series of 250 water lilies unfurled over a 30-year period. There is a sense in which social media has short-circuited this slow evolution toward perfection. Images are now posted within seconds of capture, begging for "Likes" and "Comments." I can't imagine that a modern-day Monet's

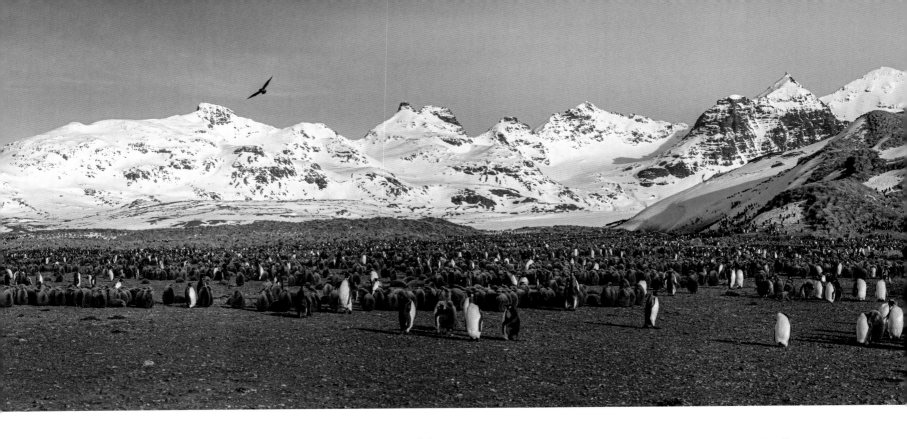

250th water lily would receive more than a yawn on Instagram, and this effect discourages repetition.

Candidates for my own favorite flight photographs come in many flavors: a favorite place, a favorite bird, a favorite posture or a favorite time of year. Each of these categories are represented among the images in this chapter. Seven of the ten images are associated with water, straddling the globe over a 111-degree arc from the Outer Hebrides (latitude 56.4 degrees north) to the island of South Georgia (54.4 degrees south). My own affinity for water is more than matched by the magnetism that draws vast colonies of birds to the aquatic feeding opportunities in many of these favorite places. The richness of wildlife on Bass Rock in Scotland or in South Georgia bombards the senses and leaves the visitor gasping in awe, particularly at the latter enclave, which is inhabited by more than 30 million pairs of birds and, during the winter, only half a dozen fortunate humans. While the majority of these birds are penguins and do not fly, Brown Skuas (*Stercorarius antarcticus*) and Southern Giant Petrels (*Macronectes gigantus*) patrol the skies above penguin colonies seeking just the slightest chink of an opportunity to wreak havoc below. Landscapes like these make an imprint on the soul.

A single Southern Giant Petrel soars above a massive King Penguin (*Aptenodytes patagonicus*) colony on Salisbury Plain, South Georgia, looking for the opportunity to steal an egg or a wayward chick.

A Brown Skua scores a Rockhopper Penguin (*Eudyptes* sp.) egg on New Island, Falkland Islands

A Bald Eagle, with its head vertically aligned, pivots in the air to rapidly change direction.

A pair of Keel-billed Toucans contemplate sharing food. Boca Tapada, Costa Rica.

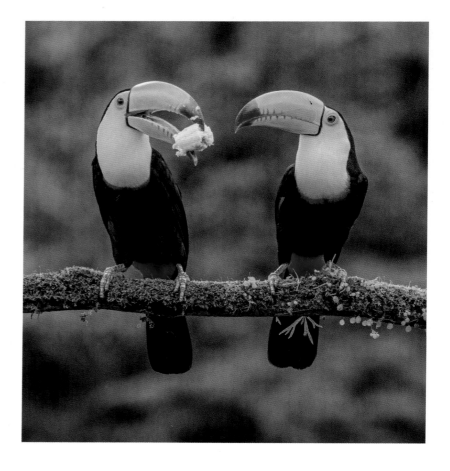

The revolving door from which my new favorite bird species periodically emerges is fed by opportunity, new exposures and new insights in bird behavior. Owls, eagles, puffins, boobies, quetzals and weavers have all spent time at the top of my leaderboard, which is currently occupied by the Keel-billed Toucan (*Ramphastos sulfuratus*). Cartoon toucans have proven popular with many people over the years, popping up in advertisements for Guinness and Fruit Loops cereal, but the joy of seeing the real bird for the first time — sparkling vibrantly on my LED viewfinder — remains an absolutely memorable event.

Some images are elevated to favorites because they remind me that birds can sometimes fly like high-performance jets. So much about aircraft design has been borrowed from birds. However, more than a century of progress in human-powered flight has not yet managed to emulate the versatility and nuance that 140 million years of bird flight

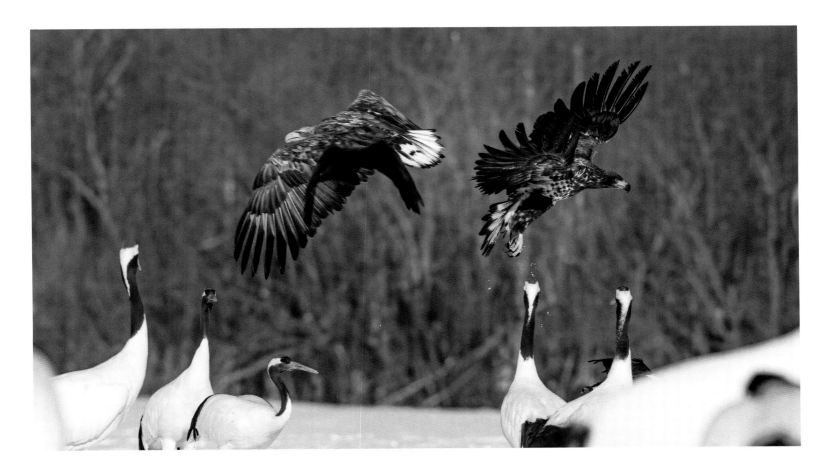

Adult (left) and juvenile White-tailed Eagles (*Haliaeetus albicilla*) cross paths above a group of Red-crowned Cranes on a snow-covered field in Hokkaido, Japan.

evolution has produced. When a fast-flying Bald Eagle (*Haliaeetus leucocephalus*) drops a wing and rolls smoothly into a 90-degree banked turn, the viewer is witnessing aeronautical perfection. As I confess elsewhere, I have an insatiable thirst for photographing Bald Eagles, both because of their advanced flying skills and their striking appearance.

Occasionally, the beauty of both season and bird combine to leave an indelible impression. My winter visit to Hokkaido, Japan, to photograph Red-crowned Cranes (*Grus japonensis*) and sea-eagles when the entire landscape was carpeted in deep snow was one of those occasions. It is a photo shoot that I often replay in my mind, ambivalent over whether to let it rest as a unique pinnacle event or revisit it to perhaps capture even better images. That dilemma expresses the joy and the opportunity of favoritism: Images that we love sustain us, but they also motivate us to seek ever more appealing subjects in front of our lenses.

Atlantic Puffin

Species
Fratercula arctica

Length
10.2–14.2 in. (26–36 cm)

Wingspan
18.5–24.8 in. (47–63 cm)

Weight
1.0 lb. (460 g)

Conservation Status
Vulnerable; endangered in Europe

Population
12 million–14 million birds; decreasing

Island of Lunga, Inner Hebrides, Scotland (July)
Canon EOS-1D X | EF 70–200 mm f/2.8L IS II USM +1.4x | 1/4000 sec at f/6.3 | ISO 1000

The German composer Felix Mendelssohn visited the Inner Hebrides archipelago in 1829. A stop on the Isle of Staffa was of particular significance for him. The overwhelming sensory stimuli of this wild place — the echo of waves crashing against towering hexagonal columns of extruded basalt inside a mystical cave — flowed into his brain and emerged as one of his best-loved pieces of music, *The Hebrides Overture*, also known as *Fingal's Cave*. The overture's haunting theme led Queen Victoria to visit the cave herself, and my own mother to declare *Fingal's Cave* to be her favorite piece of music, so it was with considerable nostalgia that I visited the cave and then climbed the steep path to the cliff top above. There is little doubt that Mendelssohn saw puffins, since every yard of cliff edge on these otherwise uninhabited islands is occupied with a puffin burrow, and a constant flow of puffin traffic toils between sea and shore.

Puffins are clumsy, labored fliers. Their wings are a design compromise for both flying and swimming. Auks, the family of birds to which puffins belong, actually "fly" underwater. Studies have shown that puffin wings are partly folded as they rotate when the birds are swimming and not outstretched as they are in air. To the photographer on the cliff top, puffin "pop-ups" like the one in this image can be challenging to capture. The birds make a steep ascent from the water and are not visible until just before touchdown. This offers only a very brief instant for locking focus on the rapidly approaching bird. I took over 3,000 shots during two brief visits to Lunga, and this is one of the few sharp flight images I have of a "loaded" bird bringing food back to its burrow. Despite their large worldwide numbers, Atlantic Puffin populations are decreasing at an alarming rate. The European population is expected to decrease by up to 79 percent in three generations because of food shortages, human and animal predation and entanglement in fishing gear. A world without puffins would certainly be a diminished place.

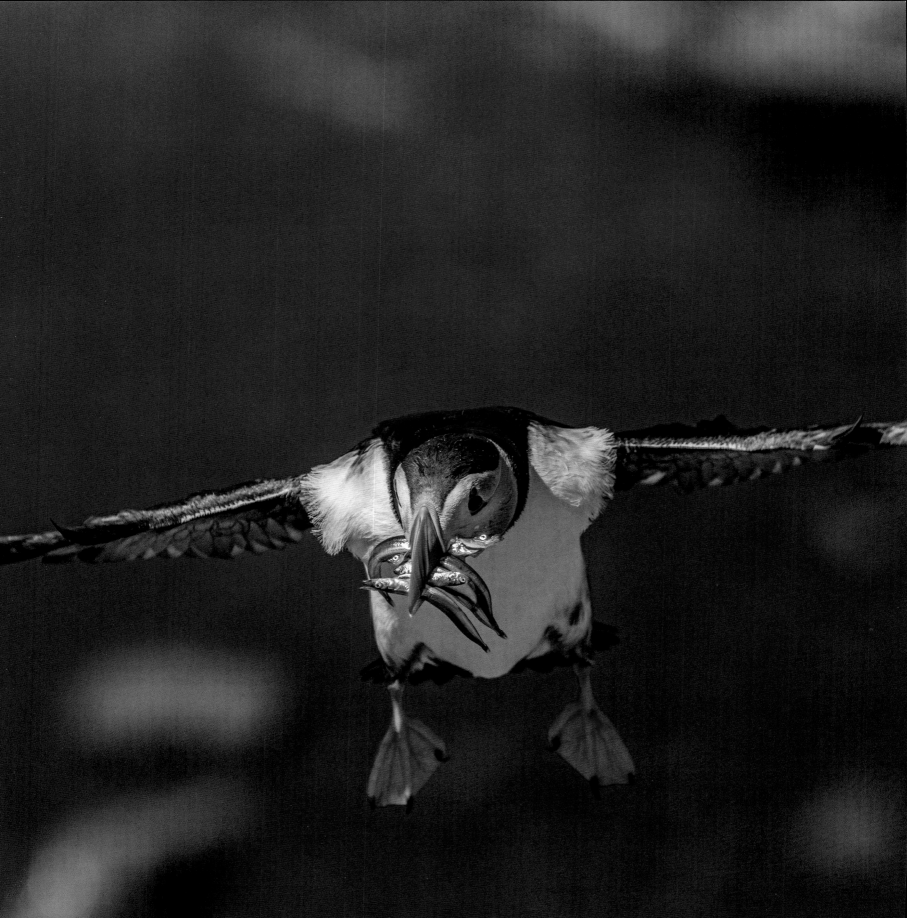

Southern Yellow-billed Hornbill

Species
Tockus leucomelas

Length
15.7 in. (40 cm)

Wingspan
6.0–7.1 ft. (182– 215 cm)

Weight
Male: 5.4–8.5 oz. (153–242 g)
Female: 4.9–7.4 oz. (138–211 g)

Conservation status
Least concern

Population
Unknown; decreasing

Finding a hornbill nest during the breeding season is a bonanza for a bird photographer. The cycle of incubation, hatching and feeding of the chicks leaves the female sealed off and incapacitated, and transforms the male into a food deliveryman who can be dependably photographed on his many provisioning trips to the nest.

Much of what we know about the nesting behavior of these absolutely fascinating birds comes from doctoral dissertations that provide behavioral and physiological data from inside nest cavities. We now know that once the couple agree on a suitable tree hole for the nest, the female birds settle in and seal the entry with mud, feces and other debris, so that there is just a small vertical slit for air and food access. Then, in quick succession, she sheds her tail feathers, lays up to five eggs and sheds her wing feathers. She is now completely dependent for the next 60 days on her faithful partner who makes constant visits to the nest, dropping food, such as the millipede shown in this image, into the nest for the female and, after about 30 days, their chicks. The dark side of this otherwise touching story of harmonious co-parenting is that the female bird will sometimes engage in cannibalism of both eggs and chicks. The latter is thought to occur in order to reduce brood size when the male is not delivering enough food.

As we were driving close to the Letaba River, my guide — master birder Bruce Lawson — spotted this bird leaving the nest tree. For the next several hours we cataloged the day's menu of protein-rich scorpions and millipedes, as well as occasional fruits. Before each delivery, the male landed on an intermediate perch and looked around to make sure that the coast was clear of predators and food thieves. He then flew to the nest opening, flapping his wings rapidly to maintain position for the drop-off.

Letaba, South Africa (January)

Canon EOS-1D X | EF 500 mm f/4L IS USM | 1/3200 sec at f5.6 | ISO 2000

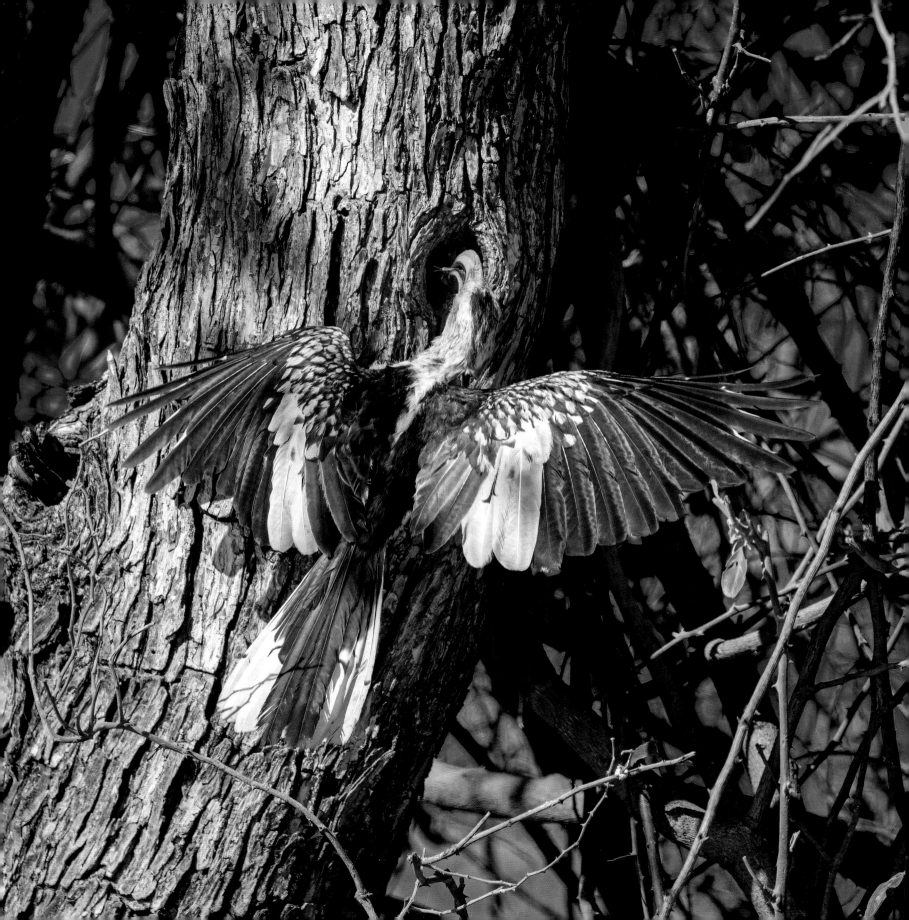

Snowy Sheathbill

Species
Chionis albus

Length
13.4–16. in. (34–41 cm)

Wingspan
2.4–2.6 ft. (75–80 cm)

Weight
1.0–1.8 lb. (460–810 g)

Conservation Status
Least concern

Population
10,000 pairs; stable

They appeared like phantoms, dropping out of the clearing fog to make a fluttered landing on our safely anchored ship, the *Ushuaia*. This former National Oceanic and Atmospheric Administration vessel would eventually carry us through the challenging seas of the Southern Ocean to the fastest-warming place on Earth, the Antarctic Peninsula. On this day, however, we were positioned for a Zodiac landing at Ocean Harbor on the island of South Georgia, a former hub of the early 20th-century whaling industry that only ceased its carnage when almost no whales were left to catch.

The Snowy Sheathbill was described by an early observer as "a genus with the general appearance, gait, and flight of a pigeon, with the beak and voice of a crow; with the habits of a wader, yet dreading the water, and with pugnacity and familiarity with man of a rasorial [gallinaceous] bird."[1]

This appropriately white-washed bird makes a hard living in snow-covered locales, scavenging on the fringes of penguin and marine mammal colonies, where it is a constant presence. Sheathbills have the not-so-endearing habit of eating the feces of the birds and mammals they live with. In keeping with the crow attribution, they are omnivorous and will take whatever food is available, from krill to penguin chicks and seal placentas. This search for food is highly preoccupying: Studies have shown that sheathbills spend 86 percent of their time on feeding or displaying activities. After the first sighting shown in this image, we encountered Snowy Sheathbills at almost every stop in South Georgia and the Antarctic Peninsula.

South Georgia Island, southern Atlantic Ocean (November)
Canon EOS-1D X | EF 100–400 mm f/4–5.6L IS USM at 105 mm | 1/8000 sec at f/5.6 | ISO 2000

Southern Rockhopper Penguins

Species
Eudyptes chrysocome

Length
20.1–24.4 in. (51–62 cm)

Weight
4.4–8.4 lb. (2.0–3.8 kg)

Conservation Status
Vulnerable

Population
2.5 million mature birds; decreasing

The Neck, Saunders Island, Falkland Islands (January)

Canon EOS-1D X | EF 100–400 mm f/4–5.6L IS USM at 100 mm | 1/5000 sec at f/6.3 | ISO 800

Penguins do not have the wings to fly, but, as is obvious from this photograph, that does not stop them from getting airborne. Southern Rockhopper Penguins have a challenging lifestyle, starting first thing in the morning when they wake up in a colony that is often several hundred feet above sea level.

Rockhoppers are magnificent in the water but clumsy on land. Rockhopper locomotion involves two-footed hopping up and down obstacles — flippers outstretched like a tightrope walker — with walking in between hops. They make the long trek from the colony to the water's edge in small groups, often down a steep gully and then enter the water at a rocky ledge. The return to land is risky. In often heaving seas, rockhoppers either ride a wave that crashes on shore or swim hard toward shore at high speed and leap from the water, hoping to make landfall. Often they fail and get pounded against the shore.

Getting this shot required resisting the powerful pull of the other species that inhabit the Neck at Saunders Island. A massive colony of Black-Browed Albatrosses (*Thalassarche melanophris*) was within easy walking distance; Gentoo Penguins (*Pygoscelis papua*), who also make occasional airborne landings, abounded; and even a few King Penguins (*Aptenodytes patagonicus*) call this unique saddle of land between two hills their home. But once I had made my decision that a "flight" shot of rockhoppers was to be the day's primary target, I settled on the rocks with a handheld zoom lens and tried to identify birds swimming shoreward underwater at high speed in order to start locking focus on potential "fliers."

Collared Aracari

Species
Pteroglossus torquatus

Length
15.0–16.9 in (38–43 cm)

Wing Length[2]
5.4–6.3 in. (13.6–15.9 cm)

Weight
Male 6.2–9 oz (175–254 g)
Female 4.9–8.7 oz (183–246 g)

Conservation Status
Least concern

Population
Unknown; decreasing

Boca Tapada, Costa Rica (February)

Olympus OM-D E-M1X |
M 40–150 mm f/2.8 at 95 mm
(full-frame equivalent: 190 mm) |
1/4000 sec at f/2.8 |
ISO 2000

Collared Aracaris love to travel in company or, more correctly, in a durante (the odd collective noun memorializing the musician and actor Jimmy Durante [1893–1980], who was renowned for his very large nose). I have loved these birds ever since I saw a handsomely colored Chestnut-eared Aracari (*Pteroglossus castanotis*) in the treetops of Brazil's Pantanal.[3] I left the Pantanal without an aracari flight shot and, like the Saddle-billed Stork (see pages 120–121), this genus lingered on my "to get" list for a number of years. Incidentally, the genus name *Pteroglossus* means "feather tongue" (from the Greek), a reference to the very long, rough-edged tongue that is occasionally visible inside the bird's serrated mandible when it moves a food morsel from the tip of its bill to its throat.[4]

In this image, the wings are at the top of a vigorous upstroke and not far from being parallel to the plane of the camera's sensor. We therefore get a good view of the outline of a wing on the far end of the design spectrum for avian aspect ratios, meaning the ratio of wing length to average wing width. In this case, that ratio is approximately two. Wings with a high aspect ratio are very efficient for soaring, while those with a low aspect ratio are much more useful for the aracari's maneuverings among the branches and dense vegetation of fruit-bearing trees.

Once landed, aracaris' movement in trees is predominantly a series of powerful out-of-phase hops (one foot before the other), taking them horizontally or to higher branches without so much as a wing flap. These movements can occur very rapidly (almost four hops per second), which contributes to their animated appearance and to the challenge that the photographer faces to capture them.[5]

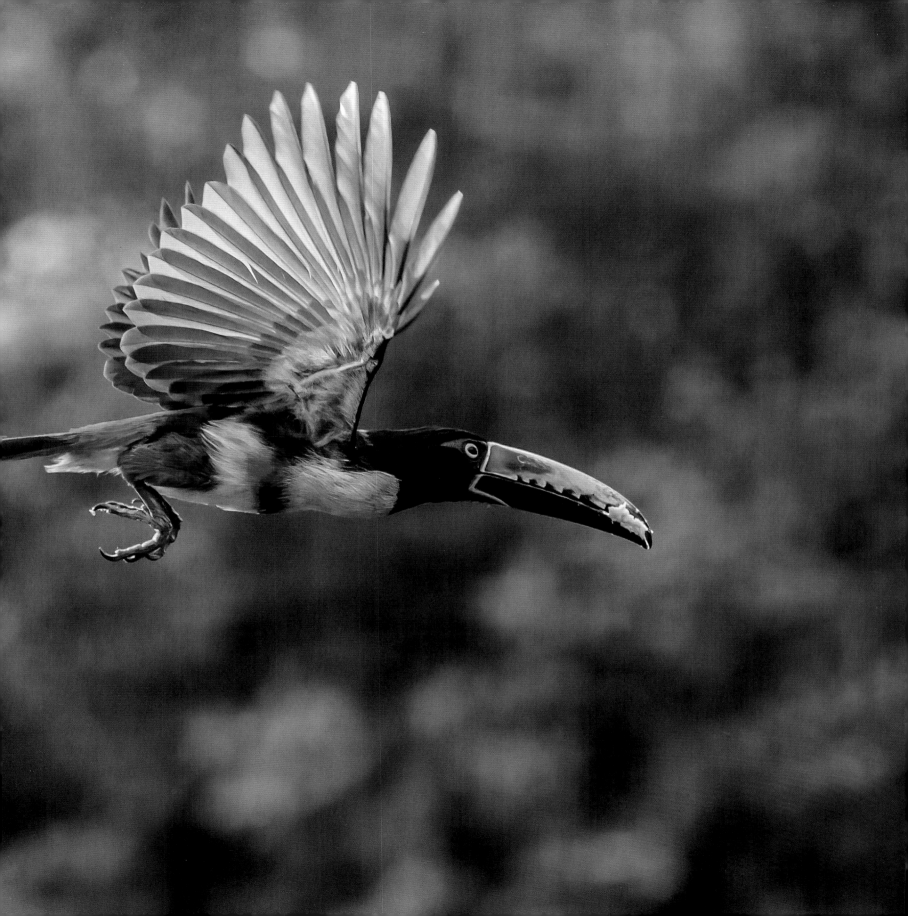

Glossy Ibis

Species
Plegadis falcinellus

Length
18.9–26.0 in. (48–66 cm)

Wingspan
2.6–3.1 ft. (80–95 cm)

Weight
0.8–1.8 lb. (350–840 g)

Conservation Status
Least concern

Population
230,000–2,200,000 birds; decreasing

Chobe River, Botswana (July)
Canon EOS 50D | EF 600 mm f/4L IS USM | 1/1250 sec at f/4.5 | ISO 500

Australian photographer Trent Parke once remarked that "light turns the ordinary into the magical." In its usual incarnation, the Glossy Ibis is just another ordinary (if somewhat handsome) bronze bird pursuing its day job of foraging along the riverbank, but in this image, the bird is transformed into a magical being by brilliant African morning light illuminating its metallic green and purple plumage.[6] The setting was equally dramatic: a low-slung pontoon boat moving slowly along the Chobe River with the breath of gaped-mouthed hippopotamuses hanging menacingly in the air.[7] These are moments that become hardwired into the brain, easy to recall and savor again many years afterward.

Turning from the metaphysical to the mundane, this photograph also contains some interesting clues about the aerodynamics of the moment. The bird's outstretched left wing exposes the three main layers of its upper wing, which are laid out like thatch on a rooftop. The lower layer is composed of the primary and secondary flight feathers, the middle row is the main coverts and the top row contains the secondary coverts. Notice that the secondary coverts are ruffled. This indicates that the airflow is turbulent over this portion of the wing and that the wing is about to stall (similar to the Sandhill Cranes on page 216). Birds use stall landings to drop into preferred perches with minimum forward velocity. The apparent break in the line along the leading edge of the left wing provides a very good view of the alula, which is a small winglet of three to five feathers on the remnant of the bird's "thumb," which allows it to modulate the airflow over the top of its wing.

The binomial name of the Glossy Ibis is a doubling down on the bird's most prominent structural feature, its scythe of a bill: *Plagados* means "sickle" in Ancient Greek, and *falcis* is Latin for "sickle."[8] In my mind, however, this bird will always be associated with magical light, rather than evolutionary adaptation.

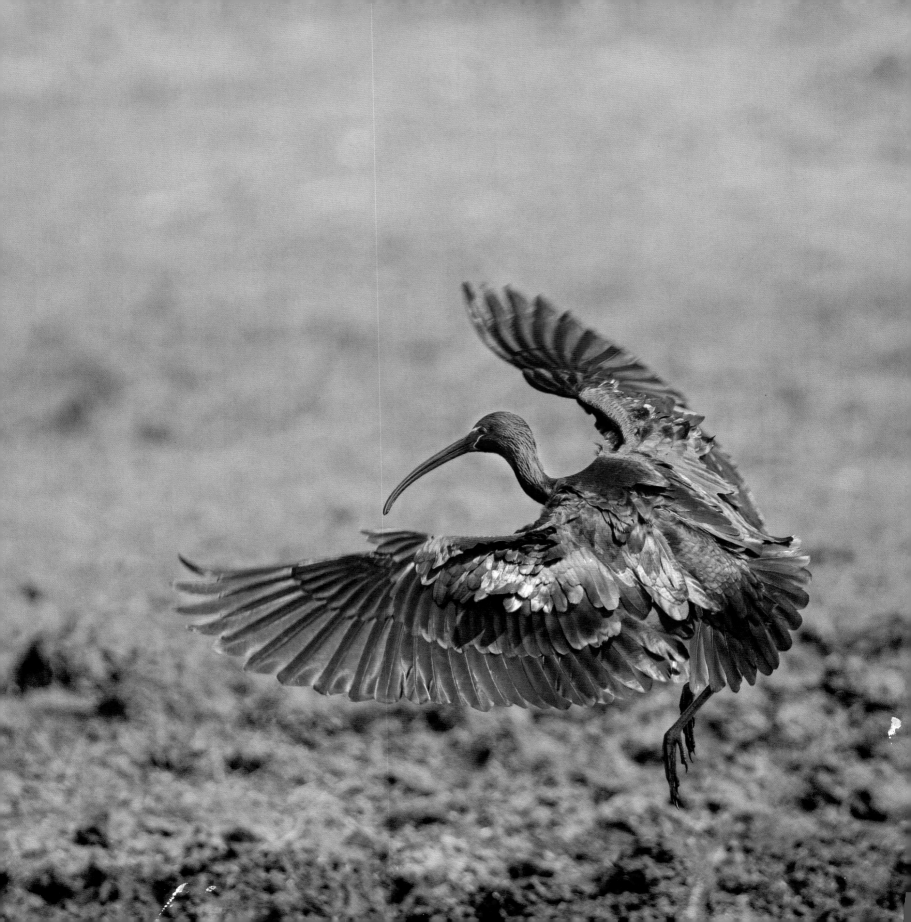

Red-and-Green Macaws & Scarlet Macaws

Species
Ara chloropterus and *Ara macao*

Length
Red-and-Green: 2.9–3.1 ft. (90–95 cm)
Scarlet: 2.7–2.9 ft. (84–89 cm)

Wingspan
4.1 ft. (125 cm)

Weight
Red-and-Green: 2.3–3.8 lb. (1,050–1,708 g)
Scarlet: 1.9–3.3 lb. (900–1,490 g)

Conservation Status
Least concern, but pet trade is a threat

Population
Red-and-Green: unknown; decreasing
Scarlet: 20,000–49,999 birds; decreasing

The bow of our narrow, motorized canoe sliced cleanly through the broad, muddy waters of the Tambopata River in the Peruvian Amazon. We had left the lodge just after dawn so that we could push upstream and arrive at the clay lick before the macaws. By the time we came ashore, the early birds were already there: flecks of brilliant color perched high in the treetops above the riverbank. Soon, the magnificent procession began: Red-and-Green Macaws, Scarlet Macaws, and Blue-and-Yellow Macaws (*Ara ararauna*) flew in, usually two by two and often with synchronized wing beats, all with impossibly long tails. Within minutes, several hundred birds formed a rainbow frieze across the green foliage. The macaws visit the lick to eat salt in the clay, which is thought to be missing in their diets, but they are easily scared off by raptors, which know this to be a good place to hunt. Sometimes the show never gets underway. On this day, a lone Scarlet Macaw conducted a reconnaissance mission. It flew down and cautiously perched on the rim above the clay lick; finding itself still alive and not under hawk attack, the bird climbed down onto the exposed nose of orange clay. That was the signal the waiting birds needed: The clay was soon a palette on which some of the brightest colors that the bird world has to offer were spread.

But caution was always on display. While the birds were clinging to the clay wall, diligently pecking to access their needed nutrient, they were in a highly vulnerable situation — facing away from, and blind to, incoming danger. Although there was no visible sign of an attacker, something frightened the group, perhaps the call of a raptor. Almost in unison, they leapt from the wall, turned 180 degrees and, seconds after this image was taken, were gone for the day.

Chuncho Clay Lick, Tambopata National Reserve, Peru (May)
Canon EOS-1D X | EF 500 mm f/4L IS USM +1.4x | 1/4000 sec at f/5.6 | ISO 1600

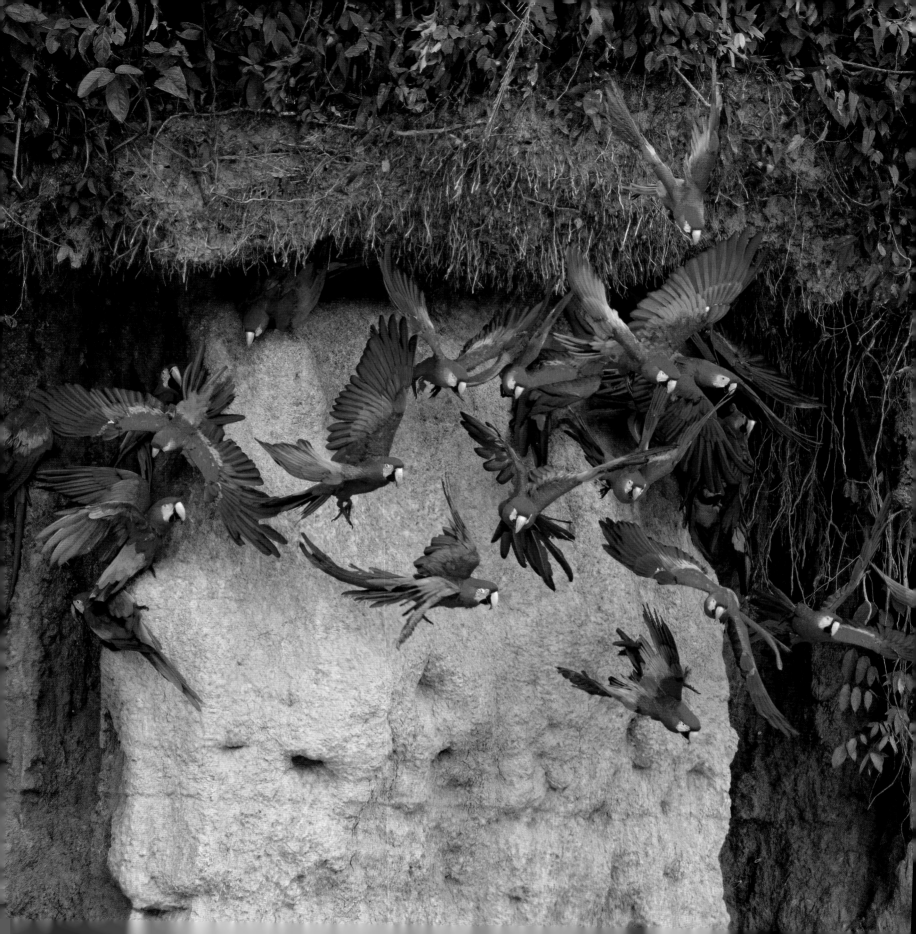

Wandering Albatross

Species
Diomedea exulans

Length
3.5–4.4 ft. (107–135 cm)

Wingspan
8.3–11.5 ft. (254–351 cm)

Weight
Male 18.1–26.3 lb. (8.1–11.9 kg)
Female 14.8–19.2 lb. (6.7–8.7 kg)

Conservation Status
Vulnerable

Population
20,100 mature birds; decreasing

South Atlantic (November)

Canon EOS-1D X | EF 100–400 mm f/4–5.6L IS USM at 100 mm | 1/1000 sec at f/9 | ISO 1000

I think we should all carry albatrosses around our necks just like the Ancient Mariner in Samuel Taylor Coleridge's poem. The mariner shot a single albatross, but we have nearly wiped out the entire albatross family. Because of human actions, albatrosses share the unfortunate distinction (with cranes) of being among the most threatened groups of birds in the world. In her 2008 article, conservationist Rosemary Gates discussed the dire status of every one of the world's 22 species of albatross.[9]

Since that time, the situation has only worsened. Every member of the albatross family (Diomedeidae) except the Black-browed Albatross (*Thalassarche melanophris*) is now classified by the IUCN Red List as at least vulnerable. The major threat is long-line fishing, which is an industrial-level fishing technique that involves placing lines more than 80 miles (130 km) long in the water with thousands of baited hooks. The albatrosses take the bait and are fatally snared on the hooks. Efforts to change fishing practices have been partially successful, but old methods die hard.

This photograph of a male bird was taken during a voyage from Ushuaia, Argentina, to the island of South Georgia in the southern Atlantic Ocean. A dense cloud of birds — mostly albatrosses and petrels — followed the ship, occasionally pausing to feed on fish and krill tossed about in the ship's churning wake. The 11.5-foot (3.5 m) maximum wingspan of the Wandering Albatross is longer than any other living bird. The high aspect ratio (the ratio of length to width) is aerodynamically efficient and has been copied by the designers of modern-day sailplanes. These birds make incredibly long foraging flights over the ocean, typically 1,200 miles (1,930 kilometers) in 75 hours with only occasional flapping. They exchange energy forms during banked turns and exploit differences between wind speeds at the different heights above the ocean, which is a technique known as dynamic soaring.

In Coleridge's poem, the Ancient Mariner was given the penance of roaming the world and telling everyone he met of his sin against the albatross. This photograph of a vulnerable species serves as a modern-day reminder that we should still be heeding the mariner's lament.

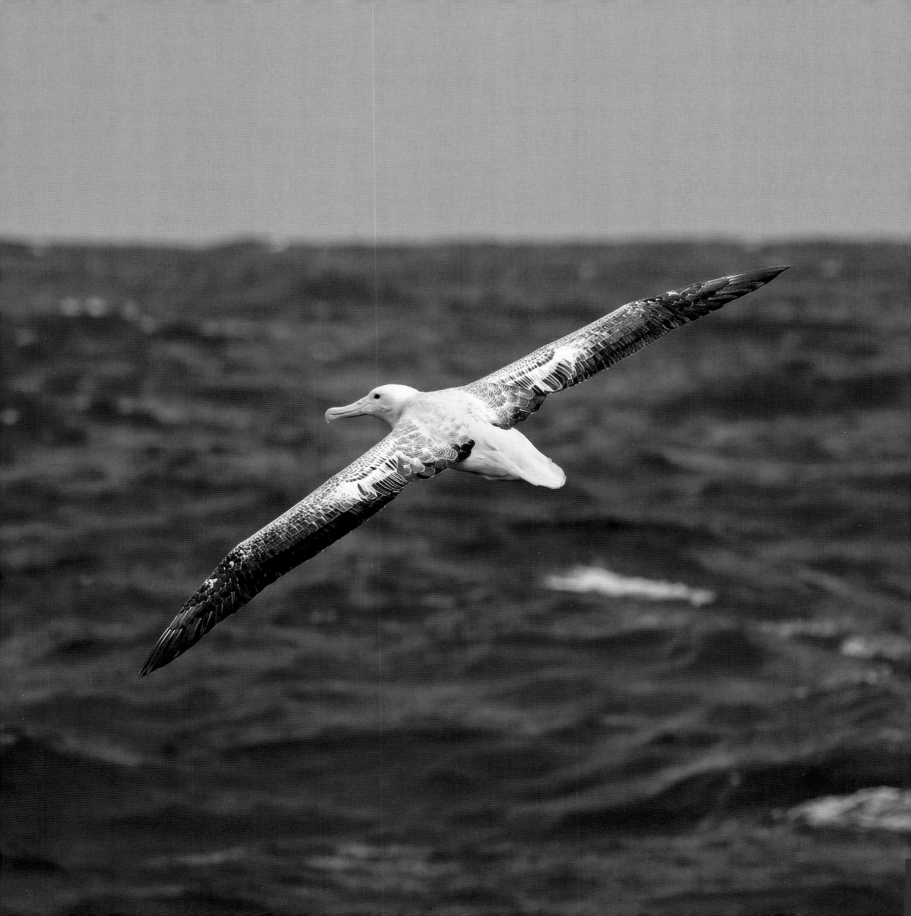

Northern Gannets

Species
Morus bassanus

Length
2.8–3.3 ft. (87–100 cm)

Wingspan
5.4–5.9 ft. (165–180 cm)

Weight
5.0–7.9 lb. (2.3–3.6 kg)

Conservation Status
Least concern

Population
1.5–1.8 million birds; increasing

When John Muir, the founder of the Sierra Club, was a child, he looked out across the Firth of Forth at the largest colony of Northern Gannets in the world. Muir and the gannets are still there today. Muir appears as a commemorative bronze statue,[10] and the birds arrive to breed at Bass Rock each year in early spring — more than 150,000 of them. At first sight, the enormous dome of volcanic rock is unearthly, with its sheer walls rising from the turbulent water to a ghostly white crown. As the small boat chartered by the Scottish Seabird Centre plowed its way toward the island, it soon became clear that the whiteness was not guano or vegetation, but rather a continuous white carpet of Northern Gannets who had claimed every available square foot for nesting.

We were fortunate that a break in the weather allowed us to land. There is no harbor on the rock, only a set of stone steps onto which the traveler has to jump as the boat rolls, buffeted by wind and unpredictable swells. Our guide, Maggie Sheddan, led us up the narrow concrete path, advising caution with the noisy chorus of not-yet-fledged gray chicks flecked-with white that pecked viciously and sometimes painfully at our legs. Maggie disappeared to rescue young birds that had fallen from the nest into a gully behind the abandoned lighthouse and would otherwise starve. We were left to roam this dense colony: a few precious hours in a world where the rules are completely defined by gannets.

Our skipper chummed the water on the way back to port, and this photograph was taken as adult gannets recovered the fish. With the Bass Rock and its lighthouse in the background, it shows two birds in the final stages of their plunge dive, wings partially folded for entry into the water.

I wonder if the young John Muir ever made a boat trip to this extraordinary rock.

Bass Rock, Firth of Forth, Scotland (September)
Canon EOS-1D X | EF 20–70mm f/4L IS USM at 24 mm | 1/5000 sec at f/4 | ISO 1000

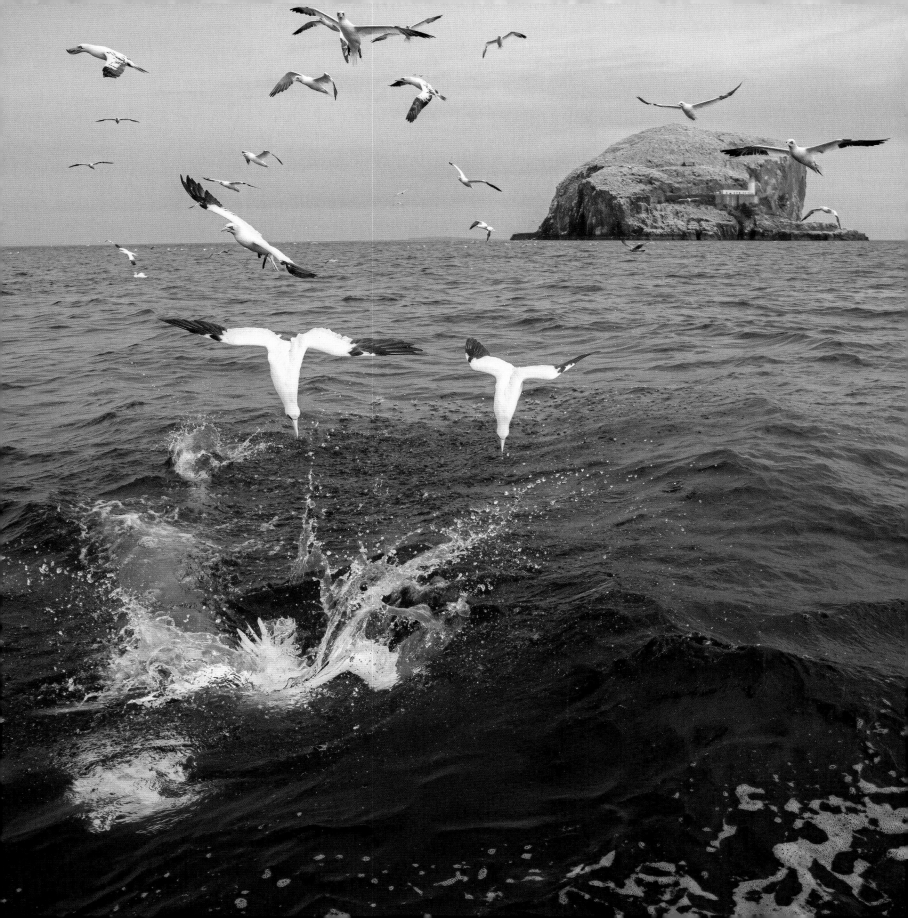

Keel-billed Toucan

Species
Ramphastos sulfuratus

Length
18.1–20.1 in. (46–51 cm)

Wingspan
3.6–5 ft. (109.2–152 cm)

Weight
Male: 10.4–21.2 oz. (295–600 g)
Female: 9.7–19.4 oz (275–550 g)

Conservation Status
Least concern

Population
50,000–499,999 birds; decreasing

Boca Tapada, Costa Rica (February)

Olympus OM-D E-M1X | M 40–150 mm f/2.8 at 95 mm (full-frame equivalent: 190 mm) | 1/3200 sec at f/3.5 | ISO 2500

This image is an appropriate finale to both the book and the chapter on favorites. It is the most recent photograph of the entire collection, taken in Costa Rica in mid-February 2020, when there was not a single confirmed case of COVID-19 in Central or South America, but just before the novel coronavirus pandemic shut down business as usual in the entire world. As I write, my photographic journeys are on hold while I look back nostalgically at images like this one.

The Costa Rican trip was planned with the Keel-billed Toucan in mind. This made me realize that I have slowly become the camera-toting equivalent of the birders in *The Big Year*. I confess that I will travel anywhere to photograph a species that has become an obsession.

My first glimpse of this truly magnificent bird banished all guilt about this now-acknowledged character flaw, as the Keel-billed Toucan shot right to the top of my list of favorite birds. How could it be otherwise, given the huge rainbow bill, sulfurous yellow throat and contrasting red bands over jet-black plumage? The function of the dramatic bill had been previously ascribed to sexual selection and effective fruit picking, and while it may be both of these, a landmark study found that the richly vascularized bill is actually a very efficient heat exchanger. The authors concluded that "the toucan's bill is, relative to its size, one of the largest thermal windows in the animal kingdom, rivaling elephants' ears in its ability to radiate body heat."[11]

While this image is a wistful backward glance to the era of unrestricted travel, it is also one that looks to the future. I took it with my new lightweight rig, a micro four-thirds camera and lens combination with a published image stabilization of seven stops, which is a game changer for wandering around with a manageable long lens for hand-held images.[12] I have since also added a Sony Alpha 1 to my armamentarium. I know this new technology is going to extend my range and challenge me to produce ever better flight images.

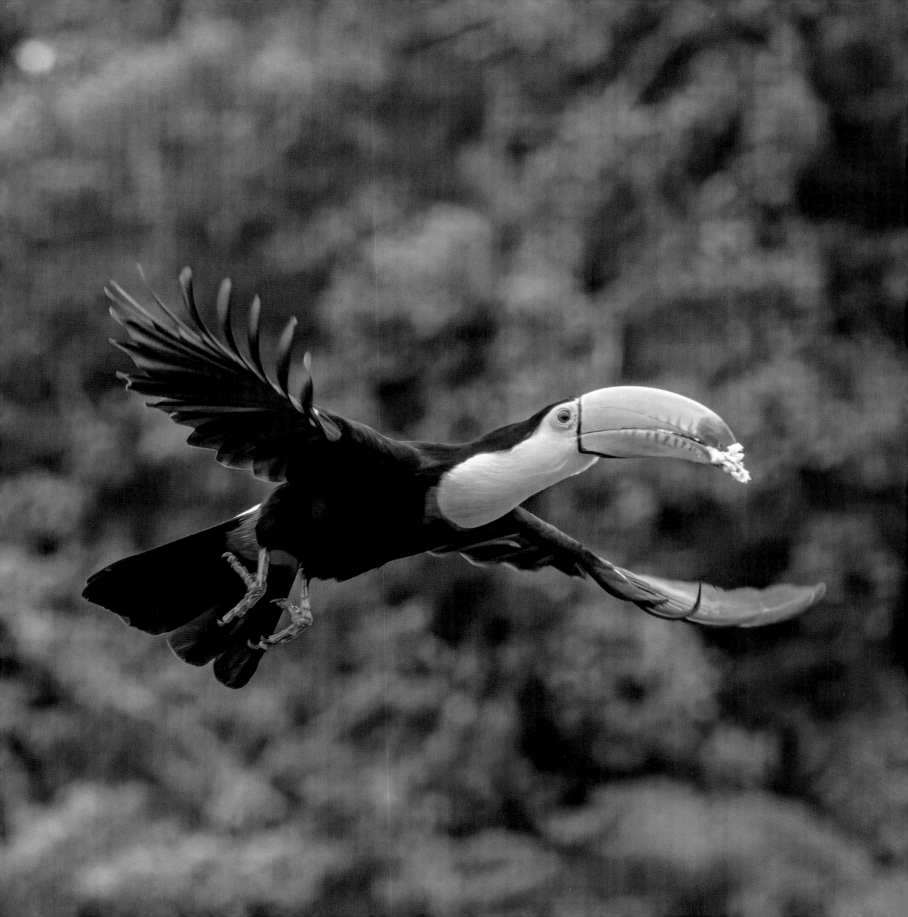

Epilogue

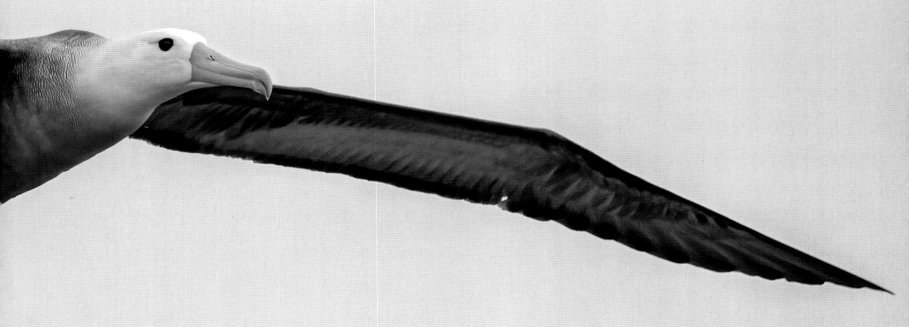

"Who has decided — who has the right to decide — for the countless legions of people who were not consulted that the supreme value is a world without insects, even though it be also a sterile world ungraced by the curving wing of a bird in flight?"

Rachel Carson, *Silent Spring*

Previous Spread

Species

Waved Albatross (*Phoebastria irrorata*)
(This species is critically endangered.)

Location

Española Island, Galápagos Islands, Ecuador (October)

Settings

Canon EOS-1D X | EF 100–400 mm f/4.5–5.6L IS II USM at 400 mm | 1/6400 sec at f/5.6 | ISO 2500

Wildlife photographers yearn for their work to celebrate life, not memorialize extinction. Unfortunately, this wish cannot be guaranteed.

The arc of human destruction of other species is long, extensive and ongoing. It started with animals that were large, lumbering and easy to kill. The mastodon and other North American megafauna succumbed to overhunting approximately 13,000 years ago. Large animals on the island of Madagascar (including the world's largest known bird, the Elephant Bird [*Aepyornis maximus*]) were driven into extinction by humans some 1,000 years ago. Next, humans turned their attention to smaller but equally accessible creatures: The Dodo (*Raphus cucullatus*), posthumously immortalized by Lewis Caroll, was lost in Mauritius in 1693, and the last breeding pair of Great Auks (*Pinguinus impennis*) were strangled by hunters in 1844 on Eldey Island. The unfathomable extermination due to "sport" hunters of a population of more than 136 million Passenger Pigeons (*Ectopistes migratorius*) was declared complete when Martha, the last captive specimen, died at the Cincinnati Zoo without offspring in 1914. Shortly after Martha's demise, a partial truce was enacted through the Migratory Bird Treaty Act of 1918, which protected birds primarily in response to the killing for plumage deemed to be fashionable.

As 20th-century urbanization and industrialized agriculture careened forward, birds (and other animals) were threatened by more covertly damaging acts such as destruction of wetlands, encroachment of habitats, pollution of land and water by toxic chemicals, climate change and acidification of the oceans. The first warning bell was loudly rung by Rachel Carson in her 1962 book *Silent Spring*, which spotlighted the effects of pesticides such as DDT on birds and other animals (including humans). The title alludes to the fact that an observer in the mid-1950s

would find that "spring now comes unheralded by the return of birds, and the early mornings are strangely silent where they were once filled with the beauty of bird song."

Carson described reports of 86 percent mortality in American Robins (*Turdus migratorius*) and "heavy mortality" in dozens of other species after DDT was sprayed on elm trees in the American Midwest. Surviving birds that ingested worms with lower concentrations of the pesticide were invariably sterile. Carson made the provocative statement that because circumstantial evidence showed that DDT had "destroyed its ability to reproduce," trends in Bald Eagle mortality "may well make it … necessary for us to find a new national emblem."

She was widely ridiculed, insulted and threatened at the time of the book's publication, but Rachel Carson is now seen as astonishingly and uniquely prescient. Her luminous legacy includes saving the Bald Eagle from extinction, and she is widely credited as the founder of modern conservationism.

Unfortunately, attention to — and action on —Carson's message of anthropogenic damage withered over time. It experienced a powerful renewal almost 60 years later when a group of biologists from the University of California, Berkeley, posed the question: "Has the Earth's sixth mass extinction already arrived?" (See the article by Barnosky and colleagues in *Further Reading*). They explored the issue quantitively, comparing present and projected loss of species to the previous "big five" mass extinctions. Their study found that the combination of, and interactions between, climate change, the rise of CO_2 levels, "habitat fragmentation, pollution, overfishing and overhunting, invasive species and pathogens, and expanding human biomass" has provided greater stress than most living species have experienced, and that the sixth mass extinction event is indeed underway.

An artist's depiction of the extinct Elephant Bird that is thought to have stood 10 feet (3 m) tall.

An engraving of a pair of extinct flightless Great Auks.

The bird families of the some 3.2 billion birds lost.

The devastating trend in loss of biomass in Latin America and the Caribbean between 1970 and 2016.

Journalist Elizabeth Kolbert won a Pulitzer Prize for translating this biological doomsday scenario into stories and language that could be widely understood in her 2014 book *The Sixth Extinction*. She identified humans as the apex predator responsible for initiating an extinction event that will potentially rival prior climate and externally mediated catastrophes.

In 2017, another distinguished group of biologists, including Stanford University's Paul Erlich, reminded us that a focus on extinction of individual species can obscure the greater truth that a widespread loss of biomass is in progress. They called it "biological annihilation" and pointed out that extinction is, after all, just the final nail in the coffin. Evidence that the avian population is in massive decline from an onslaught of human-induced stressors soon followed. A coalition of biologists from the United States and Canada reported in 2019 that there are three billion fewer birds in North America than there were only 50 years ago.

As the chart below shows, more than two-thirds of the loss has been among sparrows, warblers and blackbirds, while some families, such as vireos, ducks, geese and raptors, have actually become slightly more numerous. The net loss was over 25 percent of the 1970 North American biomass of avifauna. We know that the loss worldwide is much worse, based on the biannual reports of the World Wildlife Fund and Zoological Society of London called the *Living Planet Report*. The Living Planet Index tracks the abundance of almost 21,000 populations of mammals, birds, fish, reptiles and amphibians around the world. It indicates an average rate of decline in population size of 68 percent between 1970 and 2016. Ground zero for these losses is Latin America and the Caribbean, where a jaw-dropping 94 percent loss has been recorded.

To bring this global story of decline closer to home, I have included the conservation status of the birds for every story in this book, as provided by the IUCN Red List at the time of writing. A total of 24 species

portrayed are at least vulnerable and six are threatened, endangered or critically endangered. However, as the Living Planet Index emphasizes, that is not really the point: Among the birds whose status is known, 44 percent of the birds photographed for this book are in decline. The birds shown below are at various risk levels for extinction, but they all share the regrettable distinction of declining numbers.

The evidence is clear that we are in the midst of a dramatic and widespread extinction event. Many conservation groups focus on saving a few charismatic species by near-heroic campaigns. Whooping Cranes have been guided to new wintering grounds by ultralight aircraft (see pages 208, 210). California Condors have been reared in captivity, released into the wild and regularly recaptured for lead detoxification. A recent study showed that up to 32 bird and mammal species may have been saved from extinction since 1993. These efforts are admirable and necessary, but entirely inadequate to address the broader problem.

A seismic cultural change — a shift in the attitude of humanity toward their home base — is needed so that it is not just the informed biologists who are pressing for change, but every living person. The entire world must respect the need for, and value of, abundant wildlife. The director general of the World Wildlife Fund, Marco Lambertini, described it this way:

> [We need a change] ... that so far our civilisation has failed to embrace: a transition to a society and economic system that values nature, stops taking it for granted and recognises that we depend on nature more than nature depends on us. This is about rebalancing our relationship with the planet to preserve the Earth's amazing diversity of life and enable a just, healthy and prosperous society — and ultimately to ensure our own survival. (See the *Living Planet Report 2020* in *Further Reading*).

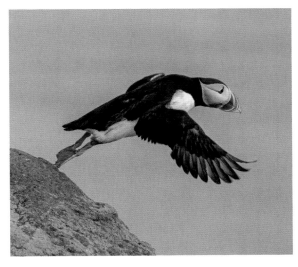

Atlantic Puffin: numerous but decreasing. Látrabjarg, Iceland.

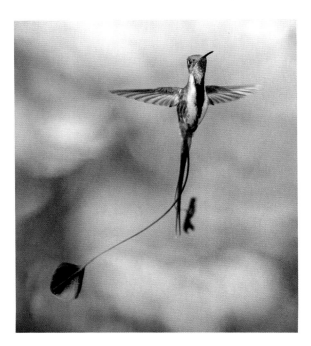

Marvelous Spatuletail: small endangered population and decreasing. Huembo Reserve, Peru.

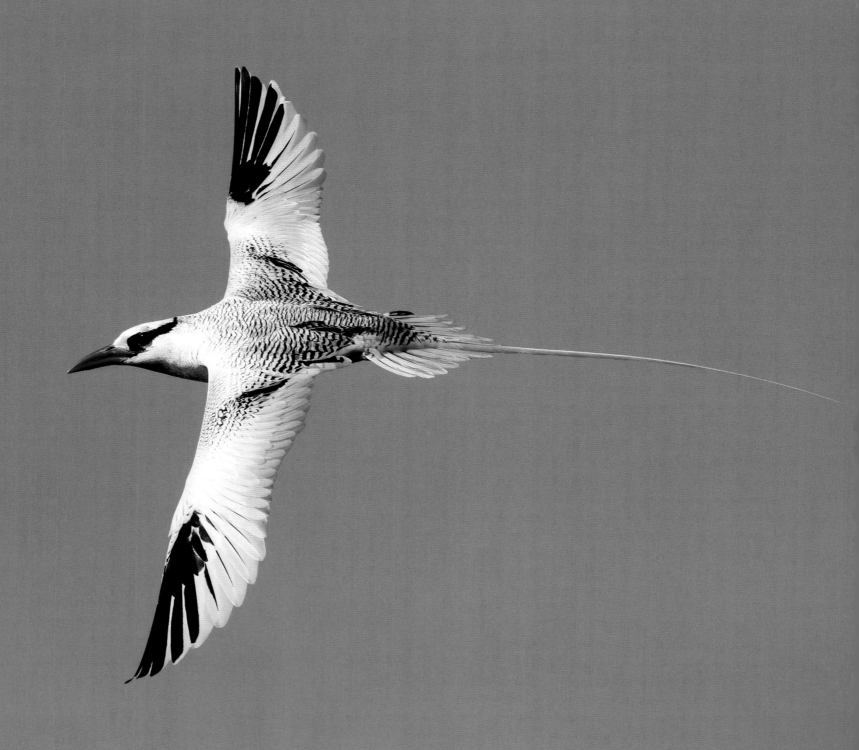

The change that Lambertini wants may only happen generationally, through the education of young people whose progression into decision-making roles will cement permanent change. It is, however, encouraging to note that shifts of opinion on related issues, such as climate change, have occurred over a shorter timescale. In the United States, a stronghold for climate denial, the percentage of people who believe that "dealing with climate change" should be prioritized rose from 34 percent in 2008 to 52 percent in 2020 (See a report from the Pew Research Center mentioned in *Advanced Reading* for the Epilogue.) Direct economic harm from weather-related events has been a powerful force in changing minds. Also, many false narratives and much obfuscation that sow doubt about climate change have been shown to be motivated by narrow-minded policies and/or self-interest (a reprise of the tobacco industry's posture on the dangers of smoking), and this reveal may itself have changed minds.

While waiting impatiently for the next generation to usher in a more nature-friendly epoch, photographers can help accelerate awareness. We travel to places that most people only know from magazines or nature documentaries, and we bring back images that can awaken consciousnesses. We visit the great reservoirs of avian biomass such as the Pantanal in Brazil and the Amazonian regions of Peru that are most threatened by deforestation and climate-induced wildfires. It is my hope that by capturing and sharing the ethereal beauty of bird flight, I may nudge some readers to take a more combative and evangelical stance on turning back the tide of the sixth extinction.

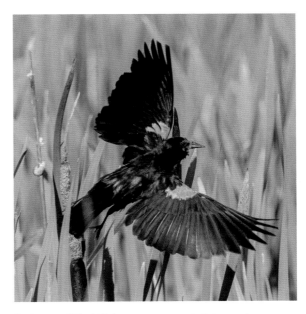

Red-winged Blackbird: very numerous but decreasing

Red-billed Tropicbird: small population that is decreasing. Genovesa Island, the Galápagos.

Endnotes

Preface

1. WING TIPS

The wings of jet airplanes started to look different in the late 1980s. Instead of the abrupt "sawn off" tip of the Boeing 707, narrow upturned tips called winglets were introduced. The wings of many birds, such as the Caspian Tern (*Hydroprogne caspia*), pictured below, show a similar configuration during flight. In both birds and airplanes, the winglet reduces drag on the wing by a complex interaction with flow over the wing.

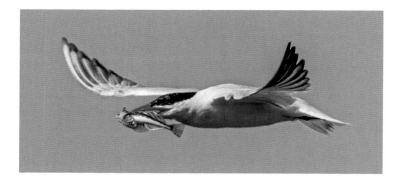

The photograph shows the wing tip of a converted 727 on which I have flown several times that is used by NASA for parabolic flight maneuvers. Like many other models, this airplane was retrofitted with winglets. Current blended winglets are estimated to save 4–6% in fuel costs and reduce noise compared to a straight tip.

2. ARCTIC TERN MIGRATION

The Arctic Tern is the animal kingdom's long-distance migration champion. This bird breeds in Greenland, flies south to Antarctica in the fall and back to Greenland in time for spring. For some birds, this is a round trip of about 49,710 miles (80,000 km). In their average 30-year life span, Arctic Terns travel a distance equivalent to going to the moon and back three times. Although the straight-line distance between Greenland and the Antarctic Peninsula is only approximately 11,000 miles (17,703 km), the terns deviate from this path due to prevailing winds and the need for stopovers.

3. BIRDS OF THE WORLD

The Cornell Lab of Ornithology's authoritative online reference to all species of birds in the world can be found at https://birdsoftheworld.org/bow/home. This site, which requires a paid subscription for access, was developed from a prior website and print version called *Handbook of Birds of the World*, which is still available as a 16-volume printed book set at https://www.lynxeds.com/product/handbook-of-the-birds-of-the-world/.

4. THE RED LIST

The International Union for Conservation of Nature (IUCN) describes itself as "the world's largest and most diverse environmental network ... [and] ... the global authority on the status of the natural world and the measures needed to safeguard it" (https://www.iucn.org/, accessed July 2, 2019).

IUCN maintains the Red List of Threatened Species, which is a comprehensive source for the conservation status of animal, fungi and plant species. Organisms are placed in one of the following categories in decreasing order of risk: extinct, extinct in the wild, critically endangered, endangered, vulnerable, near threatened, least concern, data deficient or not evaluated.

1 | *Eagles*

1. DYNAMIC RANGE

The two images below are helpful in understanding the difference in dynamic range between the eye and the camera. The top image captures a range from true black to clear white, representing the dynamic range of the human eye. The lower image extends only from mid-gray to light gray and suggests the lower range of tones that a camera can record. A darker gray outside this range is interpreted by the camera as black, and any tone lighter than the light gray will appear as white. High-dynamic-range (HDR) images are composites of multiple images, each taken at different exposures to allow a specific section of the full dynamic range to be captured.

2. MEANING OF A 'STOP' IN PHOTOGRAPHY

The use of the word "stop" in photography can be highly confusing, particularly since the term "f-stop" is also widely used to mean the setting which denotes the size of the lens aperture.

In common photographic usage, 1 stop is used to represent a doubling or a halving of any of the three determinants of exposure: shutter speed, ISO setting (sensor sensitivity) or aperture. For the first two components, this is very straightforward: Increasing or decreasing a shutter speed of 1/1000 second means changing to 1/2000 second or 1/500 second, respectively. Similarly, at a setting of ISO 400, increasing the exposure by one stop would require a setting of ISO 800 (making the sensor more sensitive to light), while decreasing exposure by one stop requires ISO 200.

With aperture, the situation is more complicated to understand, although it is simple to implement. The default aperture unit on most cameras is "full stops" of aperture. Because the definition of aperture involves a square root term, the actual numbers for a doubling or halving are not reflected in the arithmetic of the numbers that appear on the camera. In addition, a wide aperture is a small number, and a narrow aperture is a large number! Is this confusing enough yet?

Typically, this is the series of numbers that will be displayed on the camera or lens:

| 1.4 | 2 | 2.8 | 4 | 5.6 | 8 | 11 | 16 | 22 |

Each of these numbers is a one-stop change from its neighbor. So, if the user can ignore the complexity of the definition, making a change of a certain number of stops is easy: simply move through the indications on the camera by the required number of steps. To increase the exposure move to the left, to decrease it move to the right.

The manufacturers of lenses and camera bodies with image stabilization (vibration reduction) also use the term "stops" to define the extent of the stabilization that the equipment can

achieve. Five stops of image stabilization means that a sharp image can be obtained at a setting that is five stops (of shutter speed, aperture, or ISO) fewer than what is requires for a sharp image without stabilization. This is particularly important in a handheld situation where blur can result from camera shake.

3. MIRRORLESS CAMERAS

At the end of 2019, I left my heavy Canon gear behind for a brief flirtation with the micro four-thirds system (an Olympus OM-D E-M1X). But in early 2021, because of dissatisfaction with ISO noise, I migrated back to a full-frame format with the Sony Alpha 1. This camera is proving to be a game-changer for me with bird's eye autofocus and tracking that is little short of astounding.

4. BALD EAGLE WING MOVEMENTS

The behavior shown in the image of the Bald Eagle on page XX is known as a wing-tip reversal upstroke. It involves the bird rotating its "wrist" (which is at the junction of the bone that gives rise to the secondary feathers and the bone to which the primaries are attached) in a movement called supination. While it was once believed that this movement simply reduces aerodynamic drag on the upstroke, more recent studies (using pigeons and ospreys) have found that it can also contribute to lift. A detailed discussion can be found at

K.E. Crandell and B.W. Tobalske, "Aerodynamics of Tip-Reversal Upstroke in a Revolving Pigeon Wing." *Journal of Experimental Biology* 214 (2011): 1867–73. https://jeb.biologists.org/content/214/11/1867.

Ros IG, Bassman LC, Badger MA, Pierson AN, Biewener AA. Pigeons steer like helicopters and generate down-and upstroke lift during low speed turns. Proc Natl Acad Sci U S A. 2011 Dec 13;108(50):19990-5. doi: 10.1073/pnas.1107519108. PMID: 22123982

5. BATELEUR EAGLES AND WHITE-BACKED VULTURES

The image below shows the same tree as on page 29, as the male Bateleur decided that he had had enough of the new company.

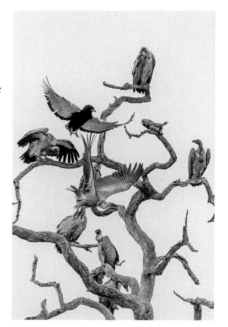

6. JUVENILE HAWK EAGLE ADVENTURES

These images show the young bird landing on a slender branch and its subsequent tumble.

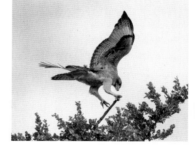 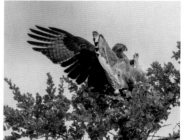

7. ELECTRONIC BUFFERING

There are now several professional and "prosumer" cameras on the market with a remarkably helpful feature for shooting action images. A setting on my Olympus OM-D E-M1X called Pro Capture allows the user to continuously fill a circular buffer with images by half-pressing the shutter release button. The last group of images in the buffer is only saved to the memory card when the shutter release is fully depressed. This means I can wait as the circular buffer is continually refreshed and save the previous 30 images to the card only once I see that action is occurring. Magically, the takeoff images are there!

2 | Hummingbirds

1. TAXONOMY OF BOOTED RACKET-TAILED HUMMINGBIRDS

Karl L Schuchmann,. André A. Weller, and Dietmar Jürgens, "Biogeography and Taxonomy of Racket-Tail Hummingbirds (Aves: Trochilidae: Ocreatus): Evidence for Species Delimitation from Morphology and Display Behavior," *Zootaxa* 4200, no. 1 (2016): 83–108. https://doi.org/10.11646/zootaxa.4200.1.3.

The paper includes the beautiful illustration below, which shows the distribution of the various species and subspecies of booted racket-tailed hummingbirds from Venezuela to southern Peru.

Note that the birds without racket-tails are the females and note the different colored "boots" in the northern (white) and southern (orange) birds.

(Image reproduced from Schuchmann et al. with authors' permission.)

2. COEVOLUTION OF THE SWORD-BILLED HUMMINGBIRD AND ITS PREFERRED FLOWERS

Florencia Soteras, Marcela Moré, Ana C. Ibañez, María Del Rosario Iglesias, and Andrea A. Cocucci, "Range Overlap Between the Sword-Billed Hummingbird and Its Guild of Long-Flowered Species: An Approach to the Study of a Coevolutionary Mosaic," *PLoS ONE* 13, no. 12 (2018). https://doi.org/10.1371/journal.pone.0209742.

This article describes the relationship between the length of the Sword-billed Hummingbird's bill and the size of flowers in various regions of its habitat. It includes the diagram in the next column, which shows what the authors call the Sword-billed's "guild of flowers."

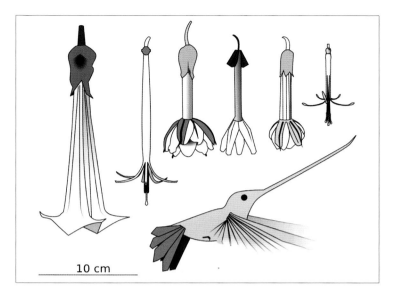

(Image reproduced from Soteras et al. under a Creative Commons Attribution License.)

3. EXPERT OPINION ON WING NOISE

In a personal communication, Dr. Chris Clark of the University of California, Riverside, speculated that there are two issues at work in relation to the wing sounds of the Purple-throated Woodstar:

> One part is that their wingbeat is simply higher than other hummingbirds — Woodstars such as the Purple-throated flap their wings some 20 times per second faster than you would expect. Based on body size alone you would expect the purple to flap 60 times per second, but they flap more like 80. But this doesn't explain the buzzy component. The other part of the answer is that the sound has a buzzy component.... I hypothesize (but do not know for certain) that they have wing feather interactions. I have figured this out for certain in some species, such as Allen's Hummingbird, but don't yet know what is going on in Purple-throated."

Chris Clark. Correspondent, email message to author, February 7, 2019.

3 | Gulls & Terns

1. WING DROOP IN GULLS

S.A. Andrews, R.E. Perez, and W.D. Allan, "Aerodynamic Implications of Gull's Drooped Wing-Tips," *Bioinspir Biomim* 8, no. 4 (December 2013): 046003. https://doi.org/10.1088/1748-3182/8/4/046003.

In this rather complex article, the phenomenon of wing droop in gulls is modelled mathematically as follows:

2. JOHN LATHAM

John Latham, *Supplement to the General Synopsis of Birds* (London: Benjamin White, 1787. Page 266)

John Latham (1740–1837) was an English physician and an avid illustrator and writer of bird books. His observations were mostly based on specimens returned by adventurers who had visited exotic locations. He is infamous for his loose naming of different species, only utilizing Linnaean taxonomy in his later years. Digital scans of his books can be found in the Biodiversity Heritage Library at https://www.biodiversitylibrary.org/bibliography/49894#/summary.

3. THE EURASIAN SPOONBILL

Eurasian Spoonbills (*Platalea leucorodia*) migrate from the coast of West Africa to nest in the Frisian Islands. In the picture below, a group of spoonbills fly over the Texel dunes after feeding in the shallows.

4. SWALLOW-TAILED GULL ON THE DEFENSIVE

This Swallow-tailed Gull on North Seymour Island in the Galápagos successfully defended its egg (behind the gull) from an attack by a Nazca booby (*Sula granti*).

5. SWALLOW-TAILED GULLS FOOD SHARING

A male bird (right) has just arrived at his nesting site on North Seymour Island in the Galápagos to woo his mate with freshly caught squid.

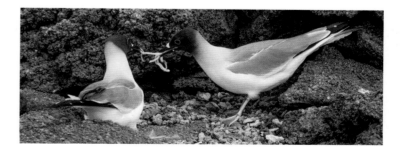

6. WET LANDING

The term "wet landing" refers to arriving on a beach by boat (usually an inflatable dinghy, such as a Zodiac) where there is no dock or jetty. The passengers slide over the wall of the Zodiac, feet first into the water and then wade ashore. On Antarctic and subantarctic beaches that are frequently rough, the Zodiac is usually stabilized by four or more guides or crew members in waders standing chest-deep in the icy water.

7. BACKGROUND FOR ANTARCTIC TERN IMAGE

Most of my shots of the Antarctic Terns from the beach in Godthul resulted in an image of a white bird against a gray background, which is not particularly attractive. The birds, flushed from their rocky perch by an arriving Antarctic Shag (*Phalacrocorax bransfieldensis*), are seen in the image below against gray water sandwiched (vertically) between a white sky and white icebergs (upper third) and the rocky gray shore.

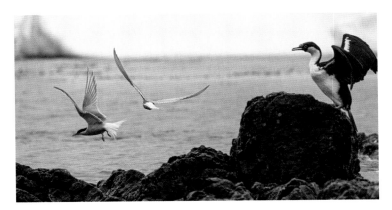

4 | *Small Waterbirds*

1. THE BLACK SKIMMER'S BILL

The elongated lower mandible that the Black Skimmer forces through the water during feeding flights is shown in the following image.

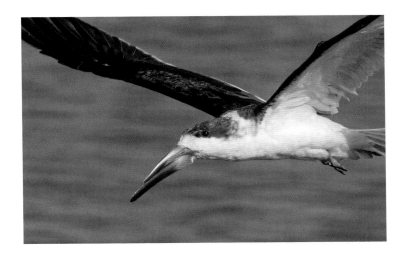

2. CAPYBARA: THE WORLD'S LARGEST RODENT

During our trip up the Cuiabá River in search of jaguars, we encountered this family of Capybaras along the shore. They were as curious about us as we were of them. The adult animals can weigh 150 pounds (68 kg) and are up to 25 inches (63.5 cm) tall.

3. FIDDLER CRAB TUNNELS

J. B. Dembowski, "Notes on the Behavior of the Fiddler Crab," *Biol Bull* 50 (1926): 179–201. https://www.biodiversitylibrary.org/page/1398694#page/196/mode/1up.

This delightful early 20th-century paper on fiddler crab behavior includes the illustration on the next page, which shows a cross section of fiddler crab tunnels.

4. BOAT-BILLED BIRDS

A number of other birds share the description "boat-billed," but none of their bills resemble the giant scoop of the heron. These include the Boat-billed Flycatcher (*Megarynchus pitangua*) and the Boat-billed Tody-tyrant (*Hemitriccus josephinae*).

5 | Large Waterbirds

1. ALLOMETRY

This definition is adapted from the good introductory article on the topic by Alexander Shingleton mentioned in the *Further Reading* list.

2. THE BOOBY FAMILY

Boobies are in the order Suliformes and placed with gannets in the Sulidae family. The most well-known family members, all of which are larger than the Red-footed Booby, are the Masked Booby (*Sula dactylatra*), Nazca Booby (*Sula granti*), Blue-footed Booby (*Sula nebouxii*) and Brown Booby (*Sula leucogaster*).

3. BLUE-FOOTED BOOBY'S COURTSHP DANCE

An image of Blue-footed Boobies during their bonding ritual is shown at the top of the next column, shot on North Seymour Island in the Galápagos. The male (left) is making sure his turquoise-blue feet are visible to the female.

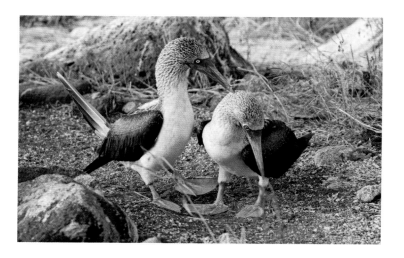

4. BIRDS IN EGYPTIAN HIEROGLYPHS

Many birds were represented in the hieroglyphs of ancient Egypt, as shown in the table below, which uses the nomenclature of English egyptologist Sir Alan Gardner. The Saddle-billed Stork is believed to be represented by G20 and G21 (although some sources believe these birds are Jabirus).

5. THE WINGS OF AN AMERICAN WHITE PELICAN

The photograph below shows a wing of an American White Pelican (reflected to show the entire wingspan) from the collection of the Burke Museum at the University of Washington.

One wing is approximately 3 feet (91 cm) long.

6. GOLIATH HERON STANDING ERECT

The image (right) shows the bird I watched for several hours. It is standing erect, showing off its extraordinarily long neck.

7. SOUTHERN GIANT PETREL AGRESSION

The photograph below was taken at Ocean Bay in South Georgia as the

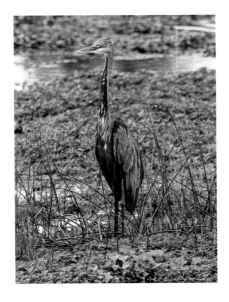

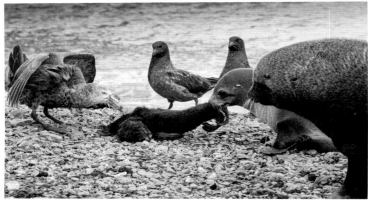

female fur seal tried to prevent her dead or dying pup from being consumed by a Southern Giant-Petrel. A pair of Brown Skuas (*Stercorarius antarcticus*) await their turn at the carcass.

6 | *Ducks, Geese & Swans*

1. AIRFLOW AND LIFT

The actual relationship between the speed of airflow across the wing and the lift generated by the wing is quadratic: The lift is proportional to the square of the airspeed. This means that each increment of airspeed will cause ever greater increases in lift. Birds try very hard to maximize airspeed across their wings by facing into the wind at takeoff whenever possible.

2. THE SOUTH GEORGIA PIPIT

I shot the image below of a near-threatened South Georgia Pipit standing near discarded whale ribs on the same beach at Godthul where the pintails were photographed.

3. FEMALE UPLAND GEESE

This female Upland Goose (on the next page) was incubating her clutch of eggs in a rudimentary nest amid the coarse, damp grass close to where I photographed the attacking male.

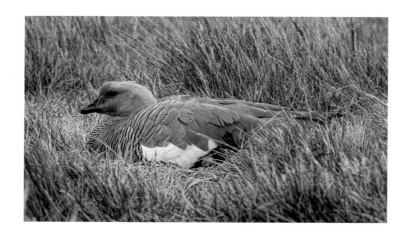

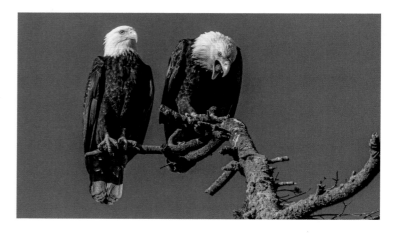

4. FIGHTING MALES
Two male Upland Geese elevate their argument into a major fight in front of agitated female spectators.

7 | Raptors

1. DISTINUGUISHING MALE FROM FEMALE RAPTORS
Sometimes it is only when the male and female are seen together that the sexes can be distinguished, often by the female's larger size. In the image in the next column, the female Bald Eagle on the right is eliminating a "cast," which is a pellet of indigestible material, while her mate displays a slightly indignant visage.

2. OWLS AS HARBINGERS OF DOOM
In act 1, scene 3 of *Julius Caesar*, Shakespeare has the conspirator Publius Servilius Casca give an account of an owl ("the bird of the night") foretelling Caesar's assassination:

> And yesterday the bird of night did sit
> Even at noon-day upon the market-place,
> Hooting and shrieking. When these prodigies
> Do so conjointly meet, let not men say
> 'These are their reasons; they are natural;'
> For, I believe, they are portentous things
> Unto the climate that they point upon.

MIT On-line Shakespeare Edition. http://shakespeare.mit.edu/julius_caesar

3. SEARCHING FOR BLAKISTON'S FISH OWL

Jonathan C. Slaght, *Owls of the Eastern Ice. A Quest to Find and Save the World's Largest Owl* (New York: Farrar, Straus and Giroux, 2020).

This book is a fascinating account from a biologist who spent years searching for and studying Blakiston's Fish-Owls in the Russian province of Primorye.

8 | Condors & Corvids

1. DUST SPOTS AND DEBRIS ON THE SENSOR

The image below shows a large dust spot and a crescent-shaped piece of debris along with the California Condor. I used the "spot removal" tool in Lightroom Classic to eliminate these and other spots.

2. KODAK 3A SPECIAL CAMERA

I purchased this No. 1A Autographic Kodak Jr. from a curio store in Pennsylvania during the 1980s. It was manufactured by the Eastman Kodak company from 1916 to 1924 and was originally priced at $17.50 to $22.50 (approximately $400 to $517 in present-day dollars). Hiram Bingham's camera looked very similar to this, but was a little more upmarket and had a number of options and accessories. To find out more about Binghma's camera, you can visit Historic Camera at http://www.historiccamera.com/cgi-bin/librarium2/pm.cgi?action=app_display&app=datasheet&app_id=577.

3. EXPOSING FOR A BLACK BIRD

The shot below shows another of the crow's dive-bombing passes at the perching Bald Eagle, before and after processing. The raw shot (left) shows a slightly underexposed eagle because I did not want to saturate the white on its head, but the crow is, in places, saturated black and lacking any detail. A curves adjustment layer in Adobe Photoshop rendered some of the crow feather detail in the head, right wind and tail visible without affecting other parts of the image.

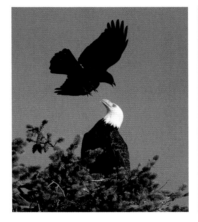 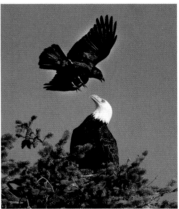

4. RETICULATE EVOLUTION

The diagram below explains the process of reticulate evolution ("Reticulate Evolution," Wikipedia, accessed October 12, 2020, https://en.wikipedia.org/wiki/Reticulate_evolution.)

Lineage B results from a horizontal transfer between its two ancestors, A and C (blue dotted lines). In the case of ravens, lineage A died-out and lineage B became Common Ravens, reversing the previous speciation event.

5. SCULPTURE OF THE HAIDA CREATION MYTH

A. Cross, *The Raven and the First Men: From Conception to Completion* (Vancouver, B.C.: UBC Museum of Anthropology, 2011): 30, http://moa.ubc.ca/wp-content/uploads/2014/08/Sourcebooks-Raven_and_the_First_Men.pdf.

This fascinating document also provides an account of the creative process surrounding Bill Reid's sculpture.

6. THE BILL REID SCULPTURE AT THE UNIVERSITY OF BRITISH COLUMBIA MUSEUM

The Raven and the First Men by Bill Reid is in a magnificent setting at the Museum of Anthropology, University of British Columbia.

The sculptor's own telling of the creation myth is as follows:

> The great flood, which had covered the earth for so long, had at last receded and the sand of Rose Spit, Haida Gwaii, lay dry. Raven walked along the sand, eyes and ears alert for any unusual sight or sound to break the monotony. A flash of white caught his eye and there, right at his feet, half buried in the sand, was a gigantic clamshell. He looked more closely and saw that the shell was full of little creatures cowering in terror in his enormous shadow. He leaned his great head close and, with his smooth trickster's tongue, coaxed and cajoled and coerced then to come out and play in his wonderful new shiny world. These little dwellers were the original Haidas, the first humans.

7. SETTINGS USED FOR THE ANDEAN CONDOR IMAGE

These settings make no sense at all! They resulted from the sudden appearance of the bird while I was working on a shot that required a large depth of field, hence the aperture of f/18. A wider aperture and higher shutter speed would have been preferable. It is easy to forget camera adjustments when a target appears without notice.

9 | *Cranes*

1. STATUE OF SADAKO SASAKI

This sculpture of Sadako Sasaki holding a paper crane aloft stands in a small, somewhat inaccessible park near Seattle's University Bridge on the west end of Portage Bay.

2. THE RITUAL OF CRANE FEEDING AT THE IZUMI CRANE OBSERVATION CENTER

The upper photograph shows hundreds of White-naped Cranes standing erect over food left on the ground by officials at the Izumi

Crane Observation Center. The lower image, taken only moments later, shows almost all heads are down as the birds feed in earnest. This cycle was repeated until the food was gone. A few Hooded Cranes can also be seen around the periphery.

3. WRONG TURN CORRIGAN
Tim Gianni, "Rare Asian Bird Takes 'Wrong Turn,' Lands in Tennessee," Reuters, last modified December 27, 2011, https://www.reuters.com/article/us-tennessee-birds-asian-crane/rare-asian-bird-takes-wrong-turn-lands-in-tennessee-idUSTRE-7BR03R20111227.

4. SANDHILL CRANE PREDATORS
The Coyote shown to the right was hunting in the Bosque del Apache National Wildlife Refuge, where thousands of Sandhill Cranes spend their winters.

5. THE DEPARTURE SIGNAL FOR SANDHILL CRANES
Moments before the Sandhill Cranes in the photograph departed, the lead bird adopted a "ski-jumper stance" to signal to the other birds that he had decided to start his departure dash and that it was also time for them to go.

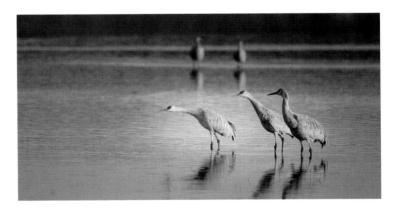

6. CRANE BALLET
This is a typical example of some on-ground Red-crowned Crane ballet, photographed at the Akan Crane Center in Hokkaido, Japan.

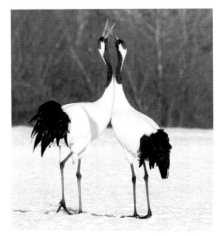

7. EARLY MORNING AT THE OTOWABASHI BRIDGE IN HOKKAIDO

This image, taken from the Otowabashi Bridge, shows the mystical tableau, including a pair of Red-crowned Cranes dancing in the morning light as steam rises from the geothermally warmed Setsuri River.

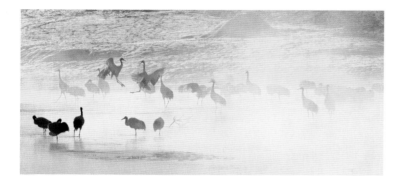

10 | Songbirds

1. SONGBIRDS IN POETRY

The English poet John Keats wrote the somewhat morose "Ode to a Nightingale" in 1819 after hearing a Common Nightingale (*Luscinia megarhynchos*) sing in a friend's plum tree. Emily Dickinson's poem "A Bird, Came Down the Walk" is notable for its beautiful description of bird flight:

> Like one in danger, Cautious
> I offered him a Crumb,
> And he unrolled his feathers,
> And rowed him softer Home —
>
> Than Oars divide the Ocean,
> Too silver for a seam,
> Or Butterflies, off Banks of Noon,
> Leap, plashless as they swim.

(The Poetry Foundation. "A Bird, came down the Walk – (359) by Emily Dickenson". https://www.poetryfoundation.org/poems/56593/a-bird-came-down-the-walk-359 Accessed January 10,2021.

2. SHAKESPEARE ON THE THRUSH AND NIGHTINGALE

Shakespeare remarked on the song of a thrush, "with his note so true" (*A Midsummer Night's Dream*, act 3, scene 1). The passage about Apollo and the nightingales is from *The Taming of the Shrew*, induction, scene 2.

3. SOUND OF THE WOODSTORK

This description is from:

Coulter, M. C., J. A. Rodgers Jr., J. C. Ogden, and F. C. Depkin (2020). Wood Stork (*Mycteria americana*), version 1.0. In *Birds of the World* (A. F. Poole and F. B. Gill, Editors). Cornell Lab of Ornithology, Ithaca, NY, USA. https://doi.org/10.2173/bow.woosto.01.

4. FOOT STRUCTURE IN BIRDS

The following diagram shows some of the foot configurations in different orders of birds:

5. SYRINX ANINMATION

There is an excellent animation of the syrinx in action at Cornell Lab of Ornithology, "All about Bird Song," accessed September 2, 2020, https://academy.allaboutbirds.org/features/birdsong/how-birds-sing.

A slideshow with similar information can be downloaded from Cornell Lab of Ornithology, "Birdsong Visualized Slides," accessed September 2, 2020, https://academy.allaboutbirds.org/bird-song-visualized-slides.

6. THE SKYLARK

The following are lines are from the poem *To a Skylark*, written in 1820 by Percy Bysshe Shelley:

> Hail to thee, blithe Spirit!
> Bird thou never wert,
> That from Heaven, or near it,
> Pourest thy full heart
> In profuse strains of unpremeditated art.
> Higher still and higher
> From the earth thou springest
> Like a cloud of fire;
> The blue deep thou wingest,
> And singing still dost soar, and soaring ever singest.

(The Poetry Foundation, "To a Skylark by Percy Bysshe Shelley," accessed August 3, 2020, https://www.poetryfoundation.org/poems/45146/to-a-skylark).

7. STATE OF THE BIRDS REPORT

Blackbirds are listed in the 2019 *State of the Birds Report* as "common bird(s) in steep decline". Cornell University. "State of the Birds 2019" https://www.stateofthebirds.org/2019/steep-declines/ Accessed January 10, 2021.

8. BLACKBIRDS AND AGRICULTURE

The USDA report cited is the following: *Blackbirds* Dolbeer RA and Linz GM. US Department of Agriculture, Animal and Plant Health Inspection Service. Wildlife Damage Management Technical Series. August 2016.

Details of an entire symposium on the "management" of blackbirds can be accessed here: George M. Linz, (Editor) Management of North American Blackbirds https://www.aphis.usda.gov/wildlife_damage/nwrc/symposia/blackbirds_symposium/ Accessed January 10, 2021.

9. "I THOUGHT I HEARD A RED-WINGED BLACKBIRD"

An excellent rendition of this song by Scottish-Canadian singer-songwriter David Francey from his 1999 album *Torn Screen Door* can be found at David Francey, "David Francey – Red-winged Blackbird," YouTube, accessed July 24, 2020, https://www.youtube.com/watch?v=-VQPeyAGdjk.

10. PHOTOGRAPH BY OWEN HUMPHRIES

This image appeared in the British newspaper *The Guardian*, which has excellent wildlife photographs. It is the only main image in the book that I did not take myself. Shooting a murmuration of starlings remains a goal for me.

11. MONITORING NEAREST NEIGHBORS

The image to the right, taken on a beach near my home, shows what a navigation strategy might look like for a single bird inside the murmurating flock of starlings. The circled bird is monitoring its seven nearest neighbors and trying to match their velocity vectors, which encode both speed and direction.

12. THE WINGS OF WAR
The sentence plays on an utterance by Marc Antony in William Shakespeare's *Julius Caesar* (act 3, scene 1). As he plots revenge on Caesar's assassins, he exorts: "Cry 'Havoc,' and let slip the dogs of war." MIT On-line Shakespeare Edition. http://shakespeare.mit.edu/julius_caesar.

13. HOOD MOCKINGBIRDS IN BATTLE
The birds first lined up facing one another, and then they took turns making their displays of aggression:

They were soon fighting, grasping bills and pecking at heads.

The victorious birds in these duels lauded over their defeated opponents, forcing the vanquished birds' head into the sand.

14. CAMERA SETTINGS FOR THE HOOD MOCKINGBIRD IMAGES
It might seem that a larger aperture (f/4, for example) should have been used for these images, to enable a lower ISO setting. However, I wanted to preserve some depth of field for the shots of multiple birds. The action was so fast that there was no time to change settings between shots.

15. SEED PODS OF THE CANADA THISTLE
An idealized drawing of a Canada Thistle seedpod and its wispy attachments. (George Clark and James Fletcher, "Canada Thistle Seeds" in *Farm Weeds* (1906): 2, https://www.fromoldbooks.org/Fletcher-FarmWeeds/pages/056-Weed-Seeds-detail-64-canada-thistle/119x141-q75.html.)

16. GOLDFINCHES EATING THE SEEDS OF A CANADA THISTLE
American Goldfinches are highly skilled at tugging out clusters of silk threads and quickly accessing the seed.

17. THE BLACK MULBERRY TREE
Part of an old orchard, this mangy Black Mulberry tree (in its final foliage for the summer) was an ideal setting for capturing images of the visiting Cedar Waxwings.

11 | Favorites

1. HABITS OF THE SNOWY SHEATHBILL
The description of the Sheathbill is attributed in Cornell's *Birds of the World* to two early writers from 1876, Kidder and Coues.

Fang, E. D. (2020). Snowy Sheathbill (Chionis albus), version 1.0. In *Birds of the World* (T. S. Schulenberg, Editor). Cornell Lab of Ornithology, Ithaca, NY, USA. https://doi.org/10.2173/bow.snoshe2.01. Accessed January 10, 2020.

2. WING LENGTH VERSUS WINGSPAN
Wingspan estimates are not available for all species. On occasion, the length of a single wing, termed wing length, is reported. This is defined as "the distance between the base and tip (of a single wing) extended during natural flight position."

F. Gary Stiles and Douglas L. Altshuler, "Conflicting Terminology for Wing Measurements in Ornithology and Aerodynamics," *The Auk* 121, no. 3 (2004): 973–76, doi:10.2307/4090335.

3. CHESTNUT-EARED ARACARI
This is the beautifully colored Chestnut-eared Aracari that I photographed in Brazil's Pantanal.

4. "FEATHER TONGUE"
The genus name of the group to which the Collared Aracari belongs (*Pteroglossus*) refers to the long, rough-edged tongue that can be seen in the bird on the left below.

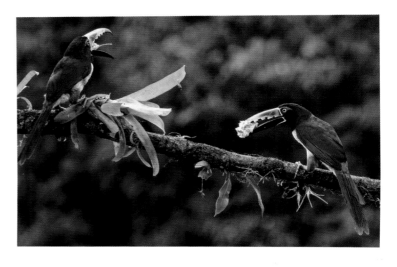

5. HOPPING IN ARACARIS

Hopping behavior in Lettered Aracaris (*Pteroglossus inscriptus*) was studied using high-speed video in Elizabeth Höfling, Anick Abourachid and Sabine Renous, "Locomotion Behavior of the Lettered Aracari (*Pteroglossus inscriptus*) (Ramphastidae)," *Ornitologia Neotropical*, 17 (2006): 363-371.

A PDF of this article is available for open access viewing on the University of New Mexico site SORA at https://sora.unm.edu/sites/default/files/journals/on/v017n03/p0363-p0372.pdf.

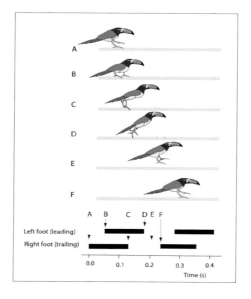

The diagram to the right demonstrates the following: "Out-of-phase hopping of the Lettered Aracari (*Pteroglossus inscriptus*) on a small diameter branch: A) touchdown of the right foot, B) touchdown of the left foot, C) right foot leaves the branch, D) left foot leaves the branch, E) no foot on the branch, F) right foot touchdowns the branch again. ... Bottom: Gait diagram representing relative duration of the stance (dark lines) and swing (space between two dark lines) phases of each foot. Mean speed: 1.49 ms-1 (± 0.12 ms-1)." (Elizabeth Höfling et al., page 363).

6. GLOSSY IBIS

This is an image of the same bird shown on page 268 looking somewhat less magical!

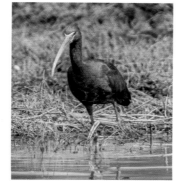

7. CHOBE RIVER

The boat trip along the banks of the Chobe River placed us a little too close for comfort to the jaws of this hippopotamus!

8. THE BIONOMIAL SYSTEM OF NOMENCLATURE

Linnaeus devised the now universally used binomial system for naming living organisms according to genus and species where both parts are in Latin. His original work was in Latin, but some translated segments can be viewed in this partial facsimile edition: C. Linnaeus, *Systema Naturae* (facsimile of the first edition), https://www.kth.se/polopoly_fs/1.199546.1550158624!/Menu/general/column-content/attachment/Linnaeus--extracts.pdf.

When the scientific name has three components, the last word denotes the subspecies. See for example, the Hawaiian Stilt (*Himantopus mexicanus knudseni*) on page 94. When subspecies do exist, the "nominate" or originally described subspecies is indicated by a repetition of the species name. In the case of the Stilt, for example, *Himantopus mexicanus mexicanus* is the nominate subspecies.

As is often the case, part of the name refers to the person who first described the bird. For the Hawaiian Stilt, knudseni commemorates Valdemar Knudsen (1822–1898), a Norwegian ornithologist and collector on Hawaii.

9. THE STATUS OF THE WORLD'S ALBATROSSES

The article detailing the dire status of almost every species of albatross is here:

Gates, Rosemary. "Flagstaff Species at Half-mast. Pages 148–151 in: *Albatrosses: Their world, their ways*. Tui de Roy, Mark Jones, Julian Fitter. David Bateman Ltd. Aukland, New Zealand. 2008.

10. JOHN MUIR'S HOMETOWN

John Muir, the founder of the Sierra Club, was born in Dunbar, Scotland, in 1838. He immigrated to the United States with his family at the age of 11 and would become what his biography on the Sierra Club website describes as the "most famous and influential naturalist and conservationist [in the U.S.]."

Sierra Club, "John Muir: A Brief Biography," accessed September 26, 2019, https://vault.sierraclub.org/john_muir_exhibit/life/muir_biography.aspx.

Today, a statue (right) of the young Muir releasing birds stands on the main street of Dunbar. Nearby, there is a fascinating museum in the house that is his birthplace.

11. THE BILL OF THE TOUCAN

Glenn J. Tattersall, Denis V. Andrade, and Augusto S. Abe. "Heat Exchange from the Toucan Bill Reveals a Controllable Vascular Thermal Radiator," *Science* 325, no. 5939 (July 24, 2009): 468–70, https://doi 10.1126/science.1175553.

A new understanding of the function of the toucan bill was uncovered by this article, which used the Toco Toucan (*Ramphastos toco*) as a subject.

The bill of a Toco Toucan (photo taken in Brazil's Pantanal).

12. IMAGE STABILIZATION

Advances in image stabilization have dramatically extended the possibilities for handheld photography in recent years. A combination of shifting image sensors and/or lens elements allow photographers to take a sharp image even when they cannot hold the camera steadily. An old-established rule with non-stabilized equipment was that the minimum shutter speed to prevent blurring should be the reciprocal of the focal length. For example, with a 500 mm focal-length lens, the minimum shutter speed would be $\frac{1}{500}$ sec. This rule has been obsoleted by vibration stabilization. However, the units given by manufacturers for stabilization can be confusing. For example, Olympus claims its M1X camera body has seven stops of stabilization (see pages 287–288). In this setting, a gain of one stop refers to a halving of shutter speed. For the example above of shooting at $\frac{1}{500}$ sec, a seven-stop gain would allow a photograph of similar sharpness to be taken at an astonishingly slow $\frac{1}{4}$ sec. (The progression of seven stops, with suitable rounding, would be $\frac{1}{250}$ sec, $\frac{1}{125}$ sec, $\frac{1}{64}$ sec, $\frac{1}{32}$ sec, $\frac{1}{16}$ sec, $\frac{1}{8}$ sec, $\frac{1}{4}$ sec.)

Further Reading

Preface

EVOLUTION OF FLIGHT

Chiappe, Luis M. 2007. *Glorified Dinosaurs: The Origin and Early Evolution of Birds.* 1st ed. Hoboken, NJ: John Wiley.

EARLY PRACTITIONERS OF FLIGHT PHOTOGRAPHY

Étienne-Jules Marey devised many novel instruments for the study of human and animal motion:

Braun, Marta. 1992. *Picturing Time: The Work of Etienne-Jules Marey (1830–1904)* Reprint Edition. Chicago: University of Chicago Press.

Ruppel, Georg, 1978. *Bird Flight.* NY, NY: Van Nostrand Reinhold Company.

ARCTIC TERN MIGRATION

Egevang C, Stenhouse IJ, Phillips RA, Petersen A, Fox JW, Silk JR. "Tracking of Arctic terns Sterna paradisaea reveals longest animal migration." *Proc Natl Acad Sci USA.* 2010 Feb 2;107(5):2078–81. PMID: 20080662.

CONTROL OF WING FEATHER POSITION AND MOTION

A study highlighting the potential role of smooth (involuntary) muscles in shaping the flight wing of pigeons:

Hieronymus, Tobin L. 2016. "Flight Feather Attachment in Rock Pigeons (*Columba Livia*): Covert Feathers and Smooth Muscle Coordinate a Morphing Wing." *Journal of Anatomy* 229 (5): 631–56.

PMID: 27320170

PMCID: https://www.ncbi.nlm.nih.gov/pubmed/?term=PMC5055087

DOI: https://doi.org/10.1111/joa.12511

WING LOADING

A good discussion of wing loading can be found on page 67 in:

Alexander, David E. 2002. *Nature's Flyers: Birds, Insects, and the Biomechanics of Flight.* Baltimore and London: Johns Hopkins University Press.

Poole, Earl L. 1938. "Weights and wing areas in North American Birds." *The Auk* 55 (3): 511–517. https://sora.unm.edu/sites/default/files/journals/auk/v055n03/p0511-p0517.pdf

1 | Eagles

US FEDERAL LAW PROTECTING EAGLES

U.S. Fish & Wildlife Service. 2009. *Possession of Eagle Feathers and Parts by Native Americans.* Arlington, VA: U.S. Fish and Wildlife Service, Office of Law Enforcement. https://www.fws.gov/eaglerepository/factsheets/PossessionOfEagleFeathersFactSheet.pdf (accessed January 21, 2019).

DUAL-AXIS GIMBAL

I use a Wimberley WH-200 Gimbal Tripod Head II with Quick Release Base:

Wimberley. 2019. "Wimberley Head – Version II." Accessed January 21, 2019 https://www.tripodhead.com/products/wimberley-main.cfm

2 | Hummingbirds

HUMMINGBIRD EVOLUTION

McGuire, Jimmy A., Christopher C. Witt, J. V. Remsen, Ammon Corl, Daniel L. Rabosky, Douglas L. Altshuler, and Robert Dudley. 2014. "Molecular Phylogenetics and the Diversification of Hummingbirds." *Current Biology* 24 (8): 910–16.

PMID 24704078

https://doi.org/10.1016/j.cub.2014.03.016

COEVOLUTION OF BIRD AND PLANT

The local coevolutionary regions of the Sword-billed Hummingbird and its chosen food sources:

Soteras, Florencia, Marcela Moré, Ana C. Ibañez, María Del Rosario Iglesias, and Andrea A. Cocucci. 2018. "Range Overlap between the Sword-Billed Hummingbird and Its Guild of Long-Flowered Species: An Approach to the Study of a Coevolutionary Mosaic." *PLoS ONE,* 13 (12).

PMID: 30586466

https://doi.org/10.1371/journal.pone.0209742

HUMMINGBIRD FLIGHT

Warrick, Douglas, Tyson Hedrick, María José Fernández, Bret Tobalske, and Andrew Biewener. 2012. "Hummingbird Flight." *Current Biology* 22 (12): 472–477.

PMID: 22720675

https://doi.org/10.1016/j.cub.2012.04.057

HUMANS AFFECTING HUMMINGBIRD RANGE

Anna's Hummingbirds extended their winter range in Arizona, California, Oregon and Washington over a 20-year period, an extension associated with an increase in the human provision of nectar feeders.

Greig, Emma I., Eric M. Wood, and David N. Bonter. 2017. "Winter Range Expansion of a Hummingbird Is Associated with Urbanization and Supplementary Feeding." *Proceedings of the Royal Society B: Biological Sciences* 284 (1852).

PMID: 28381617

https://doi.org/10.1098/rspb.2017.0256

HUMMINGBIRD HEAD STABILIZATION

How hummingbirds stabilize their heads during feeding in windy conditions:

Ravi, Sridhar, James D. Crall, Lucas McNeilly, Susan F. Gagliardi, Andrew A. Biewener, and Stacey A. Combes. 2015. "Hummingbird Flight Stability and Control in Freestream Turbulent Winds." *Journal of Experimental Biology* 218 (9): 1444–52.

PMID 25767146

https://doi.org/10.1242/jeb.114553

SEXUAL SELECTION

The Field Museum in Chicago's account on sexual selection in birds:

The Field Museum of Chicago. Zoology, Division of Birds. 2019. "Sexual Selection." Accessed February 4, 2019. http://birds.fieldmuseum.org/stories/selection/sexual-selection

ISO NOISE AND LUMINANCE NOISE

Cox, Spencer. 2019. "What Is Noise in Photography?" Photographylife. https://photographylife.com/what-is-noise-in-photography

NOISE FILTERS

Adobe Lightroom has some effective filters for ISO noise and Luminance noise in the *Detail/Noise Reduction* Tab of the Develop module.

I find the Photoshop plug-in filter Noiseware to be particularly effective in reducing luminance noise.

http://imagenomic.com/Products/Noiseware

Topaz AI Denoise AI also produces remarkable results.

https://topazlabs.com/denoise-ai-2

AGGRESSION AND MATING SUCCESS IN HUMMINGBIRDS

Purple-throated Carib Hummingbirds (*Eulampis jugularis*) defend territories with a surplus of food so that eligible females might visit, feed and perhaps decide to mate!

Temeles, Ethan J., and W. John Kress. 2010. "Mate Choice and Mate Competition by a Tropical Hummingbird at a Floral Resource." *Proceedings of the Royal Society B: Biological Sciences*, 277:1607–13. Royal Society.

PMID: 20129990

https://doi.org/10.1098/rspb.2009.2188

PRIOR THEORIES REGARDING HUMMINGBIRD TONGUES
The original hypothesis regarding capillary action of the hummingbird tongue:

Jardine, William and W. C. L. Martin. (1833) In *The Naturalist's Library: A General History of Hummingbirds or the Trochilidae*, edited by William Jardine, 65–68. London: H.G. Bohn.

Facsimile edition available as ISBN-13: 978-0548862834.

NEW DISCOVERIES OF HUMMINGBIRD FEEDING ACTION
The articles that changed ornithologists' thinking about how hummingbirds feed on nectar:

Rico-Guevara, Alejandro, and Margaret A. Rubega. 2011. "The Hummingbird Tongue Is a Fluid Trap, Not a Capillary Tube." *Proc Natl Acad Sci* USA. 108 (23): 9356–60.

PMID: 21536916

https://doi.org/10.1073/pnas.1016944108.

Rico-Guevara, Alejandro, Tai Hsi Fan, and Margaret A. Rubega. 2015. "Hummingbird Tongues are Elastic Micropumps." *Proceedings of the Royal Society B: Biological Sciences* 282 (1813).

PMID: 26290074

https://doi.org/10.1098/rspb.2015.1014.

3 | *Gulls & Terns*

BIRD INTELLIGENCE
An article about birds with unusual skills:

https://www.activewild.com/intelligent-birds/

GULLS LEAVING THE SEASHORE
http://www.bbc.com/earth/story/20160708-have-seagulls-abandoned-the-sea

BAIT FISHING BY HERRING GULLS
Herring bait fishing in the Jardin des Tuileries in Paris:

Henry P-Y, Aznar J-C. "Tool-use in Charadrii: Active Bait-Fishing by a Herring Gull," Waterbirds 29(2)(2): 233–234. 2006.

GULLS IN DECLINE
The introduction to a 2016 issue of *Waterbirds* was devoted to the status of gulls around the world.

Introduction: A historical perspective on tends in some gulls in Eastern North America with reference to other regions. Anderson JGT, Shlep KR, Bond AL, Roconi RA. *Waterbirds* (The Journal of the Waterbird Society). Vol 39. Special Publication 1. 1–288. 2016.

The article can be downloaded here:

https://bioone.org/journals/waterbirds/volume-39/issue-sp1

TUI DE ROY
Tui de Roy has made it her mission to document the wildlife and naturescapes of the Galápagos Islands.:

DeRoy, Tui. 2009. *Galápagos: Preserving Darwin's Legacy*. Auckland, New Zealand: David Bateman Ltd.

APPS TO CREATE BOKEH
Seven Apps for creating Bokeh in iPhone photographs:

"Best Apps for Creating Bokeh Effects on Phones." Wondershare. Accessed August 30, 2020. https://photo.wondershare.com/photo-editor/best-apps-to-create-bokeh-effects-on-phone.html

NIGHT VISION IN THE SWALLOW-TAILED GULL
An account of how the Swallow-tailed Gull has enhanced vision at night:

Ankel-Simons, F. 2007. "Tapetum lucidum" in *Primate Anatomy* (Third Edition). Science Direct. https://www.sciencedirect.com/topics/veterinary-science-and-veterinary-medicine/tapetum-lucidum

4 | *Small Waterbirds*

WATERBIRDS BY THEODORE CROSS

Cross, Theodore. 2009. *Waterbirds* (1st Edition). New York: W. W. Norton & Company.

GRAY'S HARBOR NWR

This National Wildlife Refuge in the State of Washington, located close to extensive tidal flats where millions of shorebirds gather in April and May, organizes a festival to cater to visiting bird lovers.

U.S. Fish & Wildlife Service. 2019. "Shorebird and Nature Festival." Grays Harbor National Wildlife Refuge, Washington. Last updated February 5, 2019. https://www.fws.gov/refuge/Grays_Harbor/cosa/shorebird_festival.html

BOIDS

The concepts behind the simple simulation of flocking behavior:

Reynolds, C. 2001. "Boids: Background and Update." Craig Reynolds. Last updated September 6, 2001. http://www.red3d.com/cwr/boids/

ICELANDIC BIRD GUIDE BY JOHANN ÓLI HILMARSSON

Hilmarsson, Jóhann Óli. 2011. l*celandic Bird Guide* (2nd Edition). Reykjavik, Iceland: Mal Og Menning. ISBN. 978-9979-3-3220-6

THE TUBENOSES

While the popular literature widely ascribes the role of the external nostril(s) in the Procellariiformes (Tubenoses) to salt excretion, ornithologists stress their role in smell for this family of birds with excellent olfaction.

Lovette I. J. and J. W. Fitzpatrick (eds). 2016. *Handbook of Bird Biology* (3rd Edition). New York: John Wiley and Sons Ltd.

EXTINCT BIRDS OF HAWAII

Stories and illustrations of Hawaii's extinct birds:

Walther, M., J. P. Hume, F. W. Frohawk, and J. G. Keulemmans. 2016. *Extinct Birds of Hawaii*. Honolulu: Mutual Publishing.

A CONSERVATION PLAN FOR HAWAIIAN FOREST BIRDS

Eben, H. P., M. Laut, J. P. Vetter and S. J. Kendall. 2018. "Research and management priorities for Hawaiian forest birds." *The Condor: Ornithological Applications* 120: (3):557–565.

ISO NOISE

Brady, B. J. 2020. "How to Avoid and Reduce Noise in Your Images." Digital Photography School. https://digital-photography-school.com/how-to-avoid-and-reduce-noise-in-your-images/

THE MECHANISM OF SKIMMER PREY LOCATION

The role of vision in location of prey by the black skimmer:

G. R. Martin, R. Mcneil, and L. M. Rojas. 2007. "Vision and the foraging technique of skimmers (Rynchopidae)." Ibis 149 (4): 750–757.

5 | *Large Waterbirds*

THE SCIENCE OF SIZE

An introduction to the science of Allometry:

Shingleton, A. W. 2010. "Allometry: The Study of Biological Scaling." *Nature Education Knowledge* 3 (10): 2. https://www.nature.com/scitable/knowledge/library/allometry-the-study-of-biological-scaling-13228439/

THE STORK IN MYTHOLOGY

The myth of storks bringing babies (and other bird myths):

Chadd, R. W. and M. Taylor. 2016. *Birds: Myth, Lore and Legend*. London: Bloomsbury.

BLUER FEET ARE BETTER

Female Blue-footed Boobies prefer males with brighter blue feet. The research shows that foot color dulls after a 48-day period when males are food deprived.

Velando A., R. Beamonte-Barrientos, and R. Torres. 2006. "Pigment-based skin colour in the blue-footed booby: an honest signal of current condition used by females to adjust reproductive investment." *Oecologia*. 149 (3): 535–42. PMID: 16821015.

PELICANS IN THE FOSSIL RECORD

Walker, M. 2010. "Oldest Prehistoric Pelican Also Had Big Beak." *BBC Earth News*. http://news.bbc.co.uk/earth/hi/earth_news/newsid_8733000/8733503.stm

LIFT FORCE FROM WINGS

The way wings generate lift:

Alexander, D. *Nature's Flyers: Birds, Insects, and the Biomechanics of Flight*. Baltimore, MD: Johns Hopkins University Press. P 17–29.

GROUND EFFECT DURING FLYING

When a flying object is less than a wingspan above the water, the pattern of shed vortices from the wings is altered in such a way that drag is lowered. For a bird, this results in more energy-efficient flying.

Smith, HC. *The Illustrated Guide to Aerodynamics*. 2nd ed. NY, NY. Tab Books. (P 80–83).

THE BENEFITS OF FOLLOWING

The benefits and requirements of following another bird during flight:

Portugal S. J., T. Y. Hubel, J. Fritz, S. Heese, D. Trobe, B. Voelkl, S. Hailes, A. M. Wilson, and J. R. Usherwood. 2014. "Upwash Exploitation and Downwash Avoidance by Flap Phasing in Ibis Formation Flight." *Nature* 505: 399–402. PMID: 24429637

IMPORTANT BIRD AND BIODIVERSITY AREAS (IBAs)

BirdLife International. 2020. "Important Bird and Biodiversity Areas (IBAs)." https://www.birdlife.org/worldwide/programme-additional-info/important-bird-and-biodiversity-areas-ibas

Wikipedia contributors. 2020. "Important Bird Area." *Wikipedia, The Free Encyclopedia*. https://en.wikipedia.org/w/index.php?title=Important_Bird_Area&oldid=938356286

Bleaker Island is IBA site FK004:

BirdLife International. 2020. "Bleaker Island Group FK004." BirdLife Data Zone. http://datazone.birdlife.org/site/factsheet/bleaker-island-group-iba-falkland-islands-(malvinas)

6 | *Ducks, Geese & Swans*

SWAN UPPING

The process of counting the Royal Swans on the River Thames:

Cleaver, E. 2017. "The Fascinating, Regal History Behind Britain's Swans." *Smithsonian*, July 31, 2017. https://www.smithsonianmag.com/history/fascinating-history-british-thrones-swans-180964249/

CONTROLLING THE NUMBER OF SNOW GEESE

The euphemistically named *Conservation Order for Light Geese* is actually a license to kill more geese:

Legal Information Institute. 2015. "50 CFR § 21.60 – Conservation order for light geese." New York: Cornell Law School. Last updated March 16, 2015. https://www.law.cornell.edu/cfr/text/50/21.60

EXTERMINATION OF CANADA GEESE

The "round-up" for Canada Geese after the *Miracle on the Hudson*:

Akam, S. 2009. "For Culprits in Miracle on Hudson, the Flip Side of Glory." *New York Times*, October 2, 2009. https://www.nytimes.com/2009/10/03/nyregion/03geese.html?_r=1&partner=rss&emc=rss

THE MIGRATORY BIRD TREATY ACT (MBTA)

Greenspan, J. 2015. "The History and Evolution of the Migratory Bird Treaty Act." *Audubon*, May 22, 2015. https://www.audubon.org/news/the-history-and-evolution-migratory-bird-treaty-act

RAT AND MOUSE ERADICATION ON SOUTH GEORGIA

The victorious five-year battle to eradicate rats and mice on the island of South Georgia:

Martin, Tony, and Team Rat. 2017. *Reclaiming South Georgia: The Defeat of Furry Invaders on a Sub-Antarctic Island*. Dundee, UK: South Georgia Heritage Trust Publishing.

SOUTH GEORGIA IS DECLARED RODENT FREE

The May 9, 2018 press release from the South Georgia Heritage Trust:

South Georgia Heritage Trust. 2018. "World's Largest Rodent Eradication Project a Success: South Georgia Declared Rodent-Free!" London, UK: Press Release, May 9, 2018. http://www.sght.org/wp-content/uploads/2018/05/2.-SGHT-HRP-embargoed-accouncement_FINAL.pdf

7 | Raptors

FOSSIL EAGLE TALONS

The reinterpretation of the cache of fossilized White-tailed Eagle talons found more than 115 years earlier in Croatia:

Radovčić, Davorka, Oros Sršen Ankica, Radovčić, Jakov, and David W. Frayer. 2015. "Evidence for Neandertal Jewelry: Modified White-Tailed Eagle Claws at Krapina." *PLoS One*. 10(3): e0119802.

DOI: 10.1371/journal.pone.0119802

NEW ANALYSIS OF THE EAGLE TALONS FROM A NEANDERTHAL SITE

The use of modern techniques that confirm the use of eagle talons as jewelry:

Radovčić, D., Birarda, G., Sršen, A.O. et al. 2020. "Surface Analysis of an Eagle Talon from Krapina." *Nature Sci Rep* 10, 6329.

DOI: 10.1038/s41598-020-62938-4

The figure is reproduced with the permission of the authors.

THE EYE OF AN OWL

Schwab, Ivan R.. 2012. *Evolution's Witness: How Eyes Evolved*. Oxford, UK: Oxford University Press, 200.

HUNTING SUCCESS OF SHORT-EARED OWLS

In a study of Short-eared Owls hunting in Kentucky, the authors followed 182 hunting flights involving 505 attacks. They reported success rates of 10.9%.

Vukovich, M. 2008. "Foraging Behavior of Short-eared Owls and Northern Harriers on a Reclaimed Surface Mine in Kentucky." *Southeastern Naturalist* 7: 1-10. https://www.researchgate.net/publication/232686301_Foraging_Behavior_of_Short-eared_Owls_and_Northern_Harriers_on_a_Reclaimed_Surface_Mine_in_Kentucky

NOISE REDUCTION IN OWL WING FEATHERS

The features of barn owl wings that are thought to attenuate wing sounds and the potential application of these features to aircraft design:

Bachmann T, and H. Wagner. 2011. "The Three-dimensional Shape of Serrations at Barn Owl Wings: Towards a Typical Natural Serration as a Role Model for Biomimetic Applications. *J Anat*. 219 (2): 192–202. PMID 21507001

The full article can be found here:

doi: 10.1111/j.1469-7580.2011.01384.x

HOW BUTEOS CATCH THEIR PREY

Live Harris's Hawks (*Parabuteo unicinctus*), in a controlled simulation, provided data for a model of the sensorimotor mechanisms of prey capture:

Brighton, C. H., and G. K. Taylor. 2019. "Hawks Steer Attacks Using a Guidance System Tuned for Close Pursuit of Erratically Manoeuvring Targets." *Nat Commun*. 10 (1): 2462.

doi: 10.1038/s41467-019-10454-z

FOOTEDNESS IN OSPREYS

Allen, L. L., K. L. Morrison, W. A. E. Scott, S. Shinn, A. M. Haltiner, and M. J. Doherty. 2018. "Differences Between Stance and Foot Preference Evident in Osprey (*Pandion haliaetus*) Fish Holding during Movement. *Brain Behav.* 8 (11).

PMID: 30299002

PMCID: 6236243

DOI: http://dx.doi.org/10.1002/brb3.1126

THE ANCESTRY OF THE GALAPAGOS HAWK

Bollmer, J. L., R. T. Kimball, N. K. Whiteman, J. H. Sarasola, and P. G. Parker. 2006. "Phylogeography of the Galápagos Hawk (*Buteo galapagoensis*): A Recent Arrival to the Galápagos Islands." *Molecular Phylogenetics and Evolution* 39: 237–247.

doi: 10.1016/j.ympev.2005.11.014.

PMID: 16376110

8 | *Condors & Corvids*

MANUFACTURE OF TOOLS BY THE CALEDONIAN CROW

The first observation that Caledonian Crows manufacture their tools in 1996:

Hunt, G. R.. 1996. "Manufacture and Use of Hook-tools by New Caledonian Crows." *Nature* 379:249–251.

The abstract is accessible here: https://www.nature.com/articles/379249a0

DOI: https://doi.org/10.1038/379249a0

RECOGNITION OF HOSTILE HUMANS BY CROWS

The creative experiment designed to measure recall of human faces by crows:

Marzluff, J. M., J. Walls, H. N. Cornell, J. C. Withey, and D. P. Craig. 2010. "Lasting Recognition of Threatening People by Wild American Crows." *Animal Behaviour* 79 (3): 699–707.

The article is accessible here:

https://www.sciencedirect.com/science/article/pii/S0003347209005806

DOI: https://doi.org/10.1016/j.anbehav.2009.12.022

SOARING ABILITIES OF CONDORS

Eight Andean Condors were monitored using on-board telemetry devices to document every single wing beat, and the birds soared 99 percent of the time without any flapping of their wings:

Williams, H.J, Mark D. Holton, P. A. E. Alarcón, R. P. Wilson, S. A. Lambertucci. 2020. "Physical limits of flight performance in the heaviest soaring bird." Proceedings of the National Academy of Sciences, Jul 2020, 201907360;

DOI: 10.1073/pnas.1907360117

YAWAR FIESTA IN PERU

Unknown Blogger. 2013. "Flight of the Condor: Peru Bull Fiestas Threaten Future of Rare Andean Bird." *News*, January 29, 2013. http://readnews24h.blogspot.com/2013/01/fight-of-condor-peru-bull-fiestas.html

CORVIDS AND CONDORS IN THE AVIAN TREE OF LIFE

A sweeping revision of the phylogeny of birds, published in 2015:

Prum, R.O., J. S. Berv, A. Dornburg, D. J. Field, J. P. Townsend, E. M. Lemmon, and A. R. Lemmon. 2015. "A Comprehensive Phylogeny of Birds (Aves) Using Targeted Next-generation DNA Sequencing." Nature. 526: 569–73.

The abstract is available here:

DOI: www.doi.org/10.1038/nature15697

PMID: 26444237

CALIFORNIA CONDORS AND LEAD AMMUNITION

The challenges of eliminating lead ammunition:

Mock, J. 2019. "Lead Ammo, the Top Threat to Condors, Is Now Outlawed in California." *Audubon*, July 1, 2019. https://www.audubon.org/news/lead-ammo-top-threat-condors-now-outlawed-california

DESPOTIC MALE DOMINANCE IN ANDEAN CONDORS

The interaction between male, female and juvenile condors at feeding sites:

Donázar, J. A., A. Travaini, O. Ceballos, A.Rodriguez, M. Delibes, and R. Hiraldo. 1999. "Effects of Sex-associated Competitive Asymmetries on Foraging Group Structure and Despotic Distribution in Andean Condors. *Behav Ecol Sociobiol* 45: 55–65.

DOI: 10.1007/s002650050539

COLOR AND DOMINANCE IN ANDEAN CONDORS

The role of facial and neck skin color in Andean Condors dominance:

Marinero, N. V., V. B. Cailly-Arnulphi, S. A. Lambertucci, and C. E. Borghi. 2018. "Pigmentation and Not Only Sex and Age of Individuals Affects Despotism in the Andean Condor. *PLoS ONE* 13 (10): e0205197.

The full article can be read here:

DOI: https://doi.org/10.1371/journal.pone.0205197

SPECIES REVERSAL OF THE RAVEN

Evidence of species reversal in the raven:

Kearns A. M., M. Restani, I. Szabo, A. Schrøder-Nielsen, J. A. Kim, H. M. Richardson, J. M. Marzluff, R. C. Fleischer, A. Johnsen, and K. E. Omland. 2018. "Genomic Evidence of Speciation Reversal in Ravens." *Nature Communications*: (906):1–13.

The article can be accessed here:

https://www.nature.com/articles/s41467-018-03294-w

DISTINGUISHING CROWS FROM RAVENS

Cornell Lab of Ornithology. 2014. "What Is the Difference Between a Crow and a Raven?" *The Cornell Lab of Ornithology All About Birds*.

http://dl.allaboutbirds.org/crow_raven_difference?

SCULPTURE OF THE HAIDA CREATION MYTH

The creative process surrounding the Bill Reid sculpture:

Cross, A. 2011. *The Raven and the First Men: From Conception to Completion*. Vancouver, B.C.: UBC Museum of Anthropology. http://moa.ubc.ca/wp-content/uploads/2014/08/Sourcebooks-Raven_and_the_First_Men.pdf

9 | Cranes

CRANE FESTIVALS

deWolf, Arthur and Amy Evanstad. 2019. "Crane Festivals." Birdorable Blog. Last modified March 28, 2018. https://www.birdorable.com/blog/crane-festivals/

THE IMMORTALS

The mythological superheroes whom cranes had the task of transporting:

Zteve T. Evans 2016. "Chinese Mythology: The Eight Immortals." Under the influence! Myths, legends, folklore and tales from around the world. Last modified November 16, 2016. https://ztevetevans.wordpress.com/2016/11/16/chinese-mythology-the-eight-immortals/

PAPER ORIGAMI CRANES

Instructions for making paper origami cranes:

"Origami Crane." n.d. Origami Instructions.com. Accessed September 14, 2019. http://www.origami-instructions.com/origami-crane.html

A NATURAL HISTORY OF CRANES

A detailed exploration of the life and times of Whooping Cranes, as well as a broader discussion of cranes in general:

Hughes, Janet C. 2008. *Cranes: A Natural History of a Bird in Crisis*. Toronto: Firefly Books Ltd.

OPERATION MIGRATION

A fascinating movie about the program that guided human-reared Whooping Cranes from Wisconsin to Florida's Chassahowitzka National Wildlife Refuge:

"Operation Migration – Safeguarding the Whooping Crane." YouTube video, 3:45. Operation Migration. July 24, 2014. https://www.youtube.com/watch?v=XCiB5QkfLx4

WHITE-NAPED CRANES IN THE DEMILITARIZED ZONE OF THE KOREAN PENINSULA

Billock, Jennifer. 2018. "How Korea's Demilitarized Zone Became an Accidental Wildlife Paradise." Smithsonian.com. Last modified February 12, 2018. https://www.smithsonianmag.com/travel/wildlife-thrives-dmz-korea-risk-location-180967842/

MOVEMENT OF HOODED CRANES

Migration maps obtained by satellite tracking of nine Hooded Cranes that wintered in Izumi:

Mi, Chunrong, Anders Pape Møller, and Yumin Guo. 2018. "Annual Spatio-Temporal Migration Patterns of Hooded Cranes Wintering in Izumi Based on Satellite Tracking and Their Implications for Conservation." *Avian Research* 9 (1). https://doi.org/10.1186/s40657-018-0114-9

WRONG TURN CORRIGAN

Gianni, Tim. 2011. "Rare Asian Bird Takes 'Wrong Turn,' Lands in Tennessee." Reuters. Last modified December 27, 2011. https://www.reuters.com/article/us-tennessee-birds-asian-crane/rare-asian-bird-takes-wrong-turn-lands-in-tennessee-idUSTRE7BR03R20111228

OTOWABASHI (OTOWA) BRIDGE

Some details of the Otowabashi (Otowa) Bridge, including a picture of the bridge and a map:

Hokkaido "Tabi" (trip) Guide. n.d. "4312 Otowa Bridge." Accessed September 23, 2019. https://map.uu-hokkaido.jp/e/otowa-bridge/

Don't be deceived by the photograph of the bridge with just a handful of photographers! There were at least one hundred times more on each of the three occasions that I have visited.

10 | Songbirds

BIRDSONG AS MUSIC

Two contributions to the debate over whether or not birdsong should be considered music:

Araya-Salas. 2012. "Is Birdsong Music? Evaluating Harmonic Intervals in Songs of a Neotropical Songbird." *Animal Behaviour*.84(2):309–313.

Hollis Taylor 2017. *Is Birdsong Music? Outback Encounters with an Australian Songbird*. Bloomington, IN:. Indiana University Press.

COMPOSER OLIVER MESSSIAEN'S USE OF BIRDSONG

Messiaen's obituary mentions the many avian influences in his music:

Allan Kozinn. 1992."Olivier Messiaen, Composer, Dies at 83." *New York Times*, April 29, 1992. https://www.nytimes.com/1992/04/29/arts/olivier-messiaen-composer-dies-at-83.html

MOZART'S STARLING

The story of the starling that Mozart kept as a pet between 1784 and 1787 is delightfully told in the following book by an author who also raised her own young starling:

Lyanda Lynn Haupt. 2017. *Mozart's Starling*. New York:. Little Brown and Company.

WHITE-CROWNED SPARROWS LEARNING TO SING

The experiments with song deprivation and many other facts about this bird's song learning:

Bruce E. Byers and Donald E. Kroodsma. 2016. "Avian Vocal Behavior." Chapter 10 in *The Cornell Lab of Ornithology Handbook of Bird Biology* edited by Irby J. Lovette and John W. Fitzpatrick. Hoboken, NJ: John Wiley and Sons.

THE NUMBER OF LIVING BIRD SPECIES

The traditional estimate of the number of species of birds still living on Earth is somewhere between 9,000 and 10,000, and this is still the number you will find quoted by many authoritative sources.

However, the *status quo* was challenged in 2016 by a group of ornithologists who believe — based on an analysis of both morphology and molecular data — that the number may be almost twice the traditional estimate.

G. F. Barrowclough, J. Cracraft, J. Klicka, and R. M. Zink. 2016. "How Many Kinds of Birds Are There and Why Does It Matter?" *PLoS ONE* 11(11): e0166307. https://doi.org/10.1371/journal.pone.0166307

https://journals.plos.org/plosone/article?id=10.1371/journal.pone.0166307

THE EVOLUTION OF THE SYRINX

Kingsley, Evan P., Chad M. Eliason, Tobias Riede, Zhiheng Li, Tom W. Hiscock, Michael Farnsworth, Scott L. Thomson, Franz Goller, Clifford J. Tabin, and Julia A. Clarke. 2018. "Identity and Novelty in the Avian Syrinx." *Proc Natl Acad Sci U S A.* 115(41): 10209–10217.

DOI: 10.1073/pnas.1804586115

PMID: 30249637

SYRINX ANINMATION

An animation of the syrinx in action:

Cornell Lab of Ornithology "All about Bird Song." https://academy.allaboutbirds.org/features/birdsong/how-birds-sing

A slide show with similar information:

Cornel Lab of Ornithology. "Birdsong visualized slides." Accessed September 2, 2020, https://academy.allaboutbirds.org/bird-song-visualized-slides

REPERTOIRE SIZE IN MARSH WRENS

Experiments to measure the extent of the song repertoire of Marsh Wrens in different parts of the United States:

D. E. Kroodsma and J. Verner. 1987. "Use of Song Repertoires among Marsh Wren Populations." *Auk* 104: 63–72.

DUET SINGING IN PLAIN-TAILED WRENS

Melissa Coleman and Eric Fortune. 2018. "Duet Singing in Plain-tailed Wrens." *Current Biology* V28(11): R643–R645.

doi: 10.1016/j.cub.2018.02.066.

PMID: 29870698

MIMICRY IN THE NORTHERN MOCKINGBIRD

Kim C. Derrickson. 1988. "Variation in Repertoire Presentation in Northern Mockingbirds." *Condor* 90: 592–606.

THE STATUS OF BREWER'S BLACKBIRD

Although the *Red List* places Brewer's Blackbird in the *Least Concern* category, the *2014 Partners in Flight Report* listed the bird as one of 33 species that are presently common but in "Steep Decline" having lost more than half of their global population in the preceding four decades.

Cornell University. 2014. "State of the Birds 2014: Common Birds in Steep Decline." *The Cornell Lab All About Birds,* https://www.allaboutbirds.org/news/state-of-the-birds-2014-common-birds-in-steep-decline-list/

CHANGE IN THE SONG OF THE WHITE-THROATED SPARROW

The new song pattern in White-throated Sparrows, and its viral spread eastwards, with a video in which the old and new patterns can be heard:

Ken Otter, Alexandra Mckenna, Stefanie LaZerte, and Scott Ramsay. 2020. "Continent-wide Shifts in Song Dialects of White-Throated Sparrows." *Current Biology* 30: 1–5. https://doi.org/10.1016/j.cub.2020.05.084

PMID: 32619475

"I THOUGHT I HEARD A RED-WINGED BLACKBIRD'"

The song by the Scottish-Canadian singer-songwriter David Francey from his 1999 album *Torn Screen Door*:

David Francey. "David Francey – Red-winged Blackbird." *YouTube* video, 2:42. September 13, 2008. https://www.youtube.com/watch?v=-VQPeyAGdjk

THE NEAREST NEIGHBOR PREDICTION FOR FLOCKING BEHAVIOR

The role of entropy in flocking:

Michele Castellana, William Bialek, Andrea Cavagna, and Irene Giardina. 2016. "Entropic Effects in a Nonequilibrium System: Flocks of Birds." *Phys. Rev.* E 93.052416.

PMID: 27300933

DOI: 10.1103/PhysRevE.93.052416

The research that led to the estimate that each bird tracks and matches the flight kinematics of its seven nearest neighbors:

George F. Young, Luca Scardovi, Andrea Cavagna, Irene Giardina, and Naomi E. Leonard. 2013. "Starling Flock Networks Manage Uncertainty in Consensus at Low Cost." *PLoS Comput Biol*. 9(1). https://doi.org/10.1371/journal.pcbi.1002894

PMID: 23382667

THE INFLUENCE OF MOCKINGBIRDS ON DARWIN'S THOUGHT

The role that the mockingbirds of the Galápagos played in Darwin's developing theories of speciation and evolution (pages 118–122):

K. Thalia Grant and Gregory B. Estes. 2009. *Darwin in the Galapagos: Footsteps to a New World*. Princeton: Princeton University Press.

WING MORPHING IN BIRDS

The consequences of wing morphing for flight control:

Brett Klaassen van Oorschot, Emily A. Mistick, and Bret W. Tobalske. 2016. "Aerodynamic Consequences of Wing Morphing During Emulated Take-off and Gliding in Birds." *Journal of Experimental Biology* 219: 3146–3154.

DOI: 10.1242/jeb.136721

PMID: 27473437

11 | *Favorites*

MOON AND HALF DOME

Celebrated black-and-white landscape photographer Ansel Adams believed that the image *Moon and Half Dome* taken in Yosemite National Park was one of his finest images.

Adams, Ansel and Mary Street 1985. *Ansel Adams, an Autobiography*. Boston: Little, Brown.

The story of the image, including a discussion of the contact sheet from the shoot, is told by his son in this video:

"Ansel Adams: Making of Moon and Halfdome." YouTube video, 4:37, Ansel Adams Gallery, July 15, 2016. https://www.youtube.com/watch?v=o0QolZ3sYag.

VIDEO ANALYSIS OF ATLANTIC PUFFINS UNDERWATER

Diving puffins were studied using high-speed video:

Johansson, L. Christoffer, and Björn S. Wetterholm Aldrin. 2002. "Kinematics of Diving Atlantic Puffins (*Fratercula Arctica L.*): Evidence for an Active Upstroke." *Journal of Experimental Biology* 205 (3). https://jeb.biologists.org/content/205/3/371

THE DECLINE OF THE ATLANTIC PUFFIN

The threats to Atlantic Puffins:

Peter E. Lowther, Antony W. Diamond, Stephen W. Kress, Gregory J. Robertson, Keith Russell, David N. Nettleship, Guy M. Kirwan, David Christie, Chris Sharpe, Ernest Garcia, and Peter F. D. Boesman. "Atlantic Puffin (*Fratercula arctica*), version 1.0". In *Birds of the World* (S. M. Billerman, Editor). Cornell Lab of Ornithology, Ithaca, NY, USA. (Subscription required) https://doi.org/10.2173/bow.atlpuf.01

HORNBILL NESTING BEHAVIOR

Kemp, A. C. 1969. "Some Observations on the Sealed-in Nesting Method of Hornbills (Family: Bucerotidae)." *Ostrich*. 40: 149–155. https://doi.org/10.1080/00306525.1969.9639117

Finnie, Michael Joseph. 2012. "Conflict & Communication: Consequences of Female Nest Confinement in Yellow Billed Hornbills." PhD diss,. Clare College, University of Cambridge. https://pdfs.semanticscholar.org/ffd2/a7eb590abb059b88a38bd5381125f998f54f.pdf (accessed September 19, 2019)

van de Ven, Tanja M. F. N. 2017. "Implications of Climate Change on the Reproductive Success of the Southern Yellow-Billed Hornbill, *Tockus leucomelas*." PhD diss., University of Cape Town. https://open.uct.ac.za/bitstream/handle/11427/27552/thesis_sci_2017_van_de_ven_tanja_m_f_n.pdf?sequence=1&isAllowed=y

Epilogue

THE LAST GREAT AUKS
The story of the killing of the last pair of Great Auks:

"When the Last of the Great Auks Died, It Was by the Crush of a Fisherman's Boot". Samantha Galasso, smithsonianmag.com. July 10, 2014 https://www.smithsonianmag.com/smithsonian-institution/with-crush-fisherman-boot-the-last-great-auks-died-180951982/

THE LAST PASSENGER PIGEON
A remembrance of Martha, the last Passenger Pigeon, by her former keepers:

"Cincinnati Zoo Remembers "Martha," the World's Last Passenger Pigeon." Cincinnati Zoo." August 26, 2014 http://cincinnatizoo.org/news-releases/cincinnati-zoo-remembers-martha-the-worlds-last-passenger-pigeon/

SILENT SPRING
The iconic book that many cite as the founding document for modern conservation efforts:

Rachel Carson: *Silent Spring* (Boston, MA: Mariner Books, 1962).

THE SIXTH EXTINCTION
The first acknowledgment of the sixth extinction:

Barnosky, A., Matzke, N., Tomiya, S. et al. Has the Earth's sixth mass extinction already arrived?. *Nature* 471, 51–57 (2011). https://doi.org/10.1038/nature09678 (This article is behind a paywall.)

The book that increased public awareness of the changes in progress:

Elizabeth Kolbert; *The Sixth Extinction* (New York. Picador, Henry Holt and Company. 2014)

BIG FIVE MASS EXTINCTIONS
The five known mass extinction events in the history of the Earth:

Gemma Tarlach. "The Five Mass Extinctions That Have Swept Our Planet." *Discover*, July 18, 2018. https://www.discovermagazine.com/the-sciences/mass-extinctions

BIOLOGICAL ANNIHILATION
The importance of considering the decline of species — and not just extinction:

Gerardo Ceballos, Paul R. Ehrlich, and Rodolfo Dirzo. Biological annihilation via the ongoing sixth mass extinction signaled by vertebrate population losses and declines *PNAS* July 25, 2017 114 (30) E6089-E6096. July 10, 2017 https://doi.org/10.1073/pnas.1704949114

THE LOSS OF THREE BILLION BIRDS SINCE 1970
An account of the "staggering decline of bird populations":

Rosenberg, Kenneth V, Adriaan M Dokter, Peter J Blancher, John R Sauer, Adam C. Smith, Paul A Smith, Jessica C Stanton, et al. "Decline of the North American Avifauna." *Science* 366, no. 6461 (2019): 120–24. https://doi.org/10.1126/science.aaw1313

LIVING PLANET REPORTS FROM THE WWF
The 2020 report from the World Wildlife Foundation:

Almond, R.E.A., M. Grooten, and Petersen T. (Eds). "Living Planet Report 2020 — Bending the Curve of Biodiversity Loss." Gland, Switzerland, 2020. https://www.zsl.org/sites/default/files/LPR%202020%20Full%20report.pdf

REINTRODUCTION OF CALIFORNIA CONDORS
A brief history of the California Condor recovery program:

California Condor Reintroduction & Recovery. National Parks Service. https://www.nps.gov/articles/california-condor-recovery.htm

SPECIES SAVED SINCE 1993
An account of bird and mammal species that have been saved by human intervention:

Friederike C. Bolam, Louise Mair, Marco Angelico et al. "How many bird and mammal extinctions has recent conservation action prevented?" *Conservation Letters*. 09 September 2020, https://doi.org/10.1111/conl.12762

Index

Page numbers in italics represent photos/illustrations/charts.

aerial combats. *See* battles, air
African Fish-eagles, 17, 34, *35*, 128
African Hawk-eagles, 32, *33*
African Sacred Ibis, 111, *113*
airplanes, 146, 172, 256–7, 286, *286*
Akan Crane Center, 18, 222, 297
Allen's Hummingbirds, 54
allometry, 110
altering bird behaviors, 40
Amazon Kingfishers, *85*
American Avocets, 11, 88, *88*
American Crows, 182–3, 192, *193*
American Goldfinches, *228*, 246, *247*, *301*
American Robins, 248, 281
American White Pelicans, 126, *127*, *293*
Anatidae overview, 134–5, *137*
Andean Condors, *180–1*, *183*, *184*, 188, *194*, *195*, 202, *203*, 296
Anderson, John, 65
Antarctic Terns, 82, *83*, *291*, 291
Aquila constellation, 14, *15*
Aransas National Wildlife Refuge, Texas, 126
Arctic Terns, 63, 65, 82, 286
Atlantic Puffins, 88–9, *89*, 258, *258*, *283*
Audubon, John James, 122, 234

Bahama Mockingbirds, 244
Bald Eagles, *12–3*, 16, *25*, *160*, *193*, 256
 overview, 14–5
 allometry, 110
 vs. American Crows, 192

 feeding, 168
 mortality, 26
 photographing, 17
 sexes, 294, *294*
 vs. Steller's Sea-eagles, 20
 as threatened, 281
 wings, 288
Band-rumped Storm-Petrels, 92, *93*
Bateleurs, 28, *29*, 288
battles, air, 26, 162, 166
battles, ground, 154, 244, 300, *300*
Belcher, Edward, 66
Belcher's Gulls, 66, *67*, 110
bills, 92, 159, 292
Bingham, Hiram, 111, 190
binoculars, 22, 34
binomial system for naming, 302
"A Bird Came Down the Walk" (Dickinson), 298
birding, 28
Birds of America (Audubon), 122
Birds of the World (Cornell), 238, 250, 286
Black Kites, 10, 172, *173*
Black Mulberry tree, *301*
Black Skimmers, 96, *97*, 98, *99*, *291*, 291
Black-Browed Albatrosses, 264
Black-headed Gulls, 78
Black-legged Kittiwakes, *60*
Blacksmith Lapwings, 128
Black-tailed Godwits, 100, *101*
Blakiston, Thomas Wright, 176
Blakiston's Fish-Owls, 176, *177*
Bleaker Island, Falkland Islands, 130
Blue-footed Boobies, 80, 116, *116–7*, 118, 292, *292*
Boat-billed Herons, *106–7*
Bolivar Peninsula, Texas, 96
Bolivian coat of arms, 183
boobies overview, 292

booted racket-tailed hummingbirds, 289, *289*
Bosque del Apache National Wildlife Refuge, New Mexico, 216
brains, 182–3
Brewer, Thomas Mayo, 234
Brewer's Blackbirds, 234, *235*
Brown Pelicans, 124, *125*
Brown Skuas, 82, 255, *255*, *293*
Buffleheads, 140, *141*

California Condors, *185*, 186, *187*, 283
Californian Marsh Wrens, 232
calls, 230–2
Canada Geese, 146, *147*
Canada Thistles, 246, *300–1*
Capybaras, 291, *291*
Carcass Island, Falkland Islands, 178
Carson, Rachel, 280–1
Caspian Terns, 65, 68, *69*, 286, *286*
Cedar Waxwings, 248, *249*
Chestnut-eared Aracaris, 266, *301*
Chilean Flamingos, *111*
Clark, Chris, 54, 289
Codex on the Flight of Birds (da Vinci), 172
Colca Canyon, Peru, 188
Collared Aracaris, 266, *267*, *301*
Common Nightingales, 298
Common Ostriches, 111
Common Ravens, 196, *197*, 200, *201*, 295, *295*
condors and corvids overview, 182–5
Corrigan, Douglas "Wrong Way," 214
"Corrigan the Crane," 214
cranes overview, 206–9, *207*, 220
Cross, Theodore Lamont, 11, 86

da Vinci, Leonardo, 10, 172
Darwin, Charles, 134–5, 244
Darwin's finches, 80
De Roy, Tui, 70
Dickinson, Emily, 298
Dodos, 280
ducks, geese and swans overview, 134–5, *137*
Dunlins, 90, *91*

eagles overview, 14–5, 26
Ecuador coat of arms, *183*
Elephant Birds, 280, *281*
emotions, 183
environmental issues, 280–5. *See also* species in decline
Española/Hood Mockingbirds, 244, *245*, 300, *300*
Eurasian Skylarks, 232
Eurasian Spoonbills, 78, 290, *290*
European Starlings, 242, *242–3*
eyes/seeing, 80, 159, 161, *161*, 236

facial flushing, 202
Falkland Steamer-Ducks, 134
feeders, 40–1
feeding
 air battles, 166
 Band-rumped Storm-Petrels, 92
 Black Skimmers, 96
 Blakiston's Fish-Owls, 176
 Blue-footed Boobies, 116
 Boat-billed Herons, 106
 Brown Pelicans, 124
 California Condors, 186
 Caspian Terns, 68
 Collared Aracaris, 266
 condors, 183
 gulls, 62–3
 hornbills, 260
 hummingbirds, 38–9, 42, 56, 58

Lava Gulls, 70
Ospreys, 161
photographing, 161
Red-crowned Cranes, 18
Short-eared Owls, 162
Snow Geese, 142
Snowy Sheathbills, 262
Striated Caracaras, 178
Whimbrels, 104
White-naped Cranes, 212
Woodland Kingfishers, 236
Yellow-legged Gulls, 78
feet, 116, 168, 231, *231*, *298*
fiddler crab tunnels, 291, *292*
Fingal's Cave (*The Hebrides Overture*) (Mendelssohn), 258
Firth of Forth, Scotland, 274
Flight Mechanics
 aerodynamic hindrance, 48
 alula, 268
 allometry, 242
 aspect ratio, 272
 downstroke, 24
 dynamic soaring, 272
 feather rotation, 24
 feet as control surfaces, 114
 flight mechanics, 11
 gulls, 62, 290
 head stabilization, 42
 hovering, 38–9, 42
 hunting, 162, 166
 landing, 140, 220, 291
 leading edge, 46
 lift and airspeed, 150, *293*
 lift force, 126
 lift generation, 24, 92
 lift-to-drag ratio, 68
 murmuration, 242
 noise-reducers, 164
 of hummingbird flight, 38, 46, 56
 plunge dive, 274
 redundancy, 144
 size/mass, 110
 soaring, 30, 183, 188, 272, 310
 slotted wings, 10
 take off, 144, 216
 terminal primaries, 10
 thrust, 148
 turbulent airflow, 78
 turning, 18
 wing loading, 30
 wings underwater, 258
flying
 overview, 10–1, 24
 aggregation, 242, 299–300, *299*
 American White Pelicans, 126
 Andean Condors, 183
 Black Kites, 172
 Black Skimmers, 96
 Black-tailed Godwits, 100
 Buffleheads, 140
 Caspian Terns, 68
 Dickinson poem, 298
 European Starlings, 242
 evolution of, 106
 excess water and, 76
 Falkland Steamer-Duck, 134–5
 feet, 116
 and fighting, 26, 56, 162
 in formation, 90
 hummingbirds, 42
 landing, 140, 220, 291
 mistakes, 98
 and molting, 144
 neck and legs, 111
 as perfection, 256–7
 puffins, 258
 Red-billed Choughs, 198
 Sandhill Cranes, 216, 220
 soaring, 30, 183, 188, 272, 310
 swallows, swifts and martins, 250
 terns, 82
 Whooper Swans, 150
 wing loading, 30
 and wings, 78, 111, 148, 246, 286, *293*
foot color, 116

fossils, 124
Franklin, Benjamin, 14
Frigatebirds, 80

Galápagos Hawks, 174
Galápagos Islands, Ecuador, 70, 80, 102, 174
Gates, Rosemary, 272
geese. *See* ducks, geese and swans overview; *specific types*
Gentoo Penguins, 178, *178–9*, 264
Glaucous-winged Gulls, 63, *65*, 72, *73*
Glossy Ibis, 268, *269*, *302*
Godthul, South Georgia, 152
Golden Eagles, 14, 30, *31*
Goliath Herons, 128, *129*, *293*, 293
Gray Whales, 90
Graylag Geese, *136*
Great Auks, 280, *281*
Great Blackbacked Gulls, 65
Great Frigatebirds, 114
Great Horned Owls, 159, *161*
Great Salt Lake, Utah, 11
Great Seal of the United States, 14, *15*
Grey Herons, *112*
gulls and terns overview, 62–3, 65

Haida People, 200, 296
Hawaiian Stilts, 94, *95*
Hawk Eagles, *288*
Heermann's Gulls, *64*
Herring Gulls, 63, 65
hieroglyphs, 292, *292*
Hilmarsson, Jóhann Óli, 15, 100
hippopotamus, *302*
Hooded Cranes, 214, *214–5*
hopping, 302
House Finches, *233*
hovering, 38–9, 42
Hughes, Janet, 207
hummingbird geoglyph, 41, *41*
hummingbirds overview, 38–41, *39–40*, 42, 113

"I thought I Heard a Red-winged Blackbird" (song), 240
Icelandic Bird Guide (Hilmarsson), 15
Important Bird and Biodiversity Area (IBA), 130
Inca Terns, 74, *75*
Indigenous Peoples, 15, 200, 296
Inner Hebrides, Scotland, 258, *258*
International Union for Conservation of Nature (IUCN), 286–7
irruptions, 164
Izumi Crane Observation Center, 212, 296–7

Jabirus, *108–9*
juveniles, 26, 32, 62, 82

Kagoshima Prefecture, Japan, 172
Kakaso'Las Totem Pole, *17*
Kauai, Hawaii, 94, 114
Keats, John, 298
Keel-billed Toucans, *256*, 276, *277*
King Penguins, 264
Klaassen van Oorschot, Brett, 246
Kodak 3A Special camera, *295*
Koepcke's Hermits, 44, *45*
Kolbert, Elizabeth, 281–2
Kruger National Park, South Africa, 22, 32, 34, 128, 236

Lambertini, Marco, 283
large water birds overview, 110–1, 113, 128
Latham, John, 76, 290
Lava Gulls, 70, *71*
Lawson, Bruce, 32, 34, 260
Laysan Albatrosses, 114
Leadwood trees, 23, 28
legs, 94
Lettered Aracaris, 302, *302*
Lilac-breasted Roller, 232, *232*
Lilienthal, Otto, 10
Linnaeus, C., 302

Living Planet Index, 282
Lost City of the Incas (Bingham), 190

Magnificent Frigatebirds, 102, 118, *119*
Manú National Park, Peru, 44
Marvelous Spatuletails, 48, *49*, *283*
Mendelssohn, Felix, 258
migrations, 90
Migratory Bird Treaty Act, 135, 137, 280
mobbing, 192
Moyobamba, Peru, 52
Muir, John, 275, 303, *303*
murmuration, 242
Mute Swans, 134, 230

A Natural History of a Bird in Crisis (Hughes), 207
Nazca Boobies, 102
Nazca Lines, 41, *41*
Neanderthals, 158–9
nesting, 260
New Caledonian Crows, 182, *183*
New Island, Falkland Islands, 154
Northern Gannets, 274, *275*
Northern Harriers, 162
Northern Jacanas, 88, *88*
Northern Mockingbirds, 231, 232
Northern Pintail, 138, *139*

Ocher Sea Stars, 72, *73*
"Ode to a Nightingale" (Keats), 298
origami, 206–7
Ospreys, 76, 156–7, 158, *159*, 161, 168, *169*
Otter, Ken, 238
owls overview, 162, 294

Parke, Trent, 268
Passenger Pigeons, 135, 280
passerines, 231, *231*
pelicans, 106
penguins, 178, 255, *255*. *See also specific types*
Peregrine Falcons, 166

Peruvian Booted Racket-tails, 46, *47*
photography, of birds
 overview, 10–1, 24
 accidents, 164
 air battles, 26
 American Goldfinches, 246
 Andean Condors, 194, 296
 Antarctic Terns, 291
 Atlantic Puffins, 258
 avian aspect ratios, 266
 backgrounds, 82, 218
 birds loving, 234
 black colored birds, 184–5, 192, 295, *295*
 Blue-footed Boobies, 116
 Cedar Waxwings, 248
 composition, 118
 contrast, 24
 and destination knowledge, 102
 ducks, geese and swans, 137
 dynamic range, 287
 Española/Hood Mockingbirds, 300
 favorite images, 254–7
 feeding, 161
 human reaction time, 34
 landing shots, 140
 large birds, 110
 Magnificent Frigatebirds, 118
 Northern Pintails, 138
 Ospreys, 161, 168
 Red-crowned Cranes, 220
 Red-footed Boobies, 114
 Red-tailed Hawks, 166
 Red-winged Blackbirds, 240
 Rufous-chested Swallows, 250
 Sandhill Cranes, 218
 Short-eared Owls, 162
 small birds, 88–9, 232–3
 small water birds, 87
 Snow Geese, 142
 Southern Rockhopper Penguins, 264
 staking out species, 104
 sunsets, 220
 swallows, swifts and martins, 250
 waiting for shot, 15, 22, 28, 120, 128
 wet weather, 224
 White-crowned Sparrows, 238
 wings, 220
photography, camera details
 1.4x extender, 34, 120
 70–200 mm zoom lens, 89
 500 mm lens, 22, 26, 34, 104, 303
 bokeh (artifacts), 74, 75
 circular buffers, 233, 238, 288
 depth of field, 74
 "exposure compensation" setting, 124, 185, 196, 198
 exposures/apertures, 17, 40, 184, 185, 192, 220, 224, 287–8
 fast lenses, 76
 fast shutter speeds, 40, 48, 76, 94, 104, 118, 138, 192, 233
 without flashes, 48
 focusing, 22, 100, 114, 140, 220, 250
 gimbal stabilizers, 18, 26, 96, 194
 high-continuous drive, 192
 image stabilization, 303
 ISO speed, 48, 76, 104, 106
 light, 268
 light reflection, 17
 and location of sun, 24
 micro four-thirds combination, 276
 mirrorless cameras, 184, 185, 233, 288
 pixels, 184–5
 ready cameras, 150
 sensors, 186
 shots in a day, 22
 shutter release cables, 22, 34
 single-lens reflex (SLR) cameras, 184
 slow shutter speeds, 42, 94, 106, 198, 303
 spot-metering, 184–5
 stops, 287–8
 strobe lights, 40, 44, 52
 test shots, 185
 zoom lenses, 220
Pichincha, Ecuador, 42
Plain-tailed Wrens, 232
poisoning birds, 234
post-processing
 black details, 192
 bringing up shadows, 17
 noise filters, 48
 spot removal, 186, 295, *295*
purple colour, 54
Purple-throated Woodstars, 54, *55*, 289

Quito, Ecuador, 58

raptors overview, 158–9, 161, 294
rats, 152
The Raven and the First Men (sculpture), 200, 296, *296*
Reclaiming South Georgia (Martin), 152
Red Floripontio, 38, *39*, *51*
The Red List, 286–7
Red-and-Green Macaws, 270, *271*
Red-billed Choughs, 198, *199*
Red-billed Tropicbirds, 102, *103*, *284*
Red-crowned Cranes, 18, 206, 208–9, 222, *223*, 224, *225*, *226*, *227*, *257*, 297–8
Reddish Egrets, 86–7, *87*
Red-footed Boobies, 114, *115*, 118
Red-tailed Hawks, 166, *167*
Red-tailed Tropicbirds, 114
Red-winged Blackbirds, 240, *241*, *285*

Reid, Bill, 200, 296
HMS *Resolute*, 66
Resplendent Quetzals, *253*
Rico-Guevara, Alejandro, 58
Ring-billed Gulls, 65
Roseate Spoonbills, 122, *123*
Rubega, Margaret, 58
Ruddy-headed Geese, 135, 144, *145*
Rufous-chested Swallows, 250, *251*
Rufous-crested Coquettes, 52, *53*
Rufous-tailed Hummingbirds, 56, *57*

Saddle-billed Storks, 120, *121*, 230
Sandhill Cranes, 208, *209*, 210, 216, *217*, 218, *219*, 220, *221*, *297*, 297
Sandwich Terns, 76, *77*
Sanibel Island, Florida, 76
Sasaki, Sadako, 206–7, *296*
Scarlet Macaws, 270, *271*
"seagulls," 62
sexual dimorphism, 140
Shakespeare, William, 230, 294, 298, 300
Sheddan, Maggie, 274
Shelley, Percy Bysshe, 299
Shining Sunbeams, 58, *59*
Short-eared Owls, 162, *163*
Silent Spring (Carson), 280–1
The Sixth Extinction (Kolbert), 281–2
size/mass, 110
To a Skylark (Shelley), 299
small birds, 232–3
small water birds overview, 86–9
snags, *23*, 28, *29*
Snail Kites, 170, *171*
Snow Geese, 142, *142–3*
Snowy Egrets, *111*
Snowy Owls, 161, 164, *165*
Snowy Sheathbills, 262, *263*
song birds overview, 230–3
songs, 230–2, 236, 238, 248, 250
South American Fur Seals, 130

Southern Giant-Petrels, 130, *130–1*, 255, *255*, 293, *293*
Southern Rockhopper Penguins, 154, 264, *264–5*
Southern Yellow-billed Hornbills, 260, *261*
species in decline
 overview, 280–4, *282*
 Atlantic Puffins, 88–9, *89*, 258, *258*, 283
 Black-Browed Albatrosses, 264
 Brewer's Blackbirds, 234, *235*
 California Condors, *185*, 186, *187*, 283
 cranes, 207–9 (see also *specific types*)
 Galapagos Hawks, 174
 gulls and terns, 65 (see also *specific types*)
 Hawaiin Stilts, 94, *95*
 Lava Gulls, 70, *71*
 Laysan Albatrosses, 114
 Marvelous Spatuletails, 48, *49*, 283
 The Red List, 286–7
 Ruddy-headed Geese, 135, 144
 sea stars, 72, *73*
 Steller's Sea-eagles, 20, *21*
 Striated Caracara, 178, *179*
 Trumpeter Swans, 135, 148, *149*
 Wandering Albatrosses, 272, *273*
 Waved Albatrosses, 174, *278–9*
 White-tailed Eagles, 18, *19*, *27*, 158–9, *257*
 Whooping Cranes, 204–5, 208, 210, *211*, 283
 Wood Ducks, 135
 Yellow-Billed Pintails, 152, *153*
Squacco Herons, 128

Steller, Georg Wilhelm, 20
Steller's Sea-eagles, 20, *21*
The Storks (Andersen), 111, 113
Striated Caracaraw, 178, *179*
Swainson's Hawks, 174
Swallow-tailed Gulls, 80, *81*, 102, *290*
swans. *See* ducks, geese and swans overview; *specific types*
Sword-billed Hummingbirds, 38, *39*, 50, *51*, 289, *289*
syrinx, 232

talons, 158–9, *158*, *159*, 166
taxidermy, 122
Temple of the Condor, 190, *190–1*
terns. *See* gulls and terns; *specific types*
Texel, the Netherlands, 78
Toco Toucans, *303*
tools, 182–3, *183*
torpor, 39
Toth, *113*
trachea, 232, *232*
Trumpeter Swans, 135, 148, *149*
Tsurui Ito Tancho Crane Sanctuary, 224
Turkey Vultures, 10

Upland Geese, 154, *155*, 293–4, *294*

Verreaux's Eagle-Owls, 161
Violet-tailed Sylph, *40*
The Voyage of the Beagle (Darwin), 134–5

Wagler, Georg, 234
Wahlberg, August, 22
Wahlberg's Eagles, 22, *23*
Wandering Albatrosses, 272, *273*
water, 88, 89, 92, 255
waterbirds. *See* large water birds overview; small water birds overview; *specific types*
Waterbirds (Cross), 86
Waved Albatrosses, 174, *278–9*

Whimbrels, 104, *105*
White Storks, 10, *111*, 113
White-backed Vultures, 28, *288*
White-crowned Sparrows, 231, 236, *239*
White-naped Cranes, 212, *213*
White-tailed Eagles, 18, *19*, *27*, 158–9, *257*
White-whiskered Hermits, 42, *43*
Whooper Swans, *132–3*, *137*, 150, *150–1*
Whooping Cranes, 204–5, 208, 210, *211*, 283
wings
 alula, 10
 American White Pelicans, 126, *293*
 avian aspect ratios, 266, 301
 Bald Eagles, 288
 and flight, 30, 111, 144, 148, 246
 as focal point, 220
 Glossy Ibis, 268
 hummingbirds, 39, 54, 289
 leading edge, 46
 noise-reducers, 164
 patagium, 24
 Sword-billed Hummingbirds, 289
 threatening pose, 244
Wandering Albatrosses, 272
wing droops, 63, *290*
wing tips, 286, *286*
Wire-crested Thorntails, *36*
Wood Ducks, 135
Wood Storks, 230
Woodland Kingfishers, 236, *237*
Woodpecker Finches, 182
Worshipful Company of Vintners, 135
Wright brothers, 10

Yanacocha, Ecuador, 50
Yawar fiesta, 183–4
Yellow-Billed Pintails, 152, *153*
Yellow-legged Gulls, 78, *78–9*

Acknowledgments

This journey began when Rick Matson, a bird photographer himself, invited me to join the Department of Orthopaedics and Sports Medicine at the University of Washington in 2008. During time away from the lab, my eyes were soon opened to the rich ecosystems of the Pacific Northwest. I began seeking out and photographing flying birds as a gateway into this new universe.

Since then, I have learned and benefited from many guides and co-travelers with whom I have shared wild places around the globe. They have led me to species that I could never have found if left to my own devices. Also, the often-unrecognized individuals who have worked tirelessly to protect these sanctuaries and their avian inhabitants for future generations deserve unending gratitude.

Assembling the photographs and stories for this book has been its own adventure, one that has required help and encouragement from many sources:

Ann Vandervelde challenged me to progress beyond photo-documentation with her finely honed sense of artistic composition, color and balance. She believed in my new direction from the outset and enhanced the result by her presence and love. Our children and grandchildren have supported their (grand) father's second act with love, patience and curiosity.

The first reader and editor, Beth St George, bought both literary and birding skills to what was, at the time, an orphan manuscript. Her early enthusiasm for the book was sustaining.

At Firefly Books, I am grateful to publisher Lionel Koffler for his confidence in the work. My editor Darcy Shea was a thoughtful mentor and advocate during the inevitable push and pull involved in fashioning a "real" book from my initial concept. Copy editor Nancy Foran untangled some occasionally twisted prose and fact-checked many of my statements. The layout benefited greatly from designer Hartley Millson's keen eye for style.

The support of curators and judges at the Seattle Museum of Flight, the Seattle Aquarium, and the Audubon Society has been important to my development as a photographer and as a storyteller of bird flight.

Each photograph in the book is the result of a chance encounter between my eye, my camera lens and a flying bird. When the shutter clicks to record that conjunction, I acknowledge the privilege and joy of being a witness to a near-perfect biomechanical process that started with the first avian flight some 150 million years ago.